DYLAN GOES ELECTRIC!

ALSO BY ELIJAH WALD

Talking 'Bout Your Mama:
The Dozens, Snaps, and the Deep Roots of Rap

The Dozens:
A History of Rap's Mama

The Blues:
A Very Short Introduction

How the Beatles Destroyed Rock 'n' Roll:
An Alternative History of American Popular Music

Global Minstrels:
Voices of World Music

Riding with Strangers:
A Hitchhiker's Journey

The Mayor of MacDougal Street:
A Memoir by Dave Van Ronk with Elijah Wald

Escaping the Delta:
Robert Johnson and the Invention of the Blues

Narcocorrido:
A Journey into the Music of Drugs, Guns, and Guerrillas

Josh White:
Society Blues

River of Song:
A Musical Journey Down the Mississippi
(with John Junkerman)

Exploding the Gene Myth
(with Ruth Hubbard)

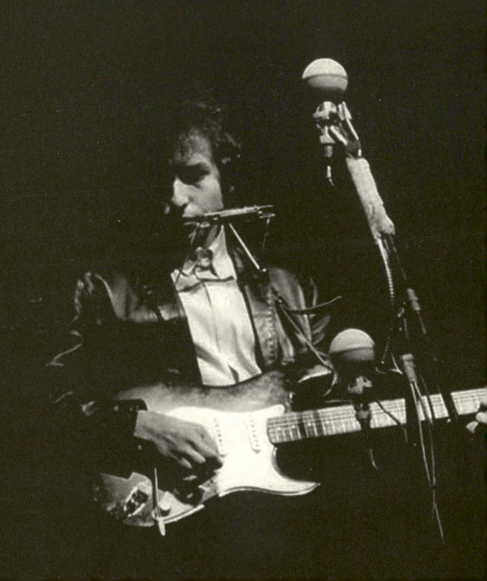

Newport, Seeger, Dylan,
and the Night That Split the Sixties

DYLAN

GOES
ELECTRIC!

ELIJAH WALD

DEY ST.

DEY ST.

HarperCollins books may be purchased for educational, business, or sales promotional use. For information please e-mail the Special Markets Department at SPsales@harpercollins.com.

FIRST EDITION

Designed by Shannon Plunkett
Title page photograph by Diana Davies, courtesy of the Ralph Rinzler Folklife Archives and Collections, Smithsonian Institution

Library of Congress Cataloging-in-Publication Data has been applied for.

ISBN 978-0-06-236668-9

15 16 17 18 19 OV/RRD 10 9 8 7 6 5 4 3 2 1

To Sandrine

CONTENTS

ACKNOWLEDGMENTS

This book explores the world I grew up in, and the first round of thanks goes a long way back: To Pete Seeger and Bob Dylan, both of whom profoundly influenced me, though I've never met Dylan and had only a few visits with Seeger. To Dave Van Ronk, who taught me so much about music, writing, and life, and Eric Von Schmidt, the only person ever to hire me as a harmonica player. And to my parents, George Wald and Ruth Hubbard, who bought me records, took me to concerts, and immersed me in the political struggles of the 1960s—though, alas, they never took me to the Newport festivals.

I tried whenever possible to go back to primary sources—recordings, film, and writing from the periods I was covering—and was fortunate to have fuller access to some key sources than the myriad previous researchers who have covered much of this ground. In particular, I was able to hear clean copies of virtually all the Newport Folk Festival tapes, with guidance as to who appeared on every concert and workshop and what they sang, allowing me to correct and expand on previous descriptions not only of Dylan's set but of performances by Seeger, Joan Baez, the Paul Butterfield Blues Band, the Chambers Brothers, Richard and Mimi Fariña, and many others. The greatest pleasure of this project was being able to immerse myself for days on end in the incredible

music at those festivals, and when I quote or describe a Newport performance without a citation in the endnotes, I am working directly from audio or film of the events, supplemented by background material from the deliberations and correspondence of the festival board. Most of the tapes were preserved by Bruce Jackson and are now available at the Library of Congress, where I owe special thanks to Todd Harvey, who also provided Alan Lomax's files of Newport board meetings and correspondence; to Ann Hoog; and to Rob Cristarella, who digitized the tapes and explained sonic subtleties I would have missed. I was able to fill remaining gaps thanks to Fred Jasper at Vanguard/Welk Music, and I owe a special debt to Murray Lerner, whose films *Festival!* and *The Other Side of the Mirror* are matchless resources on Newport and Dylan, and who provided added context and access to footage of moments that were not caught on the audio tapes. Particular thanks (and a dinner in New Orleans) to Mary Katherine Aldin for her unique concordance to the Newport tapes and her infinite patience. Further thanks to Jeff Place, Stephanie Smith, Greg Adams, and everyone at Smithsonian Folklife, who guided me through Ralph Rinzler's files of Newport board minutes and correspondence and Diana Davies's photographs; Mitch Blank, Dylanologist extraordinaire, who welcomed me to his home and showered me with documents and recordings; and to all the people over the years who have preserved Dylan's concert and interview tapes. Also to Jasen Emmons at the Experience Music Project for Robert Shelton's reporter's notebook from the 1965 festival; Herb Van Dam for the scrapbook he and Judy Landers compiled that year; Ron Cohen, who once again opened his voluminous files on the folk revival; Steven Weiss and Aaron Smithers at the University of North Carolina's Southern Folklife Collection; Dave Samuelson for the Weavers' electric session; Jeff Rosen, Todd Kwaite, Nick Spitzer, and Joe Carducci for passing along interviews with key figures; and all the helpful folks at the Tufts University Library, the Medford Public Library, and the Boston Public Library.

I am likewise indebted to all the people I interviewed or who

answered my emailed queries, and I apologize to those who are not quoted: I favored period sources, which I often understood only because I had the chance to talk with people who were there, and some of the most helpful conversations did not end up in print. So equal thanks, in alphabetical order, to M. Charles Bakst, Jessie Cahn, Willie Chambers, Len Chandler, John Cohen, Jim Collier, John Byrne Cooke, Barry Goldberg, Bill Hanley, Jill Henderson, Bruce Jackson, Robert Jones, Norman Kennedy, John Koerner, Al Kooper, Barry Kornfeld, Jim Kweskin, Jack Landrón, Julius Lester, Raun MacKinnon Burnham, Janie Meyer, Geoff Muldaur, Maria Muldaur, Mark Naftalin, Tom Paley, Jon Pankake, Tom Paxton, Arnie Riesman, Jim Rooney, Mika Seeger, Betsy Siggins, Peter Stampfel, Jeffrey Summit, Jonathan Taplin, Dick Waterman, George Wein, David Wilson, and Peter Yarrow. Plus the many other people who were at Newport and added useful tidbits and insights, including Peter Bartis, Christopher Brooks, Dick Levine, Ann O'Connell, Ruth Perry, and Leda Schubert.

Further thanks to everyone who provided hints, encouragement, and words of advice, including David Dann, Greg Pennell, Clinton Heylin, Ben Schafer, and all who responded to my attempts at Facebook crowd-sourcing. I could not possibly name all of you, so please forgive my omissions. Among the unomitted, thanks to Peter Keane for many long and fruitful conversations and to Matthew Barton for reading through the manuscript and saving me from some grievous errors.

At the production end, I must first thank my wife, Sandrine Sheon (a.k.a. Hyppolite Calamar), who interrupted her clarinet studies to lend a hand with transcriptions of quotations, put up with six months of deadline panic, and employed her design skills to craft the photo insert. My redoubtable agent, Sarah Lazin, worked overtime to find this book a good home and confronted me with a difficult choice between several (thanks to Suzanne Ryan and Ben Schafer for understanding and continued friendship). Denise Oswald at Dey Street Books has been a consistently helpful, encouraging, and appropriately challenging editor. Heather Pankl quickly and reliably transcribed many of the interviews.

Ben Sadock's copyediting saved me embarrassment and sent me on some interesting fact-finding missions, and his expansive knowledge of music and languages turned up some unexpected tidbits. Marilyn Bliss once again provided her admirable indexing skills. To all of you, and to everyone else who was supportive and helpful in this process, many, many thanks.

INTRODUCTION

On the evening of July 25, 1965, Bob Dylan took the stage at the Newport Folk Festival in black jeans, black boots, and a black leather jacket, carrying a Fender Stratocaster in place of his familiar acoustic guitar. The crowd shifted restlessly as he tested his tuning and was joined by a quintet of backing musicians. Then the band crashed into a raw Chicago boogie and, straining to be heard over the loudest music ever to hit Newport, he snarled his opening line: "I ain't gonna work on Maggie's farm no more!"

What happened next is obscured by a maelstrom of conflicting impressions: The *New York Times* reported that Dylan "was roundly booed by folk-song purists, who considered this innovation the worst sort of heresy." In some stories Pete Seeger, the gentle giant of the folk scene, tried to cut the sound cables with an axe. Some people were dancing, some were crying, many were dismayed and angry, many were cheering, many were overwhelmed by the ferocious shock of the music or astounded by the negative reactions.

As if challenging the doubters, Dylan roared into "Like a Rolling Stone," his new radio hit, each chorus confronting them with the question: "How does it feel?" The audience roared back its mixed feelings, and after only three songs he left the stage. The crowd was screaming louder than ever—some with anger at Dylan's betrayal, thousands more

because they had come to see their idol and he had barely performed. Peter Yarrow, of Peter, Paul, and Mary, tried to quiet them, but it was impossible. Finally, Dylan reappeared with a borrowed acoustic guitar and bid Newport a stark farewell: "It's All Over Now, Baby Blue."

That is the legend of Dylan at Newport, and much of it is true. Seeger did not have an axe, but that story became so widespread that eventually even he found a way to fit it into his remembrances, saying he shouted, "If I had an axe, I'd chop the mike cable." Some people certainly booed, many applauded, and later fans have pored over film clips of the concert trying to sort out the crowd's reactions—a fruitless exercise, since most clips have been doctored to fit the legend, splicing the anguished shouts after Dylan left the stage into other parts of his performance to create the illusion that the mythic confrontation was captured on tape.

Why did that matter? Why does what one musician played on one evening continue to resonate half a century later? One answer is that Dylan was the iconic voice of a decade famed for rebellion and Newport was the epochal break of the young rocker with the old society that would not accept him. He was already recognized as a mercurial genius, the ultimate outsider, compared to Woody Guthrie in *Bound for Glory*, Jack Kerouac in *On the Road*, Marlon Brando in *The Wild One*, Holden Caulfield in *Catcher in the Rye*, the nameless protagonist of Albert Camus's *Stranger*—and most frequently of all to James Dean in *Rebel Without a Cause*. He was the decade's existential hero, ramblin' out of the west, wandering the midnight streets of Greenwich Village, jotting angular words at scarred tables in crowded cafés, roaring down the road on his motorcycle, sauntering onto the stage, or striding off, ready or not.

Dylan at Newport is remembered as a pioneering artist defying the rules and damn the consequences. Supporters of new musical trends ever since—punk, rap, hip-hop, electronica—have compared their critics to the dull folkies who didn't understand the times were a-changing, and a complex choice by a complex artist in a complex time became a parable: the prophet of the new era going his own way despite the jeering rejection

of his old fans. He challenged the establishment: "Something is happening here, and you don't know what it is, do you, Mr. Jones?" He defined his own transformation: "I was so much older then, I'm younger than that now." He drew a line between himself and those who tried to claim him: "I try my best to be just like I am, but everybody wants me to be just like them." And he warned those wary of following new paths: "He not busy being born is busy dying."

In most tellings, Dylan represents youth and the future, and the people who booed were stuck in the dying past. But there is another version, in which the audience represents youth and hope, and Dylan was shutting himself off behind a wall of electric noise, locking himself in a citadel of wealth and power, abandoning idealism and hope and selling out to the star machine. In this version the Newport festivals were idealistic, communal gatherings, nurturing the growing counterculture, rehearsals for Woodstock and the Summer of Love, and the booing pilgrims were not rejecting that future; they were trying to protect it.

Pat though it may be to divide history into neat decimal segments, the 1960s were a period of dramatic upheaval, and 1965 marked a significant divide. The optimism of the early decade had been shaken by the murders of William Moore; of Medgar Evers; of four young girls in Birmingham; of John F. Kennedy; of Goodman, Schwerner, and Chaney; of Viola Liuzzo and dozens more; and again in February with the killing of Malcolm X. Three weeks after the Newport festival, Watts exploded in rioting, and the communal swell of "We Shall Overcome" was broken by shouts of "Black power!" It was still three years before the killings of Martin Luther King and Robert Kennedy, and many people continued to believe in the dream of integration, equality, and universal brotherhood. But the weekend Dylan walked onstage with his Stratocaster, President Johnson announced he was doubling the military draft and committing the United States to victory in Vietnam.

It was still two years before *Sergeant Pepper,* three years before the Days of Rage, four years before Altamont, five years before Kent State. In the simplifications of legend and hindsight, Dylan is often remembered as

a voice of those later years, and it is easy to forget that after a motorcycle accident in 1966 he disappeared from view, stopped touring, gave few interviews, and spent the rest of the decade making cryptic albums that seemed willfully oblivious to the events exploding in the headlines. In 1968, pressed by an old friend to explain why he was not more engaged in the Vietnam protests, he responded: "How do you know I'm not . . . for the war?"

We knew because he couldn't be. He had written "Masters of War," had put a generation's inchoate feelings into words with "The Times They Are a-Changin'," had provided the soundtrack for our expanding consciousness with "Mr. Tambourine Man," had shouted out our alienation with "Like a Rolling Stone"—and wherever he was now, whatever he was doing, those songs were everywhere and meant more than ever. We quoted him and recognized our friends because they finished the quotations with us: "Don't follow leaders—watch the parking meters"; "Money doesn't talk—it swears"; "You don't need a weatherman—to know which way the wind blows." He was more than a musician, more than a poet, certainly more than an entertainer: he was the *Zeitgeist*, the ghost-spirit of the time.

This book is about Dylan in the years before he became a holy ghost, and about Newport, and about Pete Seeger, who was never the spirit of a time but was very much the spirit of the folk revival. It is about a particular Dylan: the musician who served an apprenticeship as a teenage rock 'n' roller and was drawing on the energy, passion, and rebel attitude of that apprenticeship the night he appeared at Newport with an electric band, was cheered and damned, and came out of the confrontation stronger than ever. That Dylan has tended to be obscured by another: the innovative, meditative songwriter who was not a great singer, not a great guitarist, not a great harmonica player, not a great showman, but who wrote such compelling lyrics that he could not be ignored. For a few years in the early 1960s almost everyone heard Dylan's songs before they heard him: from Seeger; from Peter, Paul, and Mary; from Joan Baez; from Judy Collins; from hundreds of young musicians who sang in coffeehouses and

thousands of kids who strummed guitars and sang with their friends; and then from Johnny Cash, the Byrds, and Cher. It was first the songs and only afterward the thin young man with the unruly hair who somehow produced them. So it is easy to forget that before Dylan was a poet exercising his craft or sullen art in the still night, he was a professional musician rooted in country and western, rockabilly, R & B, and blues, or that he was hailed in the *New York Times* and signed by a major record label as a singer and guitarist before he was known as a songwriter—and the *Times* review described him singing Blind Lemon Jefferson, not Woody Guthrie, while the liner notes to his first album listed the Everly Brothers, Carl Perkins, and Elvis Presley among his influences.

In 1965 Dylan was only twenty-four years old, but he had already gone through a lot of changes and been criticized and attacked for each of them. His first performances as a teenage rock 'n' roller were met with laughter and jeers. When he turned to folk music, the high school girlfriend who had shared his early passions was troubled, asking why he'd given up "the hard blues stuff." When he turned from singing traditional folk songs to writing his own material, old supporters accused him of becoming "melodramatic and maudlin"—one, stumbling across a typescript of "The Times They Are a-Changin," demanded, "What is this shit?" When he turned from sharp topical lyrics to introspective poetic explorations, followers who had hailed him as the voice of a generation lamented that he was abandoning his true path and "wasting our precious time." When he added an electric band, he was booed around the world by anguished devotees, one famously shouting "Judas!"

With every change and attack Dylan's audience grew, and his new fans always felt superior to the old fans who hadn't really understood him, and each new wave hailed him as a defiant outsider. His electric apostasy at Newport was the most dramatic declaration of independence, a symbol for a rebellious decade and a generation that did not want to succeed on their parents' and teachers' terms or succumb to the establishment, the system, the machine. If the booing at Newport has often been exaggerated, that is because it was essential to the legend, proof that no mat-

ter how high Dylan's records climbed on the pop charts, he was neither selling out nor buying in, but bravely going his own way.

This book is also about Newport and the folk scene, the early 1960s, the civil rights movement, the triumph of rock, the worlds that shaped Dylan and rejected him and embraced him and made him an iconic symbol and went their own ways as well, sometimes with him, sometimes without. The Newport Folk Festivals of that period were like no gatherings before or since, and some of the people who remember them most fondly had no interest in Dylan and can't even remember whether they saw him perform. For many of them Newport was also a symbol of rebellion against the demands and expectations of the mainstream—not only the mainstream of segregation and militarism but the mainstream of million-selling rock, pop, and even folk stars.

Newport included many artists who were older and more conservative than Dylan, many who were more clean-cut and accessible, and some who were younger, wilder, more difficult, more committed, more radical, or more obscure. The folk revival was a motley, evolving world, and in hindsight it is easy to remember it as a bunch of nice boys and girls with guitars and forget that they were sharing stages with Mississippi John Hurt and Eck Robertson, the Moving Star Hall Singers, the Blue Ridge Mountain Dancers, Jean Carignan, Spokes Mashiyane, Bill Monroe, Maybelle Carter, Son House, Muddy Waters, and the Reverend Gary Davis. In the shock of Dylan's electric reinvention it is easy to forget that Lightnin' Hopkins, the Chambers Brothers, and the Paul Butterfield Blues Band had all already played electric sets at Newport that weekend. And it is easy to separate Dylan, the lone genius, from the friends and peers and rivals who helped and taught and inspired and influenced him: Dave Van Ronk, Eric Von Schmidt, John Koerner, the Clancy Brothers, the New Lost City Ramblers, Jim Kweskin, Peter Stampfel, Len Chandler, Joan Baez—and the old guard that welcomed them, some eagerly, some warily: Alan Lomax, Sis Cunningham, Irwin Silber, Odetta, Theodore Bikel, Oscar Brand, and always, everywhere, Pete Seeger.

Seeger is a central figure in this narrative, because the story of Dylan

at Newport is also the story of what Seeger built, what Newport meant to him, and the lights that dimmed when the amplifiers sucked up the power. It is about what was lost as well as what was gained, about intertwining ideals and dreams that never quite fit together, and about people who tried to make them fit and kept believing they might. In a simple formulation, Seeger and Dylan can stand for the two defining American ideals: Seeger for the ideal of democracy, of people working together, helping each other, living and believing and treating each other as members of an optimistic society of equals; Dylan for the ideal of the rugged individualist, carving a life out of the wilderness, dependent on no one and nothing but himself. In those terms, they can also stand for the two halves of the 1960s: In the first half, folk music was associated with the civil rights movement, with singing together in the spirit of integration, not only of black and white but of old and young and the present with the past, the old Left, the labor movement, the working class, "Everybody might just be one big soul," "We Shall Overcome." In the second half, rock was the soundtrack of the counterculture, the New Left, the youth movement, expanding our consciousness, "Fuck the System!," "Turn on, tune in, drop out," "Free your mind and your ass will follow."

Of course those are oversimplifications, not least of Dylan and Seeger, two complicated, talented, shy, driven, and often difficult men. But they are worth keeping in mind, because so many people saw themselves and each other in those terms. What happened at Newport in 1965 was not just a musical disagreement or a single artist breaking with his past. It marked the end of the folk revival as a mass movement and the birth of rock as the mature artistic voice of a generation, and in their respective halves of the decade both folk and rock symbolized much more than music.

Fifty years later both the music and the booing still resonate, in part because Dylan continues to be an icon, in part because the generation that cared then has continued to care—but also because the moment itself has become iconic. This book traces the strands that led to that moment, sometimes seeking to untangle them, sometimes emphasizing how tangled they remain, sometimes suggesting where later chroniclers

may have imagined or added strands that did not exist or were not visible at the time, sometimes trying to explain, sometimes trying to make the story more complicated, sometimes pointing out how different a familiar strand can seem if we look at it in a new light. Dylan is one strand, the Newport Festivals another, Seeger a third. There are many more, but those are the three to keep in mind, because Dylan is the hero and Newport is the setting, and because it is impossible to imagine Newport, or Dylan, or the folk scene of the 1960s without Pete Seeger.

Chapter 1
THE HOUSE THAT PETE BUILT

In the spring of 1949 Pete Seeger and his wife, Toshi, began building a log cabin on seventeen acres of land by the banks of the Hudson River outside the town of Beacon, New York. They lived in a tent and cooked over an open fire, chopped and dressed logs, dug up stones and mixed mortar for a chimney, and by fall, with the help of Toshi's brother and the stream of friends who dropped by to lend a hand, they had four walls and a roof, with simple windows and doors. "It wasn't much fixed up," Seeger recalled. "But we'd built a house."

They built a place in the local community the same way. When their children began school, Toshi got involved and was shortly a leader of the PTA. When more space was needed for the school grounds, a group of fathers volunteered to clear land and Pete went down and put in his hours with the others. He enjoyed manual labor, was happy to get his hands dirty and to be part of a crew. Many years later I attended a weekend retreat for leftist singers and songwriters not far from Beacon. As at all such gatherings, there were plenty of egos on display, people showing off their musical skills, their latest compositions, their superior experience and command of radical orthodoxies. Pete, by then a hallowed icon in his sixties, showed up for lunch on the second day and was asked to say a few words. His entire speech, as I recall it, was: "This is a wonderful event, and I wish I could spend the whole weekend with you, but unfortunately

I can only be here for a couple of hours. So if anyone wants to talk with me, come on back to the kitchen and we can talk while we do the dishes."

Seeger was a hard man to know and sometimes a hard man to like, but he was an easy man to admire, and he backed up his words and beliefs with his actions. Some people might think it was hokey to build that house with his own hands, the Harvard boy homesteading on a patch of prairie an hour and a half north of Manhattan. It went along with dragging a log onstage and chopping it with an axe to accompany a Texas work song—my older brother saw him do that in the late 1950s and remembered it ever after as corny bullshit. But, corny or not, the house got built and Pete and Toshi lived in it for the next sixty years, adding a comfortable barn and guest quarters, skating on the nearby pond in the winter, tapping the maple trees for syrup. It was part of his myth and fitted his image, but it was a real house, and when he came home from the road he sat in front of the fireplace built with stones from their land, and friends dropped by to play music, and he answered all the letters people wrote him, signing each with a little drawing of a banjo, and always seemed to find time for everybody, or at least to try very hard.

Pete built the folk revival of the 1960s in much the same way, log by log and stone by stone. He had more help, but in a lot of ways it was also a family affair. It was not his the way the house was—he always pushed other people forward and tried to act like part of the crew, and although he encouraged every musician who came along, he was often unhappy with how the scene grew and changed, and eventually it got away from him. Even when he was clearly a central figure, hosting concerts and planning the Newport Folk Festivals, he was more often described as a model or inspiration than as an organizer or manager, and increasingly in later years he was described as a saint, not always as a compliment. He was a warm, welcoming presence onstage, but off it he could seem distant and somewhat cold, and his unrelenting efforts to always do the right thing could be tiresome or off-putting. And sometimes the right thing didn't turn out to be so right, whether it was opposing US entry into World War II during the period of the Stalin-Hitler pact or objecting

to Bob Dylan's electric set at Newport in 1965. He tried to correct his mistakes—joining the army in 1942, recording with electric instruments in 1967, expressing his anguish over the Soviet dictatorship—but they too have become part of his legend.

In retrospect that legend often overshadowed his work, and it is easy to forget what the work was. This is particularly true because Seeger was first and foremost a live performer, and only a shadow of his art survives on recordings. That was fine with him—he always felt the recordings were just another way of getting songs and music out into the world. If you complimented him, he would suggest you listen to the people who inspired him, and a lot of us did and discovered Woody Guthrie, Lead Belly, Uncle Dave Macon, Bob Dylan, and hundreds of other artists whose music we often liked more than his. Which, again, was fine with him. That was his mission, and in a lot of ways it reached its ultimate expression in the Newport Folk Festivals, especially the first two or three after Pete and Toshi got involved with the planning and direction in 1963, reconceiving them as inclusive forums for traditional artists from rural communities around the country and around the world, for the songs of the civil rights movement, and for young players mastering old rural styles and writing new songs about their times and feelings.

The folk revival was riddled with contradictions, in part because it was never in any sense an organized movement. Pete's interests and accomplishments were similarly broad, and at times similarly contradictory. It is always tempting to simplify a story, to give characters particular attributes or have them represent particular viewpoints. In stories about Bob Dylan, the youth culture of the 1960s, and the rise of rock, Seeger is often given the role of conservative gatekeeper, stuck in the past, upholding old rules and ideals that were perhaps noble but certainly outdated. There is some truth in that simplification, just as there is some truth in the simplification that Dylan was a cynical careerist, but both obscure more interesting stories.

Pete would quote his father, Charles Seeger: "The truth is a rabbit in a bramble patch. One can rarely put one's hand upon it. One can only

circle around and point, saying, 'It's somewhere in there.'" If we want to understand the folk revival, Pete is the best person to follow around the brambles, because he was always there, circling, pointing at flashes of sleek fur, perked ears, or shiny eyes—and maybe sometimes only imagining he saw a rabbit and convincing other people they saw it too, and being startled or disappointed when it turned out not to be there, or to be something else. For two or three years in the early 1960s, a lot of people circling that thicket thought Dylan was the rabbit, and at moments some of them thought they'd got their hands on him. And though he always slipped their grasp, for a few years the folk scene was certainly his bramble patch.

Granting the messiness of that metaphor, it is worth keeping in mind, because the tendencies and cliques of the American folk scene in the late 1950s and early 1960s were endlessly tangled, but Seeger served as a guide for virtually everyone, whether they considered themselves traditionalists, revivalists, agitators, or potential pop stars. Even the people who insisted on beating their own paths through the brambles could not escape his influence, because their paths were defined in part by avoiding his. Some of the most important elements of Seeger's story and work have tended to be neglected or forgotten, for exactly the reasons he thought they should be, and some remembered for exactly the reasons he wished they would not: his most lasting accomplishments survive independent of his biography or recordings, while his personal reputation survives as an artifact of the celebrity culture and "great man" concepts of history that he tried to combat throughout his career.

There were myriad views and conceptions of the folk revival, but in general they can be divided into four basic strains: the encouragement of community music-making (amateurs picking up guitars and banjos and singing together with their friends); the preservation of songs and styles associated with particular regional or ethnic communities (the music of rural Appalachia, the Mississippi Delta, the western plains, the Louisiana Cajun country, the British Isles, Congo, or anywhere else with

a vibrant vernacular culture); the celebration of "people's music" and "folk culture" as an expression of a broader concept of the people or folk (linking peasant and proletarian musical traditions with progressive and populist political movements); and the growth of a professional performance scene in which a broad variety of artists were marketed as folksingers. People committed to one of those strains often tried to distance themselves from people identified with another—purists criticized popularizers, popularizers mocked purists—but they all overlapped and intertwined, and all flowed directly from Pete Seeger.

Seeger's name was inherited from a German great-great-grandfather who immigrated to the United States in 1787, but most of his ancestors had come over from England in the early Colonial period. His parents were classical musicians, his mother a violinist and his father a pianist and musicologist. A photo from 1921 shows two-year-old Pete seated on his father's lap as his parents play music in a dirt clearing between their homemade wooden trailer and a makeshift tent. They were trying to bring culture to the common people, touring in support of socialism and the populist dissemination of "good" music. A later photo shows Pete at age nine or ten, standing in the woods dressed in a loincloth and headband, aiming a homemade bow and arrow. He was briefly home from one of a series of boarding schools, which led to Harvard, which he dropped out of at nineteen, moving to New York City to be a newspaper reporter. He had picked up a banjo along the way, though it was a tenor four-string rather than the rural five-string variety, and his first performances were with his high school's hot jazz quintet. He was also becoming interested in folk music, having spent a summer in Washington, DC, where his stepmother, Ruth Crawford Seeger, was transcribing field recordings collected by John and Alan Lomax, the pioneering father-and-son team of folklorists.

The big event of that summer was a trip Pete made with his father to Asheville, North Carolina, where a banjo player named Bascom Lamar Lunsford hosted an annual Folk Song and Dance Festival. It was his first

experience of rural music in something like its native habitat, and he recalled it ever afterward as a revelation:

> Compared to the trivialities of the popular songs my brothers and I formerly harmonized, the words of these songs had all the meat of human life in them. They sang of heroes, outlaws, murderers, fools. They weren't afraid of being tragic instead of just sentimental. They weren't afraid of being scandalous instead of giggly or cute. Above all, they seemed frank, straightforward, honest.

In New York, Alan Lomax introduced Pete to the legendary African American songster Lead Belly, who taught him the rudiments of the twelve-string guitar. Lomax also got him a job cataloguing folk recordings at the Library of Congress and arranged his first appearance as a folksinger. The date was March 3, 1940; the event was a "Grapes of Wrath" concert for the benefit of Oklahoman progressive organizations; and the other performers included Lomax, a midwestern balladeer named Burl Ives, the Golden Gate Quartet singing gospel songs, Aunt Molly Jackson singing about Kentucky mine workers, and a newcomer from out west named Woody Guthrie. Pete was nervous and forgot the words to his one song but was captivated by Guthrie, whom he recalled as "a little, short fellow with a western hat and boots, in blue jeans and needing a shave, spinning out stories and singing songs that he had made up himself."

Two months later, the Dust Bowl balladeer and the naive young banjo player headed west. Seeger often joked that Woody must have liked his playing, "because everything else about me must have seemed pretty strange to him. I didn't drink or smoke or chase girls." Guthrie did more than his share of all three, and although they continued to work and at times live together through the rest of the decade, it was often a difficult relationship. On that first trip they made it to Texas, where Guthrie was in the process of leaving a wife and three children. Then Pete struck out on his own, hitchhiking and hopping freight trains to Montana before

working his way back to New York. Woody had taught him some juke-box hits that were good for earning tips in western bars, and he picked up a few extra dollars singing political songs in union halls. He was acting on Woody's exhortation to "vaccinate yourself right into the big streams and blood of the people," and recalled that trip as an essential part of his education, later advising young fans to spend their summer vacations hitchhiking around the country, meeting ordinary folks and learning how to fend for themselves in unfamiliar territory.

Back in New York, Seeger spent most of the 1940s playing with Guthrie and various ragtag aggregations on picket lines, in union halls, at "rent parties" in the communal house they shared, and at square dances—folk dancing was a big part of the urban folk revival, and Pete met his future wife, Toshi Ohta, through a square dance group he was accompanying. The only significant break was two and a half years in the army—his left-wing politics and Japanese-American fiancée made him a security risk and kept him out of combat, but he served in the South Pacific as an entertainment coordinator and banjo player, singing with a hillbilly band and performing pop numbers like "Sidewalks of New York" and "Tea for Two." By then he had amassed a large and varied repertoire and took pride in his ability to get other people to join in with him. As he wrote home, "Even though the song may not be the greatest, when the audience feels sure of themselves, then they really sing out with confidence, and it sounds swell."

That would always be Pete's unique talent: no matter the audience, no matter the situation, he could get people singing. For the rest of the decade he honed his craft, practicing, jamming, and performing wherever he could. For a while he lived in a three-story communal house on West Tenth Street with a shifting cast of characters including Woody, a stout bass singer from Arkansas named Lee Hays, Bess Lomax (Alan's sister, with whom he chastely shared a room), Sis Cunningham (an accordionist who would later edit *Broadside* magazine), and an aspiring writer named Millard Lampell. They called their building Almanac House and performed in mix-and-match ensembles as the Almanac Singers—Hays

supplied the name, explaining that in country cabins the only books you'd find were a Bible and an almanac, one to get you to the next world and the other to see you through this one. They made a few recordings as well, including an album of sea chanteys and one called *Sod Buster Ballads* on which Guthrie sang "House of the Rising Sun," but their specialty was whipping up agitprop political lyrics for every issue and occasion. Those included *Songs for John Doe,* a quickly suppressed and forgotten album of "peace songs" composed during the Nazi-Soviet pact and attacking Franklin Roosevelt as a warmonger, but their most popular album was *Talking Union,* which became ubiquitous in progressive households along with similar offerings by Guthrie, Paul Robeson, Josh White, and the Red Army Chorus.

In the 1940s Robeson, Guthrie, and White were all better known than Seeger, as were Lead Belly, Burl Ives, Richard Dyer-Bennett, and, by the end of the decade, some younger artists like Susan Reed. That was how he liked it, since a basic tenet of leftist organizing was to be an exemplary member of the crew, working hard and speaking up about issues that concerned everybody, but not putting oneself forward as a public spokesman or leader. Seeger had always been shy, and the philosophy of anonymous participation suited his nature as well as his political beliefs—though it caused some friction in the Almanac Singers, since he and most of the others felt their songs should be presented as anonymous, communal creations, while Guthrie wanted to be properly credited for his work.

When Seeger got out of the army in 1945, he was more confident of his abilities and took some jobs as a soloist, but most of his energy was devoted to building an organization called People's Songs, which provided topical compositions and singers for progressive causes. Best remembered for its *People's Songs Bulletin,* the predecessor to *Sing Out!* magazine, this group served as a booking agency, sponsored concerts-cum-sing-along-sessions billed as "hootenannies"—they were primarily responsible for introducing the word, and in the 1950s the *New York Times* would ban it from advertisements because of its association with leftist radicalism—and at its peak boasted over a thousand members in

twenty states. Though often attacked as a "Communist front," People's Songs received little encouragement from the Party, which did not think folk songs were likely to appeal to urban proletarians and preferred to cultivate artists like Duke Ellington—Seeger recalled a Communist functionary telling him, "If you are going to work with the workers of New York City, you should be in the jazz field. Maybe you should play a clarinet."

In the winter of 1946–47 Seeger made a first brief foray into the nightclub world, appearing at the Village Vanguard on a bill with the pianist Maxine Sullivan, the Haitian singer and dancer Josephine Premice, and a small cocktail combo. *Billboard* hailed him as the "tall, slim Sinatra of the folksong clan," singling out his performance of "House of the Rising Sun," a couple of politically oriented compositions, and a banjo showpiece called "Cumberland Mountain Bear Chase," and commending his "fine voice which, glory be, has no trace of the nasal tone so often found in top people's songsters." Mostly, though, he worked on the *Bulletin*, presented educational programs about folk music, and played at benefits, square dances, and community events like the Saturday morning "wingdings" he held for kids in his Greenwich Village apartment.

He and Toshi were living in the basement of her parents' house on MacDougal Street—her Japanese father and Virginian mother were committed radicals, so he fit right in—and Pete seems to have been happy with this situation, earning minimal pay, serving progressive causes, and, in his words, "congratulating myself on not going commercial." Then, one afternoon in 1949 when he was working at People's Songs, someone called to ask if Richard Dyer-Bennett was available for a benefit. Irwin Silber, who was managing the office, said he wasn't sure about Dyer-Bennett, but Seeger was available. "Oh, we know Pete," the caller responded, but "we need someone who can bring a mass audience. We need to raise money."

Seeger was taken aback, and the call prompted "some hard rethinking": "Here I was, trying to follow what I thought was a tactical, strategic course, and yet Dick Dyer-Bennett—who was making a career in a traditional fashion—was more use than me." There were also family

pressures: he and Toshi now had two children, and her parents' basement was feeling cramped. So, at age thirty, he decided it was time to build a more serious professional career.

There would be nothing particularly notable about this decision—over the next twenty years hundreds of folksingers tried to build commercial careers, most with limited success—were it not that a year and a half later he had the most popular record in the United States. Once again it was as a member of a group: together with Lee Hays and a pair of younger singers, Fred Hellerman and Ronnie Gilbert, he formed a quartet called the Weavers. They honed their skills for a few months at rallies and benefits, then in December 1949 got a booking at the Village Vanguard. It was a small room, and they had to split the same fee Seeger had earned as a solo act three years earlier, but it was a chance to be seen and work out their bugs in front of a paying audience. By late January they were doing good business and *Billboard* gave them a positive review, writing, "The act is rough, unpolished, needs costuming and better routining. But allowing for the individual shortcomings, the group has a drive and a spirit that indicates more than casual commercial value." Gordon Jenkins, a popular bandleader and record producer, agreed. The Weavers had already made one recording, a Seeger-Hays composition called "The Hammer Song," but it had attracted virtually no attention—though in May 1950 Irwin Silber adopted its exhortation to "sing out danger, sing out a warning, sing out love between all of my brothers" as the title for his new folk music magazine, *Sing Out!* Jenkins had a bigger audience in mind and brought the quartet to Decca Records, where he added pop orchestration to their banjo, guitar, and vocal harmonies, and in the summer of 1950 their version of "Goodnight Irene" went to number one on *Billboard*'s radio, jukebox, and sales charts.

The Weavers arrived at a perfect moment. Ten years earlier the pop market had been monopolized by a handful of Manhattan-based sheet music and record producers, but a publishing dispute opened the radio field to unsigned songwriters, jukeboxes added a democratic component by tracking listeners' tastes, and a dispute between the American Fed-

eration of Musicians and the major record labels encouraged smaller, regional companies to pick up the slack. Meanwhile World War II brought a lot of rural southerners and midwesterners to coastal cities, and their music traveled with them, while the increasing use of electric amplification meant that hillbilly and blues bands could work jobs that previously had demanded full dance orchestras. As a result, more and more pop music was coming from the south and middle of the country, and rural styles were creeping into the hit parade. The only record to out-sell "Goodnight Irene" in 1950 was "The Tennessee Waltz," a similarly gentle, nostalgic number recorded by Patti Page, a singer from Oklahoma who had grown up on country and western, and "Irene" also hit the pop Top 10 as a duet by the country singers Ernest Tubb and Red Foley, as well as in versions by Jo Stafford and Frank Sinatra.

The postwar pop scene was eager for pleasant, reassuring records, and the Weavers' mix of homey harmonies with a touch of swing and sophistication fit the bill. From the outset, though, Seeger had second thoughts. He enjoyed the challenge of working in a tightly arranged, well-rehearsed group, but also found it restricting and chafed at the compromises that went along with mainstream success. "Irene" hit at the high point of the McCarthyite Red Scare, and Decca strove to obscure and downplay the singers' political pasts. Now he could draw good crowds at left-wing benefits, but the Weavers' manager forbade him to play any, and the group's songs were vetted for potentially troublesome content. In a letter to *Broadside* magazine fourteen years later, he explained how they had to rework "So Long, It's Been Good to Know Yuh," one of Guthrie's ballads of the Oklahoma Dust Bowl:

Decca Records insisted that the words must be changed "because no one is interested in a dust storm; it must be made into a general song for anyone in the world to sing." At that time they had complete right to decide what song we would record, and how (including use of orchestras). We talked it over with Woody, and we all decided it was worth a compro-

mise. Remember, that at that time Woody's songs were not being recorded as they are now, and the guy needed money to feed his family. Woody came to the apartment of Gordon Jenkins, the band leader, and sprawled on the floor, scrawling some new verses on a big sheet of paper, with us all throwing in ideas and suggestions. The new words, while not as good as the dusty verses, were not bad. However, I think I can speak for all the Weavers that we are glad the old dusty lines are the ones that are mainly sung by all the young guitar pickers now.

A previous *Broadside* letter had praised Guthrie while attacking the Weavers for "emasculating" his song in pursuit of easy profits and concluded, "For that they probably never will be forgiven." Similar attacks had begun as soon as the group appeared on the pop charts, with Irwin Silber accusing them of debasing Lead Belly's art in a *Sing Out!* article headlined "Can an All-White Group Sing Songs from Negro Culture?"

For most of his life Seeger's politics and music stayed proudly outside the mainstream, and that was where he and his associates were most comfortable. They believed they were working for the good of humanity, drawing on the shared values and traditions of humanity, and pointing the way toward a better life for most of humanity, but they were intensely aware of the forces martialed against them: the capitalist system and the monied interests that upheld it. When that system rewarded them or those interests applauded them, it was natural to look for the catch—to wonder whether they were providing an alternative to the capitalist machine or had somehow become cogs in it.

The Weavers' success provided Seeger with a platform but also served as a warning. From the summer of 1950 through the winter of 1952 the group scored a string of hits and established much of the folk revival canon: "Goodnight Irene," "So Long, It's Been Good to Know Yuh," "Midnight Special," "Rock Island Line," "Wreck of the John B.," the Hebrew "Tzena, Tzena, Tzena," the South African "Wimoweh," "On Top of Old Smoky" (on which Pete created a model for future sing-along

leaders by speaking each line before the group sang, like a preacher "lining out" a hymn), and a few original compositions, such as "Kisses Sweeter than Wine." It was exciting to hear their music on radio and jukeboxes, but the Jenkins orchestrations diluted their style, and, along with inspiring thousands of young people to pick up guitars and banjos, their success inspired pop professionals to cash in on the trend. Sinatra had a hit with "Irene"; Mitch Miller covered "Tzena, Tzena" and produced folk-flavored hits for Doris Day, Frankie Laine, and Guy Mitchell; and hundreds of groups would emulate the Weavers' model over the next fifteen years, many with commercial success. The Four Lads hit with "Down by the Riverside" and "Skokiaan" in 1954, the Tarriers with "Cindy, Oh Cindy" and "The Banana Boat Song" in 1956, and the Kingston Trio with "Tom Dooley" in 1958.

The Trio added a new, young, collegiate flavor and became the defining pop-folk group of the early 1960s. In 1961 the Highwaymen followed with "Michael, Row the Boat Ashore," and the Tokens topped the charts by adding jungle drums and new lyrics to "Wimoweh" and retitling it "The Lion Sleeps Tonight." The next year the Trio reached the Top 40 with Seeger's "Where Have All the Flowers Gone"; Peter, Paul, and Mary got their first Top 10 hit with his "Hammer Song" (retitled "If I Had a Hammer"); and by 1965 the Byrds were at number one with his "Turn, Turn, Turn."

Some of those groups were dedicated folksingers; others were just latching onto a trend; but all came directly out of the Weavers, to the point that for most Americans in the 1950s and early 1960s, "folk music" pretty much meant the Weavers' style. As their critics often pointed out, this had very little to do with authentic folk traditions. Joe Boyd, who produced numerous folk and rock groups in the 1960s, characterized their approach as watered-down and ideological, "taking a blues and a country song and a Spanish Civil War song and a South African miners' song and a Scots ballad and a Russian song and singing them all stylistically as close, as similarly as they possibly could, and giving them all the same kind of harmony, and giving them all the same kind of strum on

the guitar. As if that would somehow prove that all men were brothers, all working men were brothers certainly . . . an ideal that I think is great, but it didn't make for very exciting music."

In his more introspective moments Seeger tended to agree. Writing about "Michael, Row the Boat Ashore," a song originally transcribed in the nineteenth century from African American boatmen in the Carolina Sea Islands, he mused:

> It must have been an absolutely magnificent thing. The raw voices in the formal sense—but superbly trained voices in the sense that they'd been singing all their lives. . . . Now it comes back to me from numerous schools and summer camps, such a pale wishy-washy piece of music compared to what it was once. And I realize that my own singing of it is kind of pale and wishy-washy, compared to what it was once. It makes me wonder, is it possible to revive folk music? Well, I finally came to the conclusion: yes, it is possible. We can try. All you can do in this world is try. And a good attempt at trying is sure better than never having tried.

Seeger understood the complexities and compromises of the folk revival as well as anyone, and if he was ever inclined to forget, he had friends ready to remind him. Alan Lomax grumbled, "Peter looked at folk music as something to bring everybody in, whether they could sing or play in tune or anything like that." Lomax, by contrast, wanted to focus attention on authentic proletarian artists and music. He was happy when a well-known entertainer was willing to help with that mission, whether it was the Weavers or a pop-jazz singer like Jo Stafford, but was annoyed that Pete encouraged urban amateurs to think they were carrying on folk traditions.

Through the 1950s most professional performers—including the few who called themselves folksingers—continued to assume that authentic traditions were too rough for urban ears, and Lomax was leading a small, lonely crusade. By the end of that decade, though, the cult of true believers

was growing, and young purists were echoing his critique. In Minneapolis, Jon Pankake and Paul Nelson started a newsletter called the *Little Sandy Review* to promote authentic folk styles and became notorious for their attacks on "folkum" and "fakelore." In 1964 Pankake wrote an eight-page article titled "Pete's Children: The American Folksong Revival, Pro and Con," which portrayed Seeger as the source of a movement too often gone astray. It described him as a kind of archaic throwback, albeit a "phenomenal" one: "the last, perhaps, of the great platform personalities in the American tradition of Mark Twain and William Jennings Bryan." No one could resist Seeger in concert, but that just undercut the subtler virtues of authentic rural traditions, and the "atrocious production of the Kingston Trio gestated between the pages of Pete's *How to Play the Five-String Banjo* manual, nourished by his 'Gee, it's fun to doodle with folk songs' philosophy." No matter how often Pete said, "Don't learn from me; learn from those who taught me," it was more fun to just grab a guitar and lead your friends in another chorus of "This Land Is Your Land." The only consolation was the scant few listeners who heard Pete's deeper message: "About five percent of Seeger's converts have become the core of the sort of revival within a revival that will prove constructive and beneficial to the perpetuation of America's folk music in its actual form . . . long after the superficial faddists have become bored with folk music and have moved on to some other temporary kick."

Pankake's article underscored an essential fact: as the folk scene grew through the 1950s, it split into cliques that often bickered bitterly, but all came through Seeger, and while his recordings with the Weavers parented the pop-folk style, he was simultaneously parenting its traditionalist opponents. The banjo manual Pankake mentioned was typical of his approach: he wrote it in 1948 in response to requests from audience members, printed it himself on a mimeograph machine, and sold a few hundred copies a year at concerts and by mail order. Many buyers used it as a guide to his style and ended up sounding a lot like him, including Dave Guard of the Kingston Trio. But it also provided transcriptions from the playing of obscure rural artists like B. F. Shelton and Walter

Williams, and later editions added the first instructions in Earl Scruggs's bluegrass picking, inspiring both the most assiduously purist and the most dazzlingly innovative players on the urban scene.

Seeger typically downplayed this aspect of his work. During a banjo workshop at the 1965 Newport festival, he demonstrated Shelton's arrangement of "Darling Corey" and Frank Proffitt's original way of playing "Tom Dooley," but presented both as examples of the simplicity he appreciated in old-time rural playing, implying that anyone could master the style if they just listened hard and gave it a try. Around the same time he assessed his own talents in an anonymous review, writing, "Pete only occasionally does some good traditional picking. His brother Mike can play rings around him." Most old-time music fans agreed, and few remembered that he had pioneered their approach. The New Lost City Ramblers, a trio formed in 1958 by Mike Seeger, John Cohen, and Tom Paley, were the standard-bearers of the old-time string band revival, and Paley's 1953 LP, *Folk Songs from the Southern Appalachian Mountains,* is often cited as that movement's clarion call. But that record followed Seeger's *Darling Corey,* issued in 1950, and Paley is quick to credit him as an inspiration, saying that everyone who was trying to learn authentic old-time styles admired him: "Not that his playing sounded exactly like any one particular old time country player, but that he got the flavor of it right. . . . I felt I was playing pretty decently, but I didn't think I was on a level with Pete."

By 1950 Seeger was thirty-one years old, but *Darling Corey* was his first solo album, and he would not record another for several years. It was issued by a new, specialist record label called Folkways, one of several small companies taking advantage of the newly available long-playing (LP) format to present classical, jazz, and other niche genres for middle-class urban consumers. While big companies like Decca sought radio and jukebox hits, Folkways was trying to document historically important music from around the world, and Seeger's album was intended as an example of southern rural playing.

As always, Seeger saw this as part of a larger mission. Urban folksingers had tended to think of rural singers and musicians as "sources," raw

bearers of peasant traditions that had to be smoothed and polished for professional performance. A few folklorists had attempted precise transcriptions of rural singing or playing, but it was a new idea to learn and perform traditional pieces the way classical musicians learn and perform the works of Mozart or Wagner. By teaching and recording banjo arrangements learned from Shelton, Williams, Proffitt, Lilly Mae Ledford, and Uncle Dave Macon, Seeger was implicitly making that analogy, suggesting that rural musicians were worthy of study and emulation not only as tradition bearers but as composers, arrangers, and virtuosos. He was also pioneering a new concept of folk music as an active, living process, a matter of style, approach, and interaction between players and listeners. As he later wrote, "Words and melodies may not be so important as the way they are sung, or listened to. . . . In this sense, a mountaineer singing a pop song to some neighbors in his cabin might have more of folk music in it than a concert artist singing to a Carnegie Hall audience an ancient British ballad."

Seeger gave more than fifty concerts at Carnegie Hall and understood where he fitted in that formulation: "When people call me a 'folk singer,' I tell them that in some ways, I'm just a new kind of pop singer," he wrote in 1965, and although he might not have phrased that thought the same way ten years earlier, he was always aware of the difference. As he wrote in 1958:

> Perhaps the role of performers such as myself should best be thought of as that of an intermediary. We can introduce music to audiences to whom the straight stuff would seem too raw, crude, or unintelligible. We also have the advantage of being able to present a broader picture of folk music than any true folk musician could. A true folk musician may be a genius at his or her own kind of music—but that one kind is liable to be all he knows.

Seeger acted as an intermediary for a startling range of styles—along with the banjo manual, he published guides to Lead Belly's twelve-string

guitar technique, the Israeli shepherd's flute, and sight-reading from standard music notation—and recreating other artists' arrangements was just part of that larger process. In 1947 he narrated Alan Lomax's film *To Hear Your Banjo Play* and contributed banjo interludes that framed clips of Guthrie, the ballad singer Texas Gladden, and the blues duo of Sonny Terry and Brownie McGhee; in the mid-1950s he and Toshi began making their own documentary films, first of American artists like Big Bill Broonzy and Elizabeth Cotton, then of community musicians in Africa, Europe, and Asia. It was a continuum: in 1950 he recorded the Zulu song "Wimoweh" with the Weavers; in 1955 he recorded a full album, *Bantu Choral Folk Songs,* with the Song Swappers, a group of New York teenagers including Mary Travers of the future Peter, Paul, and Mary; and in 1964 he and Toshi filmed a documentary, *Singing Fishermen of Ghana,* showing authentic African vocal music in its home environment. Similarly, he started playing traditional southern banjo styles in the 1930s, wrote his instruction manual in 1948, recorded a companion LP in 1954, and by the early 1960s was producing the first reissue of Uncle Dave Macon's recordings, helping bring southern artists to Newport and New York, and seeing that some of the profits from the Newport festivals went to support local music-making in southern communities.

Seeger always preferred to think of himself as a conduit, proselytizer, and catalyst rather than as a star. Despite his expertise on banjo and twelve-string guitar, his recordings included few instrumental showpieces, and when he made an ambitious recording of original instrumentals and arrangements of compositions by Gershwin, Bach, Beethoven, and Stravinsky, he called it *The Goofing-Off Suite* and described his creative process as just "lying on the bed, plunking away on the banjo." He valued folk music as something ordinary people played for themselves and their neighbors in their communities: his notes to *Folk Songs of Four Continents,* one of four albums he made in 1955 with the Song Swappers, described the group as "purposely composed of 'average' voices, of limited range and little training," with the aim of "encouraging group singing among lovers of folk music, amateur and professional." (Though it was

later credited to Pete Seeger and the Song Swappers, the original album included his name only in a footnote, as arranger of one song.) He sometimes argued that "the first duty of any artist is to produce good art," but did not want to discourage anyone by highlighting his own virtuosity. As a result, although he was by far the most prolific recording artist on the folk scene, issuing six albums a year from 1954 through 1958, his playing and singing were often more workmanlike than thrilling, and it is easy to underestimate both his skills and his influence on other players.

To Seeger, everything was political. His belief in folk music fitted with his beliefs in democracy and communism, and if he was often troubled by the fruits of those beliefs, he remained undaunted, repeating, "All you can do in this world is try." During the 1950s he did not record many explicitly political songs, in part due to Cold War paranoia but also because his years with the Almanac Singers and People's Songs had made him aware of the limitations of that approach. He had hoped to support a singing labor movement, but found that "most union leaders could not see any connection between music and pork chops" and ruefully noted that by the late 1940s, " 'Which Side Are You On?' was known in Greenwich Village but not in a single miner's union local." In the formulation of his biographer David Dunaway, he concluded that the most effective way to connect his music to his politics was by singing songs *by* the working class rather than writing songs *for* it.

Besides which, by the mid-1950s he was making the strongest political statement of his life in a very different venue. The Weavers' success had brought them to the attention of anti-Communist witch hunters, and as the quartet toured around the country they were trailed by FBI agents and picketed by American Legionnaires. Nightclubs and concert halls canceled their appearances, and by 1953 Decca dropped them and the group disbanded. Seeger continued to perform but was red-baited in the press and picketed at personal appearances, and in August 1955 he was served with a subpoena from the House Un-American Activities Committee (HUAC).

Although ostensibly organized to investigate espionage and subversion, HUAC functioned largely as a publicity machine for anti-Communist

politicians, subpoenaing not only active radicals but borderline liberals whose names would attract media coverage. The biggest headlines came in the early 1950s when the committee was questioning Hollywood and Broadway stars, and the fact that Seeger was not called until 1955 indicates his relatively minor status in the entertainment world. By then the committee proceedings had become almost purely formulaic, and had he behaved like a normal witness, either "friendly" (naming names of his associates) or "unfriendly" (refusing to testify on the basis of the Fifth Amendment), his appearance would have attracted little attention. That was what previous folksingers had done and what most of his friends advised, but Seeger was feeling frustrated and ineffective, and he wanted to make a stronger statement. So instead of "taking the Fifth" he announced he would assert his First Amendment right of free speech, standing on the principle that no one should be forced to say more than they chose about their beliefs or associations.

The resulting publicity made Seeger a hero to the left and an anathema to all patriotic citizens of Eisenhower's America. Some fans were more devoted than ever, but the jobs got smaller and paid less—on one tour of California, his top fee was twenty-five dollars and a typical day included elementary school appearances in the morning and afternoon, a playground show at dusk, and a private party in the evening. There were a few better paydays: in 1955 Harold Leventhal, the Weavers' manager, reunited the group for a Christmas concert that sold out Carnegie Hall, and they began touring and recording again. But in July Seeger was cited for contempt of Congress, and the following March a grand jury indicted him on ten counts, each potentially bearing a one-year jail term. He recalled the next five years as incredibly difficult—every time Toshi booked a tour, it was with the understanding that he might have to cancel to go on trial or to prison—but the persecution gave him a new sense of purpose. He had always been racked with self-doubt, and this time he knew he was right.

One result of Seeger's newfound confidence was his final split with the Weavers. The reunited quartet had recorded several albums on Vanguard Records, a small classical label, but concert bookings remained scarce

and payments low, and Seeger was increasingly uncomfortable with the group's professional compromises. While the Weavers are often remembered as keepers of the true folk flame, they were also pop record-makers and kept their eyes on the hit parade. In 1957 a young rockabilly singer named Jimmie Rodgers put their "Kisses Sweeter than Wine" in the Top 10, and Vanguard responded by rushing out a new Weavers single of the song and scheduling a session early in 1958 with drums, bass, chromatic harmonica, and three electric guitars. The result was a single of "Gotta Travel On," a semitraditional song by a young collector-singer named Paul Clayton, backed with a rewrite of an African American chain-gang song, "Take This Hammer," as a lightweight love lyric: "Take this letter, carry it to my darling." Seeger did his best to fit into the rock 'n' roll setting, and although their record didn't go anywhere, a country singer named Billy Grammer reached the pop Top 10 in 1959 with a folk-rock cover of "Gotta Travel On." But it was not the kind of music Pete wanted to be playing, and when the Weavers were hired to do a cigarette commercial a month and a half later, it was the final straw. As the group's sole nonsmoker, he bowed to the democratic process and did the session, but quit immediately afterward, noting "the job was pure prostitution . . . [and] prostitution may be all right for professionals—but it's a risky business for amateurs." He recommended Erik Darling of the Tarriers as his replacement, and vowed never to get into that situation again.

For a generation that had grown up in an atmosphere of Cold War hysteria and Madison Avenue careerism, Seeger's legal battles and resistance to commercialism went hand in hand with his musical tastes. Folk music was not just another kind of entertainment; it was a hammer of justice, a bell of freedom, and a song about love between brothers and sisters—and, corny as that may sound, Seeger and his music were beacons of hope and virtue at a time when almost everyone else on the left was running scared. Peter Stampfel, later a legendary figure on the beat, freaky, druggy downtown New York scene, grew up in Milwaukee in the 1950s and recalls that he was unexcited by the Weavers, preferring the tough, amplified sound of Muddy Waters and Fats Domino. Nor was he

impressed by the cinematic rebel icons of the time, James Dean and Marlon Brando, regarding them as movie stars whose fans were just another kind of trend followers, coming to high school in look-alike leather jackets. But by 1957 he had met a couple of genuine Bohemians:

> The woman had long hair and wore no makeup and black tights, and the guy had been living alone since he was seventeen and he had long hair, and he was a killer player on banjo and guitar, and really smart and totally cynical. The only thing that he wasn't cynical about was Pete Seeger. . . . Pete Seeger, to a lot of people, was like—there just weren't many *heroes* around then. . . . He came to Milwaukee and we went to see him play, it was in a church, with maybe a hundred and fifty people, something like that. And our take was that it seemed like, when everyone was listening to Pete Seeger—well, he was just *gooder* than anybody else we'd ever seen. He seemed to radiate goodness that was intense and powerful, and everybody in the audience seemed to be good by reflection. . . . That's what it felt like, and it was like nothing I had felt before, or thought about feeling.

Stampfel was on the Bohemian fringe, but a lot of normal American kids shared that feeling. Nick Reynolds of the Kingston Trio recalled that he and his partners saw one of the last Weavers shows with Seeger and said, "We were all in tears from the first note they sang to the last. . . . It was the most magical evening I've ever spent in my life." The music was part of it, but also "this *thing*. . . . Put them in with a couple thousand people that have got a cause, watch out man, it was so fantastic."

By March 27, 1961, when Seeger's case finally went to trial, the Kingston Trio's "Tom Dooley" had kicked off a full-scale folk boom and the week's top five albums included discs by the Trio, the Brothers Four, and the Limeliters. Folk ensembles accounted for ten of the thirteen best-selling albums by duos or groups, the Seegerless Weavers among them. Smoothly polished trios and quartets were still by far the most popular folk acts;

although Joan Baez had released her first album in January and *Billboard* tipped it as a disc to watch, it was still just reaching the cognoscenti. But the mainstream was coming around: a few months earlier, Seeger had signed a contract with Columbia Records, the most powerful of the major labels, and the *New York Post* ridiculed the justice department for pursuing his conviction, headlining its story "Dangerous Minstrel Nabbed Here" and ending with the ringing declaration: "Some jail will be a more joyous place if he lands there, and things will be bleaker on the outside."

On March 29, Seeger was found guilty of contempt of Congress. At his sentencing hearing the following week, he was asked if he wanted to make a closing statement and responded with a summation of the ideals he projected onstage:

> Some of my ancestors were religious dissenters who came to America over three hundred years ago. Others were abolitionists in New England in the eighteen forties and fifties. I believe that in choosing my present course I do no dishonor to them, or to those who may come after me.
>
> I am forty-two years old, and count myself a very lucky man. I have a wife and three healthy children, and we live in a house we built with our own hands, on the banks of the beautiful Hudson River. For twenty years I have been singing the folk songs of America and other lands to people everywhere.

He asked if he could sing "Wasn't That a Time," a song tracing American heroism through Valley Forge, Gettysburg, and the war against fascism, which had been cited as an example of his subversive views. The judge said, "You may not," and sentenced him to a year and a day in jail.

To romantic young folk fans, Seeger had joined the ranks of heroic outlaw martyrs alongside Jesse James, Joe Hill, and Pretty Boy Floyd. "They're framin' him," said a young singer named Bob Dylan who had recently come to New York to visit Seeger's old traveling buddy, Woody Guthrie. "They want to shut him up."

NORTH COUNTRY BLUES

Bob Dylan grew up worlds away from Pete Seeger, born in May of 1941 to a middle-class Jewish family in a small town on northern Minnesota's Iron Range. Seeger came of age in the Depression and never lost the sense that economic inequality was the root of humanity's problems, that a vast majority of working people was threatened and subjugated by a tiny minority of rapacious capitalists, and that the only solution was to organize mass movements that would harness the people's numbers to combat the oppressors' wealth. Twenty years later, Dylan grew up in the most economically equitable era in American history. World War II had jump-started the US economy, and New Deal reforms meant that wealth was spread more evenly than ever before. When he wanted a car or a motorcycle, his father bought one for him, and a lot of his friends had cars or motorcycles too. The battles of his youth were not organized political struggles; they were individual gestures of protest against the placid conformity of his elders and his less imaginative peers.

The economic shifts were matched by similar shifts in popular music. In Seeger's youth, pop songs were written in New York and diffused by large dance orchestras and smooth crooners. As the jazz era evolved into the swing era, the dominant styles included the sweet dance music of Guy Lombardo as well as the hot swing of Benny Goodman—both outdrawing Duke Ellington and Count Basie—and the dominant singer was Bing

Crosby. A small-town boy from Spokane, Washington, Crosby was one of the first white vocal stars to master black rhythmic approaches, but his expert jazz phrasing was overshadowed by his relaxed insouciance, and in 1931 he recorded the song Seeger often quoted to typify the pop scene's attitude toward human suffering: "Wrap Your Troubles in Dreams (And Dream Your Troubles Away)."

Twenty years later Crosby was still America's model of a pop singer, joined by disciples including Frank Sinatra, Perry Como, and Tony Bennett, but the number one record of 1951 was as far from insouciance as a white singer had ever gotten. Johnnie Ray was another small-town boy from the Northwest, but he was a strange, troubled character who served his musical apprenticeship on Detroit's black club scene, and his performances were cathartic displays of raw emotion: he writhed, fell to his knees, and wept, and his voice leapt out of radios across the country, sounding like a man possessed. The song was "Cry," and for a lot of listeners it signaled a new era. Hank Williams, the most heartfelt of country singers, hailed Ray as an antidote to the blandness of mainstream pop, saying, "He's sincere and shows he's sincere. That's the reason he's popular—he sounds to me like he means it." Ray put it in starker terms: "They come out to see what the freak is like. . . . They want to know what this cat has got. I know what it is. I make them feel, I reach in and grab one of their controlled emotions, the deeply buried stuff, and yank it to the surface." More than forty years later, Dylan still remembered Ray in exactly those terms: "He could really make you feel something." The adolescent Bobby Zimmerman was a shy kid, full of unformed, unexpressed emotions, and the pained honesty of "Cry," he said, made Ray "the first singer whose voice and style I totally fell in love with."

Dylan loved Williams as well, buying all his records and learning his songs, but there the main appeal was the lonesome lyrics, and by high school he was looking for wilder sounds. For a teenager bursting with unfocused energy, the country and western style was too restrained and also too widely available. He needed music that not only captured his

imagination but set him apart, and found it in the R & B broadcasts he picked up on his bedside radio after the staid local programming had gone off the air. KTHS, a 50,000-watt clear-channel station out of Little Rock, Arkansas, bounced a show from Shreveport, Louisiana, called *No Name Jive*, hosted by a black-sounding deejay named Frank "Gatemouth" Page. "Late at night I used to listen to Muddy Waters, John Lee Hooker, Jimmy Reed, and Howlin' Wolf blastin' in from Shreveport," Dylan recalled. "It was a radio show that lasted all night. I used to stay up till two, three o'clock in the morning. Listened to all those songs, then tried to figure them out."

In the 1930s and 1940s radio had been dominated by national networks that beamed *The Kraft Music Hall, Your Hit Parade, Amos 'n' Andy,* and *The Lone Ranger* into every home with electricity, but in the 1950s that role was taken over by television, and radio became a haven for local programming, ethnic programming, niche markets, and small sponsors. A prominent segment of *No Name Jive* was "Stan's Record Revue," sponsored by Stan's Rockin' Record Shop in Shreveport, which advertised "special packages" of records featured on the show. Since his business was largely mail order, Stan Lewis specialized in recordings on small, regional labels by people like Muddy Waters and B. B. King, which were hard to find in many music stores, and recalled his surprise when he started getting orders from way up in Hibbing, Minnesota, signed by a kid named Bobby Zimmerman.

In the 1930s Seeger had to travel to the Asheville Folk Festival to find the raw southern sounds that changed his life, but Dylan made the same journey without leaving his bedroom. To some extent that meant they had different relationships to the music: for Seeger it was inextricable from the communities that created it and the historical processes that shaped those communities, while for Dylan it was a private world of the imagination. But in other ways their discoveries were similar, and the difference was that the music was no longer a rustic curiosity. What had seemed like a dying folk tradition in the 1930s was now a hot commercial property, and if most folk fans missed that fact, some were excited

about it. Alan Lomax had gone to Europe in the early 1950s to escape the McCarthyite blacklist, and when he hosted a "Folksong '59" homecoming concert at Carnegie Hall, he described the change:

> A stampeding herd of youngsters—hillbillies, citybillies, rockabillies—had broken through the gates and set America singing, dancing, rocking to its own rhythms. The juke boxes were pouring out the wild expressive singing that I once had to hunt for in the Mississippi Delta. . . . I saw rock and roll audiences clapping time on the off-beat and watched the kids dancing more expressively than ever in my memory. When I closed my eyes I often couldn't tell a Negro from a white singer. Tin Pan Alley with its stifling snobby European standards was spinning on its pinnacle.

Few people in the folk music community shared his enthusiasm. Along with the expected hoedowns and ballad singers, Lomax's concert included Muddy Waters and Memphis Slim fronting a Chicago blues band with electric guitar, and he had also invited the Cadillacs, a Harlem vocal group with a hot rocking record called "Speedoo." The Cadillacs didn't make it, but he substituted a female doo-wop group from Detroit and recalled, "They wore little, shorty nightgowns when they came onstage and the folknik kids were shocked and booed them."

Like the devotees of modern jazz and classical "early music," folk devotees were defining themselves as intelligent, aware listeners with distinctive tastes, distinguished from the vast mass of herd followers who lapped up whatever the mainstream media were churning out that week. In 1957 a troubled folk listener wrote to *Sing Out!* that a recent Pete Seeger hootenanny had included rock 'n' roll and lindy dancing, and she was not mollified when Irwin Silber met her complaints with a "cliché . . . to the effect that 'Rock 'n' roll' comes from rhythm and blues, which is really folk music." As she wrote:

There are times when I would get on a soap-box and shout for more tolerance, and there is also nothing wrong with broadening one's horizons, musical or otherwise . . . [but] for people who want to be that broadminded, there is the Brooklyn Paramount, there is Alan Freed, and 85% of all radio stations. A hoot is supposed to be something special.

The desire to have one's own special music was not limited to any particular style, and in the 1950s a lot of rock 'n' roll fans were as doggedly purist as their folky counterparts. Later writers have made much of Dylan's devotion to Elvis Presley and Buddy Holly, and in his memoir, *Chronicles,* he further connected himself to the white teen mainstream by declaring an affinity with the TV star Ricky Nelson, but as an adolescent loner in Hibbing he took pride in more esoteric tastes. He was inspired by Presley and Holly, recalling, "Hearing [Elvis] for the first time was like busting out of jail. . . . He did it to me just like he did it to everybody else. Elvis was in that certain age group and I followed him right from 'Blue Moon of Kentucky.' And there were others; I admired Buddy Holly a lot." But it is significant that he connected Presley to that first record, released on the small Sun label in 1954 when the young singer was appearing on the Shreveport-based *Louisiana Hayride*, rather than with "Heartbreak Hotel," released a year and a half later on RCA, which hit nationally and made Elvis a pop sensation. Thanks to Gatemouth Page's *No Name Jive* broadcasts, Dylan was getting the music direct from its southern source and valued it in part because it was secret knowledge. As his high school buddy John Bucklen recalled, "Trying to make life special in Hibbing was a challenge. . . . Rock 'n' roll made Bob and me feel special because we knew about something nobody else in Hibbing knew about. . . . We started losing interest in Elvis after he started becoming popular."

Rock 'n' roll was not just exciting music; it was a way to set oneself apart and recognize kindred spirits, and, as with the later folk boom, that presented a problem when it became a national craze. There is no

honor in loving something that everyone else in your high school loves. Purism was a way of separating the few hardcore hipsters from the mass of superficial popsters, and Dylan took pride in his prejudices. In a taped conversation with Bucklen from 1958, he zealously upheld the standard of authentic R & B: at that point he was modeling himself on Little Richard, and when his buddy suggested that the result was "just jumping around and screaming," Dylan responded, "You *gotta* have expression!" Bucklen countered that Johnny Cash had expression, but Dylan responded by dolorously droning, "I walk the line, because you're mine," then insisting, "When you hear a good rhythm and blues song, chills go up your spine . . . but when you hear a song like Johnny Cash, what do you want to do? You want to *leave*! You want to, you—when you hear a song like some good rhythm and blues song, you want to *cry* when you hear one of those songs!"

As for mainstream rock 'n' roll, Dylan dismissed Ricky Nelson as an Elvis imitator who "can't sing at all," then moved on to the Diamonds, a white Canadian doo-wop group that had recently hit the pop charts with pale covers of R & B records by the Gladiolas and the Rays: "They're popular big stars, but where do they get all their songs . . . ? They copy all the little groups. Same thing with Elvis Presley. Elvis Presley, who does he copy? He copies Clyde McPhatter, he copies Little Richard, he copies the Drifters."

Bucklen challenged him to "name four songs that Elvis Presley's copied," and Bob responded with Little Richard's "Rip It Up," "Long Tall Sally," and "Ready Teddy," stumbled for a fourth, but when Bucklen suggested "Money Honey," jumped back with: "No, 'Money Honey' he copied from Clyde McPhatter. He copied 'I Was the One,' he copied that from the Coasters. He copied 'I Got a Woman' from Ray Charles."

As it happens, "I Was the One" was written for Elvis and never recorded by the Coasters, but it is still significant that Dylan picked that song rather than its flip side, the chart-topping "Heartbreak Hotel." The details mattered less than the display of arcane expertise: to know the black R & B originals rather than their white mainstream equivalents

was a point of pride, especially for a kid from the boondocks who might otherwise have doubts about his hipster cred. It also reflected Dylan's link to the music's southern source. As Nick Reynolds of the Kingston Trio told *Down Beat* magazine in 1959: "We found that the natives of Nashville and Memphis, regardless of race, put down Elvis and dig Bo Diddley. New York tends to be more square."

In the right circles, obscure musical knowledge was social currency. When Dylan met a fellow fan named Larry Kegan at a Zionist summer camp in 1954, he made an immediate impression by knowing every record Kegan named "*and* what was on the flip side." Soon they formed an a cappella group, the Jokers, and in 1956 cut a vanity-pressed 78-rpm record with "Be-Bop-a-Lula" on one side and "Earth Angel" on the other and appeared on a television show in the Twin Cities wearing sleeveless cardigans with the group's name stitched on the front. Kegan was a city boy whose regular singing partners included several African American teenagers, and they may have been the first black people Dylan met.

Back in Hibbing, musical knowledge also won Bob his first serious girlfriend. Echo Helstrom was a working-class teenager from the wrong side of the tracks and recalled, "He was always so well dressed and quiet, I had him pegged for a goody-goody." But one day she was at a local café with a girlfriend and saw him standing outside, playing his guitar on the street, and when he came in he explained that he was forming a band. Helstrom had been tuning in to the late-night R & B broadcasts from Shreveport and asked if he knew the song "Maybellene." In her recollection, Bob exploded:

> " 'Maybellene' by *Chuck Berry*? You bet I've heard it! . . ." And on and on about Chuck Berry, Fats Domino, Little Richard, Jimmy Reed—Bob thought he was fabulous, the best!— and everybody who was popular those days in other parts of the country, but who might as well have not even existed as far as most of Hibbing was concerned. He kept going on about their music and how great it was, how he loved to play it him-

self, and how someday he wanted more than anything else to
be a rock and roll singer—all with his eyes sort of rolled up in
his head, in a whole different *world* until . . . He stopped what
he was saying, leaned halfway across the table, his eyes great
big, and whispered, "You . . . you don't mean that you too . . .
you listen to Gatemouth Page?

That was 1957, the year Bob turned sixteen, and he shortly made his
rock 'n' roll debut with a quartet of schoolmates dubbed the Shadow
Blasters. It was at a variety show in the high school auditorium, and
they appeared in matching pink shirts, sunglasses, and their best attempt
at pompadours. Bob pounded a piano and screamed two Little Richard
numbers, and was greeted as a bizarre novelty—Echo recalled, "People
would laugh and hoot at Bob, and I'd just sit there embarrassed, almost
crying"—but the group was invited to play another gig at the local junior
college. His bandmates, though, were more into jazz than rock 'n' roll,
and it was not until the following year that he formed a regular group, the
Golden Chords, with the school's best electric guitarist, Monte Edward-
son, and a motorcycle buddy named LeRoy Hoikkala on drums. Once
again they made their debut at a school event, and this time the response
went beyond laughter. Bob was singing a new anthem of teen rebellion,
"Rock and Roll Is Here to Stay," standing at the piano in front of three
microphones—he had corralled every amplifier in the school, and it was
horrifically loud—and playing with such unrestrained energy that he
broke a foot pedal. This was more than the principal could stand, and he
cut off the house system and pulled the curtain, later explaining: "He and
the others were carrying on in a terrible way, right on the stage, and it got
out of hand. I couldn't tolerate it. . . . He got so *crazy*."

Echo remembered the crowd laughing and mocking but Bob exulting
in his triumph: "He was as big-eyed and excited as ever. I guess Bob lived
in his own world, 'cause apparently the audience's booing and laugh-
ter hadn't bothered him in the least." Other schoolmates recalled being
thrilled by the energy of the performance, and the trio made a follow-up

appearance a couple of weeks later at a talent contest sponsored by the Hibbing Chamber of Commerce where they took second prize, then at a record hop at the National Guard Armory. A newspaper ad promised "Intermission Entertainment by Hibbing's Own GOLDEN CHORDS, featuring Monte Edwardson / Leroy Hoikkala / Bobby Zimmerman." They also appeared on the *Chmielewski Funtime* polka and variety television show in nearby Duluth and for a while held Sunday afternoon rehearsals above a Hibbing barbecue joint that drew a regular crew of teenage dancers.

Every researcher who has explored this terrain tells a somewhat different story, since each talks to different people and memories merge and fade. Some have the Golden Chords going strong for a year, others have Edwardson and Hoikkala soon splitting with Bob to form a more polished band, the Rockets. One way or another, he kept performing through his high school years. He had a group in Duluth called the Satin Tones, briefly joined the Rockets, adopted the pseudonym Elston Gunn to front a band called the Rock Boppers, and played the Hibbing High School Winter Jamboree with Bucklen on guitar, the bass player from the Shadow Blasters, and a three-girl backup chorus from the local junior college, singing an obscure rockabilly number, "Swing, Daddy, Swing," and a mournful country ballad, "Time Goes By."

Bob's main instrument in this period seems to have been piano, and his high school yearbook picture bore the inscription "to join 'Little Richard.'" He played guitar as well, first a cheap Silvertone acoustic, then a sunburst Supro solid-body electric, and there are pictures of him posing with the electric and playing the acoustic onstage with the Golden Chords, but piano was more distinctive and percussive, a pounding accompaniment to his shouted vocals. Aside from music, his other passion was movies—his uncle owned the local theater, so he could go as often as he wanted—and friends recalled him being particularly fascinated by *Rebel Without a Cause*, watching it over and over and buying a red jacket like James Dean's character wore. For a lot of teenagers in the 1950s, actors like Dean and Brando provided a visual counterpart to

the rebel music on the radio—there was little opportunity to see rock 'n' rollers on television, and listeners often had to imagine fantasy lives and faces for their musical heroes. There was even less chance to see most of those artists in person, especially in northern Minnesota, but one exception was Buddy Holly, who played the Duluth Armory on January 31, 1959, on a bill with Link Wray and Ritchie Valens, three days before his plane crashed in an Iowa cornfield. Dylan sat in the front row and would often recall the connection he felt to the singer that night. In his memoir he also wrote of one other brush with stardom: he was playing guitar on a makeshift stage in the lobby of the Hibbing Armory as walk-in entertainment before a wrestling extravaganza, and the star wrestler, Gorgeous George, strode by "in all his magnificent glory," glanced Dylan's way, and winked encouragingly.

Dylan's teenaged companions remember him as a loner, shy, quiet, somewhat goofy, often distant, sometimes mean—even his closest friends describe him playing practical jokes on them, mocking them, or putting them on—and absolutely convinced that he was going to be famous. It was as if he felt his true peers were not the ordinary kids around him but people like Holly, Dean, and Gorgeous George. He got his younger brother to photograph him roaring around a corner on his motorcycle, like Brando in *The Wild One*. He was determined to be larger than life, one way or another.

The only person who served in any way as a real-life mentor appeared, once again, as a voice on the radio. A small local station began broadcasting a one-hour R & B program hosted by a deejay named Jim Dandy who lived a half hour away in Virginia, Minnesota. Not only was Dandy playing the right kind of records, when Bob and Bucklen inquired about him it turned out that he was African American—in Bucklen's estimate "the only black guy within fifty miles." That alone would have been enough to fascinate Bob. Echo recalled him being "furious" that there were no "colored people" in Hibbing and avidly pursuing any connection to black culture: "He loved their music so much, everytime he'd hear about one coming through town he'd go and find him just to meet him and talk to him and

find out what he was like." The two teenagers drove over to Virginia and found a quiet, thoughtful man in his thirties named James Reese, who welcomed them into a third-floor apartment with more records than they had ever seen. They visited several times over the next months, sometimes with Echo along, and Reese did his best to educate them about contemporary African American music. Like many grown-ups in the R & B business, he regarded what he played on the radio as a compromise with the crude tastes of a mass public and preferred the intricate explorations of cool jazz and hard bop: Bucklen remembers him saying, "I like blues. I like rock music. But there's no depth to it like jazz." Dylan was not ready for that message, but valued the messenger. As Bucklen says, "He was good for us. It was like going to a guru. You'd sit with legs crossed listening to this guy talk . . . just a black guy whose soul was in the right place."

By that time Dylan was ready for something different, and if jazz was not it, there were other options. When he graduated high school, his parents held a party to celebrate, and someone—perhaps an uncle—gave him an album of Lead Belly 78s. The next day he called Bucklen: "Bob almost shouted over the phone: 'I've discovered something great! You got to come over here!'" This time, though, his friend did not share his enthusiasm. Instead of a hot electric band, the records just had an old guy singing with an acoustic guitar, and Bucklen recalled, "It was too simple for me in 1959."

Lead Belly was more of an inspiration than a direct influence—few if any of his songs turn up on Dylan's many tapes and records—but his music suggested a path toward something deeper than teen radio hits. Before heading that way, though, Bob had one more brush with rock 'n' roll. He was headed to college in Minneapolis in the spring, but took a summer job as a busboy and dishwasher in Fargo, North Dakota, and met a local singer who was two years younger but had made an actual record for an actual label. Bobby Velline had put together a band of teenaged friends, renamed himself Bobby Vee, and got his big break when Buddy Holly's death left a dance in Moorhead, Minnesota, without its star attraction and they were hired to fill in. He shortly cut a record, "Suzie Baby," capitalizing on Holly's

"Peggy Sue," began getting more jobs, and was thinking about adding a piano player when, he recounted, "One day my brother Bill came home and said he was talking with a guy at Sam's Recordland who claimed he played the piano and had just come off a tour with Conway Twitty." It was Bob, though Vee says he gave his name as Elston Gunnn, "with three n's— kind of weird, but we thought, let's try him out."

> By now we were making enough money to buy him a matching
> shirt and with that he was in The Shadows. His first dance
> with us was in Gwinner, North Dakota. All I remember is an
> old crusty piano that hadn't been tuned . . . ever! In the middle
> of "Lotta Lovin' " I heard the piano go silent. The next thing
> I heard was the Gene Vincent handclaps, bap-bap—bap, BAP-
> BAP—BAP, and heavy breathing next to my ear, and I looked
> over to find Elston Gunnn dancing next to me as he broke into
> a background vocal part.

That was about it for Elston with the Shadows—there were few ser- viceable pianos in North Dakota's teen dance venues—but it added a touch of reality to Bob's rock 'n' roll dreams, and Vee ended his reminis- cence, "There were no hard feelings on the part of anyone as he made his exit for the University of Minnesota."

On the cusp of the 1960s, going to college was still a major rite of passage and meant not only leaving home, meeting new people, and get- ting an education, but also growing up musically. Rock 'n' roll was fun, but it was teen music, and R & B was tougher, but it was working-class music. Everyone, including most rock and R & B fans, expected that if they went to college they would learn to appreciate more adult, intellec- tual styles, the most obvious being jazz or classical, and by the mid-1950s some small jazz and classical labels were adding folk LPs to their rosters. Three-chord, guitar-based folk songs were an easy step for teens weaned on three-chord, guitar-based rock 'n' roll, and if the music was hardly more sophisticated, the liner notes provided cover: folk albums were

educational, whether consisting of peasant songs from foreign climes, Negro songs from the American South, or saucy Restoration erotica—Ed McCurdy's *When Dalliance Was in Flower and Maidens Lost Their Heads* was a ubiquitous dormitory favorite. In 1958 this trend was kicked into high gear by the insistently collegiate Kingston Trio, and soon a *Billboard* headline announced "Campus-Type Folknik Hipsters in Demand."

With bongo drums adding beatnik cachet, the Kingston Trio provided a zesty introduction to folk Bohemia and prompted a lot of Pat Boone and Connie Francis fans to pick up guitars and banjos, and maybe even to check out artists like Pete Seeger and the New Lost City Ramblers. However, that trajectory worked better for New Yorkers seeking an earthy alternative to mainstream pop than for small-town kids who associated banjo hoedowns and nasal twangs with driving a tractor or waitressing at Mom's Cafe. A teenager who disdained Elvis Presley as a pale imitation of Clyde McPhatter and got excited about Lead Belly was not going to have his world changed by the Kingston Trio. When Dylan recalled his initiation into folk music, the model he cited was cut from rougher cloth: a charismatic black singer and movie star named Harry Belafonte.

Belafonte is not generally remembered as a folksinger, but for a lot of people in the 1950s he was the defining folk star, selling millions of albums and appealing across all lines of age, race, and taste. "The swathe he cut through popular culture was north, south, east, west, high, and low," Peter Stampfel recalls, noting that the "cool kids" at the University of Wisconsin were into him, but "my mother and her lower-middle-class friends were also huge fans, saying they'd never thought of sleeping with a black man before, but they'd do him." As Dylan wrote in his memoir:

> Harry was the best balladeer in the land and everybody knew it. He was a fantastic artist, sang about lovers and slaves— chain gang workers, saints and sinners and children . . . and also a lot of Caribbean folk songs all arranged in a way that appealed to a wide audience, much wider than the Kingston Trio. Harry had learned songs directly from Leadbelly and

Woody Guthrie. . . . He was a movie star, too, but not like
Elvis. Harry was an authentic tough guy.

Belafonte had originally modeled himself on Josh White, the black
guitarist and singer from South Carolina who made rural blues palatable
to New York cabaret audiences, then branched out into left-wing topical
songs and Anglo-American ballads. Between them, White and Belafonte
inspired a wave of African American folksingers: Stan Wilson, the Kings-
ton Trio's mentor in San Francisco; Brother John Sellers, Casey Ander-
son, and the Tarriers' Clarence Cooper and Bob Carey in New York;
Inman and Ira in Chicago; Jackie Washington in Boston; and numerous
others around the country. The most respected was Odetta, who had
grown up on the West Coast and trained as a classical singer, then picked
up the guitar and switched to folk songs in the early 1950s. Dylan appar-
ently heard one of her records while still in Hibbing and recalled, "Right
then and there, I went out and traded my electric guitar and amplifier for
an acoustical guitar, a flat-top Gibson." For a young musician who had
trouble keeping bands together, there was an obvious appeal to music
that could be played solo, and Odetta's songs also fitted with his matur-
ing literary tastes—he had begun writing poetry as a kid, and high school
friends remember him raving about the novels of John Steinbeck. Rock
'n' roll was fun, but, as he later recalled, "it wasn't enough."

> "Tutti Frutti" and "Blue Suede Shoes" were great catch
> phrases and driving pulse rhythms and you could get high on
> the energy but they weren't serious or didn't reflect life in a
> realistic way. . . . When I got into folk music, it was more
> despair, more sadness, more triumph, more faith in the super-
> natural, much deeper feelings . . . "My Bonnie Love Is Lang
> a-Growing," "Go Down, Ye Bloody Red Roses," even "Jesse
> James" or "Down by the Willow Garden," definitely not pussy
> stuff. There is more real life in one line than there was in all the
> rock 'n' roll themes. I needed that.

In comparison with the R & B singers he had been modeling himself on, most white folksingers sounded nondescript and square, but Odetta's rich blend of bel canto and blues provided a connection to the artists Dylan already loved. If his voice sounded nothing like hers, that was hardly a barrier for someone who had previously modeled himself on Little Richard, and he arrived in Minneapolis with a repertoire largely drawn from her records: "Santy Anno," "Muleskinner Blues," "Jack o' Diamonds," "'Buked and Scorned," "Payday at Coal Creek," "Water Boy," "Saro Jane," and his first Woody Guthrie songs, "Pastures of Plenty" and "This Land Is Your Land"—the two Odetta had recorded.

Dylan also picked up a couple of songs from Belafonte, but judging by what survives on early tapes his second-strongest influence was yet another classically trained black folksinger, Leon Bibb, who provided him with a half-dozen songs, including his big showstopper, a gospel shout called "Sinner Man." The rest of his repertoire in those early months was a mix of folk standards picked up from other people on the Minneapolis scene or learned off recordings by Bob Gibson, Ed McCurdy, the Weavers, and whoever else caught his ear.

There were a handful of coffeehouses in the Twin Cities that featured or at least allowed folk music, and soon Dylan was a regular performer, distinguished by his increasingly large repertoire and inexhaustible energy. He was doing his best to sing like Odetta and Bibb—John Koerner, who played with him occasionally, recalled, "He had a very sweet voice, a pretty voice, much different from what it became." The surviving tapes of him from this period sound fairly nondescript, but Koerner says he was already "an unusual and noticed person. . . . He was a little different from the rest of us, and had a certain knack. . . . He played confidently, shall we say. It seemed like he wasn't too worried about how he was doing." Dylan's background as a teen rock 'n' roller gave him an edge on people who had just picked up guitars after arriving at college, and also an extra dose of rhythmic power. Koerner's roommate, Harry Weber, recalled Dylan reworking an old gospel song, "Every Time I Hear the

Spirit," and said, "It was like the Negro spiritual he based it on, except it had a rockabilly beat."

Dylan was also thinking more professionally than most people on the scene. At one point Koerner went to Chicago to see Odetta at the Gate of Horn, and he recalls Dylan giving him an audition tape to bring to her. He was naturally shy, but performing brought something out in him: "I could never sit in a room and just play all by myself," he wrote. "I needed to play for people and all the time." It was a way of relating to his new acquaintances, but also in some respects a way of shutting them out, and not everyone was supportive. "You'd go to a party and Bob would get a chair and move right into the center of the room and start singing," Weber recalled. "If you didn't want to listen, you got the hell out of the room, and I resented it."

Some listeners found his singing inept and his manner pushy and annoying, but for the first time in his life Dylan was surrounded by people he could regard as peers and mentors. He stopped going to classes in his first semester and instead hung out in coffeehouses, bars, and friends' apartments, soaking up conversation, music, books, and the Bohemian culture that had been so lacking in Hibbing. One particularly influential friend, Dave Whittaker, steered him toward beat and existentialist authors and also shared his interest in African American culture. Whittaker recalled:

> There was a black club we used to go to, and all of these prostitutes were sitting there, and you'd come in and there'd be these guys playing the blues. And using drugs. Drugs were coming in. The truckers were using bennies and we used to take four or five and we'd go on for two or three days at a time, drinking beer, playing guitar, and going from scene to scene. He used to get really fucking drunk, we all did. But he would always play that guitar.

It was a mercurial period, and Dylan was exploring new worlds and trying out new personas. A singer or record would capture his attention,

and he would pick up another dozen songs, sing them for a few days, keep the ones that worked for him, and discard the rest. It was the same with people: "When you need somebody to latch onto, you find somebody to latch onto," he explained. "I did it with so many people, that's why I went through so many changes."

Minneapolis was a hotbed of passionate players, listeners, and arguers, and Dylan could not have arrived at a better time. It was off the beaten track, and although there was a circle of older folklore devotees at the university, most of Dylan's acquaintances were feeling their way with relatively little guidance and at times diverged from their peers on the coasts. Among the most influential younger fans were Paul Nelson and Jon Pankake, who had recently discovered there was more to folk music than Belafonte, McCurdy, Bibb, Odetta, and the Kingston Trio—Pankake recalls that even Seeger was relatively new to them: they had heard the Weavers, of course, but his solo records were on Folkways, "and there were not many record stores around that carried Folkways. But Paul was working for a record distributor, and they had a few Folkways albums." Nelson was particularly intrigued by a set of three double-LP collections of southern rural recordings from the 1920s, titled *Anthology of American Folk Music* and compiled by a beat eccentric named Harry Smith. "It looked interesting," Pankake says, "so he sneaked it home so we could listen to it, and wow!"

The Smith anthology introduced them to Appalachian fiddling, down-home blues, backwoods gospel, Cajun accordion, and scratchy ballads accompanied by frailing banjos, and they responded to its revelations with evangelical fervor. They had mistaken commercial pap for authentic folk art, and it was their duty to rescue other innocents who had been similarly beguiled. So in the spring of 1960 they started a small fanzine, the *Little Sandy Review*, to spread the gospel and, as they wrote in their second issue, fire "a general Give 'Em Hell blast at any and all phonies who water, dilute, and pervert American folk music—transforming it into Folkum rather than folk song."

The *Little Sandy Review* was simultaneously a sincere effort to edu-

cate the masses and a gleeful barrage of poisoned darts, and from the start it attracted fans who eagerly repeated its latest libels: Belafonte was "Belaphoney," a new Bibb album "might make a better martini tray," and the first emanation of the burgeoning Cambridge folk scene was dismissed with the comment "It is pathetic to think of the amount of time and talent Joan Baez has wasted learning letter perfect Odetta's ludicrous version of 'Sail Away, Ladies.'" (Baez became a favorite target, constantly called to task for turning genuine folk music into callow art song.) But if the magazine attracted the most attention with its pans, it devoted far more pages to praise and helped dozens of traditional and revivalist artists reach audiences that otherwise would not have known they existed.

Dylan was hanging out with Pankake and Nelson and had access not only to their reviews but to all the LPs they were writing about. In particular, they had sent away to England for records by Ewan MacColl and Peggy Seeger, Alan Lomax, and another American expatriate who called himself Ramblin' Jack Elliott. Dylan was fascinated by Elliott's performances of everything from cowboy ballads to blues and field hollers. The singing was wild and uncontrolled, with yodels, moans, and bits of uncanny mimicry—on *Jack Takes the Floor,* Elliott performed "New York Town" as a duet with Woody Guthrie, taking both parts and interspersing the verses with comments in Woody's Oklahoma twang. For some listeners it was a bit much: even Pankake and Nelson occasionally had doubts, writing that Elliott sang African American prison songs "in so daringly ethnic a manner that one must at least respect him for trying, if not succeeding." But Dylan was enthralled and inspired: when Pankake went out of town for a couple of weeks he helped himself to a bundle of records, and his current girlfriend, Bonnie Beecher, recalled him playing the Elliott albums, one after another, insisting that she recognize their brilliance: "Literally, you are in this room until you've heard them all, and you get it."

In retrospect Dylan's attraction to Elliott has tended to be framed in terms of Woody Guthrie, who was a model and something of a men-

tor to both of them. But the Dylan performances that most obviously reflect Elliott's influence were songs like Jesse Fuller's "San Francisco Bay Blues"—the lead track on *Jack Takes the Floor*—which he performed in a similarly rough and rowdy style, complete with propulsive guitar chording and studiedly offhand commentary. Guthrie exerted a strong influence on both men, but they were also linked in other ways—both Jewish, middle-class, introverted loners who reinvented themselves as mythic wandering minstrels. Woody was an inspiration as much for his anarchic independence as for his specific musical skills, and although they sang dozens of Guthrie's songs, that was almost an afterthought. Elliott recalls that when he was bumming around with Woody, "most of the stuff we sang was old Carter Family songs and things like that," and the first Guthrie records Dylan fell in love with were his recordings with Cisco Houston and Sonny Terry—praised in the *Little Sandy Review* as "the best Woody Guthrie now available" and among "the greatest folk LPs ever pressed anywhere"—which included no original compositions.

For a lot of young fans, Guthrie's most influential writing was not the songs but his memoir, *Bound for Glory,* and his music was inextricably connected to his life—or more accurately, since the book is highly fictionalized, to his legend. The Guthrie of *Bound for Glory* is a drifting hobo folksinger, picking up songs wherever he goes, sometimes improvising a lyric to suit a particular situation, but in general singing the familiar songs of ordinary working people. The real Guthrie spent a lot of time at a typewriter but sang a similar range of material, and on records, radio, and stage performances he showed no preference for his own compositions. For Dylan, Guthrie was exciting as a singer, player, and songwriter, but most of all as a man who lived life on his own terms. Given how large Guthrie has loomed in Dylan's biographies, one of the most striking things about the surviving tapes of that year and a half in Minneapolis is how little Guthrie material is on them: a scant five songs, at least four of which Dylan had learned from other people's recordings.

Dylan's friends from that period tend to remember Elliott and Guthrie as his major influences, but also all the songs he picked up from Koerner

and other local players, and from records of everything from Negro spir-
ituals to British ballads. The details of who learned what from whom
are long since lost, since most of the artists Dylan knew and played with
were never recorded or only recorded years later, and everyone's memo-
ries were affected by later events. Nelson remembered Dylan changing
instantly and dramatically after hearing those first Jack Elliott albums:
"He came back in a day, or two at the most, and . . . from being a crooner
basically, nothing special . . . he came back and sounded like he did on
the first Columbia record." In reality Dylan's evolution was neither that
quick nor that clear. He heard hundreds of singers and songs, picked up
anything that interested him, retained what he could use, and moved
on—a typical process for an enthusiastic teenager. He was quicker than
most, was particularly adept and insistent about getting in front of audi-
ences, and had an unusual knack for recognizing styles and material that
suited his talents, but his road from Odetta through Elliott to Guthrie
included multiple detours. For example, the same issue of *Little Sandy*
that featured Elliott's records had a review of a self-produced LP from an
art gallery and bar in Denver, Colorado, *Folk Festival at Exodus*, featur-
ing yet another black folksinger, Walter Conley, along with such lesser
local lights as the Harlin Trio and a young Judy Collins. The next Dylan
tape included four songs that were on that album, and he shortly showed
up at Conley's door in Denver, asking if he could play at the Exodus.

That was the summer of 1960, and Dylan followed his trip to Denver
with other short journeys through the fall, to Chicago and Madison,
Wisconsin. It was his brief taste of the rambling life, hitchhiking, sleeping
on couches, and seeing a bit of the world beyond Minnesota. It also gave
him a taste of the professional folk scene in the middle of the country: in
Denver, he played an opening set for a clean-cut folk-song and comedy
duo called the Smothers Brothers, who thought he was lousy, and then
Conley set him up with a gig at the Gilded Garter in Central City, which
he would later describe as a "strip club" but was actually a faux Wild
West tourist trap where the noisy, drunken crowds ignored him.

Dylan had gone as far as he could go in the Twin Cities and was ready

for something different, but it was not at all clear what that might be. He was searching for direction, and Guthrie provided a beacon—not for long, but Dylan fixed on it with the ardor of a teenage romance. He was nineteen, still trying to figure out who he was. Little Richard and Odetta had been inspirational models, but Guthrie was more than just an exciting musician: he was a storyteller, a legend, and that fall he seems to have become a fixation. The *Little Sandy Review* had published a special Guthrie issue in the summer, including a short piece by Pete Seeger and a bunch of Woody's letters from the hospital in New Jersey where he had been confined since the mid-1950s with a degenerative nerve disease. The letters were effusions of quirky orthography and exuberant wordplay that would remain a potent influence on Dylan's prose, and the news that Guthrie was alive and accessible captured his imagination. Friends remember him adopting the older singer's voice, mannerisms, and at times even his identity. Bonnie Beecher recalled, "If you didn't call him Woody, he wouldn't answer." Another friend remembered Bob telephoning the hospital and asking a nurse to tell Woody he was on his way. In December he made a last trip to Hibbing, stopped for a week or two in Chicago, then made a brief visit to Madison, where he hooked up with a couple of students who were driving to New York. In later interviews, some old friends and acquaintances remembered him saying he was going there to become a star, and maybe he was. But first he was going to stop being just another kid from Minnesota who sang folk songs. He was going to become a rambler and a rover, drifting out of the West to see Woody, sing for him, and live a slice of his life.

Chapter 3
NEW YORK TOWN

Bob Dylan arrived in New York in January 1961 and headed to Greenwich Village, where he introduced himself to the local scene by playing a couple of songs at a coffeehouse on MacDougal Street. Then he set out to find Woody Guthrie—some versions have him first visiting the Guthrie family's home in Queens, then making his way to the Greystone Park Psychiatric Hospital in New Jersey; others have those visits reversed; but in any case within that first week he met Guthrie, sang for him, and established himself as one of the few young performers who had a direct connection to Woody, not only as a legend but as a person.

More than that, he established himself with the New York folk crowd as a new incarnation of the Woody who had rambled out of the West twenty years earlier. Though generally sticking with the fact that he was born in Duluth, he claimed to have grown up in Gallup, New Mexico, run away from home multiple times, and wandered all over the country. He'd picked up his early songs from cowboys back home in Gallup, and when he started playing slide guitar a few months after arriving in New York he added that he'd learned that style in Gallup as well, from a one-eyed black musician named Wigglefoot. He'd joined a carnival when he was thirteen and traveled with carnies off and on through his teens, playing piano for the dancers. He sometimes said he'd met Woody out in California ("I think Jack Elliott was with him") before he started playing

guitar. Everywhere he'd been, he found musicians to learn from: a blind street singer named Arvella Gray in Chicago; Jesse Fuller, the one-man blues band, in Denver; a farmhand named Wilbur ("never knew his last name") in Sioux Falls, South Dakota, who played autoharp; some more cowboys ("real cowboys—can't remember their names") in Cheyenne, Wyoming; "a lady named Dink" down by the Brazos River, and the rural songster Mance Lipscomb in Navasota, Texas; Big Joe Williams, whom he'd accompanied on the streets of Chicago or maybe met while hoboing on freight trains. And he'd played piano with Bobby Vee and recorded with Gene Vincent in Nashville, though he didn't know if the records had been released.

Friends in Hibbing and Minneapolis had gotten used to Bob spinning fantasies about his deeds and acquaintanceships—when he came back from North Dakota, he showed John Bucklen a Bobby Vee record and claimed to have made it himself under that pseudonym, and he had told the real Bobby Vee about a stint with Conway Twitty. What was new was the kind of people who now populated his myths. He had absorbed the aesthetic of the *Little Sandy Review* and, instead of claiming kinship with stars, was establishing his authenticity as a folksinger who had learned his music at its roots as he hoboed around the country. Some of the claims were absurd: the lyric everyone knew as "Dink's Song" had indeed been learned from a woman named Dink in Texas, but in 1908, by the folklorist John Lomax. Some were credible: Jesse Fuller did play in Denver around the period Dylan was there, though if they spent any significant time together, it is odd that the only Fuller song in his repertoire was learned from a Jack Elliot record.

Another difference was that Dylan's stories were now backed up by reality: he had hitched a ride to New York from the distant middle of the country and sought out Woody Guthrie, so there was no reason to doubt that he had roamed to other places and learned from other old musicians. "He had that Guthriesque persona, both on and offstage, and we all bought it," Dave Van Ronk recalled. "Not that we necessarily believed

he was really a Sioux Indian from New Mexico or whatever cockamamie variation he was peddling that day, but we believed the gist of his story." It helped that they wanted to believe. The New Yorkers had all read *Bound for Glory* and learned Woody's songs, and Pete Seeger had established Woody as the Apollonian ideal of a folksinger, drawing on a deep well of tradition to create lyrics that combined current concerns with the wisdom of the past and singing them in a voice that had the rough beauty of a craggy canyon and the grit of prairie dust. Younger singers admired Jack Elliott for having latched onto that legend, running away from a comfortable Brooklyn home to join a rodeo in his teens, then traveling out to California with Woody. They admired all the vanished rural artists they heard on rare 78s, and survivals like Roscoe Holcomb, a gaunt Kentucky banjo player who made his New York debut a couple of weeks after Dylan arrived, at the first concert of the Friends of Old Time Music. But Woody had been a unique mix, an authentic prairie bard who not only served as a tradition bearer but sang with Pete and Lee Hays and Alan Lomax and the rest of them, right there in Greenwich Village, and showed how old styles could be reshaped to illuminate contemporary issues. He was the real thing, but also one of them. When he succumbed to Huntington's disease and could no longer sing or write, he remained the ideal. And here was Dylan, fresh out of the West and a potential successor, welcomed by Woody himself.

People who actually knew Woody or hung out with Dylan always knew it was not that simple. "There were detractors who accused Bob of being a Woody Guthrie imitator," says Tom Paxton, a singer from Oklahoma who had arrived in the Village a year or so earlier. "But that was silly on the face of it, because Jack Elliott was a more conscious Woody clone than Bob ever was. When Bob sang Woody Guthrie songs it was very distinctive, but Bob sang like Bob right from the beginning." Seeger agreed: "He didn't mold himself upon Woody Guthrie. He was *influenced* by him. But he was influenced by a lot of people. He was his own man, always."

Dylan loved Guthrie's songs and cared about visiting him and singing for him, and some people close to Woody felt that Dylan established a stronger connection than any of the other young singers who made the pilgrimage. Elliott recalled that Guthrie could no longer speak intelligibly but said, "I knew Woody so well that we would talk to each other without words . . . [and] it was the same with Bob." Nora Guthrie has similar recollections, saying, "His relationship with my dad, I believe, was completely sincere and completely helpful. . . . Bob was there for Woody as opposed to being there for himself." She added that her father feared his songs would be forgotten, so "with someone like Bob, who could just play every song my dad ever wrote, it was just delightful." There is a tape of Dylan playing at the home of Robert and Sidsel Gleason in East Orange, New Jersey, where Guthrie spent weekends as a respite from the hospital, and it is easy to hear why Guthrie would have enjoyed his performances. He sings "Pastures of Plenty"—in the year since his Minneapolis recording, he had switched from Odetta's version to Woody's and added harmonica—and Guthrie's versions of two traditional ballads, "The Buffalo Skinners" and "Gypsy Davy," as well as "Remember Me (When the Candle Lights Are Gleaming)," a sentimental country favorite that few New Yorkers would have been likely to know. The Gleasons said Guthrie was pleased and impressed, telling them, "That boy's got a voice. . . . He can really sing it," and when Dylan got his first formal club gig, Sidsel Gleason reportedly gave him one of Woody's suits to wear.

Dylan was thrilled to have a direct connection with Guthrie and fired off a postcard to friends in Minneapolis: "I know Woody. . . . I know him and met him and saw him and sang to him. . . . Goddamn." On a recording made during a brief trip back to the Twin Cities in May he introduced "Pastures of Plenty" with the comment, "I learned this from Woody. He says I sing it—once he told me I sing it better than anybody." Meanwhile, Dylan was hearing a lot of other music in New York and exploring a lot of other styles. Along with the Guthrie songs on the East Orange tape, he sang a version of an old spiritual, "Jesus Met the

Woman at the Well," that showed an obvious debt to Van Ronk, and on the Minneapolis recording he did Van Ronk's version of a Muddy Waters song, "Two Trains Running," and two songs from Van Ronk's hero, the Reverend Gary Davis. Just as the Guthrie songs were performed in a creditable simulacrum of Woody's style, the pieces learned from Van Ronk suggested Dave's distinctive guitar arrangements and gruff blues phrasing, and on the Davis songs Dylan managed an approximation of the Reverend's rough gospel shout.

Everyone recalls the speed with which Dylan absorbed styles and shifted personas—he was "a sponge," "like blotting paper," "a chameleon"—and the only safe generalization about him at this point is that he was very hard to pin down. He was turning twenty that May and taking advantage of the opportunity to create a new identity in a new environment. If his choices and statements often seemed contradictory, that was not surprising. Not only was he changing, but the situations in which he found himself kept changing. Sometimes he was one character, sometimes another; sometimes he wanted to fit in, sometimes to distinguish himself.

None of that made him particularly unusual. Greenwich Village was full of young people trying to establish identities, to find new personas and relate to new situations, and to distinguish themselves from outsiders and from one another. It was famous for that—in novels, movies, and magazines, and on television in everything from sitcoms to detective shows, the Village was portrayed as a haven for artists, eccentrics, beatniks, and weirdos. The first club Dylan played on MacDougal Street was a tourist trap, the Café Wha?, designed to attract out-of-towners who wanted to check out the freaks. The nearby Café Bizarre had started the trend a couple of years earlier, mixing haunted-house décor with "poets and folkswingers," advertising itself as "Where the beat meets the elite" and promising, "Be prepared 4 the *unexpected*." Advertisements for the Wha? showed a sketch of a beatnik in beard, beret, and shades and promised folk singing, comedy, calypso, congas, and poetry at its "*FREE* HOOTENANNY—Every afternoon, man!"

The summer before Dylan showed up, the *Village Voice* ran a series of articles on the MacDougal scene that began with a local painter lamenting:

> This street has turned into a fruitcake version of "The Inferno." It's life imitating art—or the bourgeois myth of art. If I saw lions copulating with unicorns down here, I wouldn't be surprised. But even then, they'd turn out to be *papier-mâché.* . . . People don't come here as fools for art any more, just as fools. It's like Times Square now. Better yet, Coney Island.

Anyone hoping to understand the cultural upheavals of the 1960s has to recognize the speed with which antiestablishment, avant-garde, and grass-roots movements were coopted, cloned, and packaged into saleable products and how unexpected, confusing, and threatening that was for people who were sincerely trying to find new ways to understand the world or to make it a better place. Nat Hentoff described a scene two years later, when Dylan got an audition for CBS television's premier variety showcase, *The Ed Sullivan Show.* A half dozen of the show's arbiters listened as he played a few songs, then explained to the agent who accompanied him that they could not make an immediate decision.

> "They said," the agent told Dylan, "that they've never heard anyone like you before. They need time to decide what you are."
>
> "Huh?" said Dylan. "I was right in front of them. They either like me or they don't."
>
> "It's not that simple," said the man from MCA. "They figure you're far out, but they don't know yet whether you're the kind of far out that sells."

In terms of folk music in the early 1960s, it seemed pretty clear what kind of far-out was selling. "Rockless, roll-less and rich, the Kingston Trio by themselves now bring in 12% of Capitol's annual sales, have surpassed Capitol's onetime Top Pop Banana Frank Sinatra," wrote *Time*

magazine. The article was headlined "Like from Halls of Ivy" and positioned the group as titillatingly Bohemian but reassuringly collegiate. Leader Dave Guard was a recent graduate of Stanford, where he "earned a reputation as a sort of stubble-bearded prebeatnik who was heading nowhere except way out." His pals Nick Reynolds and Bob Shane had gone to the less prestigious Menlo College and dedicated their energies, respectively, to tennis and alcohol. Now all three had gotten their act together, were earning $10,000 a week, and could have more than doubled that if they were willing to play Las Vegas, but insisted, "We prefer a less Sodom-and-Gomorrah-type scene." Which is to say they were a little wild, but basically bright, healthy, middle-class lads, a welcome alternative to both illiterate teen rockers and sleazy lounge crooners.

In 1961 the Trio was the best-selling group in the United States, accounting for seven of *Billboard* magazine's hundred top LPs. Harry Belafonte had three, the Limeliters had one, and the only other folk-oriented entry was the Broadway cast album of *The Sound of Music,* if you count Theodore Bikel's guitar-strumming turn as Captain von Trapp. Two years later the Trio had fallen to number four, overtaken by Peter, Paul, and Mary at number one and Joan Baez at number three (Andy Williams was number two), and the other folkies in the top fifty were the Smothers Brothers, the New Christy Minstrels, Belafonte, and Trini Lopez, a Chicano rocker whose album featured a Latin-beat reworking of "If I Had a Hammer" and a rock 'n' roll "This Land Is Your Land." The most obvious formula for making it in folk music was to form a group, and plenty did: the Chad Mitchell Trio, the Shenandoah Trio, the Ivy League Trio, the Cumberland Three, the Brothers Four, the Modern Folk Quartet, the Highwaymen, the Journeymen, the Lettermen, the Villagers, the Tarriers, the Wayfarers, the Gateway Singers, the Belafonte Singers, the Tiffany Singers, the Serendipity Singers, the Folk Singers, the Womenfolk, and hundreds more.

To the mass national audience, that was the face of the folk revival, along with some long-haired girl ballad singers, all playing uniform, orderly arrangements and singing in mellifluous voices. As Alan Lomax explained in *House Beautiful*:

The popularization of a folk song is, in effect, a translation
from one language into another and, as usual, something is
lost in the process. Most of us like the popularized versions
because they are engaging tunes in the familiar musical lan-
guage of the popular song. The tunes are melodic, the har-
monies close, the beat jazzy and strong, and the musicians are
polished performers—by our standards.

His point was that mainstream listeners needed to recognize the lim-
itations of those standards; that "unless we learn to distinguish the real
from commercial versions, we will never know the world of emotion and
experience from which folk music comes." But really, how many people
wanted to know that world? When the Revlon cosmetics company spon-
sored a *Folk Sound USA* program on CBS in 1960 with Cisco Houston,
John Lee Hooker, Lester Flatt and Earl Scruggs, a pre-Paul-and-Mary
Peter Yarrow, and a nineteen-year-old Joan Baez, *Variety*'s television
critic summed it up as "the kind of folk music I associate with far-out
Bohemian types. I mean the kind who wear leather thong sandals and
entertain you after dinner (a casserole of garlic bulbs and goat hearts,
stewed in bad wine) with their scratchy old recordings of blues songs by
Leadbelly and Blind Willie Johnson."

Normal people might find it amusing to visit the Café Bizarre or
the Wha? and see the weirdos in their native habitat, but the Kingston
Trio was not only more polished and entertaining; they were also more
honest: as Dave Guard said, "Why should we try to imitate Leadbelly's
inflections when we have so little in common with his background and
experience?" The Bohemians were a bunch of poseurs who dressed badly,
listened to screechy music, and were at best ridiculous and often frankly
annoying.

Of course, the Bohemians saw the situation rather differently: to them,
the Trio and its fans were a bunch of empty-headed conformists march-
ing in lockstep to the drumbeat of Madison Avenue and the Cold War
military-industrial complex, and any effort to succeed on the commercial

folk scene represented a compromise with a corporate culture that was bland, retrograde, and evil—the culture of blacklisting, segregation, and nuclear annihilation. Plus, it was lousy music. In Van Ronk's words:

> Their version of the folk crowd consisted of boys in neat little three-button suits with narrow little lapels and skinny little ties, and girls in evening gowns. Crew-cuts! Crew-cuts up the wazoo. And most of the music was so precious, and so corny, you could lose your lunch. . . . There was an obvious sub-text to what these Babbitt balladeers were doing, and it was: "Of course, we're really superior to all this hayseed crap—but isn't it *cute?*" . . . These were no true disciples, or even honest money-changers—they were a bunch of slick hustlers selling Mickey Mouse dolls in the Temple. Join their ranks? I would sooner have been boiled in skunk piss.

There were plenty of people who bridged that cultural divide, wearing neatly pressed shirts, proper dresses, and penny loafers on weekdays, then changing into jeans, sandals, and peasant blouses to sing with their friends in Washington Square on Sunday afternoons. But there were also some who took pride in being true Bohemians, devoting their lives to other goals than a good job and a house in the suburbs, as well as a substantial majority who wanted nothing to do with anything even faintly Bohemian. Nor was that simply a matter of taste: Cold War paranoia meant that choices that seem innocent in retrospect could have significant repercussions. In 1960, John Cohen of the New Lost City Ramblers told a reporter he had heard of "actual fist fights, held in dormitory rooms, where students tried forcibly to prevent their roommates from going to the hoots—on the grounds that it would seriously impair their future chances, particularly for Government jobs, if it were known that they associated with people like us." In 1963, Dylan's girlfriend Suze Rotolo was told that her cousin's husband, a career army officer, had lost a promotion that required security clearance because she was pictured with Dylan on the cover of his *Freewheelin'* album, and

as late as 1968 a friend of mine was kicked out of his high school band on Long Island simply for attending a Pete Seeger concert.

In that context, "people like us" included everyone from the New Lost City Ramblers to the Weavers, but in other contexts the folk scene was developing further divides, and commercialism and politics were not the only factors. Through most of the 1950s serious fans drew a distinction between authentic folksingers, who played the traditional music of their communities, and "singers of folk songs" like Seeger, Burl Ives, Richard Dyer-Bennett, and Odetta, who performed material collected in those communities but had not grown up in the culture. Urban singers learned rural songs but rarely attempted to master or mimic authentic rural styles—Seeger's occasional efforts to transcribe and recreate Appalachian banjo arrangements were exceptions even within his own repertoire. By the end of the decade, though, some young players were dissatisfied with the approach of previous urban interpreters. The music they were hearing on reissue albums like the *Anthology of American Folk Music* and *The Country Blues*—an LP of prewar "race records" issued by Folkways in 1958—was not only more authentic but more technically virtuosic and artistically demanding than anything being played by the well-known revivalists, and if they were going to play that music, they wanted to get it right.

Van Ronk, a leading figure in this group, later dubbed them the "neo-ethnics." Some played old-time hillbilly music, some played blues, some sang medieval ballads, and there were lots of other flavors in the mix:

> Someone would go off to Mexico or Greece and come back with a few new songs, or someone would stumble across an album of African cabaret music and learn a couple of tunes. . . . It was much more eclectic than it became a few years later. The one limiting factor was the insistence on "authenticity," on reproducing the traditional ethnic styles, all the way down to getting the accents right. It did not matter if you were ethnic à la Furry Lewis or à la Jimmie Rodgers, or à la Earl Scruggs;

that was a matter of personal taste. But that it should be authentically ethnic was a matter of principle.

The agora of the neo-ethnic movement was Washington Square Park, where players and fans gathered every Sunday afternoon. Roger Sprung, the man who brought bluegrass to New York, would be there with his banjo, accompanied by Lionel Kilberg playing a homemade one-string bass and a gaggle of young acolytes who over the next few years formed the core of the urban bluegrass and old-time scenes. Kids who had learned union songs at progressive summer camps raised their voices in socially committed sing-along circles. Folk dancers swirled; ballad singers warbled; blues singers growled, moaned, and traded guitar licks. In Dylan's recollection, "There could be fifteen jug bands, five bluegrass bands, and an old crummy string band, twenty Irish confederate groups, a southern mountain band, folksingers of all kinds and colors singing John Henry work songs."

Music was permitted in the park from noon till five, and if you weren't sated by then there would be a hootenanny and concert that evening at the American Youth Hostels building on Eighth Street. Then serious pickers and singers would convene at 190 Spring Street, where several musicians had apartments, or in various other lofts, basements, and walk-ups around the Village or Bowery, and the playing would continue till dawn. In terms of hearing new songs and styles, meeting other musicians, and building skills and repertoire, the parties were at least as important as the clubs and coffeehouses. The Village musicians all learned from one another and were each other's most important audience. Some influential players and singers rarely even bothered to perform onstage, except perhaps in informal jams on hoot nights, and only a tiny fraction of the music from that period survives on recordings. When touring musicians came through from California, Cambridge, Chicago, or Minneapolis, their public shows were always followed by parties and get-togethers with local players. When old-time rural performers began coming through town, they became part of that mix as well—it was great to see Mississippi John Hurt or Doc Watson onstage at the Gaslight Café, but even

better to share a drink and pick a few tunes with them afterward, or hear them pick tunes with each other.

The twin poles of the neo-ethnic movement were white old-time, hill-billy, and bluegrass and black blues, jug band, and gospel. On the Village scene, the most influential figures in those styles were, respectively, the New Lost City Ramblers and Dave Van Ronk. The Ramblers evolved out of the Washington Square jam sessions: Tom Paley had carried Pete Seeger's early attempts at old-time banjo styles to a new level and added fingerstyle guitar and high mountain harmony, and in 1958 he joined with John Cohen, likewise on vocals, guitar, and banjo, and Mike Seeger, Pete's younger half-brother, on vocals, guitar, banjo, mandolin, fiddle, autoharp, harmonica, and pretty much any other instrument that came his way. Immersing themselves in old records, then traveling south to meet the original players, they transformed themselves into a living labo-ratory and museum of southern rural styles: dressing in vests and ties like the players in old photographs, exhuming forgotten songs, and mastering an unprecedented range of instrumental techniques. They reshaped songs and arrangements to fit their tastes and talents, but always within the musical languages of the rural South, and within three years had recorded six albums for Folkways and spawned imitators across the country.

Van Ronk, by contrast, came to the Village as a wannabe jazz musician, playing banjo and guitar with New Orleans revival bands, but one Sunday afternoon he happened to hear Paley fingerpicking some blues in Washing-ton Square and realized he could get more work if he learned that style and became a soloist. A dedicated eclectic, he continued to play jazz, ragtime, vaudeville novelties, British ballads, spirituals, and whatever else caught his fancy—he even occasionally sang Elizabethan madrigals in a loose quar-tet with Dylan, Ed McCurdy, and John Winn, a recent transplant from Denver's Exodus scene—but blues was his meat. He was a bearded giant, topping six foot three and over two hundred pounds, and his voice ranged from a raspy whisper to a gruff shout. His music was indebted to older players, from archaic rural stylists like Lead Belly and John Hurt to sophis-ticated hit-makers like Leroy Carr and Bessie Smith, with a strong overlay

of Louis Armstrong and a nod to Josh White—but he always sounded like himself, and by the time Dylan hit town he was "the mayor of MacDougal Street," hosting weekly hoots at the Gaslight and holding court at the bar next door, the Kettle of Fish. Dylan spent numberless nights hanging out with Van Ronk, crashing on his couch, absorbing songs and guitar techniques, and picking up occasional jobs through Dave's wife, Terri, who functioned as a part-time manager and booking agent. The relationship was not just about music. They drank a lot of wine, played a lot of chess, and smoked a fair amount of dope, and Van Ronk did his best to school Dylan in literature and left-wing politics—behind his gruff blues persona, he was awesomely well-read and a dedicated Trotskyist with a sideline in anarcho-syndicalism. But music was always at the heart of it, and soon Dylan was playing decent fingerstyle guitar and singing a lot more blues.

For most young urbanites it was a stretch to sound like a southern sharecropper or a Texas cowboy, but for Dylan the hardcore neo-ethnic styles were liberating. He had grown up on Hank Williams and R & B, and was never really comfortable mimicking the round tones of Odetta and Leon Bibb. Elliott, Guthrie, and Van Ronk had voices that suggested hard-won experience in tough environments rather than conservatory training, and they provided models of how to reshape a wide range of disparate material into a cohesive, personal style. He met another raspy-voiced model in the summer of 1961 on a trip to Boston: Eric Von Schmidt was a painter, guitarist, and the uproarious Bohemian godfather of the Harvard Square scene, combining Van Ronk's devotion to old jazz and blues with Elliott's anarchic enthusiasm. He was known for reshaping old songs, expanding a ragtime lyric about champagne and whiskey to include peyote and reworking tunes and guitar arrangements to the point that they could be considered original compositions, and his concerts often turned into impromptu jam sessions, with friends crowding the stage and pushing each other to unexpected and irreproducible heights.

Later chroniclers have made a fetish of tracing Dylan's sources, searching out the records or people he learned from and imitated, but songs were constantly being passed around and mutating, and even

when we can pin down a single source, there were often multiple inter-
mediaries: someone learned a song from an old 78 and sang it at a party;
someone else heard it and repeated it from memory, changing a few
words and adding a couple of verses from another song; someone else
adapted it from banjo to guitar. "We were sort of living from this place
to that—kind of a transient existence," Dylan later recalled. "You heard
records where you could, but mostly you heard other performers." That
included some of the people who made the old records—he mentioned
Clarence Ashley, Doc Watson, Dock Boggs, the Memphis Jug Band,
Furry Lewis—but also young peers like Van Ronk, Von Schmidt, Mark
Spoelstra, Jim Kweskin, Len Chandler, Jackie Washington, and many
others long since forgotten.

What the musicians played onstage was an extension of the offstage
jams. Dylan played a few gigs as a triple-bill with Kweskin, who was
soon to form the decade's most influential jug band, and Peter Stampf-
el, a fiddle and banjo player who went on to notoriety with the Holy
Modal Rounders and the Fugs, and the shows typically consisted of
four sets, one by each of them and one where they mixed and matched
duos and trios. Dylan and Kweskin sang Guthrie-Houston duets and
Stampfel added fiddle on the hoedowns or played kazoo on "San Fran-
cisco Bay Blues" while Dylan flatpicked rhythm and Kweskin finger-
picked ragtime leads.

It was a vibrant, supportive scene, and Dylan was surrounded by
fellow musicians, trading songs, learning from each other, and spurring
one another on. He has sometimes been criticized for how much he bor-
rowed from others, but that was not an issue until he became famous.
At the time, as Van Ronk put it, "We all lived with our hands in each
other's pockets. You'd learn a new song or work out a new arrangement,
and if it was any good you'd know because in a week or two everybody
else would be doing it." In retrospect some people resented Dylan for
stealing their songs or arrangements, while others were proud of what
he picked up from them, and in both cases it only mattered because of
what happened later.

In those first months a lot of people regarded Dylan as just another young folksinger with a particularly abrasive voice, and some are still baffled by his success. But others say he stood out immediately: "He just had it," Kweskin recalls:

> He was electric. You couldn't take your eyes off him. He was magnetic. At the time, to me, it was more his presence than it was his music. I liked his music, but what was special was his personality. He was just one of those people that he got up onstage and he owned it.

Van Ronk noted that Dylan's performances in this period were very different from anything he did in later years:

> Back then, he always seemed to be winging it, free-associating, and he was one of the funniest people I have ever seen onstage. . . . He had a stage persona that I can only compare to Charlie Chaplin's "Little Fellow." He was a very kinetic performer, he never stood still, and he had all these nervous mannerisms and gestures. He was obviously quaking in his boots a lot of the time, but he made that part of the show. There would be a one-liner, a mutter, a mumble, another one-liner, a slam at the guitar. Above all, his sense of timing was uncanny: he would get all of these pseudo-clumsy bits of business going, fiddling with his harmonica rack and things like that, and he could put an audience in stitches without saying a word.

The Village scene provided Dylan with a unique opportunity to learn and polish his skills. He had come to the big city and been instantly accepted in the seething center of the folk revival, and with all the clubs on MacDougal he was working constantly. The audiences were often mobs of drunken tourists, but that made it all the more necessary to find ways of capturing and keeping their attention. When he made a brief visit to Minneapolis, Jon

Pankake was startled by the transformation: "I thought he was terrible but I was fascinated by him. When he had been here, he had been as inhibited as the rest of us but now he was howling and bobbing up and down. He picked up his freedom before he had gotten his technique."

Pankake had not seen Bobby Zimmerman pounding the piano in Hibbing, or he might have made a different connection. Dylan was playing the standard neo-ethnic mix of old ballads and blues, but unlike most people on the folk scene he did not present them as museum pieces. He made the music come alive in new ways, and if some of his peers were nonplussed by the result, others found it thrilling. Stampfel, for one, says it changed his life:

> When I first saw him it was in the Fat Black Pussycat, and he had on that little cap and was carrying a guitar, and I thought, "This guy's a greaser from New Jersey, and he heard that if you carry a guitar case in the Village, you can get laid." You know: "I've got his number . . ." But then I saw him at Folk City, singing an old-time song called "Sally Gal," and it blew my mind. . . . His singing style and phrasing were stone rhythm and blues! He fitted the two styles together perfectly, clear as a bell, and I realized for the first time that my two true loves, traditional music and rock music, were in fact one.

Many people find Stampfel's comments surprising—Dylan was not singing rock 'n' roll back then, they say, he was singing Woody Guthrie songs. But Stampfel's recollection is backed up by the Everly Brothers riff that sets off "Highway 51" on Dylan's first LP and the ferocious vocal attack and guitar rhythms of an unreleased "Fixin' to Die Blues" with Van Ronk, as well as numerous recordings of "Sally Gal" on which Dylan's raw energy may suggest Elliott or Von Schmidt more than Little Richard, but with a churning rockabilly drive. In any case, there is no reason why we should expect recordings to capture Dylan's music from this period at its most powerful, since none of them were made in the

type of situation where he blew Stampfel away, pulling out all the stops to get the attention of a noisy and potentially hostile bar crowd.

Nor was the mix of folk material and rock 'n' roll as unique as Stampfel initially suggested—when pressed, he quickly came up with the Fendermen's "Mule Skinner Blues," a Top 10 hit in 1960, as a similar effort, and that record's driving guitar and uninhibited yodeling do sound somewhat like Dylan's early New York style. It may not be coincidental that the Fendermen were from Wisconsin, one state over from Minnesota, and their hit was on the same Minneapolis label that recorded Bobby Vee. The whole idea of rockabilly is a fusion of hillbilly music and rock 'n' roll, going back to Elvis's "Blue Moon of Kentucky" and, a decade earlier, the Delmore Brothers' "Hillbilly Boogie," and in some ways the divide between folk and pop-rock was not so much musical as ideological: "Mule Skinner Blues" was originally recorded in 1930 by Jimmie Rodgers, the "blue yodeler," and he sounded like a guy who knew what it was like to drive mules, working long hours in the hot sun for lousy pay. Guthrie recorded it in the 1940s, as did Bill Monroe and his Bluegrass Boys, and it was exactly the sort of song the folk revivalists favored— Elliott, Dylan, Odetta, and Belafonte all sang powerful versions, evoking a tough rural lifestyle. By contrast, the Fendermen treated the song as a joke. Like the Kingston Trio, Smothers Brothers, and other collegiate folk groups—they were, as it happens, a collegiate rock band—they were having fun with rural music but carefully distancing themselves, portraying it as cute and comical. They had oodles of youthful pep, but none of the guts of Rodgers, Guthrie, Elliott, or Belafonte—or of Little Richard or the young Elvis Presley.

For Dylan, as for Pete Seeger, the attraction of folk music was that it was steeped in reality, in history, in profound experiences, ancient myths, and enduring dreams. It was not a particular sound or genre; it was a way of understanding the world and rooting the present in the past. As he later reflected, thinking back on that time: "Folk songs were the way I explored the universe, they were pictures and the pictures were worth more than anything I could say. . . . It wasn't that I was

anti–popular culture or anything. . . . I just thought of mainstream culture as lame as hell and a big trick. . . . What I was into was the traditional stuff with a capital *T* and it was as far away from the mondo teeno scene as you could get."

There was always a disconnect between the aesthetic of the hardcore folk scene and the marketing categories of the music business. Going by the marketing genres, Ray Charles, Bobby Darin, and Frankie Avalon were rockers and Guthrie, Baez, and the Kingston Trio were folksingers. But neo-ethnics like Van Ronk, Elliott, and the *Little Sandy* reviewers loved Charles and Guthrie, despised Darin, Avalon, and the pop-folkies, and had mixed feelings about Baez, whose taste they approved of but whose singing was too refined. The divide was in part political—the music of the proletariat, as opposed to the music of the bourgeoisie—but on a visceral level it was a reaction against the soul-deadening vapidity of mainstream commercial culture. Dwight MacDonald, a writer much admired in Village intellectual circles, railed in the *New Yorker* and *Partisan Review* against the homogenizing effects of mass production on art, inventing the term "midcult" (middlebrow culture), which he warned was replacing both high art and folk art.

The Weavers, Belafonte, and the Kingston Trio all paid lip service to folk traditions, but from the point of view of the neo-ethnics they were making midcult, melting-pot music. As MacDonald wrote, quoting Randolph Bourne, an early theorist of what would become known as multiculturalism, the ideal of the melting pot was virtuously egalitarian but in practice meant boiling the distinctive qualities of myriad ethnic cultures down "into a tasteless, colorless fluid of uniformity . . . the American culture of the cheap newspaper, the movies, the popular song, the ubiquitous automobile." Or, most obviously in the early 1960s, television, where colorlessness and uniformity were explicitly enforced by blacklisting and racial segregation.

Rock 'n' roll had emerged in the 1950s as roots music, roaring out of the rural South and the urban ghettos of the North, and a lot of kids hailed it as an antidote to the midcult mainstream. Within a few years,

though, savvy pop marketers had added the new styles to their cauldron, boiling out the impurities and condensing a bland commodity that still called itself rock 'n' roll but was as tame and uniform as *American Bandstand* could make it. In 1961 a favorite Dylan novelty was Von Schmidt's "Acne," sung in an aching evocation of the Frankie Avalon sound, at times with Jack Elliott providing suitably satirical backup: "Found out I have acne (doo-wah) / Now you won't ask me (doo-wah) / Now you won't ask me to the senior prom."

Rather than refining the rock 'n' roll style, Dylan was digging back to its roots, from Elvis to Jimmie Rodgers and the Carter Family, and from Little Richard to Rabbit Brown and Robert Johnson. Most people framed that process as a search for rural purity, but on the New York scene there was also a long history of folk music overlapping with more recent African American pop styles. When Lead Belly died in 1949, Alan Lomax organized a memorial concert that included Pete Seeger, Woody Guthrie, Jean Ritchie, and the Reverend Gary Davis, but also Hot Lips Page, Sidney Bechet, Count Basie, and Sonny Terry and Brownie McGhee accompanying Brownie's brother Stick, who had just topped the R & B charts with a rocking hit called "Drinkin' Wine Spo-Dee-O-Dee." Oscar Brand played that evening as well, and when he published his pioneering history of the folk revival, *The Ballad Mongers*, in 1962, he noted those connections and suggested that artists like Elvis Presley continued to serve as a bridge between pop and roots styles: "Since his training reflected the Southern concatenation of country music and gospel shouting, it helped make the folk sound more palatable generally."

Some folk fans were outraged by that comparison, since Presley symbolized everything they hated: a Hollywood simulacrum of authentic blues, embraced by Madison Avenue as a way of selling black culture without showing black faces. But the sight of a young Elvis shouting "You ain't nothin' but a hound dog" undoubtedly primed a lot of kids for the raw energy of Bob Dylan singing Woody Guthrie songs at Folk City. "I played all the folk songs with a rock 'n' roll attitude," Dylan recalled. "This is what made me different and allowed me to cut through

all the mess and be heard." It was easy to miss that connection on his Woody Guthrie songs—though he obviously had inflections and rhythms that were different from Guthrie's—but it became increasingly clear as he immersed himself in blues.

When Dylan reached a wide audience a few years later, it was primarily as a songwriter, so his artistic growth has tended to be traced in those terms—he came to New York singing Guthrie compositions, wrote his first songs in Guthrie's style, then expanded into other styles. That narrative works if you think of him arriving at Woody's bedside, writing the two original songs on his first album, "Song to Woody" and "Talkin' New York," then proceeding to "Blowin' in the Wind" and "The Times They Are a-Changin'." But it ignores all the other changes he was going through in those years.

For a start there was his harmonica style. Dylan does not seem to have played the instrument much before coming east, but his first regular gig in the city was as a harmonica accompanist to Fred Neil, a blues-influenced singer who ran the hoots at the Café Wha? He quickly established himself as a desirable sideman and in that context played quite differently than he would later on his own records. Dylan would become known for his rack playing, with the harmonica in a metal holder, leaving his hands free to play guitar, and his rack style was energetic and effective and became one of the most distinctive sounds of the era. Technically, though, it never reached the level of his harmonica work in this early period, when he was concentrating on the instrument, holding it in his hands and cupping or fanning it to add tonal and rhythmic effects. A home recording from December 1961 includes his six-minute version of Sonny Terry's showpiece, "Long John," alternating a powerful rhythmic chug with wails, moans, and imitations of highballing freight trains and barking dogs, and, while not on Terry's level, it is a startlingly creditable performance.

By the standards of the time and place, Dylan's playing stood out, and his first professional recordings were as a harmonica accompanist. The most impressive in pop terms was a session for Harry Belafonte's album *Midnight Special*, which showcased his wailing backup on the title track,

and he also played on three songs by Carolyn Hester, a singer and guitar-
ist from Texas who had been signed by Columbia Records as their answer
to Joan Baez. By blues standards, though, his greatest coup was backing
Big Joe Williams, an authentic Mississippi master, on several songs for
Victoria Spivey, herself an important blues artist of the 1920s who had
recently started her own record label. Williams and Dylan both claimed
their relationship went way back—Williams sometimes said he had met
Dylan in the 1940s and Dylan said he had followed Williams around
the streets of Chicago as a kid—and, whatever the truth of those claims,
they clearly liked each other and enjoyed playing together. Len Kunstadt,
Spivey's partner, was astonished by their rapport, saying that very few
people could play with Williams: "He's erratic, irregular, unpredictable,
and I've never seen anybody follow Big Joe that well."

Dylan's guitar skills were developing along with his harmonica chops.
Van Ronk recalled that he was too restless to learn guitar arrangements
precisely, but he quickly picked up the rudiments of fingerpicking and
a repertoire of ragtime-flavored songs from Van Ronk, Elliott, and Von
Schmidt: "Cocaine Blues," "Candy Man," and "Baby, Let Me Follow
You Down" became staples of his repertoire, and he played them with
relaxed, swinging skill. Where he really cut loose and made his mark,
though, was a fusion of blues fingerstyle licks with the flatpicked rhythm
of his rock 'n' roll days. This playing had a freshness and power that
matched the over-the-top intensity of his singing, and provided a con-
trast to moody performances like "Song to Woody" and "He Was a
Friend of Mine."

Dylan was also beginning to develop some songwriting skills—Kweskin
says he was constantly scribbling on notepads—but for the moment his
original songs were novelties in a large grab-bag of traditional and semi-
traditional material. Among the neo-ethnic crowd, songwriting tended
to be viewed with suspicion, in large part because it was associated with
the Seeger-Weavers generation and pop-folk trends. The older players had
adulterated the tradition with pseudo-proletarian fabrications like "If I
Had a Hammer" and "Kisses Sweeter than Wine," and now a new wave

of hit-makers was compounding the felony with sappy schlock like "They Call the Wind Mariah" and "Scarlet Ribbons (For Her Hair)." Even the more hardcore made exceptions in some contexts—it made sense to pen a topical lyric if you were singing at a rally or demonstration—but if you wanted to sing about daring outlaws or the pangs of despis'd love there were centuries of great material available, from "Gypsy Davy" to "Black Snake Moan." Serious, authentic folksingers stuck to traditional material, played in their best approximation of traditional styles.

Blues, though, was a bit different, because improvisation was part of the tradition. All the old blues singers mixed and matched verses, adding new ones when they forgot a rhyme or were struck by inspiration, and all tried to put their own mark on what they sang. Dylan presented himself as someone who was absorbing music directly from traditional roots artists. In his first newspaper interview, he told Robert Shelton of the *New York Times* that he had learned songs from Mance Lipscomb, Jesse Fuller, and the mythical Wigglefoot, as well as from records by Rabbit Brown, Blind Lemon Jefferson, Ray Charles, and Little Walter. When Israel Young, who ran the Folklore Center on MacDougal, questioned him for the program notes of his first formal concert at the Carnegie Chapter Hall, he talked of spending time with Blind Arvella Gray, and described an afternoon at Alan Lomax's house swapping songs with Bessie Jones of the Georgia Sea Island Singers. The connection he was establishing went deeper than repertoire and technique: the New Yorkers were learning rural traditions as outsiders and needed to be careful to get them right, but Dylan acted like an insider, someone who had picked up whatever came his way as he wandered around the country: "I sing old jazz songs, sentimental cowboy songs, Top Forty hit parade stuff—people have to name it something so they call it 'folk music.'" He was not just learning from the folk; he was one of them, and sounded like it. He told Young that his favorite singers were Van Ronk, Elliott, Stampfel, Kweskin, and Von Schmidt, all rough-voiced individualists, and put himself in the same class: "My songs aren't easy to listen to."

Given his skills and tastes, blues was a natural direction for Dylan to

explore. That was where the acoustic guitar pickers at the Gaslight Café overlapped the rocking bands on *No Name Jive,* and the convergence freed him to shape his own sound. When he sang Woody Guthrie songs, he sounded a lot like Woody or Jack Elliott, but when he sang blues he sounded like nobody else, and his idiosyncratic approach to African American styles attracted attention in some surprising places. Within four months of arriving in New York he got a gig at the most prestigious showcase of the neo-ethnic scene, Gerdes Folk City, opening for the legendary John Lee Hooker, and a few months later his talents were recognized by another legend, the record producer John Hammond. Hammond had supervised Bessie Smith's last sessions, was currently spearheading the reissue of Robert Johnson's recordings, and was famous for discovering Billie Holiday, Count Basie, and, most recently, an eighteen-year-old Aretha Franklin. He had also fought against the blacklist, persuading Columbia Records to add Pete Seeger to its roster, and was branching out to the younger folk scene. He brought Carolyn Hester to Columbia and met Dylan at a rehearsal in the apartment Hester shared with her husband, a dulcimer player named Richard Fariña. Hammond was more impressed by the young man's attitude and appearance than by his musicianship, but thought he had something special, and when he heard "Talkin' New York" it clinched the deal: "It was just one of those flashes. I thought, 'I gotta talk contract right away.'"

It probably helped that Dylan showed up for Hester's recording session with a rave review from the *New York Times.* He was at Folk City again that week, opening for the Greenbriar Boys, the top Village bluegrass band, and the *Times* gave him an outrageously positive write-up, mentioning the headliners only in the last two paragraphs. No other young player had been treated to that kind of attention, and the review's author, Robert Shelton, would continue to pop up at key moments over the next few years. Shelton may actually have been involved in getting Dylan the Folk City booking and certainly went beyond normal journalistic practice in boosting Dylan's career and establishing him as a scruffy Bohemian archetype. Writers who described other male performers in terms

of their music consistently drew attention to Dylan's looks and clothing, and virtually every description mimicked Shelton's original: "Resembling a cross between a choir boy and a beatnik, Mr. Dylan has a cherubic look and a mop of tousled hair he partly covers with a Huck Finn black corduroy cap." Dylan's voice was "anything but pretty," but that just accentuated the purity of his art: "He is consciously trying to recapture the rude beauty of a Southern field hand. . . . He may mumble the text of 'House of the Rising Sun' in a scarcely understandable growl or sob, or clearly enunciate the poetic poignancy of a Blind Lemon Jefferson blues."

Shelton expanded these encomiums in the liner notes to Dylan's first album, writing under the pseudonym Stacey Williams, and Dylan told Izzy Young that he was spending his off hours practicing piano at the writer's house. This relationship undoubtedly exacerbated the resentment of some of Bob's peers: Shelton recalled that the *Times* piece was applauded by Van Ronk and Elliott, but "much of the Village music coterie reacted with jealousy, contempt, and ridicule." When it was followed by a Columbia recording contract, "Dylan felt the sting of professional jealousy. He began to lose friends as fast as he had made them." In Shelton's view, this was largely what would now be called playa hating: "The folk world tended to knock anyone who was 'making it.'" But the problem was not just the amount of attention Dylan was receiving; it was the kind of attention. He was treated as a new kind of celebrity, an intriguing young Jack Kerouac character whose music simultaneously evoked Kentucky coal mines and beatnik lofts. In a *Playboy* piece on the burgeoning folk boom, Nat Hentoff wrote:

> Bob Dylan, a 22-year-old wanderer . . . has somehow assimilated a rainbow of styles from archaic Negro blues to acrid white mountain wailing, and has emerged as a penetratingly individual singer as well as an expert harmonica whooper and guitarist. Dylan, the most vital of the younger citybillies, looks at first like a fawn at bay; but when he starts to sing, the slight boy in the black corduroy cap, green jumper and blue corduroy pants draws his audiences into his stories as if he were an ancient bard.

Time magazine, in a cover story featuring Joan Baez, wrote:

> The tradition of Broonzy and Guthrie is being carried on by a large number of disciples, most notably a promising young hobo named Bob Dylan. He is 21 and comes from Duluth. He dresses in sheepskin and a black corduroy Huck Finn cap, which covers only a small part of his long, tumbling hair. He makes visits to Woody Guthrie's hospital bed, and he delivers his songs in a studied nasal that has just the right clothespin-on-the-nose honesty to appeal to those who most deeply care.

The snideness of that last phrase typified mainstream attitudes to the whole folk scene, and would have been as likely to turn up in a review of the New Lost City Ramblers. But the Ramblers always made it clear that they were exploring other people's traditions: they devoted their lives to playing authentic rural music, searching out older musicians, and helping them record and find jobs on the growing revival circuit. For their efforts, they were rewarded with small audiences on college campuses and recorded for the poorly distributed and ill-paying Folkways label; no one gushed over their long, tumbling hair or compared them to fawns at bay. Meanwhile, Dylan was singing old songs in a way that struck some people as fresh and distinctive but that many traditionalists considered forced, pretentious, and inept.

More to the point, neither *Playboy* nor *Time* would have been giving Dylan that kind of coverage if he had not been on a major national record label, and a lot of people couldn't understand what he was doing there. Aside from the small, fervent band of admirers he had developed in the Village, few listeners thought he was anything special, and when his album arrived in stores the general public was neither thrilled nor incensed, but simply ignored it. Sales were poor, and around Columbia he became known as "Hammond's Folly."

In the context of Dylan's later career, that first record is particularly interesting for what it suggests about his musical tastes and skills. Billy

James, the Columbia publicist assigned to write his bio, was impressed by the oddity of "a skinny little white young kid sounding like an eighty-year-old black man . . . and doing it with the sureness and intensity, and that unswerving understanding of who he was, and what he wanted to do." Which is to say he thought of Dylan as a sort of acoustic Elvis Presley, and that analogy is not just a product of hindsight. The core of neo-ethnic purism was a distinction between authentic roots music and commercial debasements, and the scope of this distinction was not limited to Appalachian fiddle tunes and Delta field hollers; real country music was Jimmie Rodgers, not Jim Reeves; real jazz was Bunk Johnson or Thelonious Monk, not the Dukes of Dixieland or Dave Brubeck (though Paul Desmond was OK); real blues was Muddy Waters, not B. B. King (at least not B. B. King with a horn section); real rock 'n' roll was Little Richard, Buddy Holly, or Elvis Presley on Sun, but not Pat Boone, Frankie Avalon, or Elvis in *Blue Hawaii*. The *Little Sandy Review* approvingly referred to Eric Von Schmidt's "wild, almost Presleian voice," and when Dylan told Shelton he had recorded with Gene Vincent in Nashville, it was an assertion of authenticity, not a divergence from it. Far from obscuring his rockabilly roots, the liner notes to that first LP pointed out that the "diesel-tempoed 'Highway 51' is of a type sung by the Everly Brothers" and listed his influences as "Hank Williams, the late Jimmie Rodgers, Jelly Roll Morton, Woody Guthrie, Carl Perkins, early Elvis Presley."

In musical terms, that album was a very mixed bag. Along with "Song to Woody" and "Talkin' New York," it had three gospel songs, two straightforward blues, two ragtime blues, a yodeling hillbilly blues, a perky British ballad, Van Ronk's arrangement of "House of the Rising Sun" reworked into a flatpicking piece à la Guthrie or Elliott, and "Man of Constant Sorrow," a soulful country lament that Dylan later described as the disc's most successful performance. In retrospect most writers have tended to highlight the two original songs, which along with Dylan's pick fit the image of a Guthriesque balladeer evolving into a songwriter. But most of the selections point in another direction, and the early sessions for his next album back them up. Dylan kept writing songs, including some

on topical themes in the Guthrie tradition, but he was simultaneously extending his musicianship through an ever-deeper immersion in blues.

Bob Dylan was released in March 1962, and a little over a month later he went back into the Columbia studio and cut fourteen songs. They included his first political compositions: the satiric "Talking John Birch Paranoid Blues," the haunting "Let Me Die in My Footsteps," and the gruesome and didactic "Death of Emmett Till." There were three other original compositions—a couple of "Talking" novelties and a Guthriesque tall tale, "Rambling, Gambling Willie"—as well as a Hank Williams song and "Sally Gal," the harmonica-driven hoedown that had blown Stampfel away a year earlier. But the remaining six songs were straight blues, including reworkings of Robert Johnson's "Milk Cow's Calf" and Muddy Waters's "Louisiana Blues."

None of those recordings made it onto the album that was eventually released as *The Freewheelin' Bob Dylan,* and at his next session in July Dylan recorded "Blowin' in the Wind," the song that changed everything. But at the time he does not seem to have recognized that song as pointing a new direction: the July session started with one of his wildest efforts, "Babe, I'm in the Mood for You," an exuberantly loose takeoff on a traditional tune punctuated by orgasmic whoops, and four of the five other songs were blues of one kind or another. The odd song out—confusingly titled "Bob Dylan's Blues"—was a rhymed shaggy-dog monologue that in hindsight presaged later excursions into lyrical surrealism but at the time seemed like one more nod to Guthrie, complete with an introduction that mimicked Woody's Oklahoma drawl: "Unlike most of the songs nowadays 're bein' written uptown in Tin Pan Alley—that's where most of the folksongs come from nowadays—this is a song, this wasn't written up there. This was written somewhere down in the Yew-nited States."

Columbia had twenty-one songs in the can by then, more than enough for an album that would have been a logical follow-up to Dylan's debut. It would have had a few more original songs, showing his growing skill as a writer, and his blues work was also more assured, the guitar picking more expert and distinctive, the vocals more confident, and several

lyrics reshaped to the point that they could be considered original compositions. Instead, in August Dylan signed with a new manager, Albert Grossman, and all old bets were off. Rather than issuing the expected record, he stayed out of the studio for the next three months, and when he went back in late October it was with a backing band of piano, bass, drums, and electric guitar. The sound was a throwback to the early Sun hits, complete with a cover of Elvis's "That's All Right, Mama," and on the cusp of 1963 Columbia released Dylan's first single, a self-penned rockabilly romp called "Mixed-Up Confusion."

Dylan has tended to dismiss this foray into straight-up rock 'n' roll, saying he wrote "Mixed-Up Confusion" in a taxi on the way to the studio and never had much interest in the resulting single, but someone must have had hopes for it, since the recording team devoted three sessions to getting it right and completed fifteen takes. In hindsight these sessions clearly presaged Dylan's later musical evolution, down to the appearance of Bruce Langhorne, who went on to play guitar on *Bringing It All Back Home* in 1965, opening "That's All Right" with the same riff he would play on "Maggie's Farm." Considering what was on the charts at that moment, though, it was a tough sell. *Billboard* gave the single a four-star rating, indicating "sufficient commercial potential to merit being stocked by dealers," but if any acted on the advice they must have been disappointed. It went nowhere; the song was quickly forgotten, and although the flip side, "Corinna, Corinna," did make it onto the final version of *Freewheelin'*, it had more subdued accompaniment and attracted little attention.

Indeed, by the time that album was released in June 1963, the idea of marketing Dylan as a distinctive blues interpreter, inventive guitar stylist, and borderline rock 'n' roller had been abandoned. He recorded thirteen more tracks, but only two were blues and neither was included on the finished record. Instead he was reborn as a songwriter, the album's three blues covers were written off as filler, and he became the poetic voice and conscience of a generation.

BLOWIN' IN THE WIND

While the neo-ethnic folk revivalists in Greenwich Village were assiduously attempting to master old southern rural styles, a new generation of southern singers was engaged in a very different kind of revival. Guy Carawan was born in Los Angeles in 1927, but his parents were from the Carolinas, and in his early twenties he became interested in folk music as a way of reconnecting with his roots. In 1953, armed with a degree in sociology, he made his first trip to the Southeast with a couple of musician friends, Frank Hamilton and Jack Elliott, "singing on street corners, in country stores, gas stations, saloons, at folk festivals and on the radio." He fell in love with the region and its music, and also became interested in the dawning civil rights movement. In 1957 he went to Moscow with Peggy Seeger to attend a World Youth Festival, went on to China in defiance of a State Department travel ban, then came back to the United States and began touring colleges, singing and talking about his experiences. He made his first album for Folkways in 1958, a collection of traditional songs, and the *Little Sandy Review* ranked him alongside Elliott as a young urban singer who was successfully absorbing and reworking rural styles. In the liner notes he explained that he had reacted against the topical and political songs common on the folk scene: "The whole idea of singing about present day or recent events, issues and persons seemed very strange to me and I didn't like it." However, he had

gradually realized that the stumbling block for him was "the fact that so many of these songs were bad," and decided there was a place for good new songs that expressed contemporary concerns—though on his own records he continued to stick to traditional material. The following year, on Pete Seeger's recommendation, he was hired as music director for the Highlander Folk School in Tennessee.

Highlander was an educational center for community organizers, founded during the labor struggles of the 1930s, and its philosophy was to teach by providing resources and assistance, not by presenting its staff as authorities or leaders. In the 1950s it began hosting workshops around racial issues, supporting African American activists in establishing "freedom schools" that taught the skills needed for voter registration tests, spreading the philosophy of nonviolent resistance, and giving organizers from various regions a place to meet one another, share their experiences, and formulate tactics. Rosa Parks was at Highlander in 1954 and a few months later challenged the segregated Montgomery transit system, sparking the bus boycott that brought Martin Luther King into the movement. A photo from 1957 shows Parks, King, and Seeger at Highlander for the school's twenty-fifth anniversary, and another picture from that visit was soon plastered on billboards around the South under shouting capitals: MARTIN LUTHER KING AT COMMUNIST TRAINING SCHOOL.

In keeping with Highlander's philosophy, Carawan described his job as "to help get people singing and sharing their songs. When someone began to sing, I'd back them up softly on my guitar so they'd get courage and keep going." He also helped spread songs from one group to another and, following the Almanacs' model, encouraged activists to rework material to fit their needs. In particular, he suggested adapting familiar spirituals and hymns.

> Some people were offended at first—these were very personal songs about salvation. But sometimes people would be suddenly moved to change a word—like Bernice Johnson Reagon did when she changed "over my head I see trouble in the air" to

"*freedom* in the air"—and something happened. People real-
ized that these were their songs and they could change them to
express what they were feeling.

Soon hundreds of songs and verses were being adapted: "This Little
Light of Mine" shifted from the light of Jesus to the light of freedom, and
"Keep your hand on the plow" became "Keep your eyes on the prize."
In the process, songs that had been forgotten in the South and revived
by urban folksingers came home: Seeger had worried that his version of
"Michael, Row the Boat Ashore" sounded insipid, and the version the
Highwaymen took to the top of the pop charts in 1961 was paler still,
but their soothing radio hit was reclaimed by southern protestors, and in
a McComb, Mississippi, jail cell, the civil rights activist Bob Moses was
cheered to hear fellow prisoners singing "Michael row the boat ashore,
alleluia . . . Mississippi's next to go, alleluia."

In 1960 Carawan organized a workshop to discuss the role of music in
the southern freedom movement and introduced a song Seeger had picked
up from another Highlander staff member, Zilphia Horton, in the 1940s.
She sang it as "We Will Overcome," but Seeger changed "will" to "shall,"
and when Carawan and his compatriots sang it a few weeks later at the
organizing conference of the Student Nonviolent Coordinating Committee
(SNCC), it became an anthem. Bernard LaFayette of the Nashville Quar-
tet, one of the first movement singing groups, recalled its power: In 1961
he was a "freedom rider," traveling through the South with an interra-
cial group to desegregate bus stations and public accommodations, and in
Montgomery they were trapped by an armed, angry mob.

> Our only hope was to stay together. We joined hands in a circle
> and started singing "We Shall Overcome." The song has differ-
> ent meanings at different times. Sometimes you're singing about
> the problems all over the world—"We shall overcome"; some-
> times you're singing about problems in the local community—
> "We shall overcome." But in that bus station it was a prayer—a

song of hope that we would survive and that even if we in that group did not survive, then we as a people would overcome.

In the 1930s the Almanac Singers had dreamed of a singing labor movement, but found that few workers were interested. In the southern civil rights movement their dream became a reality. All over the South people made up songs, many adapted from spirituals and gospel favorites, but also reworking blues, hoedowns, and R & B hits. The most popular were simple, communal compositions that changed and grew as protesters added new verses to suit the moment or their inspiration. Seeger wrote that when he asked marchers for the words to a song, they would often tell him, "There are no words"—the basic song was just a framework, and the best he could collect were "*some* words," the lyrics a particular person or group happened to feel like singing on a particular day. Protesters sang in church meetings, on marches, at sit-ins, and to keep their spirits up in jail. Many were teenagers, and in April 1962 the third issue of New York's *Broadside* newsletter included a song using the tune of a recent dance hit, "(Baby) Hully Gully," reworked as "Freedom, Freedom Rider" by Marilyn Eisenberg, who had spent a month and a half in Mississippi's notorious Parchman prison farm. An accompanying note said, "In prison the girls were always dancing—the Twist, the Watusi, and the Hully Gully were their favorites." On the following page was a defiant plaint about the fallout shelters being dug in cities across America in preparation for impending nuclear war, titled "I Will Not Go Down Under the Ground." It denounced the ubiquitous fearmongering, the idea that "'stead of learning to live they are learning to die," and its author was Bob Dylan.

In the 1950s there had been few opportunities for urban leftists to sing at rallies and on picket lines. Isolated, harried, and discouraged, some continued to write topical songs, proving that they were keeping up the fight and reminding one another that they were not alone, but their compositions just circulated at private gatherings and small hootenannies, at progressive summer camps, on occasional recordings, and in the pages

of *Sing Out!* Their models were Woody Guthrie and the Almanacs, and the most visible artist was Pete Seeger, whose prolific output for Folkways included a 1958 album, *Gazette, Vol. 1,* of recent compositions about everything from the Ku Klux Klan to space travel. In 1961 Seeger made a tour of the British Isles and was amazed by the vitality of the folk scene there, and in particular the amount of topical songwriting. Folk clubs met in the back rooms of pubs all over England and Scotland, and young songwriters were composing "songs demanding an end to atom bomb insanity, songs scandalizing corrupted politicians, songs frankly telling Uncle Sam to take his nuclear submarines out of the Clyde and stick 'em." Back in the States he suggested to his old Almanac coworker Sis Cunningham that they should encourage a similar flowering of new compositions, and she started a home-printed biweekly songsheet-cum-newsletter called *Broadside.*

Broadside's eight-page debut issue appeared in February 1962 and included the first printed Bob Dylan song, a satire of anti-Communist paranoia called "Talking John Birch." Two months later, "I Will Not Go Down Under the Ground" lamented, "There's been rumors of wars and wars that have been / The meaning of life has been lost in the wind." And in late May, the front page of issue 6 was taken up by a three-verse extension of that thought, titled "Blowin' in the Wind." A note on the next page announced the release of Dylan's first album and a projected songbook, adding, "Only 20 years old, some consider him to be the nearest composer we have had to Woody Guthrie in recent years," and promising that a future issue would include his "Ballad of Emmett Till," about the murder of a black teenager in Mississippi.

Broadside had good reason to be excited. The newsletter would soon become a forum for a generation of young songwriters: Tom Paxton, Phil Ochs, Len Chandler, Buffy Sainte-Marie, and Peter LaFarge, as well as Malvina Reynolds, an older leftist who contributed dozens of songs including "Little Boxes," and of course Pete Seeger. In those early issues, though, Dylan was the cream of a rather paltry crop. Gil Turner, who ran the Folk City hoots and served with Seeger as the newsletter's advisor

and talent scout—memories differ as to which of them brought Dylan on board—suggested in the first issue's opening statement that he was aware of this, writing, "BROADSIDE's aim is not so much to select and decide as to circulate as many songs as possible and get them out as quickly as possible. . . . The only way to find out if a song is good is to give it wide circulation and let the singers and listeners decide for themselves."

There was always a chicken-or-egg relationship between *Broadside* and its contributors: it provided a forum for Dylan and his peers, and they wrote topical songs in part because there was a forum. Some of Dylan's fans thought this was a wrong turn; ending a rave review of his first album, the *Little Sandy* wrote, "We sincerely hope that Dylan will steer clear of the protesty people, continue to write songs near the traditional manner and continue to develop his mastery of his difficult, delicate, highly personal style." But Dylan's problem was not that he had limited energies and needed to channel them; it was that he was exploding with ideas and needed opportunities to try them out. Like his singing and instrumental skills, his songwriting was raw, and *Broadside* was one more place he could perform and test himself. He was not writing protest songs about fallout shelters and murdered teenagers instead of hobo ballads and lovesick blues—he was writing all kinds of songs, and also learning more old songs. Early in 1962 he fell under the spell of Robert Johnson, whose recordings from the 1930s had just been reissued by Columbia—John Hammond gave him an advance copy of the release—and soon was playing versions of Johnson's "Kind Hearted Woman" and "Rambling on My Mind."

The *Little Sandy* might argue that Dylan's political songs were weaker than his old repertoire, but that was beside the point. When Moe Asch had commissioned Woody Guthrie to write an album about the executed anarchists Sacco and Vanzetti, Guthrie took pride in his ability to compose a dozen songs around the limited subject matter, and although none of them came up to his best work, it was still an impressive feat and an exercise of his craft. If some of Dylan's political songs were mediocre, they nonetheless forced him to stretch and develop his songwriting mus-

cles. He was writing constantly, and the clumsier efforts were quickly for-
gotten. Early in 1962 he taped a *Broadside* radio show with Seeger and
Turner, and Pete started by requesting some of his new songs, explaining,
"Of all the people I've heard in America, he seems to be the most pro-
lific," and asking, "Bob, do you make a song before breakfast every day,
or before supper?"

Dylan first demurred: "No, sometimes I can go about two weeks with-
out making up a song." But then he explained:

> Well, those are the songs I sing. . . . I write a lot of stuff, in
> fact I wrote five songs last night, but I gave all the papers away,
> someplace—it was in a place called the Bitter End, and some
> were just about what was happening on the stage. And I would
> never sing them anyplace. They were just for myself and for
> some other people: they might say, "Write a song about that,"
> and I do it.

He added that he was not the kind of songwriter who would "spread
newspapers all around and pick something out to write a song about,"
but some of his songs were in that vein, about specific incidents he saw
in the papers or on television. He was writing about whatever inter-
ested him and the people he was hanging out with, and at this point the
"protesty people" included some of his closest friends. He had been sur-
rounded by leftists of various stripes since his Minneapolis days—there
was no escaping that in urban Bohemia—and in August 1961 he met a
seventeen-year-old named Suze Rotolo, who would be his companion,
lover, and sometime muse for the next two years. Rotolo had gone to
socialist summer camp and been suspended from high school for circu-
lating a "ban the bomb" petition, volunteered for the Committee for a
Sane Nuclear Policy, attended the first civil rights march on Washington
in 1958, picketed local branches of Woolworth's in support of student
sit-ins at the store's southern lunch counters, and by 1961 was work-
ing in the Manhattan office of the Congress of Racial Equality (CORE).

That was the spring of the freedom rides, and white northerners who had remained oblivious to the troubles down south were being confronted with photographs of riders, black and white alike, being brutally beaten by racist mobs and arrested by police who ignored their attackers. In Rotolo's words: "White people were looking at themselves and what their history had wrought, like a domestic animal having its face shoved in its own urine."

Dylan's first topical songs addressed a checklist of current concerns— racist violence, Cold War paranoia, capital punishment—but early in 1962 he composed a lyric that captured the broader, vaguer feeling that the world was troubled and longstanding injustices could no longer be ignored. Rather than telling a specific story or making a didactic point, it posed questions: "How many years can some people exist before they're allowed to be free?" "How many times must the cannonballs fly before they are forever banned?" and "How many times can a man turn his head and pretend that he just doesn't see?" Guthrie had used a similar approach in his most explicit antiwar song, asking "Why do your warships sail on my waters, why do your bombs drop down from my sky?" But Dylan combined the direct questions with others that were more symbolic: "How many years can a mountain exist before it is washed to the sea?" and "How many seas must a white dove sail before she sleeps in the sand?" The melody was lilting and pretty, adapted from a nineteenth-century slave song that Odetta had recently recorded: "No More Auction Block for Me."

Dylan's friends at *Broadside* immediately recognized that "Blowin' in the Wind" was exceptional. He sang it to Gil Turner in the basement of Folk City, and Turner was so impressed that he played it onstage that night, taping the handwritten lyrics to his microphone. For the time being, though, Dylan was still pursuing other directions. A brief set at Folk City in April 1962 found him playing mostly blues-based songs, including a Texas honky-tonker, "Deep Ellum Blues," and when he followed with "Blowin' in the Wind," his introduction sounded almost apologetic: "This is here, this is just a—it's a—" He paused, looking for the right words. "It ain't a *protest* song or anything like that, 'cause I don't write protest

songs. I try to make 'em, uh, I mean, I, I'm just writing it as something sort o'—that's something to be said, for somebody—by somebody."

Dylan was known as an energetic interpreter of southern and rural roots music, and "Blowin' in the Wind" was something different. Earlier in the set he had played "Talking New York," and the audience applauded the line in which a coffeehouse owner dismissed him with the comment, "You sound like a hillbilly, we want folksingers here." They recognized the criticism as a badge of pride, proof that, rather than sounding like the callow college kids being marketed as folksingers, Dylan was in the same camp as Dave Van Ronk and the New Lost City Ramblers, evoking the authentic ethnic traditions of people like Lemon Jefferson and Roscoe Holcomb. But "Blowin' in the Wind" was not the sort of song you might hear in a Texas juke joint or on a back porch in Kentucky. It was folksinger music.

Dylan's halting introduction may have reflected his knowledge of the Folk City audience rather than his own doubts, but the song was a departure for him, and he understood that some listeners might have misgivings. In terms of songwriting craft, it was more ambitious and skillful than "Talking John Birch" or "The Death of Emmett Till," but those songs fitted with the rest of his repertoire, addressing current concerns in gritty rural language. His first album had just appeared, and as a performer he was still honing his blues style, taking an increasingly daring approach to lyrics and working out tighter, tougher guitar arrangements. *Broadside* was providing him with a different audience and the opportunity to explore a Guthriesque sideline, but although some readers typed him as a topical songwriter, it remained a sideline. Even as a writer, his political lyrics were always outnumbered by songs about rambling and romance. He was *Broadside*'s strongest voice, and a handful of the songs he published there became classics, but most were forgettable efforts tailored to a limited audience whose model was still Woody and the Almanacs.

There is a tendency to think of songwriting as a more personal effort than singing or playing other people's music, but in this period Dylan's original compositions often sounded more derivative than his adapta-

tions of older material: when he sang a Robert Johnson song, he never sounded anything like Johnson, but his own songs tended to be a lot like Woody's. "Blowin' in the Wind" was an exception, but in 1962 he was not writing many songs like that. It would be five months before he composed his next important lyric, "A Hard Rain's a-Gonna Fall," and in the interim he was recording the early *Freewheelin'* sessions and his performances continued to rely heavily on blues and traditional material.

At the club level, that made sense both artistically and commercially. The Greenwich Village coffeehouses of this period are famous for nurturing artists in the Dylan, Van Ronk, and Baez mold, a mix of singer-songwriters and traditionalists singing old blues and ballads. But the most popular and prestigious Village clubs continued to feature jazz, and even the smaller, poorer-paying rooms that hired folksingers also had a lot else: in August 1962, Dylan's *Broadside* peers Len Chandler and Tom Paxton were both playing local club residencies, and Chandler was billed below a flamenco guitarist while Paxton was opening for a group of "Near-East musicians."

Meanwhile Seeger was filling Carnegie Hall, and on September 22 he hosted a hootenanny there, sponsored by *Sing Out!,* to showcase new, deserving artists: the Scottish songwriter Matt McGinn, whose brash topical lyrics had inspired him during his British visit; Bernice Johnson of the Freedom Singers; a Boston-based bluegrass band called the Lilly Brothers; and Dylan, playing for the largest audience he had yet faced. Seeger had been following Dylan's growth as a songwriter and was already describing him as "a young poet, a true poet," but Dylan first showcased his musical skills, opening with the chugging harmonica of "Sally Gal" and the Everly-flavored "Highway 51." Then came "Talking John Birch," a perfect choice for Seeger's audience, which got enthusiastic laughs and a huge ovation, after which he darkened the mood with the stark "Ballad of Hollis Brown," about a man driven by poverty to kill his entire family, and ended with the first major performance of "A Hard Rain's a-Gonna Fall." In the *New York Times,* Robert Shelton wrote that Dylan "mystified, then captivated, his audience" and described his lyrics

as having "one foot planted in the conversational folksay of the American plains and the other in the 'swimmy waters' of the symbolist poets." The quotation was from a note Woody Guthrie had written in the 1940s, "I got to steer clear of Old Walt Whitman's swimmy waters," which Seeger had quoted in a piece for the *Little Sandy Review,* and although most readers undoubtedly missed the reference, to insiders it carried a powerful message: Dylan had filled Guthrie's shoes and now was going where Guthrie had feared to tread.

As for Seeger, he stayed in the background, serving as "the gracious and modest master of ceremonies," but Shelton was surprised to learn that he and Lee Hays had composed "If I Had a Hammer," currently in its sixth week on the pop charts and climbing toward the Top 10 thanks to the latest pop-folk sensations: Peter, Paul, and Mary.

Shelton had profiled the trio almost a year earlier when they were appearing at a swanky uptown supper club, the Blue Angel. In its nightclub listings, the *New Yorker* tersely summed them up as "two beards and a doll," and, demeaning as that description was, it neatly captured the concept: hip plus glamour. As Shelton explained, "Sex appeal as a keystone for a folk-song group was the idea of the group's manager, Albert B. Grossman, who searched for months for 'the girl' until he decided on . . . the tall, willowy Mary Travers, a blonde with cascades of hair, a mobile face, and an aura of allure." The other members were Peter Yarrow, who had attracted some attention as a solo act on the college circuit and was already managed by Grossman, and Paul Stookey, a hip comedian billed on MacDougal Street as "The Salvador Dali of the Mouth." They rehearsed for several months under Grossman's eye before opening at the Village's new pop-folk showcase, the Bitter End, where they were an immediate success. Their initial album, released in March 1962, spawned two Top 40 singles, held the number one spot on *Billboard*'s LP chart for seven weeks, and remained in the top hundred for three and a half years. Their arrival signaled what the *Village Voice* called a "high renaissance" of folk music, "soaring to giddy heights of fame and fortune along a nightclub trail blazed for them by their harmonic ancestresses, the ever-popular Andrews Sisters." The

article continued: "Not since Charlie Chaplin piled up millions in the guise of a hapless hobo has there been a breed of entertainer to match today's new professional folksingers in parlaying the laments of poverty into such sizable insurance against the experience of it."

Similar charges had been leveled at the Weavers in 1950 and the Kingston Trio in 1960, and as Dylan came to the notice first of Seeger's audience, then of the larger audience attracted by Peter, Paul, and Mary, he got the same treatment: "An atmosphere of the ersatz surrounds him," *Time* magazine wrote the following spring, "and his citified fans have an unhappy tendency to drop their g's when praisin' him . . . yet Dylan is the newest hero of an art that has made a fetish out of authenticity." There were two distinctions that set him apart from previous folk stars: he was primarily a songwriter, and he had a lousy voice.

As Dylan's reputation grew over the next couple of years, those traits went hand in hand. Shelton had previously called him "one of the most compelling white blues singers ever recorded," but now wrote, "His voice is small and homely, rough but ready to serve the purpose of displaying his songs." The message was that he was a writer, not a singer or entertainer. *Time* described his appearance at the Monterey Folk Festival on a bill "with such champions of folk- and fakelore as The Weavers, Bill Monroe, Mance Lipscomb, and Peter, Paul and Mary," and wrote that "although nearly everyone sang better . . . a crowd of 5,200 rewarded him with earnest and ardent applause." The review emphasized Dylan's vocal deficiencies: "Sometimes he lapses into a scrawny Presleyan growl," and "at its very best, his voice sounds as if it were drifting over the walls of a tuberculosis sanitarium—but that's part of the charm." He was the antithesis of a slick pop-folk warbler. Instead, "he has something unique to say, and he says it in songs of his own invention that are the best songs of their style since Woody Guthrie's."

The image of Dylan as a songwriter who triumphed despite a lack of vocal and instrumental skills almost entirely supplanted his earlier reputation as a dynamic interpreter of rural roots music. His work had excited strong opinions from the outset—people tended either to love or hate it—

but in the past those opinions had been based on his singing, playing, and stage presence. Positive reviews referred to the "searing intensity" of his voice, his "exciting, bluesy, hard-driving harmonica and guitar," and the brilliance of his off-the-cuff banter and Chaplinesque body language. Now, though, he was reaching an audience with very different standards from those of the neo-ethnic hardliners at the *Little Sandy Review* and the Gaslight Café. It might still appreciate authenticity, but the model was Joan Baez, a mysterious young woman with a startlingly beautiful voice who recorded for a classical record label, avoided nightclubs, and sang ancient ballads with aching conviction. When *Life* magazine gave Peter, Paul, and Mary their first national exposure, it was as part of a comic photo feature in which a "Flock of Fresh Folk Singers" acted out the titles of their songs—the Kingston Trio gathered around a candle representing "This Little Light of Mine," the Smothers Brothers danced in a moored skiff à la "Dance, Boatman, Dance," and PP&M were expanded to a quartet with the addition of "Ole Blue," a doleful basset hound—but Baez, described as "a loner, a rabid traditionalist," refused to go along with the concept and was pictured singing in a quiet cove near her California home, wearing a simple burlap dress and displaying the "stylistic purity that places her in a class almost by herself."

No one connected with commercial folk music understood that intricate interplay of images better than Albert Grossman. He had made a play for Baez in 1959, but as she recalled, "He terrified me by saying things like, 'You can have anything you want. You can have any*body* you want.'" He got her onstage at the first Newport Folk Festival that year and into John Hammond's office at Columbia, but she fled to the more congenial company of Manny Greenhill, a low-key presenter of concerts for the Boston Folklore Society, and Vanguard Records, whose motto was "Recordings for the Connoisseur"—though she recalled that Grossman remained a lurking presence through the 1960s, a "show business shadow . . . reminding me that no matter how well I was doing, I could do a lot better if I teamed up with him."

Baez was a dauntingly sincere artist, in Joan Didion's phrase, "the

Madonna of the disaffected." Grossman saw both the appeal and the limitations of that image and presented Peter, Paul, and Mary as more accessible and fun, but still sufficiently high-minded to be in a different class from the Kingston Trio and its collegiate clones. Rather than sporting a perky, frat-house look, Yarrow and Stookey had the hip goatees, dark suits, and skinny ties of the Modern Jazz Quartet and affected a similar appeal: they were authentic Greenwich Village folksingers, but well-rehearsed and presented with taste and class. Nor was that just an image: Travers had recorded with Pete Seeger back in 1955; Yarrow had established a solid reputation on the college circuit; and all three were serious about both their music and their political commitments. Their material was also distinctive: rather than just rehashing summer-camp favorites, they presented an astute mix of traditional folk songs and new compositions by rising young songwriters. A couple of other groups were attempting a similar approach—most prominently the Chad Mitchell Trio—but none had comparable success or influence.

Grossman's talents as a promoter were more than equaled by his backroom financial savvy, and a bedrock truth of the American music business is that performers reap the fame, but the money is in publishing. (In a holdover from the days of sheet music, a song's publisher typically receives half of all royalty payments, though by 1960 the publisher's sole contribution might have been to persuade the songwriter to sign a contract.) He seems to have become interested in Dylan during the spring of 1962, and by most reports it was "Blowin' in the Wind" that caught his attention. As a regular denizen of Folk City he would already have been aware of Dylan's local popularity and Columbia recording contract, and he recognized untapped potential in the young man's songwriting. Dylan already had an agent, Roy Silver, but his first LP was going nowhere and when Grossman offered to buy Silver out for $10,000 it seemed like a good deal. Dylan also had a publishing contract, arranged for him by John Hammond, but Grossman had him buy that out as well and signed him to M. Witmark & Sons, a prominent subsidiary of Warner Brothers. Grossman had a unique deal with Witmark, receiving half the publisher's

royalties for any songwriter he brought to the company, and his management contract with Dylan—as with Odetta; Peter, Paul, and Mary; Ian and Sylvia; and the other acts he soon acquired—gave him 20 percent of the artist's earnings, with an additional 5 percent for income from recordings. As a result he had a very strong interest in Dylan writing songs, recording them, and having them recorded by his other acts and anyone else who might care to join the party.

Aside from the old-line showbiz promoters who handled groups like the Kingston Trio, folk agents tended to be fans first and managers second, which was not great for their artists' bank balances but preserved their separation from the commercial mainstream. Grossman was another beast entirely: he had started one of the first folk nightclubs, Chicago's Gate of Horn, coproduced the first two Newport Folk Festivals, and hung out on the Village scene, so he was very much a folk world insider, but he was also a brilliant and gleefully rapacious businessman who enjoyed distinguishing himself from the homespun Bohemians with officious displays of wealth and power. "Albert scared the shit out of people," says Jonathan Taplin, who started as his assistant and went on to become a successful film producer. "He was the greatest negotiator in history." Van Ronk recalled Grossman as an endlessly fascinating and amusing companion, but added, "He actually took a sort of perverse pleasure in being utterly unscrupulous." In 1962 most people on the folk scene were only tangentially aware of Grossman, but over the next few years he would become widely regarded as the snake in the garden.

Bob Neuwirth, who was one of Dylan's closest companions in the mid-1960s, has argued that Grossman "invented" Dylan, much as he invented Peter, Paul, and Mary: "Bob Dylan could not get arrested before Albert came along! We both sat on the curb and counted up to see if we had enough money to buy a bottle of Thunderbird. Albert made it possible to have a fifty-dollar-a-week allowance to have enough money to pay the rent." Dylan had an album on a major label and was the leading writer in the *Broadside* crew before Grossman got involved, but the record sold badly, and paying jobs were few and far between. He was a unique talent,

but no one imagined he could break out as a national star. It is far from clear what the effects of Grossman's influence are, much less what would have happened without his involvement—and if Neuwirth's recollection of a fifty-dollar-a-week allowance is accurate, Dylan's life did not change all that dramatically at first. But Grossman certainly encouraged Dylan to concentrate more seriously on songwriting and brought the songs to the attention of a new and different public.

Through the end of 1962 Dylan remained primarily an interpreter of rural roots styles: of seventeen songs recorded at a Gaslight gig in October, only four were his own compositions. But other people were catching on to his writing, and when the fall issue of *Sing Out!* featured him on its cover, it included three of his songs and an article by Gil Turner hailing him as America's "most prolific young songwriter." Turner concentrated on topical material and introduced "Blowin' in the Wind" with a quote from Dylan that underscored the lyrical message: "Some of the biggest criminals are those that turn their heads away when they see wrong and know it's wrong. I'm only 21 years old and I know that there's been too many wars. . . . You people over 21 should know better . . . cause after all, you're older and smarter."

Dylan had a gut sense that the world was a mess and admired the idealism of Guthrie and Seeger, but his politics were a matter of feelings and personal observation rather than study or theory. "He was a populist," Van Ronk said. "He was tuned in to what was going on—and much more than most of the Village crowd, he was tuned in not just to what was going on around the campuses, but also to what was going on around the roadhouses—but it was a case of sharing the same mood, not of having an organized political point of view." Contrasting him with Phil Ochs, who had been a journalism major before taking up guitar, Rotolo noted, "Dylan was perceptive. He felt. He didn't read or clip the papers. . . . It was all intuitive, on an emotional level."

Dylan's more activist peers were often frustrated by his lack of ideological commitment, but that was what gave songs like "Blowin' in the Wind" such universal appeal. Instead of hectoring, he was expressing

pervasive fears and hopes. Many people in the early 1960s shared a sense that things had gone horrifically wrong, without having a clear idea of how or when they would change. The racist violence in the South exposed the hypocrisy of a country that took pride in having conquered fascism abroad while ignoring or perpetrating it at home, and old evils remained very deeply entrenched. Some important battles were being won, but it was hard to take much pleasure in today's victories when everyone might be dead tomorrow. In October 1962, the Cuban missile crisis brought the threat of nuclear annihilation closer than ever. Suze was spending a half year in Italy, and Dylan wrote to her that he thought "the maniacs were really going to do it this time." He had spent a night in the Café Figaro, "waiting for the world to end," hoping to "die quick and not have to put up with radiation."

In that situation, Dylan did not need ideological grounding to write songs like "Train a-Travelin'," depicting the world as an engine running out of control with "a firebox of hatred and a furnace full of fears." He was simply expressing his day-to-day experiences. On the cusp of 1963 he recorded several sessions of new material for a projected series of LPs by *Broadside* contributors and was also singing more topical songs in his live shows, though one week's efforts would typically be replaced by the next, and few remained long in his repertoire. One that lasted longer than most was "Masters of War," written during a monthlong visit to London. Dylan was booked to play the role of a guitarist and singer in a theatrical production and took advantage of the visit to immerse himself in the British folk scene, hanging out in local clubs and learning from young performers like Martin Carthy. He was writing longer, more complex lyrics, and the British song forms provided useful patterns: "Girl from the North Country" and "Bob Dylan's Dream" were based on Carthy's versions of "Scarborough Fair" and "Lady Franklin's Lament," "With God on Our Side" on Dominic Behan's "The Patriot Game," and "Masters of War" on "Nottamun Town," the Appalachian survival of a mysterious English song that retained echoes of ancient mummers' rites. As usual it was a fleeting fascination, and when he got back to the States

he soon moved on to other styles, but it represented a decisive shift in how his music was heard and understood. He continued to explore blues forms and pen wryly rhymed Guthriesque monologues, but he was also writing material that appealed to artists like Baez and Judy Collins, who specialized in British balladry.

In November 1962, *Time* magazine had Baez on its cover and a five-page story about the folk boom. The tone was typically snide, but the message was clear: folk music was more than just another pop trend; it was a social phenomenon expressing the concerns of a generation. Baez explained:

> When I started singing, I felt as though we had just so long to live, and I still feel that way. . . . It's looming over your head. The kids who sing feel they really don't have a future—so they pick up a guitar and play. It's a desperate sort of thing, and there's a whole lost bunch of them.

The article distinguished three strains of folksingers: the "pures," represented by authentic rural artists like Jean Ritchie and Frank Proffitt; the "impures," represented by commercial acts like the Kingston Trio, the Limeliters, and Peter, Paul, and Mary; and the "semi-pures," represented by Baez, Dylan, Odetta, and Seeger—and it strongly suggested that, with the ascension of Baez, the impures' days were numbered.

Over at the ABC television network, some canny producers begged to differ. Any style that made the cover of *Time* and put multiple albums on the pop charts was worth exploiting, especially when that could be done on a limited budget. Folksingers were cheap, and the *Time* story suggested a perfect venue: it was college music, so why not tape live concerts at colleges? As for a name, there was one ready and waiting that combined an appeal to the *Sing Out!* fan base with a lighthearted goofiness that could attract the less committed kids: *Hootenanny!*

On March 3, 1963, *Billboard* announced that a pilot episode for the new show had been shot at Syracuse University, with the Limeliters, a

Chicago singer named Jo Mapes, and Clara Ward's gospel group, and regular broadcasts were scheduled for April. A week later Nat Hentoff broke a story in the *Village Voice,* following a tip in *Broadside*: headlined "That Ole McCarthy Hoot," it reported that although the show had taken its name from the musical gatherings Seeger had been hosting since the 1940s, network censors had ruled that neither he nor the Weavers would be permitted to appear. Baez had already announced she would not accept a booking if Pete was not invited, and a meeting of performers quickly convened at the Village Gate and announced a boycott, with Dylan, Ramblin' Jack Elliott, Dave Van Ronk, Peter, Paul, Mary, and the Kingston Trio among dozens pledging their support.

Other folk figures judged the television exposure was more important than the principle. Theodore Bikel declared that blacklisting was "sick and evil," but suggested that the Weavers, if not Seeger, would be able to get on television if they would only "act as sane, responsible people and not engage in ineffectual public protests"—presumably a reference to their consistent refusal to sign an anti-Communist loyalty oath. To make matters more complicated, Judy Collins, the New Lost City Ramblers, and the Tarriers all consulted Seeger before deciding whether to appear, and he not only told them to go ahead but subbed for the Tarriers at the Bitter End on the night of their filming. Nonetheless, many maintained the boycott. As Van Ronk recalled:

> [Pete] always felt that the music was the important thing—the man is nothing; the work is everything—and he thought that a lot of performers who deserved a national hearing were depriving themselves of an opportunity. His basic attitude was, "For God's sake boys, leave me behind, just leave me one bullet." Of course, we paid absolutely no attention to him. Our position was, "Sorry Pete, old man, but you're a symbol . . . ," and in any case *Hootenanny* was so laughably awful that it barely lasted a season.

Be that as it may, the show gave folk music unprecedented exposure in the mainstream media and further blurred the lines between pure and impure: Where was virtue when the Kingston Trio was supporting a leftist boycott and the New Lost City Ramblers were disporting themselves in the commercial marketplace? By 1964 there were three competing Hootenanny magazines: an official *ABC-TV Hootenanny Show Magazine,* a one-shot failure called *Hootenanny Songs and Stars,* and *Hootenanny,* edited by Robert Shelton, which denied any connection to the show and featured Dylan and Baez on its cover. *Sing Out!* condemned the network's blacklisting but embraced the rubric by publishing a *Hootenanny Song Book.* Columbia put out an *All Star Hootenanny* LP including tracks by Seeger and Dylan. Prestige Records ran ads for Van Ronk and Elliott albums under the headline "Hootenanny . . . Prestige Style." Mercury Records staged a nine-day spring-break hootenanny at Daytona Beach in April 1963 that drew more than seven thousand students to watch thirty-six collegiate folksinging groups compete for a recording contract. (The winners were the Rum Runners, from the University of Texas at Houston.) That same month, Dylan made his national television debut in an hour-long special, *Folk Songs and More Folk Songs,* with Carolyn Hester, the Brothers Four, Barbara Dane, and the Staple Singers, and also gave his first major solo concert at New York's Town Hall, presented on Pete Seeger's urging by Harold Leventhal, manager of Pete, Woody, and the Weavers.

The Town Hall show marked a new stage in Dylan's career, both because it established him as a concert artist and because it consisted almost entirely of original songs. In the six months since his Gaslight gig, he had dropped all the traditional material—the only exceptions were "Highway 51," which he had made distinctively his own, and "Pretty Peggy-O," which he played in response to a request, after first asking, "Oh . . . you really want to hear that?" The applause and shouts of "Yes!" convinced him, but he still sounded hesitant, saying, "OK . . . if I can remember," then offhandedly kidding his way through the familiar verses. A couple of comic novelties, "Bob Dylan's New Orleans Rag" and "If I

Had to Do It All Over Again (I'd Do It All Over You)"—introduced as "a 1930 ragtime tune I just wrote last week"—suggested a quirky new direction, and "Hero Blues" was a modernist twelve-bar blues anticipating the rock lyrics he would write a couple of years later. But the body of the show was made up of recent compositions in the singer-songwriter style he was pioneering. Almost half were topical or socially conscious, culminating with his new composition about American exceptionalism, "With God on Our Side," and when a fan requested "Song to Woody" as an encore, he demurred, saying, "I'm sorry . . . I got to sing somethin' to tell you somethin'" and instead played "Masters of War." Then, for a second encore, he recited a long poem, "Last Thoughts on Woody Guthrie."

The Town Hall concert was a formal debut for the Bob Dylan who became famous, the poetic singer-songwriter who transformed popular music. It was not yet exactly the Dylan most of us recall—there are those odd ragtime numbers, and less than half the songs appeared on any of his albums—but he presented himself as a writer first and foremost, showcased his songs of social significance, and displayed a new, mature assurance. His guitar work was more understated and his voice more controlled—he had cast off the Guthrie inflections except on two talking blues and developed a stronger sense of melody and dynamics. The only hint that he harbored any mixed feelings came in his introduction to "Blowin' in the Wind": "Here's a song I wrote that's been recorded. Uh . . . it doesn't much sound like it, like the way I do it, but—the words are the same. That's the important thing." The Chad Mitchell Trio had debuted their single of the song a month earlier on the *Ed Sullivan Show,* and it was the first time one of his compositions had taken on a new sound and role in the mainstream pop world—a strange feeling for someone accustomed to writing material for his own voice and style. But on the whole he sounded strikingly relaxed and happy.

Notably, no one in the audience clapped when Dylan started playing the soon-to-be-iconic melody of "Blowin' in the Wind" on his harmonica. The only songs to get any recognition applause, suggesting that listeners already knew and wanted to hear them, were "Highway 51" and "A

Hard Rain's a-Gonna Fall." *Freewheelin'* would not be out for another month and a half, and people who liked his first record were still requesting "Pretty Peggy-O" and "Freight Train Blues." The people clapping at the first phrase of "Hard Rain" may have heard him live in clubs or at the Carnegie hoots, or read the lyric in *Sing Out!,* but more had probably heard it sung by Pete Seeger, who was featuring it in his concerts. Dylan himself was still largely a local, word-of-mouth phenomenon, and the most impressive thing about the Town Hall performance was that some nine hundred people showed up, sat in rapt attention for more than two hours, and applauded a selection of largely unfamiliar songs.

For Dylan, this seems to have been a particularly happy and exciting time. He would shortly turn twenty-two, had melded his disparate influences into a dynamic new style, and was on the verge of becoming a major national artist, but the attention had not yet gotten crazy. He was still in a solid relationship with Suze, still hanging out with friends in the Village, still able to walk down the street or go to a club without having to worry about being hassled. He was feeling surer of himself, and typically reacted to this newfound confidence by moving away from the easy certainties of his early *Broadside* lyrics, which had often echoed the orthodoxies of the politicos around him. Now he began pushing back, insisting on the instability and ambiguity of every position, including his own. Though on the surface a critique of American hubris, "With God on Our Side" was addressed to all true believers, everyone who thought they knew for sure where virtue lay.

A couple of weeks after the Town Hall show Dylan did an hour-long radio interview with Studs Terkel in Chicago, and spent much of it mulling over two notions that would crop up again and again in the next year. Terkel was an old leftist, a contemporary of Guthrie and Seeger, and he welcomed Dylan as the voice of a new generation, but Dylan bridled, insisting that he didn't really fit with any group, generational or otherwise. He compared himself to a writer friend, Robert Gover, who had recently published an experimental novel about a white college student in love with a black prostitute: "You can't label him," Dylan said. "He's unlabelable."

Terkel took up the thread, agreeing that in the 1930s "there were young people feeling passionately, you know? Under one label or another, d'you see? But they were more or less pigeonholed." By contrast, Dylan, Gover, and people like them were expressing widespread concerns, but "belong to nobody but themselves."

"Well, maybe it's just the time," Dylan responded. "Now's a time maybe you have to belong to yourself, you know. And I think maybe in 1930, from talking with Woody, and Pete, and some other people that I know there, seems like everything then was good and bad and black and white and easy to see. . . . Nowadays, it just—I don't know how it got that way, but it doesn't seem so simple. There're more than two sides, you know? It's not black and white anymore."

He had touched on the same theme in almost the same words in "Bob Dylan's Dream," written shortly after his visit to England: "As easy it was to tell black from white / It was all that easy to tell wrong from right." Some listeners took this as a reference to his youth in Hibbing, but it could equally well have been an imagined youth in the 1930s with Woody and Pete, sitting in a cabin around an "old wooden stove," their hats hung on pegs, singing the old, sure songs. He would return to this theme again in a long poem dedicated to his Minneapolis buddy Dave "Tony" Glover, published in the Newport Folk Festival program that summer: Recalling how they used to sing "the dirt farm songs—the dust bowl songs—the depression songs—the down and out songs—the ol blues and ballads," he again connected the memory to Woody's era, when there were just "two roads to pick yer route—the American way or the Fascist way," and just "two kinds of tales to tell the news—thru the unions eyes or thru the bosses eyes." Back then "it was that easy," but somewhere along the line "things got messed up—more kinds a sides come int' the story . . . There got t be so many sides that all of 'm started lookin like each other." The old songs had suited the time he sang about in his dream, when "the thought never hit / That the one road we traveled would ever shatter and split." Now, though, it just wasn't like that.

Dylan was not saying he thought all sides were equal. He still had a

sense of malign forces at work: the "Masters of War," the "flag wavin shotgun carryin John Birchers," "the killer dogs and killer sprays"—in June, television screens showed Birmingham police turning German shepherds and fire hoses on freedom marchers—"the seventy year ol senator who wants t bomb Cuba," and whoever "stole Abraham Lincoln's road an sold us Bill Moore's highway."

William Moore was a potent image for a lot of Americans that spring. A white mailman from Baltimore, he set out by himself on a freedom walk from Chattanooga, Tennessee, to Jackson, Mississippi, to deliver a letter to the segregationist governor, Ross Barnett. He was supported by no organization, just a lone man walking through the South, wearing a sandwich board that said "Equal Rights for All—Mississippi or Bust" and talking with everyone he met along the way, friends and foes alike. It was a small, Quixotic gesture and barely made the news until the third day, when he was gunned down on a quiet stretch of road near Gadsden, Alabama.

That was three days before Dylan's interview with Terkel, and Moore's killing was on his mind, but his response was a startling divergence from the unified horror of most leftists. He was mulling over a notion he had brought up in his Town Hall introduction to "Masters of War": that a lot of people treated the atomic bomb like a god, worshipping it, striving to appease it, devoting their lives to it. Terkel agreed, adding, "Pretty good people, too, in everyday life," and Dylan broke in:

> Yeah, yeah, I don't believe they're bad people, no, I don't. Well, just like the guy that killed this fellow hitchhiking through Alabama. You know . . . the fellow that actually shot the bullet, you can't really say—you can't ask for nothing more awful. I mean, shot right in the back. And even that guy, you know, when you see something like that: I seen so many people before I got to New York that are *good* people, that are, that are, maybe are *poor*. You know, maybe a little poor, and there are other people telling them, you know, that, uh, *why* they're poor, you know, and *who* made it so that they *are* poor. And

to take their minds off that they are poor, they have to pick out, they have to pick a scapegoat.

Dylan had always been a loner. It was not just that he felt out of place in Hibbing or among the coffeehouse intellectuals in Minneapolis and the dedicated leftists in the Village. "He would withdraw anywhere at any time," Rotolo recalled. "It could happen in a noisy room full of people or when it was just the two of us alone together." To some friends and acquaintances that was a deficiency, a sign that he didn't care or thought he was better than them; to others it was just the way he was. His songs were the same way. He was not writing "We Shall Not Be Moved" or "We Shall Overcome." He was writing about individuals, and often difficult, complex individuals. "The Ballad of Donald White," one of his first topical compositions, printed by *Sing Out!* alongside "Song to Woody" and "Blowin' in the Wind," was about a young black man who was arrested as a thief, found peace of mind in prison, was released, could not handle the outside world, and, after begging to be reinstitutionalized, killed a man and ended up on death row. Dylan sang this story in White's voice, and in another song imagined himself inside "The Walls of Red Wing," a juvenile reformatory near Minneapolis, singing of his fellow inmates that some would grow up to be lawyers, others career criminals, and "some of us'll stand up to meet you on your crossroads"—an image borrowed from myriad outlaw ballads, with him as the lone highwayman and his listeners among the respectable robbed.

A lot of people on the folk scene found it easy to identify with heroic robbers, but harder to think of themselves as troubled characters like Donald White, and impossible to empathize with someone who would gun down a civil rights marcher. For Dylan to publically take that step was in part a sign of his growing confidence, and also a way of distancing himself from the aura that was already beginning to form around him, the notion that he spoke for a generation with shared yearnings and crusades. When Terkel congratulated him on "Blowin' in the Wind," saying, "That's a popular song now I believe, isn't it?" Dylan instantly responded, "God, I hope not."

Terkel hastened to reassure him that he meant "popular" in the sense of people liking it, not in the sense of pop music, and undoubtedly Dylan was reacting in part to the idea that he was joining the pop-folk trend. But the bigger issue was that he was always uncomfortable with being typed or labeled, or when anyone acted like he spoke for a group or was part of a movement. He was viscerally troubled by the evils around him and by people who casually accepted those evils—the theme of "Blowin' in the Wind"—but whatever that song's power, he did not mean it as the anthem of a generation marching shoulder to shoulder, sure of its truth and duty. "Too many of these hip people are telling me where the answer is but oh I won't believe that," he told Gil Turner, explaining the song's title line. "I still say it's in the wind."

Dylan could appreciate the deeply held beliefs of a man like Bill Moore, walking alone through the South in pursuit of a personal truth, but also those of the man who shot him, certain of a different truth. Whether posing as a wandering carny from New Mexico or recalling folks he had known back in Hibbing, he was distancing himself from the self-assured intellectuals who looked down on small-town rednecks, on "*good* people that maybe are poor." It was a stance that in some ways connected with Marxist orthodoxy, but for him was more of a personal recognition of difficult truths—when the ghettos exploded in rioting a couple of years later, some topical songwriters would try to capture the mood of pent-up anger and frustration, but none did better than a line Dylan had written back in 1961 in "Talking New York": "A lot of people don't have much food on their table, but they got a lot of forks and knives, and they got to cut something."

A month after the Terkel interview, Dylan expanded his meditation on Moore's killer into one of his sharpest topical lyrics. On June 11, President Kennedy delivered his first major speech on civil rights, declaring it a moral issue "as old as the scriptures and . . . as clear as the American Constitution," and that night a member of the Mississippi White Citizens' Council responded by assassinating Medgar Evers, the state secretary of the NAACP. It was a watershed moment, easily framed as a

confrontation between good and evil, but Dylan responded as he had in Moore's case, expressing his understanding of the killer, whom he portrayed as a potentially decent person manipulated by larger forces. This time, though, he did it in a song: "Only a Pawn in Their Game." It was nothing like other paeans to the fallen martyr, and was quickly recognized as an important statement. Civil rights activists were trying to avoid framing their cause in purely racial terms, as blacks facing off against whites, and Dylan's lyric lent eloquent support to Martin Luther King's rhetoric of universal brotherhood. Pete Seeger and Theodore Bikel flew him to Greenwood, Mississippi, to sing the song at a rally covered by the national press, and in August he was invited to sing it at the March on Washington.

What no one seems to have noted was that on another level "Only a Pawn" expressed a sensibility at odds with any mass movement. Collective action depends on individuals serving at least to some extent as pawns, small and relatively insignificant figures in a larger plan. That was Guy Carawan's role at Highlander and on the marches, playing guitar or adding his voice behind whoever raised a freedom song, and the role Seeger claimed when he acted as just one among thousands of voices at his concerts or joined coworkers back in the kitchen to do the dishes: "The man is nothing, the work is everything." Unified struggle demands the acceptance of decisions one does not fully understand and the submission of one's will to the will of the group, sometimes to the point of martyrdom. When two white civil rights workers, Michael Schwerner and Andrew Goodman, were murdered in Mississippi along with their black coworker, James Chaney, Schwerner's wife, Rita, mourned her unique husband but also recognized that the killing of two white men had attracted the attention of the federal government in a way that killings of black activists had not.

Dylan might recognize the value of that kind of self-abnegation and dedication, but he was repelled by the idea of anyone handing their mind over to any organization or ideology. He did not take part in rallies or marches and regularly denied that his songs expressed anything but his

own experiences and feelings. When he presented himself as a little guy, one of the ordinary folk, his model was Woody, the quirky Okie bard who never really fit into any group and was rejected by the Communist Party as undisciplined and unreliable. Even when he joined the *Hootenanny* boycott, he was somewhat uncomfortable arguing its logic. As he told a Carnegie Hall audience in October:

> A friend of mine and a friend of all yours, I'm sure, Pete Seeger, has been blacklisted. He and another group called the Weavers. . . . Now, I turned down that television show, but . . . I feel bad turning it down, because the Weavers and Pete Seeger can't be on it. *They* oughta turn it down. They aren't even asked to be on it because they are blacklisted. Uh—which is, which is a bad thing. I don't know why it's bad, but it's just bad, it's bad all around.

Dylan was more comfortable as a loner than as a spokesman, and when he made his strongest stand against censorship, in May 1963, it was right out of the pages of *Bound for Glory.* He had been booked to appear on the *Ed Sullivan Show,* America's most popular variety program, but when they told him he couldn't sing "Talkin' John Birch Paranoid Blues," he walked out, just as Woody had walked out of a showcase gig at Rockefeller Center's Rainbow Room in the final scene of that book.

In real life Woody was at the Rainbow Room as a member of the Almanac Singers, but when he reworked the story for his memoir he was by himself, one small guy standing up to a team of corporate bigwigs, and for anyone who loves that book it is a thrilling moment. Dylan re-created it in more public and significant circumstances, and his stand was hailed as a blow against the blacklist and cemented his reputation as Woody's heir. Considering how many better songs he had written by then, "Talkin' John Birch" was an odd choice for the Sullivan show, and it is tempting to think he chose it knowing it might be banned. It would be a strong

statement either way, since singing the song would be a ringing retort to the blacklisters, and walking off in protest when they barred him from singing it was ringing proof that he was like Guthrie and Seeger, not only a singer but an honorable dissenter, ready to stand his ground and suffer the consequences.

In any case, by the summer of 1963 Dylan was becoming known as more than just another young folksinger. The Town Hall concert was in early April, the Sullivan incident in early May, and the release of *Free-wheelin'* came two weeks later. In June Seeger sang three of his songs at a sold-out Carnegie Hall concert, and the Chad Mitchell Trio's single of "Blowin' in the Wind" was eclipsed by Peter, Paul, and Mary's—though the mainstream media remained out of touch, *Billboard* describing their record in comically apolitical terms as a "slick ditty by Bob Dylan, a sailor's lament, sung softly and tenderly." In July he traveled with Seeger and Bikel to Mississippi, and the *New York Times* featured his photograph and a verse of "Blowin' in the Wind" in an article headlined "'Freedom Songs' Sweep North," while *Time* magazine printed another verse of the song alongside "We Shall Overcome." Less than three weeks after that trip Dylan was in a private plane chartered by Albert Grossman, traveling with Peter, Paul, and Mary to the Newport Folk Festival.

Chapter 5
NEWPORT

The program for the 1963 Newport Folk Festival opens with a full-page photograph of the seaside village with arching trees and spikey church steeples, seen over the glimmering waters of a quiet harbor, through the masts of three sailboats resting on wooden scaffolds. It evokes old-fashioned, small-town values, suggesting that traditional crafts and customs survive even in this fabled haunt of metropolitan millionaires. The image was not exactly misleading: Newport was a small New England town, and many of its year-round residents had little in common with the Vanderbilts and Astors whose seventy-room "cottages" made its name a synonym for the excesses of the gilded age. At the same time, it was a resort whose opulence had prompted the social critic Thorstein Veblen to coin the term "conspicuous consumption," and although its fortunes had waned somewhat by the 1950s, it remained a summer playground for wealthy New Yorkers.

The Newport Jazz Festival arrived in 1954, by invitation: a couple of local lions, the Lorillards, were charmed by George Wein's jazz club on Cape Cod and persuaded the board of the Newport Casino to provide him with space in its tennis area for a festival that would perk up the summer calendar. In 1959 Wein decided to include a folk music afternoon with Pete Seeger, Odetta, and the Kingston Trio in the Jazz Festival's offerings, following the success of earlier programs of gospel and

blues. Though in musical terms the connection was tenuous—John Hammond's "From Spirituals to Swing" concerts at Carnegie Hall had canonized gospel and blues as the roots of jazz, but hillbilly banjo players were another story—in commercial terms it made sense. The jazz audience was aging and its youthful offspring were flocking to folk clubs.

In the 1940s New York venues like Café Society and the Village Vanguard had proved that some of the same people who enjoyed Sidney Bechet, Mary Lou Williams, and Billie Holiday were also happy to hear Josh White, Richard Dyer-Bennett, and the Weavers, and in 1958 the Kingston Trio made their New York debut at the Vanguard on a split bill with Thelonious Monk. ("At first he seemed too far out," Dave Guard told *Down Beat*. "But his music grows on you.") Along with this overlapping audience, jazz and folk shared similar histories of strife between purists and popularizers. At least one prominent critic, Ralph Gleason, traced an almost identical trajectory in both styles: he started as a "moldy fig" celebrating the traditional New Orleans jazz of Bunk Johnson over Count Basie's commercial swing, evolved into a fervent promoter of Basie, bebop, and modernism, and recapitulated this evolution by dismissing Dylan and the new wave of urban folksingers, then embracing them and becoming a booster of folk-rock.

Wein showcased contemporary styles at his Newport jazz events, from the cool school of Dave Brubeck to the hard bop of the Jazz Messengers and eventually the free improvisations of Ornette Coleman, but balanced them with plenty of "trad," whether played by old black men from New Orleans or young white Dixieland revivalists in striped shirts and straw hats. With their perky rhythms, jangling banjos, and corny jokes, the Dixielanders were obvious models for the collegiate folk ensembles, so it made sense that the first folk presentation at a Newport festival featured the Kingston Trio on a bill with Louis Armstrong's All-Stars. Fans of "When the Saints Go Marching In" were a likely crowd for "Tom Dooley" as well—and as it happened, when the Trio came back a week later for the first Newport Folk Festival, "The Saints" was a highlight of their set.

By then Wein had expanded his original idea of a folk afternoon at the Jazz Festival to fill its own separate weekend, but for the first two years the Newport Folk Festival stuck close to the Jazz Festival's model, and it inherited some similar controversies. The 1958 jazz program had included a Saturday evening blues concert that, on the urging of John Hammond, featured not only Ray Charles and the R & B shouter Big Maybelle but Chuck Berry. Wein later wrote, "I was dead set against Chuck Berry. Rock and roll, in my mind, and in the minds of jazz critics and fans that I knew, did not belong on the Newport Festival any more than Guy Lombardo did. . . . When he went into his duckwalk during 'School Days,' I literally cringed." But he added, "The grand irony lies in the fact that putting Chuck Berry on at Newport was a daring move that opened the door for similar presentations all over the world. So I get credit for being a visionary." It is telling that Wein was horrified less by Berry's hot rhythms and catchy songs than by his duck-walking. Like the folk purists, the jazz purists were not so much protecting the purity of the music itself—both styles were wildly varied and omnivorous—but a moral purity adopted from the classical world in which "the music itself" was supposed to be appreciated and opposed to commercial gimmickry.

Wein had little experience with the folk scene, so for the first two festivals he brought in Albert Grossman, whom he knew and respected as Odetta's manager and a fellow club owner, to handle the programming. The 1959 lineup was heavily weighted with nightclub and concert artists from the urban revival: on Saturday evening, July 10, Pete Seeger headlined a fifteen-act bill that included Odetta, John Jacob Niles, Josh White, the Clancy Brothers, and Cynthia Gooding, as well as the blues pianist Memphis Slim and the gospel singer Alex Bradford. Seeger ended the evening with a five-minute sing-along of "Careless Love," turning the old lyric first into an evocation of the thoughtless passions of youth, then into a plea for understanding: "Let's sing that chorus once again for every patriot and revolutionary the world ever knew, who perhaps loved humanity not wisely but too well—and their hearts are often broken."

Seeger and Slim were back on Sunday afternoon for a more rural pro-

gram, with Earl Scruggs, the Stanley Brothers, the Arkansas songwriter Jimmy Driftwood, and the New Lost City Ramblers. Then on Sunday evening the Kingston Trio headlined another fifteen-act extravaganza with Oscar Brand, Jean Ritchie, and Bob Gibson, as well as Scruggs, the Stanleys, Reverend Gary Davis, and—according to the advance advertising, though not in fact—Bo Diddley. No one seems to remember why Diddley was included or why he didn't show, but the notion of presenting him in this setting went along with Alan Lomax's unconsummated promise to present the Cadillacs at his Folksong '59 concert, a recognition that R & B was in its way a kind of folk art.

Reviewing that first Folk Festival for *The Nation,* Robert Shelton estimated that between twelve and fourteen thousand tickets were sold for the three concerts and described the audience as "predominantly youthful," but "of much more serious purpose and attentiveness than the one at the jazz festival the weekend before." In the *New York Times* he commended the program as "the most ambitious attempt ever made at delineating a cross-section of the nation's folk music," ranging from "the abrasive cries of a minister and former street singer, the Reverend Gary Davis, to that fusion of folk song and show business called the Kingston Trio."

In folk revival legend, that festival's most memorable moment came on Saturday night, when Bob Gibson brought an eighteen-year-old Joan Baez onstage to sing two songs. Though already worshipped by a small coterie of college students in Cambridge, Baez was still unknown to the larger folk world, but Grossman had brought her to Chicago that summer to open for Gibson at the Gate of Horn, and when her crystalline soprano soared over Gibson's gentle tenor in a duet of "The Virgin Mary Had One Son," she was instantly enshrined as the holy Madonna of folkdom—critics routinely described her as virginal and unearthly—with what Wein recalled as "a visual impression of purity to match her singing voice." Though few reviews mentioned her, Wein recalled Baez as "not only the great discovery, but also the living symbol, of the first Newport Folk Festival."

If Baez's debut presaged triumphs to come, the evening's final hour presaged later strife. Shelton's review stressed the Kingston Trio's commercial superficiality, describing them as bounding onstage "with their characteristic verve" and causing "the sort of stir that Valentino might have engendered visiting a spinster's home." The implication was that they were too showbiz for a serious folk program, and in an incident that in hindsight seems glaringly ironic, Grossman upheld the banner of purism, getting into a shoving match with their manager after suggesting "in the rudest terms" that they had no right to be there.

In 1959 that was still very much a minority position, and much of the audience had showed up specifically to see the current hit-makers—which created problems of another sort. According to the *Newport Daily News*:

> A wildly cheering, screaming crowd teetered on the edge of massive retaliation against the entire Newport Folk Festival early this morning until they finally got what they wanted: The Kingston Trio.
>
> The dynamic performers, originally scheduled to bring the show to a sizzling finish, were brought on stage one number early for the benefit of teenagers who had sat in intermittent drizzle for more than four hours to hear them.
>
> When the top-flight songsters wound up their stint so that banjo man Earl Scruggs could come on, the crowd roared an unquenchable burst of protest.
>
> Only the promise that the boys would be back to cap the show finally settled the crowd into their seats again.

Wein later wrote that the program was running late and he was besieged by angry parents, so he made the mistake of putting the Trio on ahead of Scruggs, with the reported result: the crowd screamed for ten minutes and only let the show proceed after Dave Guard came out, promised the Trio would return for an encore, and requested a respectful hearing for his banjo idol. Scruggs played an abbreviated set, the

headliners came back to enthusiastic applause, and Wein recalled, "For some folk purists, it would take years for me to achieve redemption." The purists' opinion mattered because they were not only his most loyal customers but in many cases his advisors and personal friends. By themselves, though, they could not fill the festival grounds—Saturday night with Seeger drew about 4,500 people, while Sunday with the Trio drew 5,500—and the *Daily News* reviewer captured the opposing viewpoint:

> Whatever the level of the demonstration, the crowd's jubilation was justified. The Kingston Trio is tops. They walked away with the show, the festival and the hearts of untold hundreds of teenage girls.

Despite some ruffled feathers, the first Newport Folk Festival was a success, and the following year Wein and Grossman expanded their offerings to three days. Baez was featured on both Friday and Saturday, joined by many of the previous year's favorites—Seeger, Odetta, Gibson, Niles, Brand, and Scruggs—and three top pop-folk groups: the Tarriers, the Brothers Four, and the Gateway Singers. There were also some more esoteric additions: the flamenco guitarist Sabicas, an eighty-seven-year-old former lumberjack named O. J. Abbott, the British ballad singer Ewan MacColl, the gospel star Clara Ward, an Israeli music and dance troupe, and a blues contingent including Jesse Fuller, John Lee Hooker (playing an acoustic guitar rather than the electric instrument he used at that year's jazz fest), and a pair of dauntingly unfamiliar artists from Louisiana: the raw fiddle and guitar duo of Butch Cage and Willie Thomas.

Under the headline "Second Newport Folk Festival Combines Primitive and Popular," Shelton applauded the "closing of the gap between popularized folk music and the real, down-home brand." Describing Cage and Thomas as "authentic performers discovered and brought North by Harry Oster, Louisiana folklorist," he wrote that their "scraping, mumbling, thrusting and obviously heartfelt blues were as warmly received as were the polished, conscious and well-thought out arrangements of

a city trio, the Tarriers." A bit surprisingly, Shelton positioned this as "possibly a bid on the part of the festival planners to win members of the jazz camp over to folk music." In the twenty years since the "Spirituals to Swing" concerts, jazz audiences had become accustomed to educational programs pairing popular stars with exemplars of the music's roots: Sonny Terry's unaccompanied harmonica, the old-time gospel of Mitchell's Christian Singers, and recordings of African ceremonial chants. Such programs were part of the mission to establish jazz as a serious art form, demonstrating that it had a deep history and its audience, like the classical audience, was willing to engage with "difficult" music. Folk promoters had tended to be less daring, and in 1960 the neo-ethnic groundswell was still limited to small gatherings of true believers in Cambridge and Washington Square. That would soon change, but of the dozens of artists featured on the first two Newport festivals, the New Lost City Ramblers were the only representatives of what was still an almost invisible fringe.

From a commercial standpoint, and perhaps even an artistic one, neither the Ramblers nor Cage and Thomas were ideal artists for a large festival stage. Despite Shelton's claim that the Louisiana duo held their own with the Tarriers, when Folkways Records included them on a traditionalist release wryly titled *The Folk Music of the Newport Folk Festival,* the notes by Irwin Silber lamented that "their old country blues were lost in the vast arena of Freebody Park. . . . They were in the wrong place at the wrong time—vainly trying to communicate to an audience that had no basis for understanding their music." They were true folk performers in the sociological sense, amateurs who played for their friends and neighbors at parties and picnics in their local community, and they were a long way from home.

The mass of urban fans appreciated the idea of music with traditional, rural roots, but like fans of any kind they were primarily attracted to artists and styles that resonated with their own lives. In terms of concert performances, that could mean Seeger, Odetta, Baez, or the poppier trios and quartets—but it went beyond concert performances, and one of the great attractions of Newport was the broader social experience. An

article in *Mademoiselle* mentioned the exuberance with which the young audience embraced a mix of "blues and union songs, hobo songs, country music, hymns, flamenco, Elizabethan ballads and ballads of latter-day coal-mine disasters," but only as a lead-in for the main point:

> Each night the music continued long after the regular performances were over, when it became the property not of professionals but of small groups of students who carried their sleeping bags and instruments down to the beach. There, around fires built in holes scooped out of the sand to keep off the fog, boys from Yale's folk-singing clubs exchanged songs and instrumental solos with students from the University of Michigan Folklore Society; and students from Cornell, the University of Vermont, Sweet Briar—along with others who didn't have their colleges emblazoned on their sweat shirts— sang and clapped to songs like *Takes a Worried Man*. The hootenanny often lasted until dawn . . . and before the morning was over students would be singing and playing again—on the beaches, in Newport's small parks, on lawns and on the narrow grass strip dividing the main boulevard.

This do-it-yourself spirit differentiated the folk fest from its jazz counterpart and from the rock festivals that followed—and arguably was what was most authentically "folk" about the folk revival. Like the religious singing schools and camp meetings of the nineteenth century or the fiddle contests and bluegrass conventions of the twentieth, the early folk festivals were as much about making friends and sharing music as about watching other people play onstage. When critics attacked the Kingston Trio, the Brothers Four, or the New Christy Minstrels for having ordinary voices and instrumental skills and relying on a small repertoire of familiar songs, they were highlighting exactly what made those groups attractive to millions of kids across the United States: the idea that anyone could be part of the movement, not only as a spectator but as a participant.

That had always been one of Seeger's dreams and was one of the reasons his approach irritated a lot of folklorists. Alan Lomax argued that young listeners should be made aware of authentic traditions, "all those tremendous artists out there who played perfectly . . . and sang beautifully with great style," rather than treating folk music as "something for summer camp, amateur night." As an assiduous compiler of songbooks that equipped amateurs with lyrics, melodies, and guitar chords, Lomax was hardly in a position to criticize, and he had been supportive of summer-camp singing in the 1940s. But by the 1960s a lot of the kids he and Seeger had inspired were no longer satisfied with campfire sing-alongs:

> "People's Songs" was supposed to involve anybody who wanted to join, who wanted to also sing. What happened was, of course, that those people who also sang became professionals and basically lowered the standards of the field eventually because they didn't have the foggiest idea. . . . They didn't have an inheritance of style, they were just kids from the summer camp who then practiced real hard and learned how to play the guitar real well.

Seeger shared some of Lomax's concerns, and, while encouraging young folks to sing along and learn to plunk a banjo or strum a guitar, he also urged them to seek out and study authentic traditional artists. The difference between their visions was that he did not see any contradiction between young urbanites learning to appreciate the intricacy and depth of rural folk styles and also creating their own less traditional or virtuosic variations of those styles. He liked the idea of people sitting in a circle and singing "This Land Is Your Land" as well as the idea of them sitting and watching O. J. Abbott sing lumberjack songs, and although he understood the contradictions and pitfalls of city kids trying to sing like Abbott, he hoped it might at least give them some sense of what it felt like to be an old man who used to be a lumberjack. If they went on to eke out a living by singing lumberjack songs in nightclubs for audiences of fellow urbanites, that was just what he had done himself a few years

earlier. And if they did well enough at it, they might be able not only to interest more people in lumberjack songs but to provide an audience for authentic rural musicians: when Wein hired him for the 1960 Newport Festival, Seeger requested that instead of paying him they use his fee to bring Jean Carignan, a French Canadian fiddler.

In 1960 that was just a nice gesture, but three years later it became the basis of a new kind of festival. First, though, came disaster: a week after the 1960 folk gathering, the Newport Jazz Festival drew a capacity crowd of fifteen thousand spectators for its Saturday evening concert, leaving some three thousand young fans shut out on the streets and not at all happy. The police tried to clear them away, eventually using fire hoses and tear gas; the kids responded by throwing beer cans; and the Marines and shore patrol were called in. The riot made headlines and the City Council voted to cancel the rest of the weekend's shows and revoke the festivals' licenses. Its sole concession was to allow the Sunday afternoon blues showcase to proceed as planned, including performances by Butch Cage and Willie Thomas, the Kansas City shouter Jimmy Rushing, and electric sets from John Lee Hooker and the Muddy Waters band, which culminated with Waters rocking, roaring, and pumping his hips in a provocative portrayal of just what it meant to get his mojo working.

Wein was not ready to give up on Newport, and although it took two years of backroom politicking, he brought the jazz festival back in 1962. Reviving the folk fest took a year longer, but that was in part because he had decided to make some fundamental changes. By then Albert Grossman was managing a stable of stars including Peter, Paul, and Mary and Bob Dylan, and even if he had been available to help run the festival, a lot of people on the scene regarded him as a sordid commercial huckster. Wein wanted to create an event that would take advantage not only of the music but of the idealism of the folk world, and felt the way to do that was to put its helm in the hands of someone who "would uphold— even embody" those ideals, "a prominent figure whose own interests were indistinguishable from those of the folk movement . . . , [who] had the respect of traditional musicians as well as contemporary songwriters,

and the ability to work just as easily with more commercial acts. In other words," he said, "I needed Pete Seeger."

Wein drove to Beacon with his wife, Joyce, and over dinner in the Seegers' log house Pete and Toshi presented their concept for a festival that would take advantage of the varied strengths of the folk world. On the drive home from Newport in 1960, Toshi had wondered whether Pete's choice to subsidize Carignan's appearance could be expanded into a general principle. She imagined a nonprofit event organized by musicians rather than promoters, which would pay everyone a basic fee of fifty dollars a day plus travel and lodging. If stars like Seeger, Baez, and Peter, Paul, and Mary went along with this scheme, they could draw tens of thousands of paying customers, and the money saved from their usual fees could be used to bring unfamiliar traditional artists.

Wein loved the idea, Seeger invited Theodore Bikel to complete the planning committee, and the three of them drew up a proposal for a foundation run by a revolving, unpaid board of directors. The first year's board would consist entirely of performers who would organize the festival and disburse any profits "to the benefit of the entire field of folk music." The initial program would consist of three big evening concerts with assigned seating and paid admissions, but also eight to fifteen small "workshop sessions" focusing on particular styles, instruments, or regions; one or two daytime hootenannies "where anyone who wants can get a chance to do one number"; two or three "jawtalk" sessions where people could discuss issues related to the folk scene; and "dozens of impromptu sessions around town on lawns, beaches, in homes, restaurants or bars—encouraged by the festival."

The first board included Seeger and Bikel along with the Appalachian ballad singer Jean Ritchie; Bill Clifton of the Dixie Mountain Boys, who had organized one of the first bluegrass festivals two years earlier; Erik Darling, who had replaced Seeger in the Weavers, scored two Top 10 hits with the Tarriers, and recently had a number one hit with the Rooftop Singers; Clarence Cooper, an African American singer who was in the current Tarriers; and Peter Yarrow. It was a canny selection, balancing

marquee appeal with artistic bona fides: with four veterans of chart-topping pop-folk groups and Bikel's Broadway credentials, the board was perfectly designed to reach out to well-known performers who might otherwise have been dubious about donating their services; Seeger, Ritchie, and Clifton were respected by the traditionalist wing of the revival; Bikel was a multilingual performer of international folk songs; and Seeger and Yarrow were among the most active supporters of the new generation of topical songwriters.

Dylan was already being recognized as the most talented of that generation, but he had barely performed outside New York and when he arrived at Newport in July 1963 his songs were far better known than he was. In particular, "Blowin' in the Wind" was becoming an anthem: Peter, Paul, and Mary's recording had appeared the previous month and sold 320,000 copies in a week—by some reports the fastest-selling single in Warner Brothers' history up to that point—and it had also been recorded by the New World Singers, the Chad Mitchell Trio, and the Kingston Trio. Dylan's own version had been issued in May as the lead track on his second album, though *Freewheelin'* would only begin to creep up *Billboard*'s LP chart in September. There was already some buzz around the record—the week before Newport, *Billboard* gave it a "Pop Spotlight" plug, writing, "Though his first album has yet to break through in any major way, there's a good possibility this one will"—but for the moment his audience was largely limited to cognoscenti.

Of course, Newport was a gathering of folk cognoscenti, and many of the people who flocked to the 1963 festival had already seen Dylan at Seeger's Carnegie Hall hootenannies or his own Town Hall concert, or in the coffeehouses of Greenwich Village or Cambridge. Even in that world, though, he remained a promising newcomer rather than an established leader. If he left Newport as something more than that, it was in a large part because he exemplified the hopes and dreams of the revival, one of the unwashed masses creating shared art that remained deeply rooted in familiar traditions—which is not to downplay his unique charisma and Albert Grossman's savvy management.

Thinking back on that festival, Wein recalled the defining impact of the civil rights movement. The Freedom Singers were there, fresh from the marches and arrests of the southern struggle, and along with their festival performances the quartet led a march through Newport and held a rally in the town park, joined by Baez and some six hundred other supporters. Wein embraced this activist spirit and the opportunity "to know and relate to brave individuals who staked their lives and freedom for the cause," writing that he considered the festival "a platform and a forum" for them. He added: "If the civil rights cause had a rallying cry at that time, it was Bob Dylan's 'Blowin' in the Wind.'"

That characterization was in some ways off-kilter: to the southern marchers, there were dozens of more popular and organic rallying cries—most obviously "We Shall Overcome." But in terms of rallying support among white northerners, Dylan's song was a unique and powerful statement. Most listeners associated it with Peter, Paul, and Mary, and, given their status as the most popular folk group in the country, Wein planned to give them the first evening's closing spot. However, Grossman had a different idea, and as the group's manager his ideas carried a lot of weight: he persuaded Wein to have them close the first half of the concert and give the final set to Dylan. Wein recalled that it "may have seemed incongruous to some observers" to close the evening with "this skinny kid with the nasal voice and the iconoclastic, oddball demeanor," but it perfectly summed up the festival's ideals. Dylan was not a star; he was an ordinary young man with an ordinary voice and instrumental skills who served as a conduit for extraordinary songs. As insurance, the biggest stars in the pop-folk firmament were on hand to provide him with a sure-fire encore: Peter, Paul, and Mary would not only present Dylan's song in their set but also join him for the evening's finale.

Newport's working model depended on that balance of expertly channeled star power and sincere ideals, and if it had some inherent contradictions, for a few years it created a genuinely communal experience. The first evening concert was attended by a capacity crowd of thirteen thousand people, with hundreds more listening quietly outside the gates. Rhode

Island senator Claiborne Pell started things off by reminding the audience that folk music was "the only form of art whose creative roots stem from the soul of all the people and not just from the talented few." Then came Bill Monroe and his Bluegrass Boys, at the time all but unknown to urban audiences; a tuneful young folksinger in the Baez mold named Raun MacKinnon; the Carolina blues duo of Brownie McGhee and Sonny Terry; and a set of French Canadian songs and tunes from Hélène Baillargeon and Jean Carignan. The announcement that Peter, Paul, and Mary were up next brought a surge of young fans rushing to the stage and police and festival officials shooing them back to their seats. The *Providence Journal* kidded the trio for their Bohemian appearance, writing that Peter and Paul looked "like the two Smith Brothers, with their utterly charming coughdrop, Mary," but found them to be "superb entertainers . . . satirical, amusing, righteous and lyrical by turn." They opened with "Go, Tell It On the Mountain," a traditional spiritual that had gained a newly relevant tag line, "Let my people go," in the course of the southern freedom struggle, and followed with "500 Miles," "Puff, the Magic Dragon," and a comic reworking of the ballad "Old Dog Blue" in teen-pop doo-wop style. Then Yarrow stepped forward to say a few words:

> There is a man by the name of Woody Guthrie [he was interrupted by a burst of applause], who is considered today to be one of the greatest American folk poets that has ever lived. There is a young man who is living today and writing today in very much the same way that Woody Guthrie wrote thirty years ago. His songs are so poignant and so meaningful that we feel—that is, Paul and Mary and myself—that he's the most important young folksinger in America today. He's very young—he's only 21. His name is Bob Dylan [longer, louder applause] and this is one of the songs that he's written.

They sang "Blowin' in the Wind," followed with Reverend Gary Davis's "If I Had My Way," then explained that they would be back with

Dylan later in the evening and finished with "If I Had a Hammer," bowing off to a tumultuous ovation.

The Freedom Singers opened the second half of the concert, followed by the Scottish singer Jean Redpath and the North Carolina guitar virtuoso Doc Watson, who was joined for several songs by Monroe on mandolin. Then Yarrow introduced Dylan, an artist with "his finger on the pulse of our generation." The *Newport Daily News* echoed the surprise many listeners must have felt, describing him as looking "slightly stooped" and "as if he has slept in his baggy, rumpled clothes," but with gifts that "are startlingly apparent the moment he opens his mouth. His voice, reputedly weak and scrawny, came out loud, clear and forceful as he sang the songs of his own invention. He is the voice of the oppressed in America and the champion of the little man."

Dylan opened with his latest twist on Guthrie's comic monologues, "Talking World War III Blues," and showcased his most political material: "With God on Our Side," "Only a Pawn in Their Game," "Talking John Birch Blues," and "Hard Rain." His set was well-received, but the apotheosis was yet to come. Yarrow announced he was "greatly privileged" to bring Dylan back onstage and, stepping to the mike, Dylan said: "I want to introduce some people. We're all gonna sing a song for you." One by one, he brought up Seeger, the Freedom Singers, Baez (whose name brought the loudest cheers), and Peter, Paul, and Mary, then announced, to no one's surprise: "We're gonna sing 'Blowin' in the Wind.'" He strummed a few chords and began to sing, with the others forming a chorus behind him, at first humming along with his verses and lending their harmonies to the chorus, then joining the verses as well. It was a little ragged and disorganized, but the image was unforgettable: the skinny youth in a plain, short-sleeved shirt, with the royalty of the folk world standing behind him, sharing and supporting a vision he alone had put into words. The crowd was mesmerized, then exploded in cheers and applause. Bikel tried to end the show, promising, "There will be singing through the night in the town of Newport," but he was met with shouts of "More!" and then a rising chant: "We want Dylan!

We want Dylan." The chorus of performers came back to the stage and pulled together an impromptu encore, agreeing on a key, then hurriedly beginning what Dylan introduced—to some nervous laughter from the others—as "a song that Peter, Paul, and Mary made famous, called 'We Shall Overcome.'" The eleven singers linked arms as they sang, creating an iconic image of solidarity. The message was not only of unity between the races but of famous stars stepping aside to frame the lesser-known, grass-roots artists at the music's heart: Seeger and Bikel on one end, Peter, Mary, Paul, and Joan on the other, and in the center Dylan and the Freedom Singers.

Dylan popped up again and again over the next two days, and was consistently treated as someone special: at a Saturday morning ballad workshop with British traditional singers, southern mountaineers, revivalist singer-scholars (including West Coaster Sam Hinton, who lent him a guitar), and a young female triumvirate of Baez, MacKinnon, and Judy Collins, Jean Ritchie awarded him the final song. It helped that he had rehearsed a duet with Baez of "With God on Our Side," which he introduced a bit diffidently as "a ballad of sorts," but connected to what had come before, noting that Jean Redpath had sung "The Patriot Game" and his song used the same tune. The audience was appreciative, and it was the best-attended workshop of the morning, though in keeping with the board's plans it drew connoisseurs rather than a mass public—the *Providence Journal* estimated that there were 450 people seated on the lawn in front of the latticed porch that served as a makeshift stage.

Collins sat behind Dylan, watching him with studied concentration, and on Saturday evening she included "Blowin' in the Wind" in her mainstage concert set, describing him as "one of the most important things that has happened in the past year to folk music." At Sunday afternoon's Topical Songs and New Songwriters workshop, Dylan followed the Freedom Singers, and although they earned a standing ovation simply by appearing onstage, the *Providence Journal* wrote that the audience crowded closer when he came to the microphone: "It was obvious that many had been waiting to hear the short, slight young man's bitter

songs." He sang "Who Killed Davey Moore" and "Masters of War," then was joined by Seeger to lead a sing-along of one of his newer songs, "Ye Playboys and Playgirls (Ain't Gonna Run My World)."

The Sunday evening concert culminated with a one-two punch of the most popular female and male singers of the folk world: First came Baez, who opened with "Oh, Freedom," followed by "Don't Think Twice, It's All Right." She kidded the purists, saying "I don't feel half as authentic as most of the people who've been up here tonight, but there's nothing I can do about it—I was born on Staten Island." Along with familiar favorites like "All My Trials" and "Wagoner's Lad," she performed a joking cover of a recent teen-rock hit, the Majors' "She's a Troublemaker," for an encore, jauntily mimicking the original's male falsetto, finished with the ancient ballad of "Mary Hamilton," then came back yet again with Dylan in tow, saying, "We just have to sing one," and reprising "With God on Our Side." Finally, Pete Seeger brought the weekend to a fittingly communal close. He started his set with Lead Belly's twelve-string guitar showpiece, "Fannin Street," segued into a slow boogie that somehow evolved into "Michael, Row the Boat Ashore," then encouraged local sailors to join him on the chantey "Shenandoah." After a couple more songs, he was joined by almost twenty other performers for a grand finale, and the park swelled to ten thousand voices singing the familiar chorus of "This Land Is Your Land." The Newport Daily News was particularly cheered by the zeal with which the audience greeted Guthrie's classic, writing that it "proved that however rebellious or 'beat' the present younger generation . . . might be, their love for their country was still deeply imbedded within them."

The weekend had included over seventy performers circulating through four large concerts and sixteen workshops, and plenty of people recall other moments as more exciting, moving, or skillful than Dylan's appearances. In particular, the Saturday afternoon blues workshop marked the first major appearance of Mississippi John Hurt, a sixty-nine-year-old emissary from the hallowed past—two of his records from 1928 had been included on the Anthology of American Folk Music—who also

happened to be one of the most charming and adept performers of the
1960s. A couple of years later, reflecting on the fact that young singers
had come to regard Newport as a place to grab the brass ring of folk
fame, Manny Greenhill insisted, "There is only one person who suddenly
became big as a result of a Newport appearance, and that is Mississippi
John Hurt. . . . John Hurt is the only one you can point to a date at
Newport and say bang, it happened right there, just like that." It was
the best-attended workshop of the day, with some five hundred listeners
sitting on the grass and clustered on the sides of the casino porch, and
Wein echoed Greenhill's assessment, writing that it "nearly equaled the
Friday night finale in folk world significance." Hurt was the big news,
but he had excellent company, including Dave Van Ronk, the young John
Hammond (son of Dylan's erstwhile producer) startling listeners with
his command of early guitar and vocal styles, Sonny Terry and Brownie
McGhee playing energetic duets, and John Lee Hooker playing moody
acoustic moans. Hooker also appeared on the main stage that night with
a solid-body electric, backed by Bill Lee on bass, and performed a varia-
tion of the recent dance hit "Green Onions" and his Top 20 R & B single
from the previous year, "Boom Boom"—the *Providence Journal* wrote
that he "sounds much like a rhythm and blues artist at times . . . [and]
wields an electric guitar like a six shooter."

It was a magical weekend, not only for the spectators but for the per-
formers and staff, who continued to enjoy the music after the formal
concerts ended. Wein recalled watching from the porch of one of the per-
formers' lodging houses as Hurt gave an impromptu concert for a group
of children and sticking his head into a room where "Baez and Dylan, the
virgin queen and crown prince of the folk revival . . . were trading songs."

In those first years the informal socializing and music-making made
Newport as special for the artists as it was for the audience. Young musi-
cians who had acquired their skills by hunching over scratchy records
were thrilled to find themselves chatting, jamming, and appearing on
stages with the men and women who had made those discs more than
three decades earlier. Paul Rothchild summed up a common feeling when

he compared the early Newport festivals to Washington Square Park on a Sunday afternoon, only with thousands of people and an unbelievable range of talent on display. It was awe-inspiring, and yet there was something intimate about it, a feeling that everyone was part of a small clique sharing a secret passion:

> This was all very private, this was not the Kingston Trio, this was not Harry Belafonte. We heard mountain music played by the real people. We heard Delta blues played by the real people. . . . And after these festivals we'd go away and mulch on that for a year, and by the next year some of our people would be up on those stages doing those kind of songs.

For rural musicians who had spent their lives playing for neighbors and at small local dances, the experience was even more striking. The festival organizers tried to be supportive and encouraged them to bring family members along for company, but some undoubtedly found the experience disorienting. With the profits from the 1963 festival the board commissioned Ralph Rinzler to travel around the United States in search of little-known artists, and part of his job was to prepare and reassure them, "so they wouldn't feel that they had to make a speech or stand up or put on a bow tie and a black suit or a granny dress, but to just be themselves."

For some the experience was life-changing. The Cajun fiddler Dewey Balfa had grown up thinking of his music as archaic and disrespected, to the point that when he and his brothers were invited to Newport in 1964, the word back home was, "They're going to get laughed at." Instead, they were acclaimed:

> I had played in house dances, family gatherings, maybe a dance hall where you might have seen as many as two hundred people at once. In fact, I doubt I had ever seen two hundred people at once. And in Newport, there were seventeen thousand. Seventeen thousand people who wouldn't let us get off stage.

The result was not only a professional career for Balfa and his brothers but the birth of a regional revival—word of their success up north sparked a new pride in vanishing traditions, and the Newport board provided funding for the first Cajun music festivals in Louisiana, beginning a renaissance that would spread throughout the country, and eventually around the world.

The 1963 festival program included almost twice as many urban folk revivalists as rural or "ethnic" acts, but that shifted over the next few years, and by 1967 the proportions were roughly reversed. Whatever the exact balance, the reciprocal relationship between these two groups was what made the Newport festivals so special: the traditional artists provided historical depth, technical expertise, and a foundation of authenticity, while the urban performers proved the vitality and relevance of folk-related styles in the modern world. The mix was not always easy: Wein recalled Buell Kazee, a banjo player who had recorded some of the most treasured tracks on the Folkways *Anthology,* being disturbed by the left-wing, anti-Vietnam ethos of the 1968 festival: "I don't want anything to do with tearing down America," he complained, adding, "I don't know why these folks don't do the honest thing and admit that this is ideology and not just music. If I'd known it was goin' to be like this I'd of stayed in Kentucky."

By contrast, Frank Proffitt, whose version of "Tom Dooley" had been the original source for the Kingston Trio's hit, wrote to *Sing Out!* after the 1965 festival, "I can understand the young people and others whose hearts cry out to express in songs and music, feelings and thoughts they have had about themselves and their surroundings." He added:

> I am one hundred per cent behind anyone who sings and plays any style anywhere at any time on any type of instrument he chooses. . . . One fellow wrote me: "But I don't have a tradition like you!" Upon which I replied: "If you believe in the Biblical Adam, I'm sure he songed for Eve. If your mind runs to that coming-from-monkey stuff, I'm sure the cave man beat upon

the cliff and sucked-out marrowbone and croaked out a melody or two. What more tradition do you want?

For performers and audiences alike the Newport festivals often felt like a world apart, a place where disparate groups could meet and, through their shared love of music, overcome their differences. Young radicals sat at the feet of conservative elders, and country folk tried to be polite about strange city ways. Wein recalled that on the first night of the 1964 festival, the shuttle bus that took performers from their living quarters to the festival grounds was already filled with members of a white Sacred Harp group from a small town in Alabama when it arrived at the house where the black Georgia Sea Island Singers were staying.

> There was an awkward silence; both of these groups came from places where blacks and whites had no interaction whatsoever. The Sacred Harp contingent was a fundamentalist Christian group; they were accustomed to segregation as a way of life.
> The tension on the bus was palpable. Then, without anyone saying a word, one of the men from the Sacred Harp Singers stood and offered his seat to a woman from the Georgia Sea Island Singers. After a moment's hesitation, she gratefully took it. Soon another Sacred Harp gentleman offered his seat, then another—until all of the Georgia Sea Island women were seated.

Barry Kornfeld has a similar story about arriving late for the 1959 festival with the Reverend Gary Davis, entering the performers' tent to find all the chairs taken and Earl Scruggs—who Kornfeld is sure had never heard of Davis—immediately getting up and offering his chair to the blind street singer. Wein and Kornfeld both frame their stories as examples of white southerners making commendable gestures across racial lines, but their surprise suggests they had their own stereotypes to overcome and were also learning and growing as part of their Newport experience.

That sense of warmth and community, of leaving differences at the

festival gates and joining in musical fellowship, was not Dylan's style. No one recalls him socializing with anyone unfamiliar, and John Cohen is one of several people who sound annoyed as they describe him wandering the festival grounds in 1963 with a bullwhip curled around his shoulder. Anthony Scaduto wrote that when people asked, "What do you do with that?" Dylan replied, " 'I flip people's cigarettes out of their mouths. That's what I do with it, man.' He rattled a lot of people with his arrogance, with the walls he erected around himself."

The walls were not all metaphoric. Cohen and the other New Lost City Ramblers, like the rural artists, most of the urban revivalists, and the support staff, drove or rode buses to Newport and slept in the makeshift lodgings the festival provided, many of them on folding cots. Meanwhile, Grossman's favored clients flew in from New York, first to Providence and then by private plane to Newport, and stayed in private rooms at the posh Viking Hotel. Suze Rotolo recalled it as a heady experience:

> The sense of business hovering—the sound of money, mixed with the prospect of record deals and fame—was exciting for the up-and-coming folk musicians hoping for a break. There was a lot going on. Photographers David Gahr and Jim Marshall were everywhere at once, snapping away. Bob was all business and all fun at the same time. Cracking that bullwhip. Shaking up the ground.

The photographers caught Dylan lounging with friends by the Viking's swimming pool, and one shot seems designed to highlight the contrast between his lifestyle and the festival's social mission: he stands in a short-sleeved shirt and sunglasses, palms outstretched, explaining something to the African American Bill Lee, who is separated from him by a wooden fence with a sign saying REGISTERED GUESTS ONLY MAY USE POOL. The shot was presumably staged as a wink at similar signs enforcing southern racial segregation, but also suggested the ways northern power and money replicated the same effects, with Dylan on the fortunate side.

Whatever the underlying complexities and contradictions, as a public figure Dylan embodied Newport's mix of urban youth and rural tradition, folk purity and political activism. As Shelton later wrote in his biography:

> With his raggedy clothes, biting songs, anti-show-business posture, [and] identification with Negro rights and peace . . . Dylan became the Festival's emblem. His picture was everywhere—lean, gaunt face, frail shoulders covered in a faded khaki army shirt with wilted epaulets, blanched blue jeans. . . . It all looked as spontaneous as the group spirit of Newport itself. Yet Albert and Dylan had done considerable planning.

This description was somewhat disingenuous, since the most prominent display of Dylan's picture was in the opening pages of the festival program, accompanying a poem by the gaunt young bard—and that program was edited by Shelton's pseudonymous doppelganger, Stacey Williams. Shelton later wrote that "Dylan arrived . . . an underground conversation piece, and left a star," but he also anticipated that transformation, and Grossman himself could hardly have done a better job of framing the weekend as a torch-passing ceremony from Pete and Woody to the "22-year-old song writer from New York, via Hibbing, Minnesota; Gallup, New Mexico, and all points in between."

Overall the program booklet was a model of inclusivity, its thirty-eight pages balancing old and new, urban and rural, commercial advertisements and song sheets from *Sing Out!* The inside front cover had a glossy Decca Records ad for Bill Monroe, "the daddy of 'blue grass music,'" followed by a general welcome from the festival board and brief statements of purpose from each of its seven members. Then came Dylan's prose poem "—for Dave Glover," filling one and a half pages and set off with a photo of the young poet moodily blowing his harmonica. Advertisements for records by festival performers on Elektra and Vanguard were followed by "Folklore in Your City," an article by Tony

Schwartz, who had spent a decade roaming the streets of New York with his reel-to-reel tape recorder and encouraged fellow urbanites to do likewise. Then came a glowing encomium from *Broadside*'s Sis Cunningham to the new generation of songwriters, "Woody's children," led by "Bob Dylan, only 22, whose songs in a few short months have gone around the country and overseas."

Next a full-page ad from Columbia Records showed Pete Seeger in full-throated sing-along mode juxtaposed with a studiedly Woody-ish shot of Dylan picking a battered Gibson. The text positioned them as respected king and youthful prince:

> Pete Seeger has been humming and strumming his way across the land since 1940, the year before Bob Dylan was born. Today, Pete's eminence as an authority in his field is undisputed and his special gift for involving audiences in his performances is largely responsible for the folk singing revival. Bob Dylan, who exploded onto the scene only two years ago with a style as unique as the songs he writes, has met with knowledgeable, receptive audiences well able to appreciate his exciting, unusual talents. Both artists are dynamic forces in the folk singing world. Both are on Columbia Records.

The next couple of articles, by Jean Ritchie and Ralph Rinzler, provided some grounding and bona fides, hailing the renewed popularity of the Appalachian dulcimer and the success of the Friends of Old Time Music, which had sponsored the first New York appearances of Roscoe Holcomb, Doc Watson, Jesse Fuller, and Furry Lewis and offered to act as an artists' bureau for college entertainment committees seeking similar performers.

Then came a more controversial selection: Lightnin' Hopkins and Eric Von Schmidt debating whether "young white guys" could sing blues. Hopkins was categorically negative:

> The white boys just don't have the voices for blues. They can play it but they can't sing it. . . . It isn't white man's music. He can feel it but he just don't know where it's at. . . . They haven't been through it, only get it from records and concerts and don't live it out.

Von Schmidt's response acknowledged the difficulties: "Most young white guys who sing blues have this particular hang-up. Every morning when they get up they're still white. Kind of grayish-pink, orangish-purple, yellow-green—you know, white." However, he suggested that this handicap could be surmounted if they would stop trying to recreate the past:

> White, black, or blue—you're you. Robert Johnson and Bukka White were talking about *their* times, *their* women. . . . Got to get with this NOW. Jet planes not Terraplanes, outer space instead of mules. The closest we're going to get to Clarksdale, Mississippi, is the record store on the corner. . . .
>
> Some of the younger guys are starting to do it. And when it happens it isn't going to sound like the Delta or the Southside. It's going to sound like *them*. They're listening to the roots players for approach rather than style, poetry instead of repertoire. Who needs imitations when Sleepy John and Big Joe are alive and getting their kicks? Skip the Hal Holbrook and pass me some of that Tom Wolfe.

On the Cambridge scene, Von Schmidt himself was the prime exemplar of this approach, a growling, bearded white man who sang about rocket launches and sailing his boat around the Gulf Coast. But on the national scene, Dylan was the most obvious artist mixing blues influences with Wolfeian modernism.

The program continued with music and lyrics for a traditional ballad, "The Golden Vanity," a schedule of concerts and workshops, then

an article by Shelton under his own byline about the singing civil rights movement and in particular the Freedom Singers, who with "thousands of nameless members of the chorus for integration are writing new verses each day to a stirring song that is moving people in a direct way." Four pages later came sheet music for one of those anonymous anthems, "Woke Up This Morning (With My Mind on Freedom)"—but the song presented alongside Shelton's piece was "Blowin' in the Wind."

An ad from Harold Leventhal's booking agency carried a hint that the time was particularly apt for the emergence of a new folk star: banner capitals wished "Bon Voyage!" to Seeger and his family, who were setting off on a yearlong, twenty-one-country world tour.

Then Mitchell Jayne of the Dillards provided a hillbilly parallel to Von Schmidt's exhortation. A quartet from the Ozark Mountains, the Dillards had become familiar visitors to American living rooms through recurring spots on *The Andy Griffith Show* and would shortly be the first bluegrass band to record a Dylan song. Since they met him for the first time in Newport, Jayne presumably was not thinking of Dylan when he wrote this piece, but in hindsight it reads like a defense of the new wave he was leading, starting with a satiric paraphrase of the way "pedants" were trying "to purge the music by drying up its vitality and rejecting change":

> Innovations, the very heart and soul of the oldtime music, are not to be messed with, and a violation of this commandment is an indication that the performers are interested in nothing but money, and therefore prostitutes. . . . [This] is the great error of the traditionalists, who occasionally raise the hue and cry against an artist who is leaving the beaten path of folk music for more thickety footing.

The following page showed another visitor from the Ozarks, Jimmy Driftwood, whose song "The Battle of New Orleans" had topped the pop and country charts in 1959, sitting in the audience at that year's Newport Folk Festival flanked by a quartet of cheerful teenagers.

(Behind him, apparently unnoticed by the photographer, sit Dave and Terri Van Ronk.) Below the photo was sheet music for a version of "Pretty Peggy-O," transcribed from the singing of George and Gerry Armstrong, who had appeared at Driftwood's First Annual Arkansas Folk Festival that April. It may have been purely coincidental that this song was also on Dylan's first album, though Shelton's role as writer of that album's sleeve notes suggests it may not have been.

The festival program was not simply a Machiavellian gambit in a Dylan-centric chess game, but Peter Yarrow notes that "there was a camaraderie and even a complicity of sorts between Robert Shelton and Albert Grossman," and in this period the writer felt personally responsible for much of Dylan's success and embraced the singer's work as a vessel for his own aesthetic and professional missions. He was a committed crusader for authentic folk music and progressive politics, and Dylan exemplified both. Like Guthrie, Dylan was a personification of progressive traditionalism, a populist wordsmith whose songs outshone his personal charisma and whose rough voice and neo-ethnic style would inevitably limit his appeal and keep him out of the pop mainstream.

If Shelton was wrong about that last assumption, he had a lot of company. And if Dylan was taking off with startling speed and freighted with inordinate expectations, the same was true of the folk scene in general and the Newport Folk Festival in particular. That year's event sold forty-eight thousand tickets, outstripping the Jazz Festival by more than ten thousand, and Wein told the *Newport Daily News* it was "the greatest experience of my lifetime in proving that people can do things in a selfless way." Jean Ritchie wrote that it left her with "a series of outstandingly beautiful memories, too numerous to list . . . but summarized perhaps in a *feeling* that the world is somehow better because all those people came together and all those things happened."

Chapter 6
TIMES A-CHANGIN'

Looking back from the vantage point of the 1980s, Robert Shelton described Newport 1963 as "a dress rehearsal for Woodstock Nation . . . the cocoon of an alternative culture." By then it was a tempting analogy, but in 1963 "the sixties" had not yet happened, and there was no way to know they would. The folks at Newport had hopes for a better future and saw the festival as a step in the right direction, but the rest of the country was not paying much attention or, if it was, tended to regard them as oddballs. The mores of the 1950s were still firmly in place, and even most Newport-goers imagined the better future as looking a lot like contemporary America, only more open-minded, inclusive, and peaceful. What were the alternatives? Western Europe was rebuilding from World War II with the United States as its model. Eastern Europe was looking bleaker by the day, and only the most blinkered old-line reds still regarded it as the cradle of any possible utopia. Asia was poor and racked by wars. Latin America was a crazy quilt of dictatorships and banana republics. Whatever its flaws, the United States was prosperous and safe, and the middle-class dream seemed more accessible than ever before. That was what they were marching for down South, wasn't it?— the right to eat in restaurants, vote in elections, go to good schools, get good jobs, and live in nice neighborhoods.

Anyone who was not buying into that dream was acutely aware of

being in a tiny minority, or of being personally strange, neurotic, and alone. That was what made Greenwich Village a haven, why finding a coffeehouse where other people liked the same music, books, and films was life-changing, and why protecting those shared tastes was so important. The punk rockers fifteen years later, the hip-hop fans, and the pierced and tattooed youth of the new millennium were in a different situation, because they could look back to the 1960s and see that a previous generation had rebelled and survived. In 1963 a lot of young people were looking back at recent history, at what had happened not only in the United States but in Weimar Germany. How could they not be paranoid? Within the previous decade Americans had lost jobs and gone to prison for attending the wrong concerts, having the wrong friends, supporting the wrong causes, or refusing to inform on other people who had done those things. Pete Seeger and the Weavers were still barred from network television. Ewan MacColl and Peggy Seeger, who had become a British citizen when she married MacColl, were denied visas to enter the United States. The South was exploding, and there was no telling where that would lead. There was a growing sense of optimism and signs that things were changing: the postwar baby boom had created a huge generation that was coming of age and increasingly aware that it wanted a different and better world. But there was also reaction: William Moore had been shot. Medgar Evers had been shot. Hundreds of peaceful marchers had been brutally beaten and thousands more had been jailed. Things might be getting better—when Kennedy won against Nixon it was certainly a positive sign—but it was the closest election since World War I, and the balance could easily tip in the other direction, toward conservative retrenchment, a government crackdown, even a fascist dictatorship. And that was if they lived long enough. Kennedy's new, liberal administration had no better answer to the threat of nuclear annihilation than making that annihilation more thorough, deterring Russia and China with the promise of "mutually assured destruction."

In cultural terms, it was not yet the sixties of hippies and Hendrix. It was still the sixties of *Hootenanny*: well-scrubbed and neatly coiffed col-

lege students seated in proper rows, singing along with perky folksingers in matching suits and ties. The music was more adult and intelligent than "At the Hop" or "Puppy Love," but in retrospect there is a surreal perfection to watching Leon Bibb's appearance on the show, singing "Little Boxes" to a packed hall of UCLA undergraduates, all dressed conservatively, all smiling Pepsodent smiles, all bobbing their heads and mouthing the words along with him: "The people in the houses all go to the university / And they all get put in boxes, little boxes all the same."

Newport, whatever it might be, was not that. The music was dauntingly heterogeneous; the audience included lots of blue jeans—on girls as well as boys—sandals, and a few beards; and far from being banned, Pete Seeger was everywhere: singing, playing, and giving encouragement to old rural musicians and young songwriters alike. Which is not to say the worlds were entirely separate, since three of the seven board members for the 1963 festival appeared on *Hootenanny* in the next year: Clarence Cooper, who hosted the blues workshop, could also be seen from coast to coast in a suit and tie with the Tarriers—an interracial group with a terrific banjo player, but very much in the Kingston Trio mold. Erik Darling, who had replaced Seeger in the Weavers—the group that pioneered suit-and-tie folksongery—was on with the Rooftop Singers, who had a number one pop hit with an old jug band number called "Walk Right In." And Theo Bikel was on with Judy Collins, singing a duet of the Weavers' "Kisses Sweeter than Wine." That was what made *Hootenanny* so galling: it was simultaneously the most visible showcase for the folk revival and a prop of the conservative, conformist power structure the revivalists despised. Its enthusiastic year-end wrap-up of the top folk hits featured "If I Had a Hammer" and "Blowin' in the Wind," and few viewers were aware that the composers and performers of those songs were blacklisted or boycotting the show.

To make matters more complicated, the pop-folk craze brought a lot of added attention not only to the sell-outs on television and alternative stars like Baez, Seeger, and Peter, Paul, and Mary, but to rural artists like Mississippi John Hurt and Doc Watson. Folk clubs sprang up around the

country, and if some preferred clean-cut collegiate groups, there was also plenty of work for both neo- and authentic ethnics, as well as for young people with shaky voices and limited instrumental skills who sang songs attacking the complacency of mainstream society. The audiences likewise overlapped—plenty of *Hootenanny* watchers flocked to Baez concerts and showed up when their college folk series presented Dave Van Ronk or Tom Paxton. Tastes that a few years earlier had seemed esoteric were increasingly mainstream, which was great in some ways but disturbing in others—it was, of course, wonderful that the music had a larger audience, but it diluted the feeling of sharing something secret and precious, and there was every reason to fear that the mainstream would transform heartfelt art into mass-produced schlock. As Seeger remarked during a panel on the festival's opening day, "We all know folk music has mushroomed, and now we're beginning to worry about the fallout."

One reason so many people cared so deeply about Seeger, Baez, and Dylan was that each managed to reach large audiences without seeming to compromise—and Dylan's success was even more jarring than Seeger's or Baez's. They were both unique, committed artists, but also pleasant and reliable and, if they had been willing to relinquish their political commitments, could easily have joined the *Hootenanny* wave. Dylan was a particular flashpoint in part because he was a symbol of authenticity and commitment, in part because he kept changing and startling people, but also because he sounded so different from other folk stars and potentially so annoying. At every stage his fans and supporters were surrounded by baffled critics who dismissed him as a grating, whiny poseur, and the attacks made them defend him more passionately, which made them feel all the more betrayed when he shifted gears.

Dylan's apotheosis at Newport defined his classic persona: the rumpled young heir to Woody Guthrie who wrote powerful lyrics about the problems of society and stood arm in arm with Seeger, Baez, and the Freedom Singers. But for his earlier fans this represented a shift in direction, and some felt he was losing his way and debasing his talents. His old friends at the *Little Sandy Review* greeted *Freewheelin'* with cold

scorn: "He has become melodramatic and maudlin, lacking all Guthriesque economy; his melodies bear more relation now to popular music than folk music. As a performer he is at times affected and pretentious." These were people Dylan knew and respected, and whose tastes he largely shared. So even as he was being hailed by the folk establishment as a thrilling new voice, he felt pressed to explain his changes. His poem in the festival program was a defense of his new direction, addressed to Dave "Tony" Glover, a harmonica player and *Little Sandy* blues reviewer who had recently formed a rootsy trio with John Koerner and another Minneapolis blues guitarist, Dave Ray.

Dylan addressed Glover as his "best friend in the highest form," apologizing for not being in touch and insisting that he still cared about the old music: "Folk songs showed me the way . . . showed me that songs can say something human." Now, though, "I gotta make my own statement about this day." He was still in the tradition of Guthrie and Seeger, "singin for me an a million other me's that've been forced t'gether by the same feelin," but his world was more complicated than theirs had been. Instead of left and right, black and white, it was "one big rockin rollin COMPLICATED CIRCLE." So he was seeking his own path, trying not to worry "bout the no-talent criticizers and know-nothin philosophizers." That included writing topical material, but also a lot else: the half dozen new compositions he mentioned included "Masters of War" and "With God on My Side," but also "Seven Curses," based on a Balkan legend of horse theft and hanging, and "Boots of Spanish Leather," about a lover sailing off to foreign shores. The political songs were getting the most attention, and he would write a few more—most prominently the title song of his next album, *The Times They Are a-Changin'*—but by the time that record cemented his status as the prince of protest, it was largely documenting his past.

Dylan's choice of subject matter was important to his listeners in this period, and their reactions have colored the views of chroniclers ever since, but in terms of his artistic evolution the shift away from social issues was not all that significant. It is easy to get caught up in the argu-

ments of the time, and some fans were very upset when he stopped writing explicit, *Broadside*-style agitprop, but in retrospect "A Hard Rain's a-Gonna Fall," topical as it may have been, is in a direct stylistic line with "Mr. Tambourine Man" and "Desolation Row." His big shift was not from social consciousness to introspection, but from singing old songs to writing new ones, and from playing at the Gaslight Café to playing the Hollywood Bowl. In the summer of 1963, the most obvious sign of that change was a new musical and romantic partner: Joan Baez.

Dylan and Baez had become close before Newport, but the festival was their debut as a couple, and the relationship fundamentally changed his image and audience. Baez had started as a coffeehouse singer specializing in ancient ballads, and she still came onstage with just her guitar and her lovely voice, but she was also a major star who drew crowds of ten or fifteen thousand adoring listeners. That August she brought Dylan on tour and later recalled, "Dragging my little vagabond out onto the stage was a grand experiment":

> The people who had not heard of Bob were often infuriated and sometimes even booed him when he would interrupt the lilting melodies of the world's most nubile songstress with his tunes of raw images, outrage and humor. I would respond by wagging my finger at the offenders like a schoolmarm, advising them to listen to the words, because this young man was a genius.

In musical terms, the contrast was striking. As Van Ronk put it, "Dylan, whatever he may have done as a writer, was very clearly in the neo-ethnic camp. He did not have a pretty voice, and he did his best to sing like Woody, or at least like somebody from Oklahoma or the rural South, and was always very rough and authentic-sounding." With Baez, "it was all about the beauty of her voice," and it was not just her: virtually all the female folk stars sang in styles influenced by classical bel canto. "Whereas the boys were intentionally roughing up their voices, the girls were trying to sound prettier and prettier, and more and more

virginal . . . and that gave them a kind of crossover appeal to the people who were listening to Belafonte and the older singers, and to the clean-cut college groups."

A central myth of the folk revival is that young, urban, middle-class listeners fell in love with old, rural, working-class music, but as Charles Seeger pointed out, this was always an unstable paradigm: "People, regardless of what stratum they live on, have a desire to make music in the tradition of that stratum. And the music from other strata, well, they'll listen to it sometimes but they don't want much of it." Some folk fans were exceptions to that rule, but they made up the modest crowds at the University of Chicago Folk Festival, not the millions watching *Hootenanny* or most of the tens of thousands at Newport. (Even at the Chicago fest, which concentrated on authentic rural artists, a *Little Sandy* reviewer lamented that, rather than listening to the masters, "a huge assemblage of folkniks" gathered in the basement and "sang their way through the complete Kingston Trio repertoire.")

For the mainstream, Dylan's songs were far more appealing than his way of singing them, and his reputation was largely spread by Baez—who brought him onstage, sang duets with him, and recorded his compositions—and Peter, Paul, and Mary. Some listeners went on to buy his albums and attend his concerts, but one could love the songs without caring about the author. Indeed, one could love them without caring about the folk scene: in the next year, "Blowin' in the Wind" was recorded by more than fifty artists, including Lena Horne, Eddy Arnold, Duke Ellington, Stan Getz, and Marlene Dietrich, and part of its appeal was that it sounded like a lot of music their fans already knew and enjoyed.

The song's political appeal was similar: it expressed a sense of concern and an awareness of injustice, but was not a strident call to arms, and although it was embraced by millions of people who felt the civil rights movement was a noble, historic struggle, most of them were not going to marches or rallies or necessarily cared to spend much time around Negroes. As with the hardcore folk fans who genuinely sought out and appreciated old rural styles, there were white Americans who actively

participated in the struggle and in some cases were jailed, beaten, and killed—but also a far larger, more vaguely supportive group who sympathized but preferred to remain in their own communities and associate with people like themselves.

The more thoughtful members of both movements were aware of such complexities. Van Ronk suggested that singing protest songs "doesn't do a damn thing except disassociate you and your audience from all the evils of the world," and John Cohen argued that topical songs were actually less relevant than old ballads and fiddle tunes, since they "blind young people into believing they are accomplishing something . . . when, in fact, they are doing nothing but going to concerts, record stores, and parties." Even people who believed in the power of political song had moments of doubt. Peter, Paul, and Mary performed at the University of Mississippi in 1962, while James Meredith was struggling to integrate the school, and Mary Travers had the "terrible thought" that the all-white audience singing along with "If I Had a Hammer" was "enchanted by the life and vitality of the song but deliberately oblivious" to its meaning. (In a further irony, *Jet* magazine wrote that the students applauded "without knowing that the trio's bass player is a light-skinned Dutch Negro.")

Even when artists traveled south to sing for civil rights rallies, some found the message ambiguous. Jack Landrón, who as Jackie Washington was the sole African American performer on the early Cambridge scene, went to Mississippi with a Freedom Caravan and recalled that as they sang their songs of social protest, "these black kids were sitting there in the heat, bored shitless."

> What did the people down there need that for? They were singing their asses off! It was the one thing that they had going for them—that got them through the week! They would get together and sing themselves to a fare-thee-well! Who needed Joan Baez or Phil Ochs, or me for that matter? Those people

were being used to make the singers look good. They came
down to 'help the Negro,' but they were helping themselves to
all sorts of publicity as humanitarians and then splitting.

Many southern activists welcomed northern supporters as a source of
strength and inspiration. Julius Lester recalls the "revelation" of seeing
telegrams from student councils at Harvard and Yale: "I was just amazed
that there were white people who cared. . . . It was an experience that the
kind of white people that I knew growing up in the South were not the
only kinds of white people in the world." Barbara Dane told of a woman
at a meeting in Mississippi who followed her performance by announc-
ing, "This lady has come all the way from California, leave her children
behind, come all this way to sing some songs to us. The least we can do is
get up tomorrow morning and register." In a segregated society it meant
something when people crossed racial boundaries. Recalling a trip to
Albany, Georgia, Seeger echoed Landrón's misgivings: "The black people
in Albany had their own music. Why'd they need some Yankee to come
down and sing to them?" But he also described a funny but significant
interchange during his performance: a woman leaned over to Cordell
Reagon of the Freedom Singers and said, "If this is white folks' music,
I don't think much of it," and Reagon responded, "Hush, if we expect
them to understand us, I've got to try to understand them."

Sympathetic songs might not change the world, but they could at least
draw attention to the struggle. When Martin Luther King led the March
on Washington for Jobs and Freedom on August 18, 1963, Dylan and
Baez sang from the steps of the Lincoln Memorial along with Odetta,
Len Chandler, Josh White, Mahalia Jackson, and Peter, Paul, and Mary.
Dylan sang "Only a Pawn in Their Game" and "When the Ship Comes
In," and although the huge crowd applauded his performance, it seems
unlikely that most listeners could hear him clearly enough to follow the
lyrics or cared much about his poetic abstractions. But as Harry Belafonte
pointed out, "We were not there solely to send a message to ourselves."

We were there to communicate something terribly urgent to
the power center of the culture at the time, and that power
center was white. Joan and Bob demonstrated with their par-
ticipation that freedom and justice are universal concerns of
import to responsible people of all colors.

That a couple of twenty-two-year-old folksingers could serve as a
bridge between Martin Luther King and the power center of white Amer-
ican culture was a sign of the times. For Dylan, it was also a sign that his
life was changing in unexpected ways, not all of them pleasant.

In the fall of 1963, two incidents brought that fact home with glaring
clarity. The first was a pair of news profiles that painted him as a fad
and a fraud. The Duluth *News Tribune* headlined its piece "My Son the
Folknik"—a reference to Allen Sherman's *My Son, the Folksinger* album,
which parodied folk favorites in Jewish dialect—and wrote that Bobby
Zimmerman's old acquaintances "chuckle at his back-country twang and
attire and at the imaginative biographies they've been reading about him.
They remember him as a fairly ordinary youth from a respectable family,
perhaps a bit peculiar in his ways, but bearing little resemblance to the
show business character he is today." His parents told the reporter that
Bobby had always written poems, but they were disturbed to see him act-
ing like a hayseed, and his father provided an explanation his young fans
could be expected to find particularly damning: "My son is a corporation
and his public image is strictly an act."

Dylan might have dismissed this as small-town sour grapes, but two
weeks later the story was picked up nationally by *Newsweek* and given
some additional twists. Mocking the "mostly high school and college
students to whom Dylan is practically a religion," the magazine sneered:

He has suffered; he has been hung up, man, without bread,
without a chick, with twisted wires growing inside him. His
audiences share his pain, and seem jealous because they grew
up in conventional homes and conventional schools.

Which was particularly silly, because—ah-hah!—Dylan himself was a nice, conventional boy named Zimmerman, from a home just like theirs. He might claim to have left it behind, saying, "I don't know my parents, they don't know me. I've lost contact with them for years." But—gotcha!—"A few blocks away, in one of New York's motor inns, Mr. and Mrs. Abe Zimmerman of Hibbing, Minn., were looking forward to seeing their son sing at Carnegie Hall. Bobby had paid their way east and had sent them tickets." Not only that: there was a rumor that Dylan had stolen "Blowin' in the Wind" from a New Jersey high school student—which both Dylan and the student denied, but who really knew? And yet the youngsters went on being sincere and deluded: "There's a lot about Bobby I don't understand," Joan Baez was quoted as saying, "but I don't care. I understand his words. That's all that matters."

Of course that wasn't all that mattered, by a long shot. Dylan was upset by the *Newsweek* piece, and it heightened his sense of isolation and paranoia, of being pursued and misconstrued. His friends and supporters were furious; Pete Seeger wrote him a note from Japan saying, "All I could think of was, 'Bastards.' These guys can sure think of more clever ways to crucify a person." But if anyone expected his fans to be shocked by the magazine's revelations, they were sorely disappointed. A huge part of Dylan's appeal was that people like his parents and the *Newsweek* reporters didn't get what he was all about. Oscar Brand pointed out that this was not just a matter of politics and that many older leftists were as out of touch as their peers on the middle and the right: they saw Dylan as "the second coming . . . a link to their own lost youth that validated them and gave them hope for their own resurgence." That was at the heart of all the analogies to Woody Guthrie, and some people were undoubtedly surprised to learn that Dylan was not an authentic proletarian hobo, but even Irwin Silber at *Sing Out!* recognized that, as much as Dylan loved Guthrie, there was a lot of James Dean in him as well—and if that was the relevant analogy, the exposés just cemented his bona fides. He had grown up in the humdrum, conformist world of *Rebel Without a Cause*, and the fact that he had escaped that background and created a new identity was a victory.

To his young admirers, the attacks of their elders just made Dylan seem more precious and relevant. But fans and foes alike were vesting him with powers and meanings he had not chosen and often did not want. He had originally hoped for success as a musician, and more recently as a writer, but he had not signed up to be the spokesman for a generation, and nothing could have prepared him for his role in the culture wars of the 1960s. Previous singers had expressed social concerns, but no one had hailed them as national leaders or studied their lyrics as ideological manifestos. In another two years he would be on the cover of *Esquire* magazine in a montage melding four icons of the student movement, his bushy hair and querying gaze patched together with Fidel Castro's scruffy beard, Malcolm X's piercing glare, and John F. Kennedy's confident smile. What had he done to be in that kind of company?

In 1963, no one would have grouped Kennedy with Fidel and Malcolm as a radical icon—he was a welcome change from Eisenhower, but still a representative of the existing power structure—but in November an assassin's bullet placed him firmly on the side of civil rights and progressive change. Kennedy's assassination is often recalled as a national loss of innocence, the moment when the vague concerns of "Blowin' in the Wind" became stark realities. For activists, though, it fit an all-too-familiar pattern. Phil Ochs's ballad of Medgar Evers, printed in *Broadside* the previous July, had been titled "Too Many Martyrs," emphasizing the long history of lynching and murder, and since then four girls had been killed in a church bombing in Birmingham. Suze Rotolo recalled that she and Dylan were watching Kennedy's motorcade on television when the killing happened, and he was transfixed: "Everyone was." But for a lot of people in their circle the shock was mixed with an understanding of Malcolm X's inflammatory reaction that the assassination was an example of "chickens coming home to roost." Kennedy had made some stirring speeches, and there was hope he might carry through on them, but in terms of direct action his administration had done little to protect civil rights workers or prosecute their attackers and killers. On the same day Martin Luther King proclaimed his dream of equality, John

Lewis of SNCC also spoke, and though the organizers made him soften his remarks, he had planned to demand, "Which side is the federal government on?" A lyric Dylan sang that day presaged Malcolm's comment, warning, "They'll . . . know that it's for real, the hour when the ship comes in."

Baez and Dylan often irritated friends on the left with their unfocused politics, but in social terms they were solidly with the radicals. Richard Fariña wrote that in private they were "far more likely to putter with the harmonies of a rock 'n' roll tune or run through the vital scenes of a recent movie than consider the tactics of civil disobedience or the abhorrence of biological warfare," but he was describing how they processed ideas, not the strength of their feelings:

> Like many another person in his early twenties, they derive a sense of political indignation from the totality of every-day conversations and media that surround them—a process more akin to osmosis than ratiocination. And because of this subjective approach to the problems at hand, metaphor is better suited than directness to their respective dispositions.

While the more activist theoreticians and politicos in Dylan's circle were joining organizations and arguing tactics, his own affiliations were with individuals, real or imagined. That was particularly true when it came to race: during his early New York period he formed friendships with some older blues musicians; dated Delores Dixon, a black, Alabama-born dancer who was a member of the New World Singers; and spent much of his time at the apartment of Mell and Lillian Bailey, an African American couple who fed him and broadened his musical palette with their voluminous record collection. He also played occasional benefits for SNCC and was genuinely concerned with civil rights, but he was uncomfortable with racial or sociological abstractions and when he wrote about current events he tended to personalize the protagonists, whether heroes or villains. He had been thinking, talking, and singing about assassina-

tions since the previous spring and been applauded for his complex reaction to Medgar Evers's murder, "Only a Pawn in Their Game," but while leftist theorizers recognized the song as a poetic illustration of the argument that white southerners were being manipulated by their putative leaders, Dylan was also humanizing and sympathizing with the killer. That was a subtle difference, and as an artist he was expected to create characters and use metaphors—but three weeks after Kennedy's murder he appeared at a dinner for the Emergency Civil Liberties Committee (ECLC) to receive the organization's annual Tom Paine award and found himself in a situation where his usual talents did not serve.

The ECLC was a prominent liberal organization, and most of the attendees were the age of Dylan's parents. They were middle-class grown-ups dressed in proper formal wear, and while their message was resolutely progressive, the medium was little different from a fund-raising dinner for the Metropolitan Opera or the Republican Party. Dylan felt out of place and out of sorts and wanted to leave early, but was told he had to stay and accept the award. So he drank too much wine, and when he got up to speak he said what was on his mind: He appreciated the honor and accepted it on behalf of his friends in SNCC and friends who had traveled to Cuba—but just his friends, not any group, and he had to be specific about that, because "they're all young and it's took me a long time to get young and now I consider myself young. And I'm proud of it. . . . And I only wish that all you people who are sitting out here today or tonight weren't here and I could see all kinds of faces with hair on their head." His listeners looked, he said, like "the people that are governing me and making my rules," and that made him uptight, and he wished they would all just go to the beach.

So far, so good: he had been invited as a voice of youth, and the dinner guests agreed that the older generation had messed things up and were happy to laugh at his jibes. But then it got messy. He started his usual rap about how things had gotten more complicated since Woody's day, but veered off track, complaining that the black people he saw at the March on Washington hadn't looked like his friends because they were

all wearing suits, and "my friends don't have to wear suits . . . to prove that they're respectable Negroes." Then he got to the Kennedy assassination: previous speakers had lamented the killings of Kennedy, Evers, and Moore, but Dylan took his usual tack: "I have to be honest. . . . The man who shot President Kennedy, Lee Oswald, I don't know exactly where— what he thought he was doing, but . . . I saw some of myself in him. I don't think it would have gone—I don't think it could go that far. But I got to stand up and say I saw things that he felt, in me."

It was much like what he had said about Moore's killer, the same identification that had produced one of his most celebrated songs, but this time the audience did not want to hear it, and some shouted their disapproval. Dylan responded, "You can boo, but booing's got nothing to do with it." He had known they would not understand him. As he later explained, "They looked at me like I was an animal. They actually thought I was saying it was a good thing Kennedy had been killed. That's how far out they are. I was talking about Oswald. . . . I'd read a lot of his feelings in the papers, and I knew he was uptight. . . . I saw in him a lot of the times we're all living in."

Dylan was drunk; he was a singer and songwriter, not a speechmaker; and he later penned one of his long poems as a sort of explanation or apology. He wrote that he was sick of generalizations like "We all share the blame," and instead, "I must say 'I' alone an bow my head alone / for it is I alone who is livin my life." But, rambling and ill-considered as his speech may have been, it contained a hard kernel of truth: many young people felt their elders had let them down, regardless of political affiliation. The leaders of the USA and the USSR looked very similar, a bunch of old men in suits arguing about how many megatons of nuclear warheads each would be allowed to build and how to maintain their balance of power. Simplistic as the generational framing might be, to a lot of young Americans the old leaders looked like their parents, and they were intensely aware that their parents were part of the problem, not the solution.

Hence the particular attraction of Cuba. In Dylan's concert record-

ings from the early 1960s, there is often applause when he mentions that country—for example, in the lyrics of "Who Killed Davey Moore"— and Rotolo recalled how fascinated they all were with Castro and Che Guevara, dashing young men in beards and army fatigues who started out as middle-class college students, took to the Sierra Maestra with a small band of friends, won a revolution against a US-backed dictator- ship, and now "were challenging the monoliths of the Cold War, both the United States and the Soviet Union, with their dashing, rebellious thumb-in-your-eye-plague-on-both-your-houses behavior." It was a per- fect revolution for young Americans raised on John Wayne and Marlon Brando movies, who dreamed of creating a new world through thrilling, heroic gestures.

Older leftists who had devoted their lives to building progressive organizations were alternately stirred and horrified by the young rad- icals. They wanted that youthful energy and were very much aware of their own setbacks and failures, but did they really need a twerp like Dylan complaining that the Washington marchers looked too square and empathizing with Lee Harvey Oswald? Maybe they were getting old and weren't as hip as he was, but what was he suggesting as an alternative? Their opponents had most of the money, the bombs, and the machinery of state power, and shaping a better future was going to be a long, hard struggle. Tearing down is easy; building is difficult.

All of which being said, it was not Dylan's idea to be giving a speech to the ECLC or to be the spokesman for a movement or a generation. As he wrote in a six-page, Guthriesque poem-letter to *Broadside* that January, "I am now famous by the rules of public famiousity / it snuck up on me." He didn't know what to make of people wanting his auto- graph—he liked it, sometimes, but it was weird. He didn't know what to make of all the money coming in, wondering whether to feel guilty about it and how to spend it. He was troubled by folk stars agreeing to go on *Hootenanny*, but disturbed at being called a hero for not going on the show, since it was a stupid show and he didn't need it. He was confused—"my mind sometimes runs like a roll of toilet paper / an I

hate like hell t see it unravel an unwind"—and he no longer felt com-
fortable in his ratty Village apartment. Fortunately Columbia had given
him a phonograph and Pete Seeger's new album, *We Shall Overcome*.
Pete sang two of his songs on it, as well as recent compositions by Tom
Paxton and Malvina Reynolds and several freedom songs, but the track
he was listening to "for the billionth time" was the Cuban "Guantana-
mera," with Pete's introduction about José Martí, the poet who lived
in exile and wrote seventy books before being killed in an abortive
uprising. "I believe I'd rather listen t Pete sing Guantanamera than t
own everything there is t own," Dylan wrote. "He is so human I could
cry / he tells me so much / he makes me feel so good . . . yes for me he is
truly a saint / an I love him / perhaps more than I could show." He had
recently received a letter from Seeger, signed with Woody's old saluta-
tion, "Take it easy but take it." He wanted to say the same to the folks
at *Broadside* and assure them he was "with with with you." Meanwhile,
night was closing in, and he would soon be wandering through dreams
"with newsweek magazines burnin an disappointin people smoulderin
and discustin tongues blazin."

By the end of the year *Broadside* and *Sing Out!* would be questioning
Dylan's turn away from explicit protest songs, and because a lot of other
people only discovered him around that time, it was easy for the con-
flicts to be blown out of proportion. Dylan was perplexed by his grow-
ing fame, hurt by *Newsweek*'s gotcha journalism, and unprepared for
situations like the ECLC dinner, and he responded by becoming more
withdrawn and introspective, and more insistent on following his own
direction. But in the spring of 1964 he still thought of the folks at *Little
Sandy* and *Broadside* as compatriots, all of them opposed to the mind-
deadening commercialism of *Hootenanny,* the mainstream press, and the
pop charts, and they felt the same about him. Johnny Cash responded
to Dylan's meditation with his own *Broadside* epistle, expressing soli-
darity and shouting to the world: "Don't bad-mouth him, till you hear
him. . . . He's almost brand new . . . SHUT UP! . . . AND LET HIM
SING!" Some later writers would mischaracterize this as a defense of

Dylan against critics at the newsletter, but Cash was making the opposite point, expressing solidarity with Dylan and *Broadside* simultaneously.

That was a startling thing for a Nashville star to be doing in the early 1960s. There had always been overlaps between folk and country music, and when the Weavers and Burl Ives got pop hits in the 1950s, Nashville stars did their best to follow suit, but in 1964 country music's core audience of white southerners could not have seemed farther from the *Broadside* constituency, and Cash's outreach to that world was proof of his independence. It could also be a savvy commercial choice, if it worked, since folk music was one of the hottest national trends, while country music remained a limited, regional market. Cash had the advantage of being on Columbia and had been reaching out to the folk audience with a series of historical albums: *Songs of Our Soil, Ride This Train,* and *Blood, Sweat and Tears.* None had huge sales, but in 1963 his efforts paid off with appearances on *Hootenanny* and its spin-off movie, *Hootenanny Hoot,* and in January 1964 he topped the country charts and made the pop Top 40 with "Understand Your Man," a rewrite of "Don't Think Twice, It's All Right." He wrote his letter to *Broadside* in March, as he was recording his first explicit protest album, *Bitter Tears: Ballads of the American Indian,* which featured four songs by one of the newsletter's most prolific contributors, Peter LaFarge. And in July he appeared at the Newport Folk Festival.

Cash was as controversial a choice for Newport as Newport was for him. The festival had previously booked artists with pop hits, but they were people like Peter, Paul, and Mary and the Rooftop Singers, who came out of the folk scene. Cash was a country and western star who had begun his recording career as Sun Records' heir to Elvis. He hit the Newport stage on Saturday night with the electric rockabilly jolt of "Big River," and when he played "Rock Island Line" it was patterned on Lonnie Donegan's pop hit, not Lead Belly's original. He followed that song with "Don't Think Twice, It's All Right," introducing it as "a special request from a friend of ours . . . I ain't never been so honored in my life . . . our good friend Bob Dylan. . . . We've been doing it on our

shows all over the country and trying to tell the folks about Bob, that we think he's the best songwriter of the age, since Pete Seeger."

Few people on the folk scene would have equated Seeger and Dylan as songwriters, and it is tempting to explain Cash's encomium as an obeisance to the local deity—or simply as a polite gesture, since Seeger had introduced him that evening. But Cash had been watching the folk boom from outside, and on mainstream radio "Blowin' in the Wind" arrived in the wake of "Where Have All the Flowers Gone" and "If I Had a Hammer." There was also the Columbia connection: Seeger's signing had paved the way for Dylan's and, as it happened, the company's ad in that year's festival program showed Seeger, Dylan, and Cash LPs side by side.

Another notable thing about Cash's comment is that he was "trying to tell folks" about Dylan. Most pop and country listeners got their current music from radio and television and were not reading articles on the folk-protest trend, and in the summer of 1964 Dylan was still largely unknown to them. In a *New Yorker* profile later that year, Nat Hentoff indicated his "accelerating success" by noting that his first three LPs had cumulatively sold almost four hundred thousand copies. By comparison, Cash's *Ring of Fire* LP, released shortly after Dylan's second album, sold about five hundred thousand in its first year, which still didn't come close to what Baez was selling, while Peter, Paul, and Mary were in a different league, regularly putting both albums and singles at the top of the charts.

For Cash, the folk scene represented an inspiration and an opportunity. His latest single was LaFarge's "Ballad of Ira Hayes," a bitter protest poem about a Native American war hero who became an icon at Iwo Jima but was forgotten at home. It was not typical pop or country fare, but he believed in it, and when Columbia failed to push the record, he bought a full-page ad in *Billboard* framed as an open letter to America's deejays, demanding, "Where are your *guts*?" Arguing that listeners were ready for strong material, he gave Newport as a reference:

> You're right! Teenage girls and Beatle record buyers don't want
> to hear this sad story. . . . [But] at the Newport Folk Festival

this month I visited with many, many "folk" singers—Peter, Paul & Mary, Theodore Bikel, Joan Baez, Bob Dylan (to drop a few names) and Pete Seeger. . . . The Ballad of Ira Hayes stole my part of the show. And we all know that the audience (of near 20,000) were not "country" or hillbillies. They were an intelligent cross-section of American youth—and middle age.

Many folk fans had mixed feelings about Cash; his festival bio described a rural childhood "surrounded by hard work and hymn singing with his family," but also mentioned that his first record "sold 100,000 copies in the South alone." That combination was normal for Nashville, but to some folkies it smacked of selling out. Meanwhile, country insiders grumbled that "Cash was jumping on the Dylan folk music bandwagon as a way to make greater inroads into the more lucrative pop world." It was a meeting of two worlds with strong notions of purity and tradition, each wary that the other represented the mainstream that threatened to dilute or co-opt what made them special.

The 1964 Newport Festival exemplified both the triumphs and the dangers of the folk boom. Where the previous year's lineup had included 75 performers over two days and three evenings, in 1964 there were 228 performers crowded into three days and four evening concerts, with a total of over 70,000 paid admissions—the crowd was so large that the city of Newport posted signs on the roads into town requesting that people without tickets stay away. The opening concert on Thursday evening was programmed by Alan Lomax, with 27 acts showing the breadth of traditional styles: the Irish bagpiping of Seamus Ennis; the Texas field hollers of Dock Reese; Glenn Ohrlin's cowboy songs; old-time fiddling by Clayton McMichen; a cappella ballads from Almeda Riddle; blues from Elizabeth Cotton, Jesse Fuller, and John Hurt; bluegrass from the Stanley Brothers; gospel from a white Sacred Harp group and the black Moving Star Hall Singers; and finally a juke dance backed by Muddy Waters playing acoustic delta slide. It was a terrifically varied lineup, but only about 4,500 people showed up to listen, and many were

sailors from the local Navy base who had been given free tickets. For a traditional folk program, that was a large crowd—especially considering the weather, which was chilly and damp—but nothing compared to the 15,000 who crowded Freebody Park on each of the next three nights when stars like Baez, Seeger, Dylan, Judy Collins, and Peter, Paul, and Mary were on the bill. As George Wein recalled, "Never was there so clear a contrast between the 'authentic' folk audience—a small, devoted band of aficionados—and the wider public. We were learning firsthand that the so-called national 'folk boom' had more to do with celebrity than with any deep grassroots interest."

The Newport ideal, as conceived by Wein and the Seegers, involved a tricky bit of jiujitsu: using the weight of the pop scene against itself. Listeners would be attracted by the celebrity folk stars, then discover the power and beauty of authentic traditional music and unknown artists. The *Providence Journal* suggested the limits of that approach when it described Lomax's concert as a "college survey course." Like Charles Seeger's old dream of taking "good music" to the masses, it assumed that those masses did not have their own tastes and would recognize the value of more difficult or esoteric styles if they had the chance. The strategy sometimes worked, but in general the hordes of students at Newport were there as part of their summer vacation, not in search of more course work. Nor were the hardcore traditionalists necessarily pleased when workshop audiences swelled from a few hundred spectators to thousands, especially when many of the newcomers were casual fans hoping to see favorite stars.

Friday started with the Singing Styles workshop, at which performers from various regions and ethnicities demonstrated different ways of singing a familiar spiritual, "You Got to Walk That Lonesome Valley," culminating in a duet by Joan Baez and Mary Travers that transformed it into a freedom song: "You Got to Go Down to Mississippi." A thousand people showed up, far more than were at the simultaneous autoharp and dulcimer workshop with Mike Seeger, Jean Ritchie, and Doc Watson. That afternoon, relatively small contingents gathered to hear successive

guitar and banjo workshops that included Muddy Waters, Robert Pete Williams, the Hawaiian guitarist Noelani Mahoe, and Watson, and then Mike Seeger again with Ralph Stanley, Frank Proffitt, and Elizabeth Cotton. Meanwhile, over two thousand people were watching Mike's half brother Pete host a topical songs workshop, and although it began with older artists from Ireland, Cuba, and the United States, most of the audience was there for the who's who of *Broadside* writers: Len Chandler, Phil Ochs, Tom Paxton, Malvina Reynolds, Hedy West, and Dylan. Dylan sang two new songs, "It Ain't Me, Babe" and "Mr. Tambourine Man," drawing strong applause and getting good reviews from *Broadside* and the *Newport Daily News*—though the biggest crowd-pleaser seems to have been the Chad Mitchell Trio singing "Barry's Boys," a vaudevillian satire of the young right-wingers supporting Goldwater in the upcoming presidential election. This workshop was followed by a second topical session hosted by Guy Carawan and featuring a new group of Freedom Singers up from the South to demonstrate the latest rallying songs of the struggle, but although Seeger, Chandler, Travers, and Theodore Bikel stuck around to sing along, some people clearly regarded this as old news, and at least one reporter took the changeover as a signal to head to the banjo workshop.

Not everybody could get off work and go to a festival on a weekday, and the first big crowd turned up on Friday evening. By most accounts it was the largest concert audience in Newport's history, estimated at over fifteen thousand people, and it cheered for young artists including Baez, Ochs, and the Mitchell Trio, as well as giving warm welcomes to Doc Watson and his family and to Sleepy John Estes, who led a rowdy Tennessee blues trio and proved he was up-to-date by reworking an old country dance as "Sleepy John's Twist." Still, the press was unanimous that the evening's high point was Baez, whom the *Boston Globe* called "the glamour girl of the folk world," and in particular her closing duet with Dylan of "It Ain't Me, Babe," which was followed by the two of them leading the crowd in "We Shall Overcome."

Given the hundreds of performers and thousands of listeners at the

festival, it is absurd to suggest there was anything resembling a single shared mood or experience. Blues fans still recall that year with awe: John Hurt was back, and newcomers included Robert Pete Williams, the most deeply African-sounding guitarist in the blues idiom; Fred McDowell, one of the greatest Mississippi slide players; Estes with Yank Rachell on mandolin and Hammie Nixon on harmonica and jug; Muddy Waters playing a solo acoustic set as a stand-in for his old mentor Son House and dueting with pianist Otis Spann; plus Elizabeth Cotton, the Texas singer Dock Reese, Reverend Robert Wilkins connecting blues to the gospel tradition, Joe Patterson playing homemade pan pipes, and—with no notice in the festival program, because he had been found only a month earlier in a Mississippi hospital—the legendary Skip James, whose eerie falsetto and minor-keyed guitar style remain for many listeners the most profound blues on record.

Samuel Charters, who had sparked the search for vanished blues legends with his book *The Country Blues*, recalled that Newport was not only a treat for listeners but also a unique meeting place for the musicians: "For some of them it was the first time since they were young men that they had realized that they weren't alone in their efforts to keep their older styles alive." Most of the older bluesmen were lodged in a single house, and the music continued around the clock:

> Sometimes in the morning it was Robert Pete Williams sitting on the edge of a cot in one of the downstairs rooms playing for himself as he looked out of the window at Newport's gray mist. Upstairs Hammie Nixon would be playing one of his harmonicas while Yank Rachell fiddled with the strings on his mandolin. If some music started in one of the rooms usually after a minute or so John Hurt would appear at the door and stand listening. . . . In the late afternoon after the blues workshop it was Skip James playing for a quiet group sitting on the floor and the cots around him.

Old-time fiddlers, banjo players, and ballad singers were similarly pleased to meet counterparts from other regions, and young urban revivalists are still playing tunes learned or recorded that weekend and treasure magical moments like the Friday workshop when Doc Watson met the young flatpicking virtuoso Clarence White for the first time and the two performed a series of sparkling duets.

Newport was taking its mission seriously, providing an unprecedented showplace for traditional styles. In the previous year, the Newport Foundation had also been laying groundwork for the future, funding folklore research and performances around the country. Guy Carawan had used a Newport grant to start local festivals on Johns Island, South Carolina, and brought the Moving Star Hall Singers with him to show the result. This was the "Freedom Summer," when hundreds of northern college students traveled to Mississippi to help register voters, and the *Boston Globe* found it newsworthy that at Newport "many whites from the Deep South are living in the same house, riding on the bus and appearing on the stage with Negroes. Eavesdropping everywhere, we have not heard a racial slur in either direction."

The *Globe* was also impressed by the amount of do-it-yourself music on the festival's fringes: "Under virtually every tree from the Cliff Walk Manor to Bellevue Av., a distance of nearly a mile, the amateur folk enthusiasts were picking guitars and singing songs. And each one had his own private audience of 25 or 30." A *Broadside* correspondent wrote that "the most beautiful sight during the Festival" was the beach at night, where "thousands of candles lit up the guitar players and beer drinkers." As a folk scene insider, the correspondent also wrote about a Friday night party for performers and friends at which Baez and Travers danced the twist.

The weekend provided infinite small, personal memories for amateurs and professionals alike. Tony Glover was there with his Minneapolis blues trio and took the opportunity to reconnect with Dylan, spending an afternoon at the Viking Hotel trading harmonies on old songs by Hank Williams and new ones from the first Rolling Stones LP, which had appeared less than two months earlier. He also recalled a late-night party

with Dylan, Baez, Johnny Cash, June Carter, Ramblin' Jack Elliott, and the multi-instrumentalist Sandy Bull: Dylan and Cash sat on the floor trading songs, Baez set up a portable tape recorder, and Dylan taped two songs for Cash, "It Ain't Me, Babe" and "Mama, You've Been on My Mind," for which Cash reciprocated by giving Dylan a guitar. It was the first time they had sung together, and Cash remembered it as the highlight of the festival. He had arrived a day late for his scheduled Friday appearances, almost blowing the gig, and was in the depths of his amphetamine addiction—Glover described him as "gaunt and twitchy, but real as hell"—and he later wrote, "I don't have many memories of that event, but I do remember June and me and Bob and Joan Baez in my hotel room, so happy to meet each other that we were jumping on the bed like kids." Three months later, his record of "It Ain't Me, Babe," with June singing harmony and the Nashville harmonica virtuoso Charlie McCoy playing down in emulation of Dylan's style, became the first Dylan song to hit *Billboard*'s Hot 100 chart with drums and pop instrumentation.

That was another side of Newport: folk music had become big business, and impromptu jam sessions could lead to important transactions. Glover recalled the "strange mixture of friendliness and posturing, of camaraderie and backbiting":

> That was my first glimpse of real big-time wheeling and dealing. Executives and booking agents were negotiating and hustling like berserk windmills. . . . Grown men snarled at each other, shook hands, grinned and bickered, while the musicians stood by and watched as they were bartered like sides of beef. But what the hell, we were just in it for the music.

Seeger's original concept was working up to a point: if some newcomers appreciated the festival's traditional aspect more than others, all were getting a taste of authentic rural music, and most liked at least some of it, and in any case they were there and had paid for the broadest assemblage of folk artists ever gathered at an American festival. But the folk scene

was changing, and that weekend revealed growing fissures. Peter Yarrow
had lobbied for a couple of workshops that would showcase new artists
who were neither pop-folk stars nor rural traditionalists, and he hosted
a Sunday afternoon New Folks concert including *Broadside* writers Tom
Paxton and Len Chandler along with Buffy Sainte-Marie, Koerner, Ray
and Glover, the Jim Kweskin Jug Band, a twenty-one-year-old blues
singer named Judy Roderick, and the eighteen-year-old José Feliciano,
who stole the show with a flamenco-flavored "La Bamba" and a one-man
imitation of a Dixieland band.

The problem, as Paul Nelson pointed out in a lengthy diatribe for the
Little Sandy Review, was that these young urbanites suited the tastes of
the Newport audience better than the rural tradition bearers did:

> Old men with banjos aren't the kind of Saturday's heroes the
> young generation understands very well; they may be tolerated
> because Pete Seeger says to love them and they are on the same
> stage with Joan Baez and Bob Dylan but they can't expect to
> be understood. They are quaint and lovable, like old teddy
> bears with lines on their faces, but when they sing, they sound
> funny, and they just sit there most of the time anyway.

Some young revivalists were eager to bridge that divide, joining their
elders at workshops and urging their fans to pay attention to the old
masters. Baez was out early on Friday morning for the Singing Styles
showcase, showed up at the Freedom Songs program that afternoon, and
was up again at ten Saturday morning to sing a Portuguese song at the
International Songs workshop with artists from Ireland, Israel, Sudan,
Hawaii, and Cuba, then back in the afternoon with Seeger, Yarrow,
Jean Ritchie, Bessie Jones, and two groups of folk dancers for a work-
shop of Play Party and Children's Songs. But she was an exception and,
though only twenty-three, already represented an older generation. The
folk scene had previously been divided between traditionalists and pop-
ularizers, both inspired by Seeger's aesthetic—old ballads and ringing

banjos—but an increasingly influential third group was appearing that had few connections to rural traditions even as a source of material.

Seeger's vision for *Broadside* had been to provide a forum for new songs that people could mix with their older folk repertoire, not to spawn a new style, much less a new genre. The idea was to keep the tradition in touch with current events, as Woody had done in the 1940s and the Freedom Singers were doing down south. That had been his mission for three decades, and it had been working fine. He sang old British ballads, played Appalachian banjo tunes, and wrote new songs like "Where Have All the Flowers Gone." Most people called all of that folk music, but others did not, and he was inclined to agree: "If someone asks me if [my compositions] are folksongs I can only say no, because I borrow not only from older folk music but from many other sources such as pop and classical music." But, he would add, "The best of the new songs will be remembered, and passed from singer to singer, gaining improvements and additions. And a century from now some folklorist can come along and call them folksongs if he wants. Our dust will not object."

To Seeger, folk music was defined by its relationship to communities and traditions: it was what nonprofessionals played in their homes or workplaces for their own amusement and the songs and music they handed down through that process to later generations. That did not mean it was better than the music of Beethoven or Gershwin, but it was different, and a big part of the difference was that it was shared, that no one owned or controlled it. He copyrighted his compositions and even some of his arrangements of traditional songs, but only reluctantly and often directing the money to appropriate causes, and he expected other people to adapt and rework them in turn—when Trini Lopez changed the tune of "If I Had a Hammer" and got a rock 'n' roll hit, Seeger's reaction was to note that the two melodies harmonized, adding, "Now, isn't that a good moral for the world?" In any case, no one had paid much attention through the 1940s and 1950s, because no one was getting rich off his kind of music.

That changed in the 1960s for multiple reasons. One was the new LP

format: "Goodnight Irene" had sold a lot of records, but only earned royalties for that one song and whatever was on the flip side of the 78. By contrast, if the Kingston Trio sold a million copies each of several albums and copyrighted all the arrangements, they could collect royalties on dozens of titles and buy houses with swimming pools. Even then, they could only control the rights and collect royalties for their own versions of "Tom Dooley" and "Sloop John B"—not for everyone else's. That was one of the reasons folk music had never been really big business—a record or artist might do well for a while, but it was not like owning the rights to "Summertime" or "Stardust." When Peter, Paul, and Mary hit, singing original compositions by Seeger, Dylan, and themselves, that was a whole new commercial ballgame, not only for the writers and singers but for the publishers and managers.

At first the *Broadside* writers did not tend to notice this change, since they were not thinking in commercial terms—if Dylan had been out for hits and royalties in 1962, he would not have been writing "Blowin' in the Wind" or "Masters of War." Buffy Sainte-Marie often repeated the story of singing "Universal Soldier" at the Gaslight Café and being complimented by a nice man who offered to help her by publishing the song, wrote a contract on a paper napkin, paid her a dollar, and acquired 50 percent of the fortune it made when it became an international hit—but most topical songs did not become international or even local hits. Seeger, Dylan, Ochs, Paxton, Sainte-Marie, and Malvina Reynolds had written songs because they felt an inner urge, wanted to express an opinion, or needed a lyric that fit a particular situation. Now, there was a new wave of performers who were writing songs because they wanted to be like Seeger, Dylan, Ochs, and the others—some from professional ambitions, some just because they admired those artists. That wave included a lot of kids who had started out singing "Barbara Allen" or playing "Old Joe Clark," but by 1964 it also included people whose connection to folk traditions went no further back than "Where Have all the Flowers Gone" and "Blowin' in the Wind," and they continued in that style, which was eventually dubbed "singer-songwriter." In the 1960s it was still called

"folk music," but, unlike Seeger, Dylan, and Baez, artists like Ochs could not fit into an old-time string band or blues workshop even if they wanted to, because they did not know those styles, nor were they necessarily writing songs that everybody could sing in chorus around a campfire or on a candlelit beach.

Seeger was excited about the new songwriters, and his recent albums featured their compositions, but at Newport he tended to focus on traditional songs and instrumental styles rather than topical material. For him that was the point of the festival, and in 1964 he was in particularly strong form. He had spent the previous year touring the world as an ambassador of American folk music, and it had been a welcome change from the years of political battles. He had picked up new songs, widened his experimentations with foreign styles, and gained new confidence: in the past he had rarely sung a cappella, but his mainstage concert on Sunday evening included two unaccompanied songs from the British Isles, the bawdy "Maids, When You're Young, Never Wed an Old Man" and Matt McGinn's lament of a manure shoveler whose trade has been wiped out by the automobile, "Manyura Manyah." Fifteen thousand voices gleefully joined in the chorus of "manuuuur-ah, manuuur-ah," though a couple of reviewers took him to task for the earthiness of the subject matter—indeed, it was treated as more controversial than any of the weekend's antiracist or antiwar songs, which were expected and passed without comment.

Dylan also played that evening, and his set suggested that he was moving in the opposite direction, trying to create unique, modern music and making no attempt to fit with the rest of the program. He was obviously having a good time, kidding with the audience and toying with his phrasing in a playful, almost flippant manner. Robert Shelton was so annoyed by this behavior that he did not mention Dylan's set in his *New York Times* review, instead focusing on Odetta's final sing-along of "We Shall Overcome," which demonstrated "the social commitment of folk music blended with its esthetic core in a triumphant conclusion."

The Sunday evening lineup was particularly strong: its first half

included the Stanley Brothers, Skip James, Hedy West, the Clancy Brothers, and Pete Seeger, and the second had the Staple Singers, the Kentucky Colonels, Mississippi John Hurt, the Freedom Singers, Dylan, Dave Van Ronk's short-lived Ragtime Jug Stompers, and Odetta. All but Dylan were playing music obviously steeped in folk traditions—Pop Staples's electric guitar notwithstanding—and he seemed happy to be the odd man out. He opened with "All I Really Want to Do," which Shelton would commend in retrospect as a witty "anti-love" lyric, but his old booster was increasingly disappointed as he continued with "To Ramona," "Mr. Tambourine Man," "Chimes of Freedom" and the obligatory duet with Baez on "With God on Our Side," writing that "the longer he stayed on, the sloppier his performance became. . . . As he tuned between numbers, Dylan sometimes staggered," and on the whole he looked stoned and "out of control."

Shelton's feelings were apparently shared by a few other listeners, but judging by what survives on film, this was more a matter of their mood than Dylan's performance—he looks giddily cheerful and possibly high, but also in full control and excellent voice, and he had no trouble maintaining his focus through the seven and a half minutes of "Chimes of Freedom." Most of the reviews were adulatory, the *Providence Journal* writing that he was "wonderful," showing "that strange magic which all the great ones project," and made "his imitators look like high school boys." The *Newport Daily News* was pleased to find him "appearing better dressed than he did last year," and wrote that he "obviously is the voice of the youth of America as well as of the oppressed, and is the champion of the little man. . . . Despite his long curly hair, his untidy appearance and scrawny frame, there is an aura of greatness about him," and noted that his set provided an ideal lead-in for Odetta's "majestic . . . magnificent" finale. In the *Little Sandy Review*, Paul Nelson likewise expressed pleasure in his set, though for exactly the opposite reason, dismissing Odetta as a "painful self-parody" and her finale as a "ghastly burlesque," while commending Dylan for casting off "the emotional crutch of the do-gooder" and choosing "to show

off his more personal, introspective songs rather than shoot the obvious fish in the barrel"—though adding that his fans were not ready for this change and "numbly brought him back for only two encores, instead of the usual seven or eight."

On film the crowd seems anything but numb, shouting down an increasingly harried Peter Yarrow as he begs them to let Van Ronk and Odetta take their turns. "We want more!" they chant as he pleads, "It's impossible . . . it's just impossible." Finally Dylan bounds onstage, beaming and apparently on top of the world. "Time!" he shouts happily, waving his arms: "It's all like a matter of time, they say—" He hops off-mike and shrugs theatrically, his smile only getting broader. Then, bouncing back on tiptoes: "Thank you! I want to say thank you—I love you." He is indeed dressed more neatly than in the past, in a black turtleneck jersey and suede jacket, tight jeans, and pointy cowboy boots. His hair has grown down over his collar and up to form a bushy nimbus around his head. He no longer looks like a gaunt Okie bard; he looks like a cheery Beatle.

Chapter 7
JINGLE-JANGLE MORNING

HOW MANY TIMES
DO I HAVE t
REPEAT that
I Am Not A folksinger
before people
stop saying
"He's Not A folksinger."

In May 1964 Dylan scribbled the seven-line query on the back of a sheet of stationery from London's Mayfair Hotel. On the other side was an early draft of "It Ain't Me, Babe," and the combination suggests a message to his adoring fans. They were looking for a hero, someone who could open each and every door, who would die for them and more, but, "no, no, no" it wasn't him. He had walked that road for a while, but now was on another trip, ready to joust with the local yobs who had taken the world by storm with their cheery "Yeah, yeah, yeah."

"What a drag it must have been," Marianne Faithfull mused. "Out there all by himself with an acoustic guitar, just moaning away. Especially in England, where all the musicians he was meeting were in *groups*. . . . The Animals, Manfred Mann, the Bluesbreakers, the Pretty Things, the Beatles, the Stones. All that boys-club stuff that makes life fun."

The England trip was a couple of months before the Newport Festi-
val, and Dylan seems to have been thinking along the same lines. Back
in February he had made a stab at his own boys' club, heading off on a
road trip with the singer and song collector Paul Clayton, a chess-playing
buddy named Victor Maymudes, and a friend of Suze's, Pete Karman.
They drove across the country, holding their car to the white line in Ker-
ouac's holy road, from New York to New Orleans, then west to San Fran-
cisco. It was a journey fraught with legend and nostalgia: The first stop
was Harlan County, Kentucky, to deliver donated clothing to the families
of striking coal miners. They dropped by Carl Sandburg's home in North
Carolina, Bob hoping to talk with him poet to poet, but the old man was
unfamiliar with his work and simply polite. In Atlanta they visited with
Bernice and Cordell Reagon of the Freedom Singers, and as they drove
on to Meridian, Mississippi, hometown of Jimmie Rodgers, Dylan wrote
"Chimes of Freedom." Arriving in New Orleans for Mardi Gras, amid the
swirling costumes and street bands, he began writing "Mr. Tambourine
Man." From there they headed northwest to Denver, where he looked up
old friends and made a side trip to Central City, then on out to the coast.

The scenery was classic Americana, but the soundtrack was filled with
surprises. The Beatles appeared on *The Ed Sullivan Show* as Bob and the
boys drove through Mississippi, and by the time they crossed the Rock-
ies the band had five songs on *Billboard*'s Hot 100 chart, with "I Want
to Hold Your Hand" firmly at number one. It was an infectious, poppy
record with no fancy orchestras or horns, just a basic four-piece rock 'n'
roll band with electric guitars front and center, and yet there was some-
thing about it that was completely new: in Dylan's recollection, "Their
chords were outrageous, just outrageous, and their harmonies made it all
valid." It was tight, upbeat, interesting, and fun—and right in the middle
there was a moment when all the singers shouted, "I get high! I get high! I
get high!" Those were the days when dopers talked to each other in code,
and Bob and his buddies were solid initiates, so they were thrilled to
hear these merry limeys sneaking a hidden kick into a teen-pop chart hit.
It was not until August, when Dylan met the Beatles in New York and

suggested getting stoned together, that they explained they were actually singing "I can't hide!"

Dopers or not, the Beatles were a breath of fresh air, a guitar band like Buddy Holly and the Crickets, and they were all over the radio. It was not just them, either. They were leading a pack of English rockers, and opening a door for some Americans who also had pretty wild ideas. That February's hits included Tommy Tucker singing "Hi-Heel Sneakers," a snaky, guitar-driven blues that advised a girl to go out in a red dress, wig hat, and the aforementioned footwear, adding, "You better wear some boxing gloves, in case some fool might want to fight." Johnny Cash was singing "Understand Your Man," his rewrite of "Don't Think Twice"—Dylan could hardly get annoyed, since his song was a rewrite of Clayton's "Who's Gonna Buy You Ribbons," and they both must have wigged when Cash's song hit the Top 40. Soon Chuck Berry would be there as well, for the first time since the 1950s, with a masterpiece of intricate word-play and propulsive rhyming called "Nadine." A lot of great music was coming back in style, and new connections were being made. Thanks to her gig opening for the Beatles on their first US tour, Jackie DeShannon was on *American Bandstand* singing Holly's "Oh Boy," while a cover of her earlier single "Needles and Pins" was hitting big for an English guitar band, the Searchers. And she was a major Dylan fan: a legit country rocker from Kentucky who had dismissed the folk revival as wimpy and fake, she recalled stopping through New York in 1963 and being told she had to hear "'this great blues singer and songwriter . . .' We went to his concert and this kid came out in Levis and boots and he did a thing called 'Don't Think Twice' and 'With God on Our Side.' . . . I just flipped." So, along with cutting singles and writing hits for British Invasion bands, DeShannon recorded a folk LP with four Dylan compositions.

Musical worlds were converging, and although Dylan was still locked in the folk category, his songs were keeping more varied company. As he flew back east in March, the Beatles had the two top spots on the *Billboard* album chart, and right behind them was Peter, Paul, and Mary's *In the Wind*, featuring his title song and easing down from a month at

number one. His own *Times They Are a-Changin'* was edging its way up toward number twenty, and *Freewheelin'* was drifting down from number twenty-two. He was not selling in the PP&M or Baez range, but sales weren't everything. He was hipper than they were, which would count for a lot in the next few years, and they were singing his words. Soon he would reach an audience they had barely imagined—especially in England, where he headed in May to play the Royal Festival Hall and do a round of interviews.

The English and American musical landscapes had always over-lapped, but in the early 1960s they were also very different. For one thing, England was much smaller and poorer, and was still recovering from the war, and America looked very big and rich and exciting by comparison. For a lot of young Brits, American music was a shining beacon, and not just the music their American contemporaries considered hip or current; styles that in the United States were considered regional, ethnic, or archaic were heard in the UK as part of a thrilling continuum. Back in the 1950s Lonnie Donegan played Lead Belly and Woody Guthrie songs on guitar between sets as the banjo player for Chris Barber's trad jazz band, and when his "Rock Island Line" took off, Britain broke out in a rash of skiffle bands that backed acoustic guitars with drums and played a mix of New Orleans jazz, hillbilly songs, blues, and rock 'n' roll. Muddy Waters came to England at Barber's invitation and shocked some trad fans with the earsplitting volume of his electric Chicago blues, but others ran out and bought electric guitars, learned his songs, and mixed them with numbers by his young Chess labelmates Chuck Berry and Bo Diddley.

There were musical purists in England as well, but the boundaries were drawn differently. Keith Richards recalled jamming with other students in the men's lavatory at Sidcup Art School and described the core repertoire as "basically folk music, Jack Elliott stuff," flatpicking Woody Guthrie songs and fingerpicking "Cocaine Blues," but his own showpiece was "I'm Left, You're Right, She's Gone," from Elvis's Sun sessions. Some of his mates teased him for being a pop fan: "I still liked Elvis at the time, and Buddy Holly, and they didn't understand how I

could possibly be an art student and be into blues and jazz and have anything to do with that." Nonetheless:

> It reflected that incredible explosion of music, of music as style, of love of Americana. I would raid the public library for books about America. There were people who liked folk music, modern jazz, trad jazz, people who liked bluesy stuff, so you're hearing prototype soul. All those influences were there.

That included some current teen pop, but it had to be the right stuff, groups like the Ronettes and the Crystals: "We'd hear a record and go, That's wrong. That's faking. *That's* real. It was either that's the shit or that isn't the shit, no matter what kind of music you were talking about. . . . There was a very definite line."

Soon Richards and some pals were sitting in on blues night at the Ealing Jazz Club, and by the time Dylan arrived in May 1964, they had formed the Rolling Stones and were on the charts on both sides of the Atlantic with "Not Fade Away." To someone with Dylan's background, that was a fascinating record, because Buddy Holly's original had been a rockabilly revamp of Bo Diddley's gritty Mississippi rhythm workouts and, rather than mimicking Holly's sound, the Stones took it back to its roots with distorted guitar, pounding drums, maracas, and wailing harmonica, doing their best to sound like they were coming out of the Delta or the South Side of Chicago. They were long-haired pop stars, but also dedicated neo-ethnics, as immersed in authentic roots styles as the hardcore Village folk crowd, and far more purist than the Weavers or Peter, Paul, and Mary. In the United States the Stones were marketed as part of the British Invasion, grottier counterparts to the Beatles, but in musical terms they were a different proposition, not just because they had different tastes but because they were a lot rawer: their chords were simpler, their arrangements looser, Mick Jagger was a whining, nasal singer and Brian Jones was a rudimentary harmonica player, much as Dylan had been three years earlier.

Another record on the English charts that May sounded even more familiar: the words were "Baby, Let Me Take You Home" instead of "Baby, Let Me Follow You Down," but it was the same song, complete with the line "I'll do anything in this God-almighty world," copped from Dylan's version. But this was a rock 'n' roll single with loud electric organ by a hot new group called the Animals, who shortly followed with another song off the *Bob Dylan* LP, "House of the Rising Sun," and got a number one hit on both sides of the Atlantic.

Dylan was impressed by the Beatles, but they were impeccably tight, and their songwriting owed more to Tin Pan Alley and the Brill Building than to blues or folk traditions. He was not going to sound like them, any more than he was going to sound like the Kingston Trio or Peter, Paul, and Mary. By contrast, the bluesier, rootsier English bands were playing the same music he had played before he got into songwriting, and they inspired a lot of American musicians in a quite different way: homegrown rockers who recognized the Beatles as brilliant innovators heard the Stones playing R & B covers and said, "Shit, that's a hit? I can play better than that." Dylan had an added click of recognition, since the English blues-rockers were playing songs off his records and shortly began to write lyrics that mimicked his style.

Dylan was still on another trip, playing moody acoustic songs and releasing complex, long-playing albums, not rocking pop singles. But his world was changing. Maria Muldaur recalled that when she visited him backstage after his show at the Santa Monica Civic Auditorium that February, they were trapped in the dressing room by a crowd of screaming fans, then went to a Hollywood party where "these beautiful women in gorgeous cashmere outfits, young women, were all saying, 'I'll follow you anywhere, Bob.' " London was still relatively low-key, but he sold out the Royal Festival Hall and got a telegram from John Lennon at intermission explaining that the Beatles were busy making a film and were sorry they couldn't make it. In Paris he hung out with Hugues Aufray, who was translating his songs into French; drank good wines; ate in nice restaurants; and had a fling with Nico, the German fashion model and singer

who would later join the Velvet Underground. From there he went to Berlin, then on to Greece with Nico in tow. He was writing more than ever, the images getting more imaginative, the themes more intimate.

Back in New York, Dylan recorded his next album in one nightlong session. Most of the songs were slow, the melodies lilting and pretty, the lyrics introspective and consciously poetic, the themes by turns romantic and bitter. There were a couple of revamped talking blues, the surreally paranoiac "Motorpsycho Nitemare," and another variant of "I Shall Be Free," but where in the past he had emphasized his distance from what was on the radio—"Rockaday Johnny" singing "ooh-wah, ooh-wah"—he now joked about his hi-heeled sneakers and wig hat. He also played one track on piano, the jerkily rocking "Black Crow Blues," complete with a Jerry Lee Lewis glissando and thumping boogie bassline.

A month and a half later he was in Newport, showcasing his new compositions and sharper wardrobe. The clothes might seem a petty detail, but everyone noticed them. It was a period when clothing was particularly connected to cultural affinities and divides, and every article on Dylan or Baez highlighted their odd dress and the way their fans mimicked their choices. Many reminiscences of the period are equally fashion conscious. Some suggest that truly hip characters didn't care what they wore, and that was what made it distinctive: "We created a culture where clothing was unimportant," Paul Rothchild recalled. "You could have two pairs of jeans, you could have three shirts, one pair of boots, four pairs of underpants and that was it. Literally. A belt was your option." Sometimes they suggest acute consciousness, as when Suze Rotolo recalls Dylan "in front of the mirror trying on one wrinkled article of clothing after another, until it all came together to look as if Bob had just gotten up and thrown something on." She was writing about their earliest days together, when newspapers described him as looking like "a Holden Caulfield who got lost in the Dust Bowl," but although she says that "image meant everything," she does not mean they were faking it: "Folk music was taking hold of a generation and it was important to get it right, including the look—be authentic, be cool,

and have something to say. . . . We believed we could change percep-
tions and politics and the social order of things."

It is easy to mock the Bohemians who cared about looking careless in
just the right way and the self-proclaimed nonconformists who dressed
like one another. But both the care and the carelessness could be genuine:
Dylan was a performer, and his apparently offhand dress went with his
apparently offhand singing and playing. He was establishing new criteria
and inspired a lot of people to pick up guitars and try to sing, despite
limited skills and little interest in perfecting them, and to dress in jeans
and whatever shirt happened to be relatively clean that morning, and to
write about all the crazy ideas running through their heads. Like Seeger
and Baez, he was using unusual skills to create a heightened version of
something approachable and shared. Paul Stookey recalled the shock of
seeing him walk onstage at Town Hall in street clothes, with his guitar
newly strung and the string ends flopping madly. "It was the real thing,"
Stookey said, and although he understood the theatrical aspect of Dylan's
stage persona, he meant it. It was so different from Peter, Paul, and Mary
in their suits and dresses, singing perfect harmonies. Unlike them, unlike
the Kingston Trio, unlike Elvis or Duke Ellington or Hank Williams or
Leopold Stokowski, Dylan and Seeger and Baez all walked onstage look-
ing the same way they looked when they were walking down the street
or hanging out with their friends—a conscious and striking departure
not only from previous stage wear but from the suits, makeup, and neatly
coifed hair that were still the norm for much of their audience.

At the 1964 Newport Folk Festival, Dylan was still dressing Bohe-
mian, but his hair was longer, his jacket and boots were nicer, and he
looked cool rather than scruffy. The black turtleneck was not working-
class wear; it was off the cover of *Meet the Beatles,* a European look
favored by poets, painters, and cool British rockers. The cover of *Another
Side of Bob Dylan* added a distinctive touch of homegrown hip, his left
leg cocked to display the denim gussets Suze sewed into the ankles of his
jeans so they could fit over his cowboy boots.

That album came out in early August, the same week the Animals'

"House of the Rising Sun" hit the US charts and *A Hard Day's Night* opened in New York movie theaters. A couple of weeks later the Beatles themselves were in town, and Dylan dropped by their hotel room. There is some disagreement about whether he gave them their first taste of marijuana, but they certainly got stoned together, and the world's most popular band welcomed him not only as a fellow trendsetter but as a model of lyrical artistry and an inspiration. Lennon would explain that he wrote "A Hard Day's Night" in Dylan's style, though, he said, "Later we Beatle-fied it," and they had just recorded an even more Dylanesque composition, "I'm a Loser," complete with wheezily dissonant harmonica. Their fans might be ignorant of the influence, but they were spreading the word: England's *New Musical Express* published an article in January headlined, "Beatles Say—Dylan Shows the Way," in which George Harrison explained, "I like his whole attitude . . . the way he dresses, the way he doesn't give a damn. The way he sings discords and plays discords. The way he sends up everything ." He added, "We met Joan Baez as well, in Denver. She's good, too—a sort of female Dylan as far as the words of her songs go, but more polished."

The folksingers and rock 'n' rollers had a lot to offer each other. The Beatles were originally marketed as peppy popsters—they were cute and loveable, and the girls screamed and swooned as previous generations had for Sinatra and Elvis. Their answers in press conferences were unusually clever, but when their movie came out, the *New York Times* review typified adult reactions: "This is going to surprise you—it may knock you right out of your chair," Bosley Crowther wrote, calling the movie "a whale of a comedy" and adding, "I wouldn't believe it either, if I hadn't seen it with my own astonished eyes." In the *Village Voice*, Andrew Sarris was equally startled, though more knowing, citing "the brilliant crystallization of such diverse cultural particles as the pop movie, rock 'n' roll, cinema-verite, the nouvelle vague," and comparing it favorably to *Tom Jones* and *Lord of the Flies*. "The Beatles are a sly bunch of anti-Establishment anarchists," he concluded, "but they are too slick to tip their hands to the authorities."

They were also too slick for most serious music listeners. "There must be a lot of staunch folk fans who like Dylan but who don't like the Beatles," Harrison admitted, adding that the fact that Dylan liked them "knocks us out." Compared to Dylan—or to Baez, Seeger, or any serious, adult musician—a lot of people dismissed the Beatles as commercial kid stuff. When they began attracting positive notice from intellectuals, that was a major shift not only for the band but for the future of rock and pop, and for folk fans it was a shift that spelled danger. Robert Shelton sounded the tocsin in the November issue of *Hootenanny* magazine (an aspirationally mass-market periodical unrelated to the TV show). He granted there was "something of merit in the *music* of The Beatles . . . a certain funky, bluesy quality," but reminded readers of recent history: "The Kingston Trio came along at a time when the sort of music that The Beatles have now revived had absolutely glutted the market. The meaningless gyrations of the first rock 'n' roll craze had taken the genuine country blues sense Elvis Presley brought out of Memphis and distorted it beyond recognition." Yes, the Beatles were decent musicians, and yes, the Kingston Trio played slick pop-folk, but compare "the two worlds represented by 'I Want to Hold Your Hand' and 'Tom Dooley' . . . the difference between a time-steeped ballad of an actual episode and a souped-up, over-engineered love song." Whatever their faults, the Trio had the fortitude to join the *Hootenanny* boycott; their latest album, *Time to Think*, displayed their growing social consciousness; and their fans did not signal enthusiasm by throwing jelly beans like the screaming Beatlemaniacs. Of course they were not in a class with Dylan, Baez, and Seeger, but the folk boom they had initiated was an important musical and cultural development, and, Shelton concluded, "If The Beatles end it, we'll all be the losers."

One could argue that Shelton was stuck in an archaic mindset and by November 1964 it was silly to contrast folk as adult, intelligent, and socially conscious with rock as dumb adolescent music for dating and dancing. He was right that the Beatles and their followers were a threat to the pop-folk trend—whatever their faults, the rocking Dave Clark Five

were clearly more exciting than the folky Brothers Four, and the record charts confirmed that audiences were deserting one and flocking to the other—but there was no way the Kingston Trio were more intelligent than the Beatles, no matter how many Appalachian ballads they sang, and when the Animals took "House of the Rising Sun" to number one, you couldn't even argue that the Trio's repertoire was more time-steeped and authentic. Rootsy, blues-oriented groups like the Stones and Animals were a threat to some folksingers but an inspiration for others. As Dylan told an interviewer in 1965, "Folk music is still here, if you want to dig it. It's not that it's going in or out. It's all the soft mellow shit, man, that's just being replaced by something that people know there is now."

Shelton was right that the pop-folk trend had led some listeners to deeper, more serious styles and encouraged millions of young people to make their own music and go beyond the commercial products of the hit parade. Dylan himself was an example, someone who had traveled via Harry Belafonte and Odetta to Pete Seeger, Jack Elliott, Woody Guthrie, and Robert Johnson, and found his own new voice in the process. Even *Hootenanny* had presented people like Johnny Cash, Maybelle Carter, and the New Lost City Ramblers, as well as some racially mixed groups and songs about civil rights, social justice, and the evils of war. The Beatles might be the most exciting white rockers since Elvis, but the pop machine had turned Elvis into a Hollywood kewpie doll whose latest Top 10 hit was "Bossa Nova Baby," and the closest the Beatles got to social content was "[Money] Can't Buy Me Love"—which, if you bought their albums, was countered by "Money (That's What I Want)."

By the same token, though, the British invaders were leading young listeners to Chuck Berry, Little Richard, and in some cases on to Muddy Waters and Howlin' Wolf—in May 1965 the Rolling Stones said they would only go on the popular teen music show *Shindig* if Wolf was also presented, providing the Chicago legend with the largest audience of his career. Even if one considered the Beatles lightweight, they were pointing in the right direction: a writer to *Sing Out!* described how he had "shuddered for years" as the magazine damned the commercial folk groups

by likening them to rock 'n' rollers, since it was ridiculous to compare "machine-washed pablum" like the pop-folkies to "highly emotional, rhythmic music." Now he was amused to find Izzy Young writing nice things about the Beatles, "but I suppose that if young folkniks can be converted by the Kingston Trio, he can be converted by their counterparts in rock-n-roll."

The idea that the English rockers were steering white Americans to authentic African American traditions would become a commonplace of rock history, but very few people were making that case in 1964 or 1965, and certainly not at Newport, where Muddy Waters and John Lee Hooker were familiar faces. The common equation was still that folk music was mature and handmade, while rock was adolescent and plastic. Marianne Faithfull started as a coffeehouse ballad singer and recalled that among British Bohemians, as among their US counterparts, rock was for squares and herd followers. "Jazz was hip and blues were hip, but rock 'n' roll was thought to be very slick and commercial. Rock 'n' roll at that time meant Billy Fury and guys with bleached blond hair." When she began recording, Faithfull was marketed as a Brit Baez, complete with virginal imagery: her first record, "As Tears Go By," was an obvious attempt at the mournful girl folk style—"My riches can't buy everything / I want to watch the children sing"—and her press bio described her as a seventeen-year-old convent girl with "a shy smile and a liking for people who are 'long-haired and socially conscious.'" Her next single was "Blowin' in the Wind," backed with "House of the Rising Sun."

The complicated thing about the British scene was that Faithfull's song was not written by a coffeehouse folksinger or even by a commercial songwriter counterfeiting the coffeehouse style—it was by Mick Jagger and Keith Richards, and they were simultaneously rockers and Bohemians. When Faithfull eventually hooked up with Jagger in a more intimate way, they went to his room and discussed Roman Polanski, "disturbed states of mind," and Dylan, then took a walk in the park, where she quizzed him about King Arthur and the Holy Grail. "It *was* quite ludicrous," she recalls, "but that's how we were then. You would ask your

date, 'Do you know Genet? Have you read *À rebours*?' And if he said yes, you fucked him."

That evening started backstage at a pop concert where Jagger was getting tips from Tina Turner on how to dance the sideways pony, but it was still a long way from either Elvis or the Kingston Trio. Much as Baez loved to dance and might have enjoyed a lesson in the pony, there was no setting in the United States where she would have been likely to intersect with Turner, nor did American rock stars discuss Polanski and Genet, and while some might think Dylan's songs were interesting, they did not regard him with awe. In Britain, by contrast, "Dylan was, at that moment in time, nothing less than the hippest person on earth." In Faithfull's memory, "The zeitgeist streamed through him like electricity. He was my Existential hero, the gangling Rimbaud of rock . . . wearing Phil Spector shades and an aureole of hair and seething irony."

By that time it was May 1965, and Dylan was back in the UK with a rocking electric single, "Subterranean Homesick Blues." In the year since his previous visit, he had been simultaneously pursuing two paths: On the one hand, he was writing longer, more complicated songs. In October he gave a concert at New York's Philharmonic Hall that included "Talkin' John Birch," "Who Killed Davey Moore," and a four-song segment with Baez, but also the new "Gates of Eden" and "It's Alright, Ma," clocking in, respectively, at over seven and almost nine minutes. He realized how long that was, even for an audience eager to hear angry symbolist poetry, and separated the masterpieces with a funny new seduction song, "If You Gotta Go, Go Now." As at Newport, he was passionate and poetic but also giddily cheerful, and the crowd was with him all the way—at one point, after several requests for his older songs, someone yelled, "Mary Had a Little Lamb!" and he responded, "God, did I record that?" Then: "Is that a protest song?" The fans laughed, whooped, and applauded.

Meanwhile, Dylan's producer was thinking about the Beatles, Stones, and Animals. Tom Wilson was a black, Harvard-educated jazz fan who had recorded Sun Ra and Cecil Taylor on his own label before joining

Columbia. He had taken over from John Hammond near the end of the *Freewheelin'* sessions, and although he had a low opinion of folksingers, he was immediately impressed by the message of Dylan's lyrics and especially his blues, which "were raw, different from other whites, original." He recalled telling Albert Grossman, "If you put some background to this, you might have a white Ray Charles with a message." It took a while to make that leap, but in December of 1964 Wilson overdubbed electric accompaniment on Dylan's old "House of the Rising Sun" and a couple of other songs. None was good enough to release, but he made his point, and when they went back into the studio in January, Dylan was backed by an electric band.

In some ways the band was an organic evolution. The bass player was Bill Lee, a veteran folk sideman and Newport regular, and the lead guitarist was Bruce Langhorne, who had played guitar and fiddle to Dylan's harmonica on the Carolyn Hester album four years earlier and electric lead on Dylan's "Mixed-Up Confusion" rockabilly sessions in 1962. Langhorne had picked up electric guitar thanks to another Washington Square regular, Sandy Bull, who started on old-time banjo but blew everyone's mind in 1963 by recording an album with Billy Higgins, the drummer from Ornette Coleman's quartet, which ranged from a banjo fantasy on *Carmina Burana* to a ten-minute electric improvisation in the style of Pop Staples. Langhorne recalled that for the new Dylan session he borrowed Bull's twin reverb amp and basically "played the same sort of lines that I would play with somebody like Odetta, who would provide the same sort of thing that Dylan provided . . . a really inevitable rhythmic structure." Some of his leads were more rock-oriented than that comment suggests, but they were similar to what he had played on Dylan's old single and also on a couple of tracks for Richard and Mimi Fariña's first album, *Celebrations for a Grey Day*, recorded in September 1964—which were presumably familiar to Dylan, since Mimi was Joan Baez's younger sister and they had all been hanging out together.

Folk and rock were converging more and more frequently, in a vari-

ety of ways and settings: in July an English band called the Fairies had released a single of "Don't Think Twice, It's Alright" with the usual wheezing harmonica but also a ferocious electric guitar solo by Jimmy Page, and the Rolling Stones hit with "It's All Over Now," on which Jagger nasally sneered about his baby, who used to "run around . . . playing her high-class game," but "the table's turned and now it's her turn to cry"—a rough equivalent of the story and style Dylan would shortly use for "Like a Rolling Stone." By 1965 the Stones were recording "Play with Fire," another song mocking a high-class woman who has come down to the singer's level, but this time with a folky melody and fingerstyle acoustic guitar. And that summer they were at number one on both sides of the Atlantic with "Satisfaction," an ode to alienation with ultra-Dylanesque lyrics: "When I'm watching my TV and a man comes on to tell me how white my shirts can be / Well he can't be a man 'cause he doesn't smoke the same cigarettes as me." Jagger recalled Dylan telling Keith Richards, "I could have written 'Satisfaction' but you couldn't have written 'Tambourine Man,'" and when the interviewer seemed shocked, he added, "That was just funny. It was great. . . . It's true."

Meanwhile a separate convergence between folk and rock was taking shape in Los Angeles. Ritchie Valens anticipated the trend in 1958 with "La Bamba," turning a Mexican folk song into a rocking dance hit, and the Beach Boys kept the guitar-band sound alive, retooling Chuck Berry's style as the sound of California beach culture, so when the folk boom arrived there were plenty of people ready to jump on the trend. Trini Lopez jumped hardest, putting his Bamba-inflected "If I Had a Hammer" in the Top 10 in the summer of 1963 and recording a string of albums that mixed rock 'n' roll, country, and Latin covers with songs by Lead Belly, Woody Guthrie, and eventually Dylan. At the Whisky à Go Go on the Sunset Strip, Johnny Rivers took a more blues-oriented approach, but likewise recorded with a small live band and his own electric guitar and put Chuck Berry's "Memphis" and Lead Belly's "Midnight Special" on the charts. By the summer of 1964 *Billboard* spotted a "folk-rock" trend, noting that Vee Jay records was using that

term to promote Hoyt Axton's new album and that the main LA pop-folk venue, the Troubadour, was sponsoring a new group called the Men that backed its banjos, guitars, and mandolins with rock 'n' roll drums. This inspired instant imitation back east, where New York's Café au Go-Go formed a mix-and-match group called the Au Go-Go Singers on the same model, adding electric guitar on a couple of songs courtesy of a young member named Stephen Stills. Jerry Yester, a veteran of the New Christy Minstrels and the Modern Folk Quartet who went on to play with numerous folk-rock bands, recalled the influence as direct and definitive: "The Beatles killed folk music on the *Ed Sullivan Show*. As soon as that happened, it was like a big arrow pointing in their direction."

For people like Stills and Yester, who had grown up with rock 'n' roll, following that arrow felt completely natural. The Weavers had invented the pop-folk style by combining tight vocal harmonies with the catchy rhythms of the big band era, and Lonnie Donegan, Jimmie Rodgers, and the Highwaymen had all mixed folk material with somewhat rocking instrumentation. In England the Springfields, Seekers, and Searchers backed pop-folk arrangements with drums and sometimes with electric guitars, making that sound an integral part of the British Invasion, and in retrospect it seems inevitable that a group of pop-folkies eventually got together at the Troubadour and decided to form a Beatles-style band. Gene Clark had been in the New Christy Minstrels, David Crosby in Les Baxter's Balladeers (Baxter was a mood-music impresario cashing in on the *Hootenanny* trend), and Roger McGuinn had played guitar and banjo for the Limeliters and the Chad Mitchell Trio and arranged numerous folk albums—including Judy Collins's third LP, which featured his arrangements of Seeger's "Bells of Rhymney" and "Turn, Turn, Turn." The new group started as a blatant Brit-pastiche called the Beefeaters, but their producer, Jim Dickson, had a hipper idea: "Jim suggested to us that we try something really out of left field and do a Bob Dylan song," Clark recalled. "Something a little more intellectual, something a little more poetic." They renamed themselves the Byrds—a coyly Dylanesque

orthography—and with folk vocal harmonies, McGuinn's twelve-string electric guitar, and backing by some top LA session players, recorded a Beatlefied reimagining of "Mr. Tambourine Man" that reached number one in June 1965, followed by an album with three more Dylan songs and one of Seeger's.

The Byrds' sound was a logical fusion of the Beatles and Peter, Paul, and Mary, and from the point of view of mainstream pop prognosticators it made the same sense as Chubby Checker recording a calypso twist. Hardcore folk fans were equally quick to make that connection, with a different implication: these people weren't innovators, they were opportunists. In 1963 they had button-down shirts and banjos; now they had collar-length hair and electric guitars. When a Greenwich Village folk group called the Kingsmen went electric early in 1965, they acknowledged this attitude by renaming themselves the Sellouts, which was funny for a moment, but what if it worked? Folk music and everything it represented were in danger of being swamped by a wave of dance bands with pretty vocal harmonies and lyrics somewhat more intelligent than "She loves you, yeah, yeah, yeah." The problem was not simply electricity; it was a broader confluence of conflicts: pop music versus roots music, commercial confections versus communal creations, escapism versus social involvement.

A standard trope of rock history is that the Beatles were welcomed by Americans as a zesty antidote to the national depression following the Kennedy assassination, and that formulation captures exactly what troubled a lot of people on the folk scene. Pete Seeger had suggested a very different antidote: "If you would like to get out of a pessimistic mood yourself, I've got one sure remedy for you: go help those people down in Birmingham, in Mississippi or Alabama." That was in 1963, and hundreds of young northerners took his advice the following year, heading south for "Freedom Summer," but the killings of Goodman, Schwerner, and Chaney made the journey feel a lot less optimistic. In February 1965 Malcolm X was killed. In March, Viola Liuzzo, a white northerner helping King's marchers, was fatally shot in Alabama. Universal brotherhood still felt like a wonderful ideal, well worth fighting for, but achieving it

was going to be a long, bitter struggle, not just a matter of linking arms and singing "We Shall Overcome."

For people committed to that struggle—especially people who had been committed since the 1940s and knew exactly how tough it could be—it was obvious why a lot of white youngsters would rather imagine themselves in swinging London than in murderous Mississippi, and more important than ever for the music of involvement to counteract the music of escape. The idea that the Beatles were "anti-Establishment anarchists" was a charming intellectual conceit, but in terms of its politics *A Hard Day's Night* was just a cheerier version of *Rebel Without a Cause*. Growing your hair, dancing to rock 'n' roll, and mocking your elders was obviously more fun than sulking, grumbling, and driving off a cliff, but in the early 1960s a generation had seemed to recognize that rebellion with a cause and a goal was more rewarding than rebellion for its own sake. Folk music had been part of that shift, bringing people together, providing them with a shared message, and reminding them that the good fight could also be a source of satisfaction and even fun. When things got tough, songs were supposed to keep the young rebels focused and united, not encourage them to wander off into the jingle-jangle morning and disappear in the smoke-rings of their minds.

Of course drugs were part of it. When Gene Clark heard Dylan's demo of "Mr. Tambourine Man," his reaction was, "Man, what a trippy song this is!" and the Byrds' musical arrangement emphasized that trippiness. Most of their early listeners were not hip, but it was music for smoking marijuana, dropping acid, freeing your mind, expanding your consciousness. In Paul Rothchild's words, the new drugs were "one of the big separators of us from them. And 'them' was not just our parents anymore, but our parents and our generation who were like our parents. The world separated at that point." Most of the drugs had been around for a while—my father smoked marijuana with a group of medical students in 1933, taking careful notes on their revelations—but the elevation of drug use into a drug culture, and the equation of that culture with youth, music, and social change, was something new.

The fissures of the mid-1960s were multifarious and multivalent—
generational, chemical, political, musical, and, of course, racial—and
they did not open along clear, consistent lines. Toward the end of 1964,
Irwin Silber in *Sing Out!* and Paul Wolfe in *Broadside* both took Dylan
to task for his recent lyrical, musical, and social choices: Silber suggested
he was getting wrapped up in "the paraphernalia of fame," and his new
songs were "innerprobing, self-conscious—maybe even a little maudlin
or a little cruel." Wolfe suggested Dylan would soon be concentrating his
energies on novels and films and hailed Phil Ochs as a more active, com-
mitted songwriter, while wondering if Ochs likewise would succumb to
"the pressures, the lures, the rewards and the egotism attached to being a
celebrity." Both were quickly followed by fellow folkies begging to differ
or agreeing. As one writer to *Sing Out!* put it:

> Afta years a searchin' aroun' for people who'd write an' sing
> an' play topical songs, ya finally got your guy—Dylan. An'
> what happens? He strays away from the line, starts gettin' per-
> sonal, an' all of a sudden, you're jumpin' on his back. I dig the
> People, but what about the Person. So he doesn't write about
> hard rain all the time. So what? Who does?

Ochs, who loved the Beatles and aspired to Dylan's level of success,
was particularly irritated at being appointed the anti-Dylan, telling the
Village Voice, "There's nothing noble about what I'm doing. I'm writ-
ing to make money. I write about Cuba and Mississippi out of an inner
need for expression, not to change the world." In a letter to *Broadside*
he added that if anyone wanted to argue for the importance of politi-
cal music, they should focus on Guy Carawan, "who not only writes
songs, but devotes his full time to the civil rights movement in the South,
actively working in a real struggle, promoting workshops on how to use
music in the movement, and getting his banjo broken over his head on a
picket line."

To the extent the argument was genuinely about topical songs, Dylan

provided an apt response in an interview that spring, suggesting the issue was as much a matter of fashion as of political commitment:

> I'd rather listen to Jimmy Reed or Howlin' Wolf, man, or the Beatles, or Françoise Hardy, than I would listen to any protest song singers. . . . Just because someone mentions the word "bomb," I'm not going to go "Aaiee!" and start clapping. . . . There are a lot of people afraid of the bomb, right. But there are a lot of other people who're afraid to be seen carrying a *Modern Screen* magazine down the street, you know. Lot of people afraid to admit that they like Marlon Brando movies.

What was roiling the folk scene, though, was not really a dispute over song lyrics. Seeger had encouraged young writers of topical material, but also writers of love songs and kids' songs, and people who played traditional styles, and people who just wanted to get together with friends and sing whatever music they happened to enjoy, and although he recorded plenty of protest songs, they represented only a small fraction of his repertoire. Joan Baez had recorded barely five topical songs in as many albums. Many of the older performers at the Newport Folk Festival were not even aware of the protest song movement. Nor was it primarily about amplification: most performers at Newport were still playing acoustic instruments, but that was partly a matter of logistics and partly a matter of showcasing rural traditions. No one was arguing that Baez was a more legitimate folk artist than an electrified John Lee Hooker or the Staple Singers.

The core issue was that over the last few years a vital, meaningful folk music movement had been growing, however you defined it: there were more new blues singers, more ballad singers, more bluegrass and old-time country bands, more topical songwriters, more collegiate folk groups, more authentic tradition bearers being discovered in rural backwaters, and more work for all those artists, live and on records, for an ever-growing audience served by increasing numbers of coffeehouses,

clubs, concerts, and festivals, as well as more amateurs making music for themselves and each other. A few big record companies had gotten involved; a few singers had become stars; a few club owners, publishers, agents, and managers had made a lot of cash; but folk music overall remained a grass-roots movement, and even when it was co-opted and mass-marketed, virtually everyone associated it with a sense of social consciousness, solidarity with the oppressed and the working classes, and at least an attempt to escape from mass-market consumerism. It was music for people who cared, and music they cared about.

Now a flock of eagerly commercial, apolitical young Brits had arrived wearing matching suits and playing rock 'n' roll, and the whole thing was threatening to fall apart. Careerist folkies were picking up electric guitars and trying to sound like the Beatles; millions of fans seemed ready to follow them down that rabbit hole; and Dylan, the folk poet and standard bearer for committed, meaningful music, was turning his head and pretending he just didn't see—or, worse yet, was cynically latching onto the trend. In March, he and Baez did a joint tour of the Northeast, and she was troubled by the change in his attitude: "The kids were calling out for him to do the songs that meant something to them, like 'Masters of War' and 'With God on Our Side,' " she remembered. "He didn't care. They were reaching out to him, and he didn't care. He just wanted to rock and roll." Dylan described the tour as enjoyable and continued to speak well of Baez, but he basically agreed, saying, "The only thing that dragged me when I played with her was that the audience was just such a morgue. It was like playing in a funeral parlor."

Dylan was hardly abandoning serious music for pop fluff. His new album came out at the end of March, and it had some hard-rocking electric tracks, but also "It's Alright, Ma (I'm Only Bleeding)," a seven-and-a-half-minute acoustic diatribe with aphorisms like "Money doesn't talk, it swears" and the charged warning "Even the president of the United States sometimes must have to stand naked." The cover photo showed him in the lap of luxury, wearing a tailored suit jacket and framed by a Grecian mantelpiece, accompanied by a chilly socialite, stroking a Per-

sian cat—but the LPs scattered around the room suggested his musical tastes were still solid: Eric Von Schmidt, Robert Johnson, Lotte Lenya singing Bertolt Brecht. On the mantelpiece was Lord Buckley, the hip monologuist whose routines he had memorized and performed at the Gaslight. The only current record was *Keep on Pushing,* which provided potent proof that the folk scene had no corner on relevance: Curtis Mayfield and the Impressions were creating music that not only supported the black freedom movement but came out of the movement and spoke its language: "I've got to keep on pushing, I can't stop now / Move up a little higher, some way, somehow." The lyric could also be heard as a rebuke to Dylan's critics: "I've got my strength, and it don't make sense not to keep on pushing."

Dylan was not abandoning his past; he was becoming part of a bigger conversation. Sam Cooke, the gospel singer turned R & B star, was so struck by "Blowin' in the Wind" that he wrote his own paean to social struggle, "A Change Is Gonna Come," and it was on the radio that spring in the wake of his death. The Mississippi blues-soul singer Little Milton had the biggest hit of his career in March with a socially conscious lyric, "We're Gonna Make It." Around the same time Solomon Burke, the King of Rock and Soul, went into the Atlantic studio and cut a version of "Maggie's Farm," and anyone who thought Dylan's lyrics were no longer political should have listened to Burke growling, "The sheriff and the National Guard stand around his door / I ain't gonna work on Maggie's farm no more!"

Burke's record was an obscure B-side in the United States, but in the United Kingdom it was promoted as a single, and CBS rushed out Dylan's version to compete. Back home, "Subterranean Homesick Blues" began climbing the charts in April, its rocking rhythm and Chuck Berry–style vocal making it the first Dylan record to get pop radio play. The British Invasion was wiping some US artists off the charts, but others were taking advantage of the new trend by putting out records that reached back to the same roots styles the Brits were digging. The week Dylan's single hit the Hot 100, two Texas rockers also made their chart debuts, the Sir

Douglas Quintet with "She's About A Mover" and Sam the Sham and the Pharaohs with "Wooly Bully," both rollicking records with slangy lyrics and raw electric organ riffs, which rushed past him to the Top 20, the latter going all the way to number two. Dylan's record only made it to number 39, but in the UK it reached the Top 10—though, once again, the story is a bit more complicated: he was set to tour Britain that spring, and Donovan had emerged as a local challenger to the folk throne, so Columbia pressed "The Times They Are a-Changin' " as a single, and it went to number nine and stayed on the charts for eleven weeks, two more than his rock effort.

By Dylan's own definition, he had ceased to be a folksinger when he stopped singing old songs. What was changing now was his audience, his circle of acquaintances, and his instrumentation—and he saw those changes as additions, not subtractions. On the British tour he was still performing solo, still opening with "The Times They Are a-Changin' " and singing "The Lonesome Death of Hattie Carroll" as passionately as any of his recent compositions. In his London hotel room, he was still swapping songs with local folksingers and harmonizing with Baez on Hank Williams numbers. When some young fans complained that his new rock hit didn't sound like him, he was gracious and friendly, and responded in teenage terms: "My friends were playing with me on it. I have to give some work to my friends. You don't mind that, do you?" To an interviewer a few months later, he would explain his choice a bit differently: "It just didn't sound right by myself. I tried the piano, the harpsichord. I tried it as a blues. I tried it on pipe organ, the kazoo. But it fit right in with the band." Both replies were facetious but had elements of truth. He was experimenting, taking advantage of new options, and going back to the music of his high school days with some newer, heavier friends. In London he spent an evening trying to cut a track with local blues players John Mayall, Eric Clapton, and John McVie, and he was also enjoying the adulation of the rock aristocracy. Faithfull recalled an evening when the Animals and Rolling Stones gathered in his hotel room, "serious bad boys come to pay their respects and sit meekly on

the couch as the mad dauphin came in and out talking of Apocalypse and Pensacola." The Beatles showed up as well, and Dylan struck up a particular friendship with John Lennon, further dazzling the British music establishment.

Back in January Lennon had said he couldn't see Dylan "becoming the kids' new craze," that they might "grow to like his stuff, but there can't really be Dylan-mania." A few months later, a film crew was following Dylan around London, and although he could still walk down the street without attracting much attention, he was mobbed by screaming teens after each show à la *Hard Day's Night*. Like it or not, he was becoming a pop star, though it was hard to figure out what kind. Columbia's promotion of "Subterranean Homesick Blues" was a perfect example: the sleeve for his single reproduced the *Melody Maker* story in which the Beatles hailed him for "showing the way," but when the company bought a full-page *Billboard* ad they paired it with records by Barbra Streisand and Andy Williams—admittedly the label's only other recent chart entries, but very different company from Seeger, Johnny Cash, or the Fab Four.

One might argue that Streisand herself was an anomaly, a mainstream pop singer but also a product of the Village scene, a year younger than Dylan and signed by Columbia through her agent's connection with the Clancy Brothers. As album sales overtook singles in the early 1960s, the record business began finding room for all sorts of performers who did not fit obvious marketing categories, and some overlapped in surprising ways. That was how Cash ended up at Columbia, and how Ray Charles became a superstar singing country music. It was a time when Nina Simone could bridge opera and jazz, have her "Mississippi Goddamn" published in *Broadside,* and find the Animals covering her "Don't Let Me Be Misunderstood" as their follow-up to "House of the Rising Sun." Dylan's Beatle connection and British success provided Columbia with one obvious hook, and in June the company adopted a slogan that connected his album title to transatlantic pop trends: "Dylan is 'Bringing It All Back Home.' "

By then the album was in the Top 10, behind Elvis and the Beach Boys but ahead of current releases from Peter, Paul, and Mary, the Rolling

Stones, and the Beatles—and although the Beatles and Stones discs had both been higher, PP&M would never again equal his sales. The Stones' "Satisfaction" entered the singles chart on June 12, its lyrics an obvious bow to his influence, and *Billboard* had his picture on the front page accompanied by an article announcing folk-rock as the hot new sound and ad copy hailing him as the artist who "turned the tide and reversed the English wave." Three days later he was back at Columbia's Studio A working on the single that would make him a rock 'n' roll star.

As before, Tom Wilson assembled most of the band, bringing in a crew of studio regulars, but Dylan added a vital ingredient: Mike Bloomfield had grown up in Chicago and immersed himself in the electric blues scene on the city's South and West Sides. Two years younger than Dylan, he was a blazing guitar virtuoso and had sought Dylan out in 1963 after hearing the *Bob Dylan* album touted as a blues release and dismissing it as "terrible." He recalled, "I wanted to meet him, cut him, get up there and blow him off the stage. . . . But to my surprise he was enchanting. . . . I thought Jack Elliott was the best single guy, for just a man with a guitar, for getting over [and] winning you. But Bob got over better than anyone I'd ever seen."

They jammed after the gig and hit it off, and when Dylan decided it was time to cut a serious rock 'n' roll single, he called Bloomfield and brought him to New York. Bloomfield was initially puzzled: "I figured he wanted blues, string bending, because that's what I do," but instead, "He said, 'I don't want any of that B. B. King shit, man.' He had heard records by the Byrds that knocked him out. He wanted me to play like McGuinn." Bloomfield had not paid much attention to recent rock, and the song Dylan wanted to work on was unlike anything he had expected. Nonetheless they experimented for a couple of days and eventually, Bloomfield recalled, "I played the way that he dug and he said it was groovy."

The song was "Like a Rolling Stone," and though the version Dylan took into the studio on June 15 was a moody, seven-minute waltz, the next day they shifted to a 4/4 rock beat and, with the addition of Al Kooper on organ, cut the definitive version. Kooper's contribution was a

happy accident—he had hoped to play guitar, but switched instruments after hearing Bloomfield and came up with a simple, infectious riff that immediately caught Dylan's attention. It was a loose, disorganized session, subject to chance and the moment, and the resulting record bore no resemblance to the Byrds' meticulous arrangements and mellow harmonies. Dylan's voice was harsh and biting, the lyrics were a contemptuous snarl, the band was raw and closer to the Rolling Stones than to anything that had been labeled folk-rock. At the same time, it was a complex surrealist poem that ran over six minutes, and Columbia's marketing people assumed deejays would refuse to play the whole thing, so the first promo pressings split it to fit two sides of a 45-rpm single. To the marketers' surprise some deejays began playing both sides and splicing them back together, Columbia realized its error, and the official release on July 20 was the longest 45 ever—though to avoid scaring nervous programmers, the time was listed on the label as 5:59.

Some folk fans accused Dylan of selling out to pop trends, but while the Byrds had softened and shortened "Mr. Tambourine Man," "Like a Rolling Stone" was as rebelliously uncompromising as any of his earlier work. He wanted a hit, but he wanted it on his own terms and, despite his instructions to Bloomfield, his new approach drew directly on his earlier blues style. Though they were not released until many years later, the first two songs he cut at the "Rolling Stone" sessions were a fast raw sixteen-bar blues called "Phantom Engineer," with Bloomfield bending strings like crazy and Dylan wailing on harmonica, and "Sitting on a Barbed Wire Fence," a loping twelve-bar blues with an organ riff copped from the Sir Douglas Quintet's "She's About a Mover."

It was not folk music in the Seeger tradition, but it was what would come to be known as "roots music," and Dylan was far from the only person moving in that direction. The day after the "Rolling Stone" session, four blocks north of Studio A, the first New York Folk Festival opened at Carnegie Hall with a concert titled "The Evolution of Funk," programmed by Dave Van Ronk and including Son House, Mississippi John Hurt, Eric Von Schmidt, Mose Allison, Muddy Waters with a full electric

band, and, at the top of the bill, Chuck Berry. "It was not the customary sound of banjos or ballads," Robert Shelton wrote in the *Times*. "Rather, keeping right in touch with the music that has much of the world's youth on the go, or go-go, the festival began with 'big beat' music." Van Ronk explained that he was bringing the model of "From Spirituals to Swing" up to date, showing the deep roots of current pop music: "I want to avoid the Newport Festival blues image of old men and little boys croaking at each other." *Sing Out!* applauded this move, writing, "With Chuck Berry's participation . . . the concept of folk music in the modern world suddenly took on another whole dimension," and only complaining that "a totally inadequate sound system did not allow for a full appreciation of the incredible vitality of . . . his music."

The New York festival was sponsored by *Cavalier,* a *Playboy* knockoff that was trying to connect with the college audience, and the magazine helped publicize the event by sending Carolyn Hester and Bill Monroe's Bluegrass Boys through Greenwich Village in a horse-drawn hay wagon and printing a glossy, twelve-page handout summing up the year in folk: "The topical-song movement gathered strength while 'hootenanny' faded, the ethnic-pop gap narrowed while the 'Beatles backlash' hit, the festivals grew while folk remained a close second to pop in the nation's musical diet."

Though unsigned, this summation was once again the work of Robert Shelton and led into a four-page profile of the twenty-four-year-old singer he had hailed in the *Times* four years earlier, "Bob Dylan: The Charisma Kid." Shelton had recently accompanied the "genius poet" to hear Paul Butterfield's blues band at the Village Gate, and wrote that Bob seemed more confident and happy than in the old days, saying, "I'm lucky. . . . Not because I make a lot of bread. But because I can be around groovy people. I don't have to fear anything and nobody around me has to fear anything. That's where it's at: bread, freedom and no fear." The article noted that Dylan had earned almost a million dollars, was contracted to write two books, was working on a play, and was considering movie offers. "I'm in the show business now," he said. "I'm not in the folk-music business. That's where it's at. So is Roscoe Holcomb, Jean Ritchie, Little

Orphan Annie, Dick Tracy, all the way up to President Johnson." His
success had made him the focus of "jealousy, envy, and partisanship,"
but, far from being defensive, Shelton wrote,

> He almost invites animosity as if he knows he is right and can't
> expect a fair break from anything that resembles authority or
> the Establishment. . . . The charisma kid is just going to keep
> going his own way, no matter what anyone says about him or
> his songs. He'll just keep ramblin' and tumblin' down the road,
> looking for his own compass points before he tries to lead any-
> one else down his paths.

The image of Dylan as a rebel iconoclast still worked, but it was get-
ting harder to depict him as a folksy hobo. The first week of July, Cher
and the Byrds hit the charts with dueling versions of his "All I Really
Want to Do," and a week later Sonny and Cher came out with a hyper-
poppy Dylan imitation, "I Got You Babe." The mainstream was flowing
his way, and rock and R & B were increasingly showing his influence,
while simultaneously digging back to folk-roots sources. Johnny Rivers
was in the Top 10 with "Seventh Son," a Chicago blues by Willie Dixon
that drew on southern hoodoo, and Sam the Sham was working the
same territory with "Ju Ju Hand," singing about "an alligator claw and
some goofer dust." James Brown was announcing the rise of funk with
a twelve-bar blues called "Papa's Got a Brand New Bag." There was still
plenty of schlock—along with "Satisfaction," the Top 5 included "I'm
Henry VIII, I Am," "What's New Pussycat?" and "Cara Mia"—but pop
music was entering a new age, and from the harsh whine of his voice to
the bitter brilliance of his lyrics and the blues-rooted thrust of his electric
band, Dylan was blazing the trail.

"For those who take folk music seriously, Dylan is the most important
new writer since Woody Guthrie," Shelton wrote yet again, but now he
had to add a postscript acknowledging the rest of the world: "For those
who don't, Dylan is more important than the folk revival."

ELECTRICITY IN THE AIR

The stage is now set for Newport 1965, and we all know how that story ends: Dylan in his black leather jacket with his Stratocaster, blasting his new electric music at an audience split between fervent young believers and uncomprehending old folkies. So let us start with an epitaph written by a pair of dedicated folk fans who were there and who, on the heels of that earthshaking concert, "jotted down a few impressionistic notes" about what they had just seen:

> From all parts of the United States they had come in cars and trucks, motorcycles and on foot. During the hot dusty afternoons they participated in as many of the twenty-eight workshops as they could or cared to, or gathered spontaneously in the shade to exchange songs; in four days they attended six concerts, one in a downpour; and many of them slept in cars, tents, sleeping bags, in open fields—wherever the police allowed them. And on this last night, led by Pete Seeger, they had just sung rousing versions of freedom songs with a most impressive ensemble of some of folkdom's most renowned performers. Their silence now, no doubt, was due in great part to genuine inspiration, reverence perhaps; in part to euphoric exhaustion.

As they wound their way down the dimly lit hillside toward their cars, cycles, and the road, one was reminded of similar groups in history immediate and distant, other "holy barbarians," other "pilgrims of the absolute." With their beards, long hair, and sandals, they might have been early Christians emerging from the catacombs. A young man stood on the empty, darkened stage and softly played "Rock of Ages" on his harmonica. The dry shuffle of feet and his slow, almost plaintive music filled the clear, warm summer night. Then the prayerful wail of the harmonica faded; the feet were gone. So came to an end another folk pilgrimage.

From a Dylan-centric standpoint this summation is baffling. That final harmonica solo is part of his legend—Mel Lyman, the mystical guru of the Kweskin Jug Band, was so upset by Dylan's set that he ascended the stage unbidden and unexpected, seeking to heal the rift in the folk community. But it was too late. Dylan had looked the community in the eye and gunned it down in cold blood. How could the writers have so misunderstood the meaning of it all?

As it happens, the writers were Dylan fans whose retrospective take on his transformation was, "Just when everybody's protest songs were making it big, he had the courage and integrity (as well as the shrewd showmanship) to say 'no more; it's meaningless' and turn to folk-rock." They recognized Dylan's Sunday night set, when he "electrified one half of his audience and electrocuted the other," as the "journalistic happening" of the 1965 Newport Festival. But they were not mainstream journalists; they were young folk fans caught up in the passion and breadth of the revival, and that phrase about electrifying and electrocuting was not their description of what happened; it was their paraphrase of how it was misconstrued and blown out of proportion by the squares at *Time* magazine: "Following that event, nothing short of Pete Seeger's joining the John Birch Society would stir much public interest in the American folk scene."

In other words, the squares did not understand that the scene was big enough to include both treasured traditions and electric innovations, and yeah, Dylan's set was exciting, and as a folk celebrity he was on a par with Seeger, but what was happening at Newport was not about celebrity and was more important than either of them. Nor did one have to be a starry-eyed Pollyanna to feel that way. Mary Travers was horribly disappointed by the 1965 festival, writing to a friend that while Newport 1964 had been "close to Utopia," the atmosphere this year was destroyed by the competitive squabbling of the young city singers, with their "sophisticated hostile nuance" and "I-haven't-got-time-to-communicate-with-anybody-attitude." But her four-page screed did not mention Dylan's set, focusing instead on her irritation with Baez for always being the center of attention, and she was particularly upset by the Sunday night finale, which she considered a disorganized, ego-driven mess: as a member of that "impressive ensemble," she wrote, "I never wanted to be forced to play a part in such a fiasco again."

Some Newport-goers recall Dylan's set as the most exciting event of that year, others recall it as disappointing, some were angry, and some missed it because they preferred the workshops and jams and skipped the big concerts. *Billboard* singled out Dylan's set and Seeger's finale as dual high points of Sunday evening (with Josh White a close third) and summed up the festival as "a resounding success—artistically and commercially," with "an attendance of more than 74,000 highly enthusiastic people, topping last year's turnout of nearly 70,000" and an estimated gross "in excess of $200,000." The attendance figures represented paid admissions rather than individual festivalgoers, with people who attended all four days counted multiple times, but they were nonetheless astonishing not only for a folk festival but for any kind of musical event—the jazz fest two weeks earlier had had 47,500 paid admissions, and there was as yet no such thing as a rock festival—and these high figures were a source of both celebration and concern. If there was tension on the grounds that weekend, it was not so much between acoustic tradition and electric modernity as between people excited to be part of that kind of huge,

sensational event and people worried that their pilgrimage site was being overrun by pop fans and money-changers.

Electric guitars were resented as symbols of that conflict or when their volume interfered with other music, but otherwise they were accepted with little or no comment. No one had been troubled by John Lee Hooker playing his electric boogie in 1963, and although Johnny Cash's appearance in 1964 had raised a few eyebrows, the issue was Nashville commercialism, not Luther Perkins's twangy electric leads. Muddy Waters played an acoustic guitar that year and left most of his band home, but no one complained when the Swan Silvertones and the Staple Singers used electric instruments. Newport was trying to stay abreast of the times, and although the 1965 lineup didn't include any rock 'n' roll stars, Chuck Berry and the Everly Brothers were on the board's short list of invitees, and Roger Miller was booked, though he had to cancel due to a scheduling conflict.

There were more amplifiers in evidence that year, and they were recognized as a sign of change, but few people condemned them as sacrilegious. At the opening concert on Thursday night, the first half of the show was a smorgasbord of respected older traditions: Irish and Cajun groups, the Reverend Gary Davis's guitar evangelism, and the New Lost City Ramblers backing Mother Maybelle Carter of the legendary Carter Family and Eck Robertson, a Texas fiddler who had recorded the first commercial country record back in 1922. The second half included Son House, the Mississippi Delta slide guitarist and singer who mentored both Robert Johnson and Muddy Waters. House had been scheduled the previous year but was too feeble to perform, and reviewers described him as looking older than his sixty-three years, but for blues fans he was a revelation. Mike Bloomfield recalled the shock a couple of days later:

> He's got a tremor in his hands and he's nervous, he's talking a mile a minute, 'cause he's scared shitless on that stage, and he puts that guitar in his hand and he plays *one* chord, and I have never seen anybody else—It's a transformation, it's like a mystic thing. . . . Son House turns into the blues, he turns into a

demon of some sort, and he doesn't hear, he doesn't feel, every nerve and fiber of his body is taken up in that music.

Great as he was, House's art was not ideally suited to a stadium-size crowd, and judging by the reviews he made relatively little impression on the mass of listeners. Like most of the evening's artists, he was playing exactly the sort of music Newport had been intended to showcase, but the press gave most of its attention to Baez ("a kind of jewel to this festival," wrote the *Providence Journal*) and a pair of new, young acts in the second half: the Chambers Brothers, an electric quartet from northeastern Mississippi via Los Angeles, and Donovan.

That first concert drew ten thousand people, more than twice the previous year's turnout, and most of them were young and collegiate. The *New York Times* noted "the usual gamut of folk-follower styles. At times . . . a sea of madras, but at other times it resembled a sea of denim." If the denim went with the old association of folk music with rural laborers, the madras suggested a shift, and the Chamberses' music went along with the changing times. They opened with "See, See Rider," their gospel vocals supported by twining electric guitars, harmonica, bass, and Sam Lay of the Butterfield band sitting in on drums—and although the song reached back to the early twentieth century, anyone with a radio would have recognized their debt to Chuck Willis's R & B version, which had reached the Top 20 in 1957 and inspired the "stroll" dance craze. They followed with the Impressions' "People Get Ready," a contemporary radio hit that was also a perfect choice for Newport, the lyric a churchy evocation of the freedom movement: "People get ready for the train to Jordan, picking up passengers from coast to coast." This was the kind of music the Chambers Brothers had been singing their whole lives, rich gospel harmonies roughened with a Mississippi growl, and the crowd was enthralled. They kicked the energy higher with an aggressive, rocking blues, "Goin' Upside Your Head," propelled by Willie Chambers's guitar leads, and changed the mood again with a mellow salute to the season, Gershwin's "Summertime." Then they took the crowd back

to their rural childhoods, blowing a hambone rhythm on soda bottles, punctuated with falsetto whoops—funky folk music of the most authentic kind, but also familiar to rock 'n' roll fans as the Bo Diddley beat. Finally, they broke into an ebullient Isley Brothers–style gospel-soul twist, "I Got It," getting the crowd on its feet and earning an ecstatic ovation.

The Chambers Brothers' set was a departure for Newport, and the *Providence Journal* wrote that if they had not been appearing at a folk festival, it "would have to be described as rock 'n' roll and rhythm and blues. Because this is folk music, however, one can only surmise that the quintet, electric guitars and all, are simple researchers dedicated to preserving the sound of the Beatles." The *Patriot Ledger* reached a bit further back, describing them as "four lanky, Chuck Berry-style Negroes" and suggested the crowd's enthusiastic appreciation was a sign of "how rock 'n' roll has infiltrated the hard-core of folk—or vice-versa," adding: "If this present trend maintains its pace, there will be a lot of rockin' folk singing folk 'n' roll."

Though the reporters were startled, most of the Newport pilgrims and purists embraced the Brothers without any difficulty. The quartet had been invited on Seeger's recommendation after he saw them perform with Barbara Dane, and they perfectly fitted his tastes and agenda: a family group from Mississippi, playing music organic to their home region and cultural background, and also symbols of the new spirit of the African American South. In a setting where "ethnic" was used as a synonym for traditional folk culture, they were unquestionably ethnic, their music an organic evolution from the styles of Gary Davis and Son House via the Staple Singers and Muddy Waters. It was not a matter of rock 'n' roll infiltrating folk or vice versa. They had developed their tight showmanship playing in black churches, where their music was a common community style, and started working in Los Angeles folk clubs alongside people like Sonny Terry and Brownie McGhee, who likewise had played a fair amount of R & B. Alan Lomax had been insisting since the 1950s that the most authentic contemporary folk music was what was played in working-class churches and honky-tonks, not what middle-class white

kids were "reviving" in Washington Square, and the Brothers drove that point home, simultaneously evoking rural Mississippi and the hippest styles on the radio. Coming up after them to introduce House, Lomax crowed: "I'm very proud tonight that we finally got onto the Newport Folk Festival our modern American folk music: rock 'n' roll!"

The irony was that although the Chambers Brothers had deep folk roots and rocked like crazy, in commercial marketing terms they were never going to fit the folk-rock category. When *Billboard* talked about folk-rock, it didn't mean the Isley Brothers or the Impressions taking rock back to southern rural church styles; it meant electrified extensions of the Kingston Trio and Peter, Paul, and Mary. The Brothers got the crowd dancing and clapping, but in terms of current pop-folk trends the night's most notable performer was still to come. After the Brothers exited to the loudest applause of the evening, House played a short set of Delta blues, then ceded the stage to Joan Baez, who put on a broad English accent to introduce the nineteen-year-old singer-songwriting sensation named Donovan.

Donovan was the media ideal of a teen-folk idol: his first single, "Catch the Wind," had hit the US Top 40 in May, and many people found his voice and harmonica, as well as his song title, patently derivative of Dylan. As if to cement that connection, he arrived at Newport with Baez, who joined him onstage to harmonize on his new single, "Colours." He was a fresh face and a symbol of the broadening international folk movement, but that week's *Billboard* tagged "Colours" as a strong chart contender by "the English Dylan," and he could also be considered the festival's most abject bow to current trends, folkdom's own little British Invader.

"Mr. Dylan, he's not, but talented, he is," the *Patriot Ledger* reported, and for some listeners Donovan must have been a welcome pastiche of Dylans past and present, blending hip fashion and symbolist poetry with a continued commitment to social protest. He opened with the fairy-tale "Little Tin Soldier" but followed with "The Ballad of a Crystal Man," a critique of American racism, militarism, and hypocrisy, drawing applause when he mentioned it had been banned by the BBC. Then came a romantic song by the British guitarist Bert Jansch and "The War

Drags On," a gruelingly prescient saga of a soldier disillusioned by the carnage of Vietnam. Few American singers had yet turned their attention to Southeast Asia, and the *Newport Daily News* felt he had gone too far, writing, "We realize the protest songs are a reflection of the attitudes of many of the younger generation," but this selection "could very well have been omitted, considering it was sung within hearing distance of one of the country's leading naval bases." And, the reporter added, "The same can be said of several of Miss Baez's numbers."

In fact Baez's song selection was mostly apolitical. After dueting with Donovan, she put on a southern accent to introduce Boston's guardians of country-bluegrass tradition, the Lilly Brothers, and joined them to sing harmony on an old standard, "A Satisfied Mind." Her own set began with Dylan's "Farewell, Angelina," followed by the Nashville ballad "Long Black Veil." She dedicated the traditional "Wild Mountain Thyme" to "everybody and anybody who's in love, few though there may be," then injected a brief note of social commentary, announcing her next selection as "a quick little dedication to President Johnson on his marvelous foreign policy" and singing a verse of "Stop! In the Name of Love," with its closing admonition: "Think it o-over." Some people clearly missed the point, the *Patriot Ledger* simply reporting, "As if unable to restrain an urge she lyrically swung through a couple of lines of the Supremes' hit." She followed with "Where Have All the Flowers Gone," though its message was a bit obscured—or at least shifted from an American context—since she sang the German lyric popularized by Marlene Dietrich, "Sag mir wo die Blumen sind." Another of Dylan's newer compositions, "It's All Over Now, Baby Blue," provided a soaring and wistful close, and the crowd brought her back for an a cappella version of the civil rights anthem "Oh, Freedom."

It was a strong performance, but some folk scene insiders must also have found it sad—Dylan had treated Baez as a bystander rather than a partner on his British tour, their romance was over, and her set could be read as farewell to their past. At least one fan was clearly unsympathetic, shouting "We want Dylan!" after her Supremes snippet, to which

she responded with a curt "He's not here." It was a bitter moment, and the personal split could be seen as a metaphor for broader divisions: the festival was still primarily devoted to traditional, rural, regional styles, but the big news of the opening concert had been a teenaged British pop star and a black quintet with electric guitars and a twist beat. The *Patriot Ledger* suggested Newport might have to adopt a new moniker, "Folk Festival à Go Go," and though the reviewer framed that as a joke, not everyone was laughing.

Newport was supposed to be a sanctuary for homegrown traditions and humanist values, but the organizers also wanted to prove that those traditions and values were relevant in the present, to create not only a museum but a beacon and laboratory for social change. Now it was becoming increasingly difficult to draw lines between the culture they loved and the culture they despised. Newport was still a unique showplace where a tenant farmer from rural Mississippi or a young songwriter known only to a small circle of friends could go onstage in front of thousands of people, be presented as an important artist, and be appreciated, applauded, and perhaps handed a new career. It wasn't supposed to be about the career; it was supposed to be about the music, and the eloquent farmer or ardent young spokesman was supposed to be recognized as a representative of all the unknown artists who might equally well be on that stage. Inevitably, though, the medium undercut the message: when ten or fifteen thousand people sit passively watching one person perform, it is hard to think of that person as simply a representative of the gathered many. Seeger's special magic was maintaining that illusion, and that had also been the magic of the 1963 finale: the feeling that rather than being a spectator you were joining with the Freedom Singers in a great unified chorus of "We Shall Overcome," linking arms with Pete, Bob, Joan, Peter, Paul, Mary, Theo, and all the thousands of people standing with you on that vast, generous field. But it was one thing to be there in that moment, sharing that spirit, and another to be a young singer looking at the iconic photograph of the stars onstage and imagining yourself up there linking arms with the virtuous, chosen few.

For serious devotees, Newport remained a site of pilgrimage, but for their more numerous and lackadaisical peers it was a fun music festival and even a bit of a pop festival, where they could see performers they knew from records and radio. A *Village Voice* columnist decried "its similarity to Hollywood madness . . . the great stars fawned over, sought after. . . . Young girls ran through the Viking Hotel screaming, 'BOBBY! Donovan! Dylan!'" For the performers, it was a chance to meet old friends and get in touch with the roots of their music, but also something of a trade show. A successful Newport appearance could lead to record offers, concert tours, and professional management—Arthur Gorson, who managed Phil Ochs, compared it to "the Cannes Film Festival of the folk world, with people sitting around schmoozing and making deals." At best that meant more work for fine musicians and a wider range of styles becoming available around the country and eventually around the world. At worst it meant gross commercial co-optation, a transformation of something handmade and shared into one more shiny plastic widget, mass-produced and marketed like breakfast cereal.

In the festival program, Robert Shelton staged a dramatic turnabout, suggesting that folk fans needed to be less fearful of the pop scene and that the workshop schedule should add some rock 'n' roll and a side order of Nashville country. His piece was framed by photostrips of the Beatles, the Byrds, and Buck Owens, and declared his conversion to "the big beat," urging readers to "listen to a bit of Petula Clark with your Jean Ritchie, the Supremes with the Almanacs, and . . . Chuck Berry as well as Bill Monroe."

> "Folk rock" is moving so quickly now that we can only guess at where it is going. Bob Dylan, who needs no credentials as a trailblazer, is fusing his own lyrics with the cadences and drive of Chuck Berry tunes. The Byrds are coupling Dylan and Pete Seeger songs with their own arresting surfing harmonies. The Lovin' Spoonful may very well be the "American Beatles," mixing blues, big beat, jugband and folk into a new style.

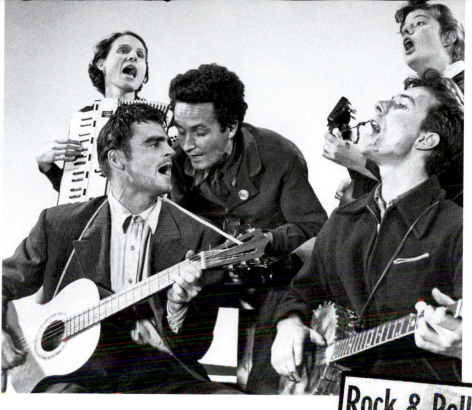

The Almanac Singers, early 1940s: Sis Cunningham, Cisco Houston, Woody Guthrie, Bess Lomax, and Pete Seeger (*Gjon Mili/Life Picture Collection/Getty*); The Golden Chords, 1958: Monte Edwardson, Leroy Hoikkala, and Bobby Zimmerman (*Courtesy of Monte Edwardson*); ad from the Hibbing Tribune (*Courtesy of Bob and Linda Hocking*).

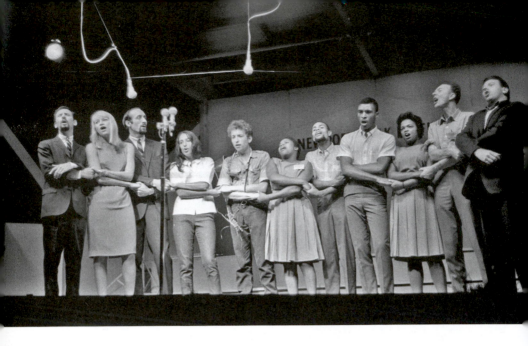

Newport 1963: *This page:* Friday night finale: Peter, Paul and Mary, Joan Baez, Bob Dylan, the Freedom Singers, Pete Seeger, and Theodore Bikel sing "We Shall Overcome" (*John Byrne Cooke*); Dylan and Bill Lee re-create southern segregation at the Viking Hotel (*Estate of David Gahr*). *Facing page:* Dylan and Baez on the cover of *Hootenanny*; Columbia Records ad in the festival program. **Newport 1964:** Robert Shelton introduces Dylan to the fiddler Clayton McMichen (*Joe Alper*).

REGISTERED GUESTS
ONLY
MAY USE POOL

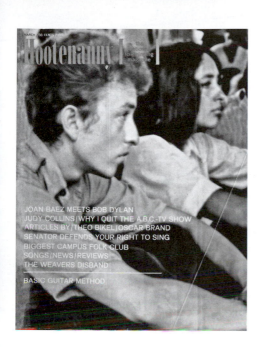

MARCH / 35 CENTS

Hootenanny
the folk singing magazine

JOAN BAEZ MEETS BOB DYLAN
JUDY COLLINS/WHY I QUIT THE A.B.C.-TV SHOW
ARTICLES BY/THEO BIKEL/OSCAR BRAND
SENATOR DEFENDS YOUR RIGHT TO SING
BIGGEST CAMPUS FOLK CLUB
SONGS/NEWS/REVIEWS
THE WEAVERS DISBAND

BASIC GUITAR METHOD

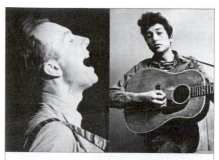

PETE SEEGER BOB DYLAN

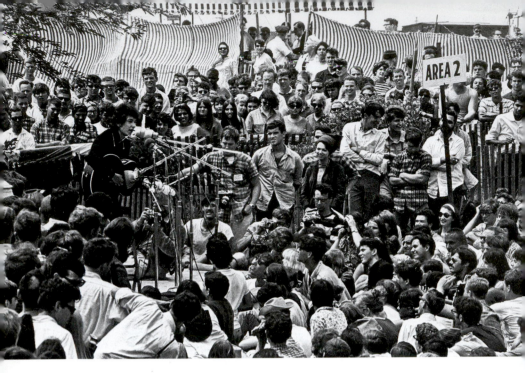

Newport 1965: *This page:* Dylan at the Contemporary Songs workshop (*Joe Alper*); Pete Seeger recording the Texas work song group (*Diana Davies*). *Facing page:* The Chambers Brothers backed by Sam Lay (*Joe Alper*); Richard and Mimi Fariña with Al Kooper and Bruce Langhorne (*Robert and Jerry Corwin*); the Butterfield Blues Band, with Alan Lomax on the right (*Joe Alper; Alper photographs courtesy of the Joe Alper Photo Collection LLC*).

JOAN BAEZ

You're smiling, Joan, but where's Bob? She said he had a cold. That's a cool red mustang!

Herby & I walked around with Donovan questioning him & stuff for about 45 minutes. When he sang with Joan Baez Thurs. night— he looked just like Dylan. NEVER heard of Bob Dylan, huh? ... Here he was hungry (ungry') and asked for a bite of my pizza. I told him I was gonna make him pay for it. Sure... He's too cool!!! Nice, too!!! Our friend, Donovan? Well..

Newport 1965: Excerpts from Judy Landers's Folk Festival scrapbook, with photos by Herb Van Dam (*Courtesy of Van Dam and Landers*).

BOB DYLAN!!!

It's All Over Nowww, Baby Blue... ♪

This
Is
Bob
Zimmerman —————

Bob Dylan & ̶e̶ of the Byrds. (All of them were there)

— We Still love Him Although He Disappointed Us by making public his change to Folk Rock Sun. Night —

This picture is really Groovy!!

Hiiii!!
I'm Bob Dylan
DIG ME'!

Bye!!
I talked to Bob, here! I was leaning on this door. He looked up & smiled. I asked him if it was him laughing in the beginning of "Bob Dylan's 115th Dream. He said, Yeaaa!!

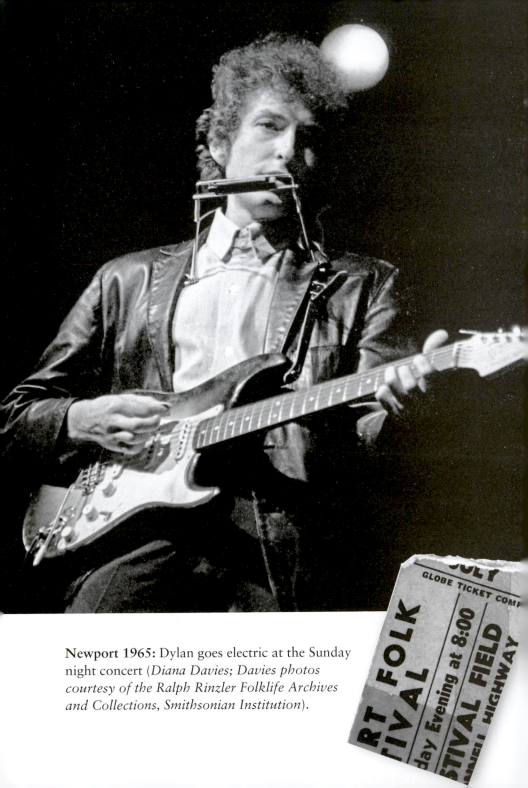

Newport 1965: Dylan goes electric at the Sunday night concert (*Diana Davies; Davies photos courtesy of the Ralph Rinzler Folklife Archives and Collections, Smithsonian Institution*).

If Shelton's essay provoked some traditionalist grumbling, the facing page must have provoked howls: the title "Off the Top of My Head" cut through the curly mane of the trailblazer himself and introduced a sample of Dylan's new prose style, an effusion of stream-of-consciousness amphetamine surrealism chronicling the adventures of Horseman and Photochick—Bobby and Joanie, perhaps?—that served no possible function except to display the author's name and convey the message that whatever he did, he remained part of the Newport mix. It stood out like a beetle in the buttermilk, a pop-art provocation amid essays on the history of rural fife and drum bands (Ed Young's backcountry Mississippi group was making its first trip north that year), the growing popularity of harmonicas (Dylan, John Hammond, and John Sebastian were name-checked, though the writer wasn't yet hip to Paul Butterfield), Irwin Silber's meditation on "The Topical Song Revolution at Midpoint" (subtitled "Music in Contact with Real Life"), and a discussion of how to preserve the Gaelic traditions of Cape Breton Island amid the onslaught of modern media.

The model of using pop celebrity to counteract the pop industry had always been risky. It made sense to Pete Seeger because that was his mission: being a Seeger fan meant going to his concerts and buying his records, but also singing the songs of Woody Guthrie; appreciating Maybelle Carter, Seamus Ennis, and Mississippi John Hurt; playing a bit of banjo or guitar; and welcoming the opportunity to interact with African, Israeli, and Appalachian folk dancers. Being a Dylan, Baez, or Peter, Paul, and Mary fan was potentially very different, because you could love them as modern exponents of the traditional, communal folk scene, but also as exceptions, exciting young stars among all those boring old geezers. That dichotomy was harder to downplay now that Dylan was hobnobbing with the Beatles and getting rock 'n' roll hits, not only because he and his music were changing, but because his new fans were potentially coming to Newport and suffering through the folk music for a chance to see the latest pop star.

There was also a growing generational rift within the folk community itself. Ardent young listeners and musicians, whatever they thought of

Dylan, were getting tired of the older generation of pop-folk stars. It was perfectly possible to love the ballads of Margaret Barry, the fiddling of Eck Robertson, the Delta slide of Son House, the rocking rhythms of the Chambers Brothers, and the electric ferocity of "Like a Rolling Stone," and yet be bored and annoyed by the cultured vocal tones and nightclub polish of the Weavers' generation. Like the white liberals who had always argued that Negroes should have equal rights and now found young Afro-Americans expressing their equality by rejecting white liberal leadership, the older singers who had seen themselves as bridges between ancient folk arts and modern concert audiences now faced a generation that felt they had diluted and deformed the authentic traditions.

Jim Rooney, a country and bluegrass musician who was running Cambridge's Club 47 and would shortly join the festival board, wrote a letter to the current board members summing up the divide: "Many of the younger people feel that the older performers are pretty artificial. The jokes, the arrangements, the gestures are all part of an act." There had been a time when people who did not personally appreciate Oscar Brand or Theo Bikel would nonetheless grant that they were part of a shared scene, but by 1965 a lot of the older urban professionals just seemed like tired cabaret acts whose time had passed. Rooney recognized that the older generation had its own quibbles: a twenty-year-old white urbanite singing like a black sharecropper was in its way "just another form of artificiality," and some young performers were equating authenticity with a lack of professionalism, dressing sloppily and ignoring their audiences. But whatever the justice of either camp's positions, he noted increased "feelings of hostility" on both sides.

Rooney balanced this observation with vignettes of camaraderie: "Bill Monroe listened to Mance Lipscomb and admired the way he sang. Michael Gorman was very taken with Tex Logan. Sammy Lay . . . talked late into the night with Arthur Smith about country music." But that list was itself a sort of manifesto: Kentucky bluegrass mixed well with Texas blues, Irish fiddling with hillbilly fiddling, Chicago blues with Nashville country. Each of those artists was in his way "authentic"; none had been

familiar to urban folk audiences a few years earlier, and that was Newport's triumph. In his *Sing Out!* review, Paul Nelson exulted: "The clear-cut lack of excitement over the 'name' performers was amazing, while the applause for such country musicians as Cousin Emmy, the McGee Brothers, Arthur Smith, Lightnin' Hopkins, and many others surprised everyone. . . . It's hard to forget people cruising out for a hot dog during Odetta or Brand or Baez, then racing back to hear a traditional musician."

But was it really so hard? Nelson's encomiums to traditional ethnic artists and the intimate workshops that dotted the festival grounds were followed by his observation that "Newport is still a place for the Big Moment, the Great Wham, that miniscule second of High Drama that freezes the blood and sparks the brain"—which was to say, the shock of Dylan's electric set on Sunday night, "the most dramatic scene I've ever witnessed in folk music."

Shelton described Newport in the *New York Times* as "the three-ring circus of American folk music," and, as at a multiring circus, what you saw depended on where you were seated. Donovan, a newcomer in the center ring, sounded both thrilled and nonplussed when he told *Melody Maker* about the experience:

> The audiences were beautiful. They mobbed Dylan and me—or maybe I should say they mobbed Dylan and I was with him. They were just like pop fans—and I must admit that brought me down a bit. I expected people at the Newport Folk Festival to be quiet. But they go round screaming and asking for autographs just like the pop fans they are supposed to put down. . . . [One] bloke went a bit mad and shouted: "I'll kill for you, Bob. Who do you want killed?"

"Did he say anything?" the interviewer asked.

"No," Donovan replied. Then: "I wonder what *should* Dylan have said? What should *anyone* have said?"

In terms of record sales and name recognition, Dylan was still behind

Peter, Paul, and Mary and roughly on a par with Baez, but in terms of current trends he was in another class. He had originally been scheduled for Thursday night, but there were so many complaints from fans who could not make that first show that he and Baez were switched, with her on Thursday and him on the final Sunday program. Joe Boyd was wandering the grounds on Friday and recalled, "You could hear people asking, 'Where's Dylan? Is he here yet?'" When he showed up the following day, reporters singled him out as the only performer "who was literally mobbed by fans." Baez was popular as well—"She really trailed a crowd wherever she went and adoring disciples gathered around her when she was at a workshop"—but she was still able to circulate and listen to the music, and "Pete Seeger, Odetta, and even Peter, Paul and Mary, went about virtually unnoticed."

The difference was not just a matter of popularity. Dylan was putting rock 'n' roll records on the charts, wearing the latest fashions from swinging London, and acting like a distant, mysterious star. Baez enjoyed mixing with the young crowd and tried to defuse their excitement—that year, she annoyed some and ingratiated herself with others by insisting on shaking hands rather than giving autographs—and she ascribed Dylan's standoffishness to a combination of paranoia and insecurity, saying he was "genuinely terrified" of the adoring multitudes, but also "in a way he needed people pounding on the car and breaking the car antenna and climbing under the hood and everything." Murray Lerner's film crew captured him looking trapped and bemused as his van inched its way through the screaming crowd on Saturday, pointedly ignoring a blonde girl who rapped hopelessly on the car window by his head. It also captured a group of teenage boys on Sunday expressing their distaste for this behavior:

"People start to idolize these artists, you know, and once that happens, you know—like Dylan yesterday, you know, everybody just comes over, masses, you know, I don't know how many people were there, and"—the young speaker mimed a fan staring openmouthed—"they all just sit there, and like, 'It's Bob Dylan, it's really him!'"

Another youth added an analogy to Pontius Pilate's *ecce homo*:

" 'There he is, there's the man!' God, and everything." Which was, for them, the end: "Who needs him anymore? He's accepted—he's part of your establishment, and—forget him."

Except that it was impossible to forget him, even if you wanted to, because Dylan was drawing pop-style crowds. The daytime workshops were supposed to be intimate events with a few hundred listeners, but between five and seven thousand showed up for the Saturday Contemporary Songs workshop where he was scheduled. Boyd recalled the crowd as "so immense that it was swamping the other workshops," and the adoring Dylanites were anything but apologetic: "People were complaining: 'Turn up the Dylan one, because we're getting bleed from the banjo one on the other side!' "

Honest pilgrims who had traveled long, dusty roads to hear hallowed masters of Appalachian banjo, Texas fiddle, Delta slide, or Cape Breton ballads were understandably irritated to be shushed by a bunch of callow pop idolaters, and it didn't help that some of Dylan's pals had already caused trouble on the previous day. In the legend of Newport 1965, Dylan's Sunday night set was the culmination of a three-day battle between electric rebels and hidebound folk purists, and the opening volley was fired on Friday by the Paul Butterfield Blues Band.

The Butterfield Band was an anomaly at Newport, and not just because it was the loudest group that had ever appeared. Butterfield was a white twenty-two-year-old who had become enthralled with blues harmonica in his mid-teens and patterned himself on the modern R & B style of Little Walter, and his interest went beyond the music: he had immersed himself in the lifestyle of Chicago's South and West Side bar scenes, hanging out with black musicians, sitting in with bands, and earning the respect of neighborhood listeners. Mike Bloomfield, who was playing his first live gig with the band that weekend, was awed by him:

> Paul was the real thing, you know, it fascinated me and yet it
> intimidated me too, you know. The cat just went down there,
> went down in the baddest black ghettoes, man, and just was

as bad as the baddest cats down there, man, wouldn't take no jive from nobody, you know? And held his own. *God*, did he hold his own.

It was a very different experience from playing in Greenwich Village or Harvard Square, and if anyone needed to be reminded of that, all they had to do was open the newspaper. Martin Luther King arrived in Chicago that Friday, declaring it "one of the most segregated cities in the United States" and making it his first stop in a drive to take the civil rights struggle north, to keep on pushing into white urban communities that preferred to think of the battles as taking place in Mississippi.

The Butterfield Band had been invited to Newport in part as a symbol of integration: Butterfield, Bloomfield, and guitarist Elvin Bishop were joined by bassist Jerome Arnold and drummer Sam Lay, black musicians who had been mainstays of Howlin' Wolf's band. But if one dug a little deeper, the story got complicated: Lay and Arnold had joined after Butterfield got a regular gig at a bar in the Old Town neighborhood, and it was not coincidental that white players were blazing that trail, or that a relatively unknown white bandleader could hire sidemen away from Wolf. The white players had paid some dues on the black club scene, but also had access to audiences their black peers couldn't reach—specifically all the white kids who wanted to enjoy the South Side sound but did not feel comfortable in ghetto bars. Bloomfield had taken his own band into the North Side around the same time, and by attracting a new audience these artists opened up opportunities for their black peers, but the fact remained that competent white novices could get jobs that expert black veterans could not.

With all its complexities and contradictions, Chicago provided unique opportunities for white players to serve apprenticeships in black clubs, for black players to reach white audiences, and for white and black musicians to mingle and work together. "The guys from Cambridge and all, they sing blues but it's an entirely different feeling," Bloomfield told Lerner in an interview on the festival grounds. "They never get to hear blues in real

life, they never get to meet these guys and go to clubs, man, little ricky-ticky clubs where they're boozing, you know, and the whores are out in the street. . . . They don't go to these clubs and they don't see blues in its natural environment, and so there's a difference there. . . . There's more of an ideological—idolized type of thing." Bloomfield admired people like Waters and Wolf, but also regarded them "as more like contemporaries of mine. . . . I work the same clubs as they do, and we play the same music."

At the same time, Bloomfield was aware of being an outsider: "It's not in my blood, it's not in my roots, in my family. Man, I'm Jewish, you know. I've been Jewish for years." He was supremely sure of his instrumental skills and felt a deep, personal connection to the music, but when he talked about the older, rural players he could sound almost like an idol-worshipping Cantabrigian. "Hell, man, I'm not Son House," he told Lerner:

> I haven't been pissed on and stepped on and shitted on like he has. I haven't gone through that. Man, my father's a multi-millionaire, you know? I've lived a rich, fat, happy life, man. . . . I can play blues, and I can feel it, in a way. But man, those guys are a different story.

Unlike his electric bandmates, Bloomfield was also connected to the Chicago folk scene—he hung out at the Old Town School of Folk Music, played acoustic styles, dabbled in bluegrass, and had even contributed a couple of "Our Man in Chicago" bulletins to *Hootenanny* magazine. Along with his Butterfield performances, he hosted a Friday morning blues guitar workshop and enjoyed an after-hours picking session with Bill Monroe. But he had no patience with people who considered electricity an adulteration of the tradition, and was outraged that Hooker and Waters had been encouraged to play acoustic guitars at their Newport workshop sets. He was familiar with the attitude—electric blues was "too easily confused with rock 'n' roll, and, like, at a folk festival you can't be rock 'n' roll, for some inane reason, rock 'n' roll seems to make

invalid the purpose of a folk festival"—but to him the urban electric sound epitomized true folk culture. As he later recalled, "This was what I heard on the streets of my city, out the windows, on radio stations and jukeboxes in Chicago and all throughout the South . . . and that's what folk art meant to me—what people listened to." At the Friday workshop he gave a glowing introduction to Lightnin' Hopkins—"My favorite blues singer, the king of the blues"—up from Texas with an amplified guitar and ready to boogie, and arranged for Lay to add percussive power to Hopkins's barroom beat.

Bloomfield was also annoyed by white fans who presumed to rate blues players on the basis of skin color. He recognized the role of race and culture in the tradition, and in some situations was willing to downplay his own authenticity, but if anyone had doubts about his bandleader, he was prepared to set them right: "There's no white bullshit with Butterfield. . . . If he was green, it wouldn't make any difference. If he was a planaria, a tuna fish sandwich, Butterfield would be into the blues."

All of which is to say the Butterfield crew came to Newport with an attitude. "We were Chicago," recalls Barry Goldberg, the band's sometime keyboard player. "That's how we grew up, that was our roots and the clothes we were wearing. It was different than the East Coast kids. We always carried that sort of Chicago toughness." It was there in the first lines of their signature song: "I was born in Chicago, nineteen and forty-one / My father told me, 'Son, you had better get a gun'"—and Geoff Muldaur points out that the lyric was not just bluster: Butterfield did in fact carry a pistol. They were hardened, street-smart, and primed to take the folk world by storm, having recently signed with Elektra Records, packed clubs in Greenwich Village, and received encouragement from Albert Grossman, who was talking about becoming their manager. Newport was a major showcase that could take them to another level, and they wanted to make the most of it, but they also regarded it as foreign and perhaps unfriendly territory, and they were not entirely wrong. To blues purists, the Chambers Brothers, Lightnin' Hopkins—even, at a stretch, Bo Diddley and Chuck Berry—were authentic exponents of an

ethnic folk culture, while Bloomfield, Butterfield, and Bishop, talented as they might be, were interpreters. That Butterfield had two black musicians in his band proved he was genuinely linked to the tradition, not that he was genuinely part of it. And however much one cared to defend the white players' bona fides, it was inarguably true that the first full-bore Chicago blues band invited to the Folk Festival was led by a young white guy, and their race was a big factor in their record contract and Grossman's interest.

If there was one person on the folk scene singularly and officiously inclined to resent that sort of favoritism, it was Alan Lomax. Though often recalled as a musical conservative, Lomax had long experience with the pop scene—he wanted to bring folk styles to a mass audience and had produced network radio shows that mixed folk artists with studio orchestras and records by mainstream hit-makers like Jo Stafford. He was the first folklorist to record a group featuring electric steel guitar, back in 1941, and the most prominent to embrace rock 'n' roll, earning boos from young purists when he presented doo-wop singers and electrified Chicago blues at Carnegie Hall in 1959. But he was firmly committed to the idea of folk music as an expression of working-class communities, the musical equivalent of a local or ethnic dialect, and intensely suspicious of middle-class kids purporting to perform folk styles. Stafford got a pass because she was a major star whose records could attract audiences to the real stuff, much as Seeger, Baez, or Peter, Paul, and Mary lured audiences to hear authentic traditional performers at Newport. But as the man who had discovered Muddy Waters on Stovall's plantation before Bloomfield or Butterfield was born, Lomax was acutely aware that there were a lot of more deeply rooted bands in Chicago.

On Friday afternoon, Lomax presented an ambitious concert-cum-lecture titled "Blues: Origins and Offshoots." It was yet another updating of "From Spirituals to Swing," with the difference that he was not just an organizer and master of ceremonies; he was an impassioned polemicist, determined to correct and chastise. Shelton's review described him as "an articulate, illuminating, fluent, but sometimes maddeningly pedantic

host-narrator" who compared blues "to the Italian stornella, the Spanish copla and the Mexican corrida [*sic*]" and, over the course of two hours, "took the listener from primitive African survivals in Mississippi to the electronic razzle-dazzle of big-beat modernity." The excursion began with Lonnie and Ed Young's North Mississippi fife and drum group beating on homemade bass drums and blowing reed flutes, and Lomax traced their connection to African traditions, jestingly nominating them as cultural ambassadors to Ghana. Next he discussed African vocal traditions, starting with the solo field holler—despite his disdain for urban re-creators, he demonstrated this style himself—then a pair of work songs performed by a quintet of ex-convicts from Texas, culminating in the epic "Go Down, Old Hannah."

Having established the roots, Lomax moved on to early blues with Son House and Mance Lipscomb. He recalled that he had recorded House twenty-five years earlier in a plantation cabin, compared House's "Levee Camp Moan" to flamenco *cante jondo,* and reminisced with the singer about backcountry juke joints where customers mixed snuff in their whiskey and danced the scraunch, billy-walk, and dog dance. Lipscomb presented a lighter style, singing a ragtime number, "Alabama Jubilee," and "Mama Don't Allow No Boogie Woogie Round Here"—a title that in hindsight seems more than a little ironic—then gave way to the first "offshoots": Sam and Kirk McGee, a team of hillbilly guitarists fresh from the Grand Ole Opry. As Kirk explained, "Most of the blues tunes that we know, we learned 'em from colored people way back when we started out. Our daddy had a store down there, so all these people would come around this little country store, and that's why we learned more of the blues." They first performed "Milk Cow Blues," a song covered by everyone from Robert Johnson to Elvis and Dylan, then Sam played his classic "Railroad Blues," prompting Lomax to remark, "There's a man who's overcome the disadvantage of not being colored." Bill Monroe was next, recalling that in his teens he played square dances with a black guitarist named Arnold Shultz and leading his Bluegrass Boys through

Jimmie Rodgers's "Blue Yodel #3" and a high-energy horse-race ballad, "Molly and Tenbrooks."

Lomax then traced the course of the great migration to "bluesville itself, Chicago, the capital of the blues since 1914." The program promised Memphis Slim, a pianist who played on hundreds of records in the 1930s and 1940s, but he had canceled and was replaced by Eddie Boyd and Lafayette Leake, backed by Willie Dixon on bass. All were Chicago stalwarts: Boyd, a sophisticated blues balladeer who briefly employed Muddy Waters as his guitarist, sang "Five Long Years," the moody lament he had taken to the top of the R & B charts in 1952. Leake was less famous as a front man, but his piano credits included everything from deep blues to Chuck Berry's "Johnny B. Goode" and "Rock and Roll Music." Dixon had also been a regular on Berry's records and with pretty much everyone else who recorded for the Chess label, where he worked as a talent scout, producer, and the most influential songwriter on the Chicago scene, author of "Seventh Son," "Hoochie Coochie Man," and myriad other hits.

The obvious next step was to present a modern electric band, and Butterfield's group perfectly fitted the "Spirituals to Swing" model, since the 1939 concert had represented that era's contemporary iteration of black music with Benny Goodman's similarly biracial unit. But Goodman was a major star, the "King of Swing," while Butterfield was virtually unknown outside Chicago and not at all the act Lomax would have chosen. If he couldn't have Muddy Waters, he would have preferred someone like Buddy Guy or the Chambers Brothers, not a bunch of middle-class interlopers who thought they were bluesmen because they'd spent some time moonlighting on the South Side. He had always complained that Newport was too commercial and saw his role on the Festival board as defending authentic traditions—his statement in that year's program book ended with the declaration "Money and prestige count for nothing in art compared to honesty." He hadn't heard these Butterfield boys—their first record would not be released for another few months—but he

knew they'd been chosen by Peter Yarrow with support from Grossman and Elektra Records, rather than by a panel of blues scholars. And to add insult to injury, after leading his audience through the most serious exploration of blues ever presented at Newport, he had to drag out his introduction so these white boys could set up their fancy gear.

To be fair, if Bloomfield had been put in the position of introducing an unknown white band on a program with House, Lipscomb, Monroe, Dixon, and Boyd, he might have been equally cranky. He could be as much of a purist as Lomax and no more diplomatic—his take on white blues groups from the Rolling Stones on down was that most were "ludicrous, accented, ridiculous, bogus, uncle tom, tasteless, crude imitations of a really nice thing"—but they were purists of different generations, with different tastes, and, goddamn it, the Butterfield Band was a seasoned Chicago bar outfit, accepted by black audiences in the ghetto, and a lot of blues acts at Newport were erstwhile folkies from New York and Cambridge who had never set foot in a black club. Plus, Grossman was watching, and Jac Holzman from Elektra, and probably a lot of other important people, the sort of people who could get them tours and hits and potentially turn them into the world's best-selling blues act. Which, of course, only increased Lomax's irritation.

So, while the band plugged in and got organized, Lomax made a final peroration on the history of blues, the journey "from a cane fife and a broken drum to electric equipment." Instrumentation changed, fashions changed, but the important thing was not the technology; it was "how much truth comes through the microphone." He had presented a program of artists for whom blues was not just music; it was the fabric of their lives, their world, their families and neighbors, their sorrows and joys, and that was not the same as coming from outside the culture and learning to replicate the sounds. Of course, there had been people like Benny Goodman who learned how to play a kind of blues: "Us white cats always moved in, a little bit late, but tried to catch up." Which brought him to the band at hand: "I understand that this present combination has not only caught up but passed the rest. That's what I hear—I'm anxious

to find out whether it's true or not." He proceeded to introduce the players. "We have with us tonight, highly recommended, already the King of Chicago, which is a big, uh, tribute: Paul Butterfield . . ." and so on, through the rest of the group, finishing, "Anyway, this is the *new* blues from Chicago, played on—" at which point Butterfield drowned him out with the opening harmonica riff of Little Walter's "Juke."

The band hit hard, and according to legend the opening instrumental backed an epic confrontation: as Lomax stepped off the stage he was confronted by an irate Albert Grossman. In Paul Rothchild's recollection, Grossman's opening words were, "What the fuck kind of a way is that to introduce a bunch of musicians? You should be ashamed of yourself."

Lomax snapped back—the folklorist Richard Reuss reported him saying, "Do you want a punch in the mouth?"

Grossman followed up—Mary Travers recalled his precise words as "I don't have to take that from a faggot like you!"

Lomax tried to push Grossman aside, or maybe it was Grossman who pushed Lomax. Either way, in seconds the portly prophet of tradition and the portly purveyor of mammon—"the two big bears," in Maria Muldaur's description—were throwing inept punches and rolling in the dust.

"It was a perfect confrontation whose symbolism was lost on none of us," Rothchild recalled, and George Wein filled in the blanks:

> Lomax symbolized the sacrosanct traditions of folklore; Grossman was the power broker whose very existence threatened to corrupt those traditions. For the first time, the tension that had lurked beneath the placid surface of the folk revival erupted in plain sight. The conflict was personified, there in the flesh.

Symbolism aside, many observers recalled the tussle with glee. In Eric Von Schmidt's words, "It was a gas, man. Everybody loved it. There were a lot of folk notables there watching the melee with great, great joy." Willie Dixon, who had been a teenaged golden gloves champion, recreated the scene back at the blues house that evening, and Samuel

Charters proposed that Lomax and Grossman be paid to reenact their battle onstage. Some onlookers took sides—Bloomfield recalled yelling, "Kick that ass, Albert!" and deciding on the spot that they needed to sign with this guy who would "put his body on the line to defend our right to boogie"—but most satisfied themselves with variations of "a plague on both their houses."

The details are inevitably confused—some people remember Lay jumping down from the stage to separate the combatants, some remember Bruce Langhorne and Richard Fariña doing that duty, while others insist the battlers were so out of shape they collapsed of their own accord—and the multiple and conflicting stories are an apt appetizer for the conflicting reports of Dylan's show on Sunday. Some witnesses disagree about when and where it happened, placing it at the main stage on Sunday, sometimes in connection with Butterfield's set and sometimes with Dylan's sound check. Most agree it was at the Lomax workshop but have the timing off, since it is almost always remembered as happening right after the introduction, but Lerner's film footage shows Grossman smiling appreciatively through the band's first number, and Maria Muldaur is probably right when she recalls the fight taking place after they finished playing.

As for the performance, the *Quincy Patriot Ledger* wrote:

> Paul Butterfield . . . greeted a crowd of long bobs and high boots with gyrating pulsating sounds a la Muddy Waters. In a matter of moments, his cathartic, chaotic and erotic rhythm produced a wide scale reaction of writhing and shouting, such is the agony and the ecstasy of the Butterfield band—a group half way between the Righteous Brothers and the Rolling Stones.

The wail of Butterfield's harmonica, the raw virtuosity of Bloomfield's guitar, and the highballing rhythm combined with the high-volume amplification had listeners shouting, cheering, and dancing. Photos show the Cambridge coffeehouse mafia—Eric Von Schmidt,

Geoff and Maria Muldaur, Dick and Mimi Fariña—enthusiastically getting down to the beat. "I was almost jumping out of my skin," Maria recalls. "I was so energized and electrified by the music. From the first note I was a goner. I just thought it was the best stuff I had ever heard." Geoff went even further:

> To me, the Butterfield Blues Band was the most important thing to happen at Newport in 1965. . . . The thing that happened that changed the world map of music was that an integrated band came in from Chicago to play real Chicago blues. Sure, that model was based on guys like Muddy Waters, but the fact was that this white guy was so good, and had a band that could pull it off and hold their own among the kings, which they did. In the blink of an eye, there would be two hundred thousand blues bands in the world based on that model.

Rothchild, who was producing the band's first album, argued that "Born in Chicago" represented a new fusion: "the songwriter tradition and the roots tradition. That's what we saw in the Beatles, the same phenomena." Dylan was not at the workshop but told a reporter for *Time* magazine who briefly caught up with him on the festival grounds, "For me right now, there are three groups: Butterfield, the Byrds, and the Sir Douglas Quintet."

In hindsight, it is interesting to find him linking three such different groups—a Chicago blues band, a group of recently electrified pop-folkies, and some Texas honky-tonkers jumping on the British Invasion bandwagon—and the reporter followed his quote with the note, "I couldn't tell if he was putting me on." Whether he was or not, the combination suggests another reason why traditionalists found the Butterfield Band disconcerting: all those quotes place it in a fundamentally different category from other blues artists—alongside the Righteous Brothers, the Beatles, the Stones, the Byrds, and Sir Douglas—but the only thing those

groups had in common was that all were white and popular. As a later writer, David Dann, put it, Butterfield and Bloomfield blew everyone's minds because "all that embellishment and improvisation—elements fundamental to much of African American music—was being created by two white kids. Translation: People *just like us*." In some ways it was similar to the excitement young New Yorkers felt when the New Lost City Ramblers won southern banjo and fiddle contests, but it was also fundamentally different—the Ramblers were firm traditionalists, traveling south to record older musicians and backing Maybelle Carter, Cousin Emmy, and Eck Robertson, and no one was comparing them to the Beatles and Rolling Stones.

There were plenty of listeners who appreciated Son House, Cousin Emmy, and the Ramblers and also enjoyed the Butterfield band and Dylan's new rock hits, but it is easy to understand why some folk fans feared their idyll was threatened. Aside from qualms about commercialism, one could love the electric excitement of contemporary rock and blues and nonetheless feel it was wrong for Newport. When the Butterfield Band returned to the Bluesville stage on Saturday, it was in more congenial company, following a mix-and-match jam session of coffeehouse blues innovators including Von Schmidt, Koerner, Tony Glover, and members of the Kweskin Jug Band. This time there was no friction among the bluesophiles, but Maybelle Carter and Mike Seeger were in the midst of an autoharp workshop when Butterfield hit on all six cylinders, and, to quote the notes of a Vanguard Records annotator faced with the result: "At this point on the tape, an electric blues band begins to play on the stage right next door, making the remainder of this acoustic material inaudible."

Most festivalgoers were unaware of the conflicts, but some tempers were fraying, and behind the scenes Lomax sought to staunch the commercial flood at its source. According to Boyd, he called an emergency meeting of the board—carefully omitting Yarrow—and they voted to ban Grossman from the grounds, both for attacking Lomax and because he was rumored to be bringing in illegal drugs. (Grossman

was a connoisseur of marijuana, and the rumor was probably accurate, but he was hardly alone—the Cambridge contingent were notorious vipers.) However, "when the verdict was delivered to Wein for implementation, he reconvened the board and explained the facts of life." To wit, Grossman was the manager of Dylan, Odetta, Ian and Sylvia, Mimi and Richard Fariña, Gordon Lightfoot, the Kweskin band, and Peter, Paul, and Mary—and if he was ejected, he was likely to take his clients with him.

The board backed off, the festival continued as planned, and if Dylan had not had any bright ideas, the kerfuffle between Lomax and Grossman would likely have been forgotten. As it was, Dylan was inspired by the presence of the Butterfield band, and although Grossman seethed more privately than Lomax, many insiders suggest that their fight left him itching to stick it to the folk establishment. When Grossman ran into Al Kooper on the festival grounds, the last piece of the puzzle fell into place. As always, the stories intertwine and details are fuzzy, but a rehearsal was convened for Saturday night, with Dylan, Kooper, Bloomfield, and the Butterfield rhythm section.

Chapter 9
YOUNGER THAN THAT NOW

Eric Von Schmidt was on the main stage Sunday night, armed with his trusty guitar and surrounded by a gaggle of Kweskinites. It was by far the largest audience he had faced, seventeen thousand people rather than his usual seventy-five or a hundred fifty, but he was treating it like he treated every gig, as a chance to hang out with some friends and make some music, take some chances, let it be whatever it was going to be. He opened with "Grizzly Bear," an African American work song he had learned from a Texas prison-camp recording made in 1951 by Pete and Toshi Seeger. It was an outlaw ballad, or maybe a protest song: the grizzly bear could be a particularly tough convict or a particularly pitiless guard. The leader would sing a line and the other workers chimed in:

He come a-huffing and a-blowing like (Grizz-a-lee Bear)
He come a-walking and a-talking like (Grizz-a-lee Bear)
He had great long tushes like (Grizz-a-lee Bear)
He had big blue eyes like (Grizz-a-lee Bear)
He had great long hair like (Grizz-a-lee Bear)
Oh the grizzly, grizzly (Grizz-a-lee Bear)

Von Schmidt had added a guitar part and recorded the song on his Folkways debut in 1961, and it became his trademark—to the young denizens of the Cambridge coffeehouses, the grizzly bear was Von Schmidt

himself, with his shaggy beard, snaggly teeth, and the wild look in his
eyes. Dylan recalled showing up on his doorstep on a rainy day, joining
the ongoing party, then wandering down to the Club 47 to hear him sing
the song, caught up in "the glad, mad, sad, biting, exciting, frighten-
ing, crabby, happy, enlightening, hugging, chugging world of Eric Von
Schmidt . . . a man who can sing the bird off the wire and the rubber off
the tire . . . the why of the sky and the commotion from the ocean."

At Newport, with Fritz Richmond's washtub bass thumping behind
him and Geoff Muldaur's guitar chopping counter-rhythms and bending
high notes to match his falsetto holler, Von Schmidt was as wild and
loose as ever, growling, howling, romping and stomping. Then he broke
in on himself, testifying like a southern preacher:

> I'm gonna tell you people about something! I heard this song
> a long time ago, about five years ago. Yes, the "Grizzly Bear."
> And I knew about it when I heard it, but I didn't know who
> wrote it. And it turns out the man who wrote it was singing it
> last night, when he was chopping down a crazy old stump up
> on this stage. Man's name is R. G. Williams, boy! He knows
> about the grizzly. *YEEEEEEE-OOOW*, LORD!
> I mean a great, big grizzly, grizz-a-lee bear—
> Yeah, that's Newport!
> Great, big grizz-a-lee—
> If you can't do something like that, you just don't *come*!
> Don't come to Newport if you don't want a few surprises!
> WOOOOH, LORD!

There was a lot happening that weekend, and the problem was how to
keep up with it, drink it in, and avoid thinking too much about what you
were missing. Friday morning, if you wanted to see that Texas work-song
group, you could have gone to the workshop on Negro Group Singing
and Rhythmic Patterns and caught them along with the Moving Star Hall
Singers, the Mississippi fife and drum group, and the Chambers Brothers,

who according to the *Patriot Ledger* "showed rock 'n' roll is probably here to stay." But then you would have missed the blues guitar workshop Mike Bloomfield was hosting with Lightnin' Hopkins, Reverend Gary Davis, Son House, Mississippi John Hurt, and John Koerner. Either of which would have been a dream for any blues fan, but there was also the string band workshop with the Kweskin Jug Band, the New Lost City Ramblers, Sam and Kirk McGee, the Lilly Brothers, and Bill Monroe's Blue Grass Boys. And if that weren't agony enough, there was Broadside: Past and Present with Mance Lipscomb and the British folklorist and singer A. L. Lloyd providing the past and Donovan, Len Chandler, Mark Spoelstra, and Guy Carawan exploring the present. Besides which Seeger had come up with the idea of an all-day Ballad Tree where the expected performers included Hurt, Joan Baez, Maybelle Carter, Ian and Sylvia, Jean Ritchie, the Irish singer Margaret Barry, Newfoundland's Arthur Nicolle, and a red-haired newcomer named Norman Kennedy on his first trip out of Scotland.

Dylan was not yet on the grounds that morning. He seems to have arrived sometime Friday night, though no one remembers for sure, because he apparently went straight to his room, or at any rate someone's room, maybe with Bob Neuwirth, maybe with Albert Grossman recounting the tussle with Lomax and the brilliance of the Butterfield Band. The first official sightings were on Saturday, when he was scheduled on the Contemporary Songs workshop.

The Newport workshops were originally intended to present music interspersed with educational discussions and demonstrations, but by 1965 most people simply thought of them as mini-concerts. There was a dance workshop on Saturday where a hundred festival-goers learned clogging and contra steps, and others showcased specific instruments or approaches, but in general they were just settings where performers could swap songs in a more intimate and casual way than on the big stage. They were particularly suited to quieter styles and artists who might not be comfortable singing in front of a large crowd, and gave listeners a chance to sit up close and have the sense of visiting an old fiddler or bal-

lad singer and hearing a few tunes on a front porch. As a student from
New York explained, "You listen to people like Son House and you're
out in this grass and everything and you almost think you're back in the
places where these people live and then some seagull starts yelling, or a
jet goes by, or a whistle blows from Newport and it makes you realize
that they are here and you're not there."

A typical workshop would have anything from fifty to a few hundred
listeners sitting or lying on the grass, and for some performers even that
was a daunting multitude. Norman Kennedy recalls the fear he felt when
he saw the crowd at the ballad stage and the added pressure of being
seated next to the legendary Maybelle Carter. Ralph Rinzler suggested
he close his eyes and pretend he was alone, and he remembers, "I shut
my eyes and I sung 'Barbara Allen,' and when I opened my eyes, she was
leaning against me, and she had her hand on my right knee, and she was
looking up in my face. And she says, 'Why, son, I know that story too.'"

The workshops were supposed to provide small, precious moments
like that: a South African pennywhistler exchanging tunes with a Missis-
sippi fifer; Son House and Mance Lipscomb playing an impromptu duet;
or Pete Seeger watching the Texas work-song group chop a log while
singing call-and-response lyrics, then "swinging a mean axe himself, bit-
ing out big chips in expert fashion in time to his own work song." At
any moment between eleven in the morning and five in the afternoon
there would be a half dozen workshops going at once, and on Friday they
drew a total of between 3,500 and 4,000 people over the course of those
six hours. By contrast, the big evening concerts on the main stage were
packed with a sold-out crowd of fifteen thousand, with another two to
four thousand listening from the parking lot. The small daytime turnout
was intentional—in 1964 the crowds had often felt overwhelming, and
in 1965 the board decided to have most of the workshops focus on par-
ticular traditional instruments and styles, signaling that they were meant
for serious devotees. One reporter described the experience of wander-
ing from stage to stage, "trying to catch the things that seemed worth-
while or interesting," and occasionally stumbling across an additional,

impromptu offering—an early morning jam session at the Bluesville stage with Lafayette Leake, Willie Dixon, Bruce Langhorne, Odetta, and the Nigerian drummer Hassan Rarak trading choruses of "Back Home Again in Indiana," or the Cape Breton troupe wandering off after their scheduled workshop to continue singing at the edge of the field: "It was one of the wonderful experiences that occur just now and then at a folk festival . . . old men with wonderfully wrinkled and furrowed faces, faces formed by the wind and weather, sitting on the grass and singing for the pure delight of it, not caring if anyone listened."

The same reporter noted that on Saturday the crowds were larger and most people were looking for more modern styles. At the Bluesville stage he found "just a handful listening to a traditionalist," and an hour later "a throng gathered to hear and cheer Eric von Schmidt or some other popular exponent of the City Blues." As for the Contemporary Songs workshop:

> It was quite an experience to be standing in a distant corner of the field and see a cloud of dust moving in the general direction of what is known officially as Area II. (That's where Contemporary Songs was taking place.) Immediately the question arises: "Who is it that has caused this great migration? Who has sent the tribes trekking across the desert?"

In that instance the reporter concluded it was Ian and Sylvia, but they were appearing toward the end of the workshop, and it seems likely that much of the horde was in search of Dylan, who was on after them. He was also scheduled at the Ballad Tree, but that was just a gnarled oak, not a proper stage, and it soon became obvious that the location could not accommodate his audience. So, while the other stages drew their coteries of dedicated listeners, the crowd in Area 2 swelled to between five and seven thousand.

Considering the extent to which the commercial folk world was turning toward young singer-songwriters, the exceptional attendance at their showcase was not surprising, and some people felt Newport was

giving them short shrift. The traditionalists continued to think of urban performers as simply bait to attract audiences for real folk music, but others—Peter Yarrow in particular—argued that these songwriters were the authentic folk artists of their time and place. The old model had made sense when urban singers were just interpreting rural traditions and could be seen as a bridge to more authentic artists: if you liked the Kingston Trio, you should hear Frank Proffitt; if you liked Baez, you should hear Almeda Riddle; if you liked Dave Van Ronk, you should check out Lightnin' Hopkins. But for people who liked the current Dylan, Donovan, or Len Chandler, there was no similarly obvious connection to older tradition bearers. Depending on your definition, you could say they were creating modern folk music or deny that their work belonged in the folk category, but either way they were doing something essentially new and different, and Yarrow strove to convince the other board members that they deserved more space: "I didn't think it was appropriate for the people like Joan Baez and Bob Dylan, and Peter, Paul & Mary to draw these huge crowds and not acknowledge the new urban singers that were coming up through the ranks." Supported by Seeger, he managed to get more bookings of up-and-coming songwriters and a New Folks concert on Sunday afternoon, but traditionalists continued to dominate the workshop schedule, and the Contemporary Songs lineup was the only opportunity on Saturday for young fans to see a bill of performers who looked like them and sang about what they were experiencing in their own lives.

As a result, that workshop would likely have been the morning's most popular event even if Dylan had not been involved. The other options were International Songs, Folk Wind Instruments, children's music, and a blues bill including Hopkins, Lipscomb, and House—but the hardcore blues fans had already seen those artists on Friday, and even some of them were ready for a change. Geoff Muldaur recalls that Newport daytimes were always full of wrenching decisions, but that particular morning, "My calendar was marked for Dylan." For a lot of people, it wasn't even a decision: Friday's workshops had drawn four thousand people, but Saturday drew close to nine thousand, and the numeric difference

neatly matched the number of listeners clustered in Area 2, suggesting that many had showed up solely for that event.

The contemporary showcase was an acknowledgment of shifting trends in another way as well: it was the first time Newport had presented a songwriters' workshop that did not focus on topical material. There were a few political lyrics, but more songs of love and heartbreak, alienation and rambling, modern blues, and comic novelties. The presentation was also different: at other workshops the performers tended to sit together and trade songs, but each of the contemporary artists or duos did a self-contained, four-song set, and the order of play roughly reflected their current popularity. Patrick Sky, a bluesy songwriter from Georgia, started things off, followed by a one-song cameo by Pete Seeger, then Gordon Lightfoot, a newcomer who had not yet released his first album but was attracting attention with his composition "Early Morning Rain," which Ian and Sylvia had made the title song for their most recent LP. Then came Eric Von Schmidt, Richard and Mimi Fariña, an unscheduled set by Richie Havens (opening with "Maggie's Farm"), a three-song interspersion by Ronnie Gilbert of the Weavers (including "Masters of War"), then Donovan, Ian and Sylvia, and Dylan.

Taken on its own, this lineup suggested the way the urban folk scene was changing. Sky and Von Schmidt were folksingers in the old sense, immersed in rural traditions and equipped with large repertoires of blues and ballads that they interspersed with their own compositions. Donovan had started out with similar tastes, but five thousand miles across the Atlantic he was getting the music as an exotic import, had been instantly noticed by canny television presenters, and with his first single was established as Britain's sensitive teen-beat folk poet. He was enjoying the chance to see people like John Hurt up close, hang with Dylan and Baez, and get a taste of the American scene, but the first thing Robert Shelton noted about him when they met early that morning was his look: sunglasses, desert boots, washed-out blue corduroys, gray turtleneck, suede jacket, and a gold earring given him by Jack Elliott's old banjo-playing

partner, Derroll Adams. Donovan was eager to talk about Adams, whom he regarded as a mentor and model of honest Bohemianism, but Shelton was more interested in talking about folk-rock, and noted Donovan's opinion that "everything should be fused."

That was another divide between the Contemporary Songs workshop and the workshops on traditional styles. When other stages mixed artists from Britain, Canada, and various regions of the United States, the point was to show their philosophical kinship as guardians of community lore and wisdom, but also to highlight the differences and particularities of each tradition. By contrast, the contemporary workshop was all about fusion and mixture, both onstage and off—Donovan's voice had Dylan's inflections on one song, Bert Jansch's on another, and Buffy Sainte-Marie's on a third, and Shelton observed that backstage Baez and Yarrow were adopting Donovan's English accent.

Richie Havens was another apostle of fusion—when his first album appeared two years later, it was called *Mixed Bag* and included a moody reading of "San Francisco Bay Blues" along with songs by Dylan and the Beatles, backed with acoustic guitar, electric instruments, and sitar—but as a black folksinger he was something of an anomaly in the singer-songwriter wave, and although he had been knocking around the Village for years as a poet, painter, and musician, he would not break out until 1967, when Albert Grossman signed him and provided access to a major label and a broader public. For the time being Grossman was still following the path he had blazed with Peter, Paul, and Mary, and the contemporary showcase exemplified his current interests: four of the seven scheduled acts were in his roster.

Lightfoot was one of Grossman's recent signings, a Canadian songwriter who had studied orchestral arranging and worked as a jingle writer in Los Angeles in the late 1950s, then moved back to Toronto and formed a pop-folk duo, spent a year in England hosting the BBC's *Country and Western Show*, and was now emerging as a solo artist. He would soon become a major star in Canada, but it would be another five or six years before he took off south of the border, hitting in the

early 1970s along with the wave of soft-rocking, country-influenced art-
ists that included James Taylor and John Denver. Interviewed by Shelton
that morning, he said he was "aiming at a new thing . . . in the area in
between folk and country," listed his main influences as Dylan, Bob Gib-
son, and Hank Williams, and mentioned a Toronto supporter who called
his style "Country and Lightfoot." He was glad to be there, but clearly
did not want to be typed as a folksinger.

If one wanted a familiar touchstone for Lightfoot's work, the obvious
choice at that point was Ian and Sylvia, Canada's most popular ambas-
sadors to the US scene. They had moved to New York and signed with
Grossman in 1962 and were a hit of the 1963 Newport Festival with their
tight harmonies, bluegrass-flavored guitars and autoharp, and astute mix
of Canadian ballads, cowboy songs, and touches of blues. They had roots
in both the traditionalist and pop-folk camps, and Grossman advised
them to sign with Warner Brothers and go for the big time, but they
opted instead for the more "classy" Vanguard label, which had done so
well for Baez. As a result they established a solid reputation on the col-
lege circuit, but the label never pushed their singles or got their records
on mainstream radio, and although both were strong songwriters, their
hits went to other artists: Bobby Bare put Ian's "Four Strong Winds" on
the country and pop charts, running neck and neck with Johnny Cash's
version of "It Ain't Me Babe," and as they arrived at Newport Sylvia's
"You Were on My Mind" entered the *Billboard* Hot 100 in a folk-rock
version by a California group called We Five, appearing thirteen posi-
tions above "Like a Rolling Stone" at number 78, and would continue
to rise alongside Dylan's disc into the Top 5. Later that year they would
adopt a more electric sound, but their new style never really took off, and
Ian later recalled 1965 as the end of the folk boom, the year "the Beatles
wiped us all out."

If Ian and Sylvia saw their star fading with the folk-rock trend, Gross-
man had another golden couple in the wings. Richard and Mimi Fariña
were Newport naturals: Mimi was Joan Baez's sister, which got her auto-
matic entrée to the pantheon, while Dick was a known songwriter in the

Broadside clique—Joan had sung his "Birmingham Sunday" at Newport in 1964—and a rare innovator on a resolutely traditional American folk instrument, the Appalachian dulcimer. He was connected to both the Cambridge and New York scenes, having been married to Carolyn Hester when she was recording her first Columbia album and later cutting a duet album in London with Von Schmidt (both projects incidentally including Dylan as a sideman). A charmer and hustler, he is remembered by virtually everyone as dashing, handsome, funny, talented, and absolutely set on becoming a star, whether as a singer, writer, or adventurous jack-of-all-trades. Half-Irish, half-Cuban, he claimed connections with the Irish Republican Army and the Cuban revolutionaries, ran with the bulls in Pamplona, and wrote articles on the youth scene for *Mademoiselle,* as well as staking a solid literary claim with his college novel *Been Down So Long It Looks Like Up to Me.* His musical skills were limited but distinctive: he tended to recycle old tunes and relied more on driving rhythms than intricate melodic lines, but with Mimi playing counterpoint on guitar the Fariñas were strong instrumentalists, and Shelton noted their broad range of influences, writing that one of their pieces "fused bouzouki, sitar and hillbilly sounds." Their first album had appeared in April and, along with Anglo-Irish melodies, vaguely Middle Eastern textures, and lyrics that explored contemporary themes in language reminiscent of medieval balladry, included two tracks with electric guitar, piano, bass, and a rock 'n' roll beat.

The Fariñas were still relatively unknown when they arrived at Newport, and Dick in particular saw it as their big chance. Mimi was happy to go along, but with somewhat mixed feelings—she loved Dick and the music they were making together, but was also an idealistic Baez, intensely aware that Dylan's star trip had been hard on her sister and that Joan and their parents, who had come to watch her big debut, considered Dick a go-getting opportunist. It was a complicated moment for the couple, both professionally and emotionally, and the proof of that came within minutes of their arrival, when Mimi saw the half-page ad for Grossman Management, Inc., in the Folk Festival program and found

that Dick had signed them up as clients without consulting her. "I was very angry," she told David Hajdu. "He didn't handle it honestly." But she added, "I understood why he did it. He wanted us to make it and start making some money, and he saw going with Albert and going to Newport as the big moves to do that."

A third move was to make sure their Newport performances attracted attention, which Dick planned to do by adding percussion and electricity. At the Contemporary Songs workshop, Dylan's presence would guarantee a large crowd and presumably a decent proportion of fans who liked the electric style, but the schedule was tight and Yarrow kept them to the duo format. The Fariñas nonetheless opened with the blues-rocking "One Way Ticket," though it sounded a bit thin without the band, and their set included "Sell-Out Agitation Waltz," one of Dick's more intricately Dylanesque exercises in social criticism: "Cut your hair and never stare at people who ain't aware / That every morning they wake up dead." They got closer to a full-band setup a couple of hours later at Jean Ritchie's dulcimer workshop, with Bruce Langhorne playing tambourine and Al Kooper on guitar—and Dick significantly introduced Langhorne as "the lead electrical guitarist on the last Bob Dylan record, *Bringing It All Back Home*," rather than mentioning his appearance on their own disc. The Fariñas' rock session had preceded Dylan's, but it was obvious who was setting the pace, and Dick would later complain about the pressure "to move as quickly as he does."

As for Dylan himself, he looked hip and handsome that afternoon in a dark purple shirt, a loose black suit jacket, tight black jeans, and black leather boots with pointy toes and inch-and-a-half heels. His new look clearly pleased some fans more than others, with one student reporter lamenting that he had "drawn to himself the whole shebang of the teenage rock and roll revelers whose screams and squeals of ecstasy as the performer came on stage were all too obnoxiously apparent." He opened with a work in progress, a version of the song he would record the following month as "Tombstone Blues," but without a chorus and set to a moody, droning melody rather than the biting blues-rock of the final

take. The crowd seemed to enjoy the surrealist lyrics, laughing audibly at some lines, but Shelton was unimpressed, describing it as "draggy."

Dylan followed with more familiar fare, the romantic "Love Minus Zero/No Limit" from his last album. A breeze had picked up, blowing away the fog and relieving the muggy closeness of the morning, and his high tangle of hair trembled in tandem with the waving leaves and branches behind him. "If You Gotta Go, Go Now" failed to get the usual laughs—the sunny outdoor setting didn't suit the late-night theme—but the audience was enthralled and attentive. A tapestry of faces stretched across the field, filling every patch of grass, crowding together and leaning forward to see the tiny figure onstage and catch his words through a sound system designed for far smaller crowds.

The program was already running late, and behind the low wooden stage Eck Robertson and other old-timers could be seen unpacking their instruments, shifting and whispering as they waited to start the fiddle and mandolin workshop. Dylan sang an appropriate closer, "It's All Over Now, Baby Blue," thanked the crowd, and tried to leave, but was met with a wave of applause that showed no sign of dissipating and angry shouts for his return, so Yarrow brought him back for an encore. There were a couple of calls for "Mr. Tambourine Man," then a flood of requests for "Rolling Stone"—as well as one for "Happy Birthday," which got a chuckle from Dylan, who seemed amused by all the shouting. "This is a good one, you'll all like this one," he said, and despite another few shouts of "Rolling Stone!" launched into "All I Really Want to Do." The first line was greeted with far louder applause than his previous selections, suggesting that some listeners were pleased to hear a hit they recognized from Cher and the Byrds.

Dylan was still drawing his old fans and remained a favorite with the Newport regulars, but he was also bringing in a new crowd. All through his set the photographers swarmed around, clambering on the snow fence behind him, mounting a corner of the platform where he stood, kneeling in the grass, adjusting telephoto lenses. Murray Lerner's film crew made sure to capture his face up close and to shoot the crowd from behind him,

silhouetting the slim, black-clad figure with the guitar against the multitudes in their light-colored summer clothing. He was not only the most famous performer at the workshop and by general agreement the most talented; he looked and sounded different. Everyone else was still in folk mode, dressing in work clothes or Bohemian casual, and their voices were gritty like old rural singers or smooth like concert professionals. Dylan's voice had a cutting edge, the sound of his old blues style sharpened with the cool assurance of an artist at the top of his game, still raw, still abrasive, but absolutely, definitively his own. You could love that sound or hate it, but you could not deny its uniqueness.

Two hours earlier Pete Seeger had stood on the same stage and performed one of his quietest, simplest compositions: "One grain of sand," he sang, in a slightly quavering tenor, "one drop of water in the sea / One grain of sand—one little you, one little me." He was carrying on as ever, bobbing on the Newport tide. He had started Thursday night, playing banjo for the Blue Ridge Mountain Dancers and presenting the Reverend Gary Davis, hosted the workshop on group singing styles on Friday, then showed up at the banjo accompaniment workshop, urging young players to simplify their styles. He pointed out that Frank Proffitt's version of "Tom Dooley" was played with only one chord, and B. F. Shelton had recorded a version of "Darling Corey" in 1928 that used just two notes to accompany the verses—it was also the version he had recorded on his first solo album back in 1950, but he did not mention that, instead interrupting himself to comment on the passing seagulls: "They make pretty good music, too." That evening he was on the main stage, jamming on blues banjo with Lafayette Leake and Willie Dixon—he and Dixon had appeared with Memphis Slim at the Newport Jazz Festival three weeks earlier, where he also performed "Summertime" with a five-piece jazz band—and playing a closing set that culminated with Baez, Donovan, Mary Travers, and George Wein joining him on "This Land Is Your Land."

That set included some of his usual sing-alongs—"It Takes a Worried Man," "Oh, Mary, Don't You Weep"—as well as a banjo instrumental, "Coal Creek March," which he introduced by saying: "You know, all the

streams of folk music in our land sometimes remind me of a lot of trickling little mountain streams that are off the beaten track, and people rush by on the superhighway, and they never really see them close to, where they're so pretty. It's like this song—" He played a bit, then added, "It really does trickle on, it doesn't have any ending," and continued his thought:

> All those little streams of folk music, all through the country, just trickling on. And they're not drying up yet, they're just way back in the hills, or back in the corner of someone's memory. Right here in Newport, you can find Portuguese people that remember the old Portuguese songs. (A small cheer from the audience saluted the local Portuguese.) You can find, in every city of our country, little trickling streams of music.

The streams flowed on through the weekend: ballads, autoharps, fifes, folk dancing, dulcimers, harmonicas, string bands, work songs. A final afternoon workshop of British singers was hosted by A. L. Lloyd, who had teamed with Ewan MacColl to found the British folk club movement in the 1950s—a photo from 1962 shows him smiling broadly behind the young Bob Dylan, an American visitor to their Singer's Club in London. Lloyd was pleasantly surprised by Newport, telling Shelton he had been prepared for "a big circus," and the reality was "much more agreeable than expected"—though he added that in Britain they distinguished folk from pop and topical songs and that Donovan had nothing to do with his world.

Lloyd also led a British contingent on the Saturday evening concert, but was unenviably sandwiched between an electric blues set by Lightnin' Hopkins, natty in a thin-lapelled plaid jacket and dark glasses, and the Kweskin Jug Band's psychedelic retro goodtime show. "Droll pixies," the *Providence Journal* called the Kweskin aggregation, and "a kind of folknik American answer to the Beatles. . . . Operating often in a ragtime idiom, these lads and a lass poke gentle fun at a good many of the more intense preoccupations of folk partisans and make a sound very

much from Coney Island instead of their native Boston." The evening's
big surprise was an unscheduled appearance by the South African "King
of Kwela," Spokes Mashiyane, there on Seeger's invitation and playing a
set of pennywhistle jive accompanied by Pete on banjo, George Wein on
piano, and Sam Lay on drums. The *Patriot Ledger* wrote that he got the
only standing ovation of the evening with his "swinging shepherd beat"
(a reference to a jazz flute hit from 1958, "Swingin' Shepherd Blues").

Meanwhile Dylan was making plans for his own surprise. The idea of
putting a band together may have struck him when he heard that Bloom-
field and the Butterfield crew were at the festival, or may have been a
last-minute decision on Friday evening, or even sometime Saturday. A
couple of people remember Grossman flying Al Kooper in from New
York at Dylan's behest, but Kooper writes that he was already there and
indeed came every year: "Whatever your musical proclivity . . . Newport
was one of the nicest social gatherings you could possibly attend. Most of
the musicians from downtown made the pilgrimage annually, and it was
like a Greenwich Village block party moved to the seaside." He was wan-
dering the grounds with his wife on Saturday when Grossman accosted
them, handed him a pair of backstage passes, and said that Dylan wanted
to get together that evening.

The rehearsal took place at Nethercliffe, the Newport mansion that
served as a dormitory, dining hall, and central meeting place for festi-
val staff and performers. Kooper was on keyboard, Bloomfield on gui-
tar, Lay on drums, and Jerome Arnold on bass. Barry Goldberg may
have been there as well—he had come to the festival to play piano with
Butterfield, but this had been vetoed by Rothchild, who wanted a more
stripped-down sound, and he was pleased to be added to the Dylan group
that finally appeared—but he thinks he only joined them Sunday at the
sound check. Bloomfield and Kooper had played on the "Like a Rolling
Stone" session, but Arnold and Lay had to be brought up to speed. Lay
recalled that he had heard "Rolling Stone" on the radio and liked it, but
when he was invited to the rehearsal his first reaction was, "Who the
hell is Bob Dylan?" Arnold was unfamiliar with both the singer and the

song, and seems to have found the whole situation confusing. According to Kooper, it was nonetheless "pretty fun . . . a good rehearsal"—and he wryly added, "It was a lot better than the show was." Bloomfield by contrast recalled that Arnold couldn't get the chords straight, and the whole thing was a disaster: "We're practicing there in a room, and Odetta's staring at us, and Mary Travers is there, and we're playing and it's sounding horrible."

Bloomfield admired Dylan's lyrics and vocal style—he would later single him out as one of the few white artists who could really sing blues—but was bothered by his offhand way of working with a group. Recalling their recording sessions over the next month, he complained: "We just learned the tunes right there, he sang and we played around him. He never got with the band so that we could groove together. . . . He always seems to be fighting the band." At Newport they had the added problem that it was late at night, everyone was tired, and a couple of the musicians were Chicago bluesmen who had never played that kind of music. Dylan nonetheless seems to have been exhilarated by the chance to plug in and make some noise, and after the other musicians left he kept going. A reporter who stopped by the house at 4:30 a.m. described the scene for the *Providence Journal*: Odetta, wearing a white Mexican wedding dress, "bounced up and down, striking a tambourine while a thin man named Bobby Dylan, standing in high-heeled boots to match his long hair, blasted away on an electric guitar." Dylan seemed oblivious of everything around him, ignoring Odetta and refusing to take a phone call from Baez. "No one knew what to make of the situation. Bobby Dylan pounding away as if he were a rock 'n' roll idol. Facial expressions. His gyrations. Roaring amplifiers. 'This is folk music?' someone asked."

The Weins were up as well and seem to have accepted it all as normal festival craziness. They had hosted an after-concert party until 2:30, and now George "sat in another room, nursing a drink, fighting off exhaustion," and talked with the reporter about perhaps doing a weeklong festival in 1966, with the extra days dedicated to traditional

artists, "for the real folk aficionado." Then they went upstairs to call the nearby police departments and check if there were any problems—it was a quiet night, but residents had been complaining about visitors sleeping in cars and yards, and the police were cruising around, "sending the youngsters on their way." Joyce Wein was downstairs, serving drinks, peanut butter, potato chips, Marshmallow Fluff, and cold cuts to the guests who were still up, and said she would be there till dawn, then have to deal with breakfast. "By that time," the article concluded, "the fog would have lifted, and Bobby Dylan would have turned into a folksinger once again."

Chapter 10
LIKE A ROLLING STONE

Sunday dawned muggy and overcast, and the morning religious concert was sparsely attended. The Moving Star Hall Singers led off, followed by Maybelle Carter, Viola James from Mississippi, and Roscoe Holcomb, joined on his last song by Jean Ritchie. Ritchie remained onstage to sing "Brightest and Best of the Suns of the Morning," and the *Providence Journal* reported that "by a strange coincidence a foghorn down by the Naval Training Station was so coordinated . . . that it came in with a mournful blast at the end of each bar, hitting almost exactly the same note as Miss Ritchie did." Reverend Gary Davis followed her, announcing, "I didn't come up here to give you something draggy and slow," and preached a high-energy version of "If I Had My Way," his rhymed retelling of the Samson and Delilah story. Then the Charles River Valley Boys played country gospel, the Cape Breton singers mingled their harmonies, Son House sang two a cappella selections, the New Lost City Ramblers backed Cousin Emmy, and the Chambers Brothers provided a shouting finish with "I Got It," getting the crowd on its feet and clapping along.

The afternoon would be dedicated to the New Folks concert, and Peter Yarrow wanted to do a proper sound check for the Butterfield Band, so to clear the audience away from the main stage a panel discussion titled "The Scholar and the Performer" was convened on the Bluesville platform with Alan Lomax, A. L. Lloyd, Charles Seeger, and the African American

folklorist Willis James. Yarrow's logistics were complicated by the weather—it had been cloudy for most of the weekend, and by noon the sky was looking ominous. No one wanted to present an electric band in the rain, but they hoped for the best and got the levels set for Butterfield. Yarrow had wanted to do Dylan's check at the same time, but after the all-night jam there was no way he was going to be available that early, so it was postponed until the break between the afternoon and evening concerts.

The New Folks showcase was Yarrow's particular baby, a chance to present performers who were neither well-known stars nor hallowed tradition bearers. The lineup overlapped Saturday's Contemporary bill, including Patrick Sky, Gordon Lightfoot, and the Fariñas, but it also included acoustic blues from John Koerner, topical songs from Mark Spoelstra, old-time country music from Byron and Lou Berline and the Charles River Valley Boys, sweet harmonies from Kathy and Carol, and Hamilton Camp presenting a theatrical set that included the recent Herman's Hermits hit "Mrs. Brown, You've Got a Lovely Daughter." In the normal course of events the Chambers Brothers would have been the biggest news—they brought Baez up to join them on "Just a Closer Walk with Thee," and the *Journal* called them "Mississippi's answer to the Beatles" and described the crowd's enthusiastic response as proof "that many in these audiences are willing to forsake folk music for the big beat." However, the Fariñas also aimed to inject some rock into their show and got an added boost from chance and the elements. They had planned a set that would gradually add musicians, and Barry Tashian, who played in a popular Boston rock band called the Remains, recalled showing up with his guitar amp only to have Yarrow veto it as too complicated for the sound setup. Yarrow nonetheless introduced the Fariñas as pioneers of "a very beautiful new musical form . . . one of the new definitive directions that the new folk music is taking," including "electrified instruments, which is something that's becoming of course more and more widely used and acclaimed and—not destroyed [presumably meaning "destructive"]. Of course you know that Bobby, Bobby Dylan, has used them on his last album."

The Fariñas were joined by Fritz Richmond on washtub bass and "tambourine king Bruce Langhorne" on percussion—Langhorne was widely rumored to be the inspiration for "Mr. Tambourine Man"—and Dick once again noted that he had played guitar on the last Dylan LP. They opened with a seven-minute instrumental medley driven by Dick's rhythmic dulcimer, then brought Baez up to sing harmony on his best-known topical song, "Birmingham Sunday." That was a sure hit, and they continued to build with the high-energy "House Un-American Blues Activity Dream," adding another Boston rocker, Kyle Garrahan of the Lost, on harmonica. It was during that song that they noticed some audience members looking restless and getting up to leave. "We were angry," Dick recalled. "We thought people were leaving because they didn't like us." Then he saw a flash of lightning and realized it was starting to rain.

The group played on, finishing to enthusiastic applause in what had become a downpour, and Dick leaned into his vocal mike, yelling "Wait! Wait! Wait! There will be more!" Yarrow came on, calmer, saying, "Right. Come on back, come on back," then yelling to the crew: "Move this whole thing back, all the mikes and everything." Turning to the crowd, he explained, "While we get the mikes set up out of the rain so they won't be clobbered, I want to make one point very clear: It is *not raining*!" This was greeted with a mix of cheers and boos, and he went on: "It's just—it's very simple. God was very moved, and he's weeping a bit. This number we hope will placate him, as soon as the mikes are set up." It took another minute or so, but then the Fariñas were back, dedicating the next song "to the memory of the Beach Boys" and surging into "Leaving California (One Way Ticket)." Dick urged the crowd: "Stand up and dance, right! It'll make you feel good."

Pete Seeger described the next few minutes as "a sight I'll never forget in all my life":

> Seven thousand people were getting soaking wet and they said, "What the heck, let's get wet." They started stripping off their clothing and dancing to the music. It was a real rocking number

with wonderful rhythm going. And there were people waving their shirts in the air and dancing all kind of dances, women had stripped off their shirts, dancing in their bras. It was pandemonium. Seven thousand people dancing in the thundering rain, and Dick and Mimi pounding on. It was wonderful.

With more hindsight, Joe Boyd made an obvious analogy: "The images that would become rock festival clichés in the ensuing years—young girls dancing in flimsy tops made transparent by the rain; mud staining the faces of ecstatically grinning kids—made some of their earliest appearances during the Fariñas' set that afternoon." In its documentary footage, *Festival!* captures vignettes: the sound crew crowding the stage, moving microphones out of danger, bringing blankets to cover amps. Ralph Rinzler stands behind the Fariñas, shielding them with an umbrella, as they segue into "Reno, Nevada," another upbeat boogie. Richmond thumps his washtub bass, Langhorne beats his tambourine, Garrahan leans into the mike to blow his harp. Baez is doing the frug with a Chambers brother; Paul Stookey is clapping along. The rain pours down and the listeners are dancing, smiling, covering their heads with shirts and blankets, many of them still in their sunglasses.

For a finale the Fariñas were joined by Baez and a crowd of other performers and led the crowd in "Pack Up Your Sorrows," Dick urging, "Let's sing the sun back out." The rain had stopped as quickly as it started, and the audience was wringing out clothing and daubing off seats. It would have been a fine, dramatic end to the afternoon, and many people remember it that way: David Hajdu writes that Theodore Bikel congratulated the Fariñas backstage, saying that the evening program would have to be canceled because of the weather, but their set was "a perfect way to end the festival." Boyd writes, "As we called time on the Fariñas, a rosy light bathed the western sky. Within ten minutes of the end of the concert, the downpour had ceased, a rainbow appeared following the clouds eastwards and the site glowed in soft evening colors." In fact, Bernice Reagon followed the Fariñas with an a cappella set, the

Newport Daily News writing that she got "the drenched audience clap-
ping and stomping accompaniment." Yarrow returned to explain that
the Butterfield Band could not perform on the wet stage but would play
a special opening set before the evening concert, and asked everyone to
spread the word that the show would start fifteen minutes early. Then
the Charles River Valley Boys sang "Swing Low, Sweet Chariot" and
finished the afternoon with four bluegrass numbers.

The crowd headed off to grab some dinner, and Dylan arrived for
his sound check. He was dressed more strikingly than ever, in a pista-
chio poet's shirt with large white polka-dots and flaring sleeves. Barry
Goldberg, who was going to play piano while Al Kooper manned the
Hammond B3, recalls sitting on the organ bench smoking a cigarette
while Dylan fooled around at the keyboard, playing a rock version of
"This Land Is Your Land." "It was really loose, and then we had a
regular sound check which was really a lot of angst, with Peter Yar-
row screaming, and it was very uncomfortable, and he was bad-vibing
the whole thing." Jonathan Taplin, a teenager recently hired by Albert
Grossman to do gofer work, has a similar recollection: "It was com-
pletely chaotic—you know, none of this was planned. It wasn't like
Dylan had an organized crew who would set up amplifiers. To be hon-
est, nobody there knew what the fuck they were doing when it came to
doing electric music onstage. . . . They would play a verse and a cho-
rus, and then they would stop, and Peter Yarrow was running around
yelling at everybody, and Dylan was not taking it seriously at all, and
neither was Bloomfield."

Some of this was caught on film, and Yarrow certainly seems agitated,
but it's hard to blame him—he's shirtless, in sunglasses, trying to hold
things together and get the microphones sorted out while the musicians
simultaneously try to get their parts straight. "Hold it, gentlemen, no
noise now," he cajoles, then insists: "It is *essential* that you get your lev-
els for your instruments, and for your amplifiers, and get them into your
heads!" The players run through the chord progression of "Like a Rolling
Stone," sounding pretty good, Sam Lay keeping the beat, Jerome Arnold

accenting the root notes, Paul Rothchild acting briefly as bandleader, emphasizing how they should play a chopped phrase going into the chorus: "bah-bah-bah-bah, bah!" Paul Butterfield sits on an amplifier off to one side, smoking a cigarette, looking bored. Dylan is clearly getting antsy, sighing theatrically, "Oh, man," as yet another problem comes up, and mimicking the repeated calls for masking tape.

Boyd recalled that he and Rothchild were at the soundboard with Grossman, a couple of hundred yards out in the seating area, and were particularly meticulous about Dylan's levels, marking the volume and equalization for each channel with fluorescent pink marker so they could check them in the dark.

> Back onstage, I asked each of the musicians if they were happy with the positions and levels of their amplifiers. There were no stage monitors in those days and no direct feed of electric instruments into the sound system; a mic had to be placed in front of each amp to pick up the signal. I outlined the position of amps and microphones and the settings of the dials with the pink marker. The sound we rehearsed had to be there from the first note. When the stage was cleared and the gates opened to the public, none of us left in search of food: we were too charged up with adrenalin to be hungry.

The concert was scheduled to begin at 8:00 p.m. and much of the audience was still drifting in when Yarrow came to the microphone around 7:40. "Tonight's concert is beginning early for a very specific reason," he explained:

> There was the intervention of the divine spirit this afternoon: He wept, tears of joy. It rained, but we did not admit that it was in fact rain. And for many reasons—primarily because the group would be electrocuted—the group that was supposed to go on could not play, 'cause they're playing electric instruments.

Most of you have heard them at some time or other during the weekend. They have been accompanying everybody, they have been very much involved in the festival as a whole, which is a credit to each of them. However, they are *not* sidemen, although they will be seen later this evening accompanying Bob Dylan. They are tonight accompanying themselves and the person who is in fact the leader of the group. Ladies and gentlemen, please welcome with us—with me—Paul Butterfield!

Aside from Sam Lay, the Butterfield players had not done much mingling that weekend, and Yarrow's introduction suggests he was trying to appease doubters and prove the band belonged at Newport. Judging by the welcoming applause, he need not have worried. Butterfield opened gently, singing a slow "Blues with a Feeling," and when he finished the clapping was mixed with cheers and whoops. They followed with a rocking harmonica feature, "Mellow Down Easy"; showed off Bloomfield's slide guitar on "Look Over Yonders Wall"; cooled the mood with a soul-jazz instrumental, Cannonball Adderley's "Work Song"; and finished with "Born in Chicago." By that time they had a good crowd—in the *Festival!* film sequence, shot over the shoulder of Butterfield's corduroy jacket, the seats are filled to the back of the field. Butterfield rocks back and forth, his harmonica punching, fluttering, and soaring like a tenor sax. Arnold sways behind him, Bloomfield hunches his shoulders and jabs his chin, firing sharp clusters of notes. Their set lasted almost twenty minutes, and Butterfield thanked the audience over appreciative applause punctuated with shouts of "More!"

Seeger came to the microphone and, after thanking Butterfield, set the scene for the weekend's final celebration:

As those of you who've been around for four days know, we've had more variety of music here than probably in any festival anywhere in these states. We've had axe-choppers from Texas; we've had people singing in Gaelic from Cape Breton Island,

up in Nova Scotia; we've had people from California and Georgia, from city and country; we've had people who play the shouting blues and people who sing the low, sad, quiet songs; we've had young, we've had old. And why have we done this? Because we—and when I say "we," I mean the whole board of directors of the Newport Folk Festival—believe in the idea that the average man and woman can make his own music in this machine age. It doesn't all *have* to come out of a loud-speaker. And you *can* make it yourself, whether you want to shout or croon, sing sweet or rough. And it can be your own music—and when I say "your own," it's the music of your own kind, whether it's your family or your town or your region, your race or your place, your religion, or wherever it is.

Now here you are, all seated out in the open, looking out over the lights of Newport. You see the big smokestack over there, you see the naval base here, and if it was a little bit clearer, not so foggy, you could see the ocean beyond. And we, as musicians, are always looking out beyond. We like to look beyond some of the sordid things up close, to see the beauties a little bit beyond. But tonight I've asked all the performers, young or old, to keep in mind something. In that building over there by the right, it's a hospital, and wives of the naval personnel go there when they have babies. . . . And in a sense, all the songs tonight, I've asked them to sing with an idea they're singing to a new member of the human race. What kind of a world are they going to live in, when they're grown up and we're old and gray?

Pete's sister Penny and her husband, John Cohen, had a new baby, and Pete held a tape recorder up to the microphone to play "a little universal folk music," the sound of tiny Sonya gurgling and crying. The audience applauded, and he continued his meditation:

You see, this little baby is kind of wondering what kind of a
world it's coming into, and you and I gotta help think about it,
too. What kind of bombs have we got hanging over its head?
What kind of pollution are we putting in its air and in its water?

And with that, he introduced the evening's first scheduled performer,
Mance Lipscomb, "a man whose music is really the roots of the city rock
'n' roll, it's the country blues." A seventy-year-old Texas farmer with a
varied repertoire of ragtime, pop, and blues songs, Lipscomb performed
a fourteen-minute set ranging from the ragtimey "Truckin' My Blues
Away" to a nostalgic "Shine On, Harvest Moon" and the slide guitar
moan of "Motherless Children."

Eric Von Schmidt was next, opening with a seventeen-second surre-
alist ode to the father of the hydrogen bomb, warbled in mock madrigal
harmony with Fritz Richmond: "Edward Teller told me yesterday that his
eyebrows were not real." They were joined by Geoff Muldaur for "Griz-
zly Bear," then by Maria Muldaur and Mel Lyman for a romantic blues,
"My Love Come Rolling Down." At that point Von Schmidt was signaled
to get offstage—each set was supposed to last about twelve minutes—
but, encouraged by the audience's enthusiastic shouts, he led the group in
an a cappella Bahamian chantey, "Out on the Rolling Sea."

"Fiddler" Bob Beers with his wife, Evelyne, and their daughter, Mar-
tha, were next, playing early American music with fiddle, banjo, and
psaltery, a large, plucked ancestor of the harpsichord. Their gentle set
was followed by the evening's most popular newcomer, Cousin Emmy,
a country legend who had been recorded by Alan Lomax in 1947, was
introduced by Mike Seeger as "the first hillbilly performer to ever own a
Cadillac," and had become a regular attraction at Disneyland. Described
by one reviewer as "a stage-cured ham with fluorescent blonde hair and
a fluorescent smile," she gave an ebulliently crowd-pleasing set backed
by the New Lost City Ramblers, frailing her banjo, singing a lovelorn
"Pretty Little Miss in the Garden," sawing a fiddle instrumental, blow-

ing bluesy harmonica on "Lost John," slapping the melody of "Turkey in the Straw" on her cheeks, and finishing with another banjo piece— meanwhile assuring all her "friends and neighbors" that their reception was just wonderful and filled her "full of vinegar!" It was gorgeously hokey, and the audience cheered and shouted for an encore, but the evening had to keep moving.

"Cousin Emmy's a gas, right?" Yarrow asked, then answered himself: "Right." He had to kill some time while the crew changed the stage setup, and he knew a tough moment was coming: the previous year he had faced an angry crowd that wanted more Dylan, and now the night's most popular performer was about to come up in an even less appropriate time slot, partway through the first half of the evening, again sandwiched between other artists. To make matters worse, Dylan had been clear about his displeasure: "He was affronted," Yarrow recalls. "He noted that people were gonna be very angry, 'cause there were gonna be some people who would miss him, and they would be angry because the implication was that he was being disrespected." Yarrow had tried to placate him, explaining that they wanted to avoid a celebrity billing system, but Dylan said he was just going to play the three electric songs he had rehearsed, and that would be that—so Yarrow had no recourse except to try to dampen the audience's expectations. "There's someone that's coming on to the program now—" he began, then interrupted himself: "As a matter of fact, the entire program tonight was designed to be a whole group of small performances. . . . We are all limited in the time that we can be onstage, for a very specific reason: the concept of the program tonight is to make a program of many, many different points of view." He emphasized again that the set lengths were limited for everyone, including his own group, of course, which would be playing later.

By now the amps were humming, and the musicians were coming onstage. Bloomfield plugged in his guitar and checked his tuning, and Yarrow protested, "Please don't play right now, gentlemen, for this second." Bloomfield plucked a few more notes. Then Yarrow went into his formal introduction:

The person that's coming up now is a person who has in a sense [he was interrupted by a loud electric buzz] changed [more buzzing] the face of folk music to the, to the large American public [a guitar string plinked], because he has brought it, to it, a point of view of a *poet*. Ladies and gentlemen, the person that's gonna come up now has a limited amount of time [by now the crowd knew who was coming and reacted with derisive howls]. His name [cheers, shouts, and whistles] is Bob [more cheering] *Dylan*!

The applause built as Dylan came onstage, then faded to a low murmur as the musicians tested their instruments. Dylan strummed a few chords, and Bloomfield instructed Yarrow: "Put that up, man. Give Bobby a little more volume on that one." Kooper played a burst of organ. Goldberg noodled for a moment on the piano. Dylan strummed his bass strings. "You want it louder?" Yarrow asked, and Bloomfield suggested, "More treble," then murmured to Dylan: "Start it." Dylan blew his harmonica into the vocal mike and began strumming again. "More, a little more," Bloomfield instructed Yarrow, then: "OK." By now Dylan was setting a steady rhythm, Lay came in behind him on the drums, and Bloomfield shouted like he was jumping on the running board of a getaway car—"Let's go!"—and locked into a catchy backing riff. Dylan listened for a few seconds, getting the feel of the band, stepped to the microphone and blew a note, as if checking to see how it would sound, then stepped back again, looking around at the musicians and the crowd. Bloomfield fired off a quick series of bent notes and Dylan glanced over at him, nodded, shrugged his shoulders loose, and looked back at the other players. He was dressed in a leather jacket, shiny in the lights, and a salmon-colored shirt buttoned tight at the neck. His jeans were tight and black above his black cowboy boots, and his guitar was a solid-body Stratocaster with a two-tone sunburst finish. The lights picked him out, alone, front and center, the other players shadows in the darkness behind him. He listened a moment more, feeling the power of the band, then stepped to the microphone and sang a single line: "I ain't

gonna work on Maggie's farm no more." Stepping back, he listened again as Bloomfield came in with a sharp answering passage, and let the rhythm carry him another moment before stepping up and repeating the phrase. Bloomfield answered again, and he listened a moment more before surging into the verse: "Well, I wake up in the morning, fold my hands and pray for rain, / I got a head full of ideas that are driving me insane."

Yarrow crouched in the background, fussing with the sound cords and making minor adjustments to the amplifiers. Bloomfield stood in the darkness to Dylan's right, lit momentarily by flashes from the photographers in the pit below. Dylan's voice alternated with Bloomfield's guitar fills, tight and raw. Between each verse, Bloomfield came in for a break, playing by feel, not sticking to any particular pattern, tearing off high screams, pounding bass notes, clusters of dissonant noise, then locking back into the repetitive riff that signaled Dylan's next entrance. He wasn't just accompanying Dylan; he was dueling with him, challenging and urging him on. Dylan howled into the last verse: "I try my best to be just like I am, but everybody wants you to be just like them." He turned back to Bloomfield, who stepped forward, hunching over his guitar, wagging his head with his solo. Dylan faced him, chopping out the rhythm, then turned back to the band, nodding for them to bring it home, strummed a last few chords, and was done.

With the last notes of "Maggie's Farm," we leave the realm of history and enter the realm of myth. Some spectators recall the crowd exploding in boos, some recall cheers, some only shocked silence. There are stories of Seeger striding the backstage area with an axe, threatening to cut the sound cable, or huddled in his car, in tears, unable to face the death of his dream. Some recall Dylan in tears as well, ending his set early and disappearing while the crowd screamed in anger or disappointment and Yarrow begged him to return, then finally coming back onstage, contrite or defiant, with an acoustic guitar borrowed from Yarrow or Johnny Cash, to sing a wistful or bitter farewell.

Some recollections can be confirmed or disproved—Dylan played a particular sequence of songs and was on and off stage for measurable

periods of time, and some of the crowd noise was caught on tape—but
there were upward of seventeen thousand people in the audience, with
every seat and space on Festival Field filled and another two to four thou-
sand listening from the parking lot. What anyone experienced depended
not only on what they thought about Dylan, folk music, rock 'n' roll,
celebrity, selling out, tradition, or purity, but on where they happened
to be sitting and who happened to be near them, and in the end the dis-
putes and conflicting memories may count for more than the evidence
preserved on tape and film—some of which must also be taken with a
grain of salt, since film clips were edited to heighten the drama of the
moment, splicing in the clamorous crowd noise from the beginning or
end of Dylan's set to augment the relatively low-key response captured by
the stage microphones after that first song.

For people standing near the stage, the biggest problem was the
sound—Bill Hanley, who designed and supervised the Newport system,
explains that the stage was raked, slanting toward the audience and
driving the roar of the instrument amplifiers directly into the faces of
the people up front, while Dylan's voice was only coming over the field
PA speakers, off to the sides. As a result, the privileged listeners at the
musicians' feet and backstage got the full blare of the instruments, and
many recall Dylan's singing as virtually inaudible. Out in the crowd the
sound was better—Hanley was a pioneer of outdoor audio and says the
system was capable of handling far louder bands than Dylan's—but it
still varied somewhat depending on how close one was sitting and was
much louder than most listeners were used to, nor were many people in
those days familiar with the intentional distortion of overdriven guitar
amps. Some were thrilled, some panicked, all were startled. "It was
very emotional," recalls Peter Bartis, now a seasoned folklorist, but
then a fifteen-year-old who had lied to his parents and hitchhiked to
Newport for the day. "Some people were cheering, some were booing.
Some were crying, they were really freaked out. I kind of liked it, but it
was confusing."

What survives on tape and film is a concentrated distillation—the

only microphones were onstage, the cameras were trained on Dylan—but still gives a powerful sense of the chaos and excitement: Dylan's appearance is greeted with fervent applause, gradually dying down over the next fifty seconds, as the band gets organized. They play "Maggie's Farm," stretching the song to five minutes, ending with a Bloomfield burst, a thump on Lay's drums, Dylan murmuring, "Thank you very much," and a final drumroll under shimmering organ. The applause is strong under the closing notes, but dies within seconds of the finish.

Rather than going right into the next song, there is a pause while Kooper switches from organ to bass and Goldberg takes over the B3. Arnold was having trouble with the unfamiliar material, and got through "Maggie's Farm" by sitting resolutely on one chord, ignoring the rest of the players' changes. "Like a Rolling Stone" was a more complicated song, and since Goldberg had received an advance copy of the record from Bloomfield and knew Kooper's organ part, they decided to make the switch. The instrument trading is a bit tricky because guitar cords get tangled, and there is a brief scuffle to straighten them out, during which a female voice from the crowd can be heard yelling, "Beatles! Do the Beatles!" Kooper plucks a few notes. The stage lights are up on the band, and Kooper is standing behind Dylan wearing sunglasses and the same polka-dot shirt Dylan had on earlier. Dylan blows a few notes of harmonica, checks his tuning, says "OK," and plays the opening chords, his back to the audience, waiting for the other musicians to fall in with his rhythm. It takes another twenty seconds, and he seems puzzled, walking toward the microphone, backing off and looking over his shoulder, opening his mouth to sing, backing off again, then finally spitting out the first phrase: "Once upon a time you dressed so fine, threw the bums a dime in your prime, didn't you?"

It is a hot night, and the sweat gleams on Dylan's face. He had never performed the song in public and muffs a couple of lines, but in the close-ups he looks calm and in control. The band backs him solidly, sticking close to the recorded arrangement. Dylan's lyrics are the focus, and there are no solos, though Bloomfield comes in for a moment at the end, sound-

ing like he's ready to take off, before Dylan turns back to the group and signals the finish. Bloomfield is clearly upset, saying, "I didn't know you were ending there. I thought you were—" Yarrow's voice cuts in: "Mike! Mike! Mike. Mike. Bring your volume down a little on your guitar, it's sounding too—" The audience is applauding, but after ten seconds it has quieted down except for some indistinct yelling. Dylan strums. Kooper checks the organ. A lone voice of protest rises out of the crowd, a woman shouting, "Bring back Cousin Emmy!" There are some scattered boos, more yelling, and Dylan, off-mike, says, "Phantom Engineer"—the working title of a song he would reshape and record on his next album as "It Takes a Lot to Laugh, It Takes a Train to Cry." There is some confusion onstage, indistinct murmurs ending with Bloomfield explaining, "It's a straight shuffle." Then Bloomfield tears into a backing riff, the guitar louder than ever and ragged with distortion, urged on by Kooper's organ, repeating the pattern until Dylan comes in, his drawling cool matching Bloomfield's electric energy. It's a strong start, but halfway through the first verse things fall apart—the rhythm is indeed a straight blues shuffle, but the bar count gets quirky three-quarters of the way through each verse, with Dylan extending a phrase longer than expected, then coming back early to the regular pattern. Arnold is completely lost, missing the change and turning the beat around so that he is accenting differently from the others, and Dylan tries to adapt and compensate, and that confuses everybody else. Bloomfield cuts in for a break and the energy comes up, but his solo stays on the root chord, not bothering to follow the verse pattern, Arnold is still in his own world, and the tricky measures in Dylan's next verse trip them up again. Bloomfield takes another solo; they make one more try at a verse, almost getting it this time; Bloomfield cuts in with his longest, hottest solo as Kooper wails behind him on organ, then Dylan brings the song to a patchy close, barking, "Let's go, man, that's all." Bloomfield sounds surprised, saying, "That's it?"

The audience has not heard their murmured interchange and waits quietly, then starts screaming and booing as Dylan unplugs his guitar and leaves the stage, followed by the other musicians. Yarrow steps to

the microphone, still wearing his dark shades and looking tired and worried. The crowd is going wild. "Bobby was—" he begins, then pauses, summoning his resources: "Yes, he will do another tune, I'm sure, if you call him back." Dylan's set has lasted seventeen minutes, a bit over the normally allotted time, but included only three songs and a lot of dead space, and the crowd is full of people who came to Newport specifically to see him. There is no way they are going to let him get away that easily, and they meet Yarrow's challenge with a frenzied mix of boos, applause, whistles, and shouts of "More!"

On film, Yarrow looks understandably harried. "Would you like Bobby to sing another song?" he asks, as if there were any question. He raises his arms, encouraging the applause. Then: "Listen, it's, it's the fault of the—" he cuts himself short, realizing he was about to blame his fellow organizers, then goes on, "He was told that he could only do a certain period of time." He looks off to his left, saying, "What?" From the sidelines, George Wein's voice reassures him: "He's gonna do one more." Back on mike, for the public benefit, Yarrow asks, "Bobby, could you do another song, please?"

The audience is still yelling, and Yarrow tries to cool them with a touch of hipster slang, unwittingly launching one of the evening's most persistent legends: At the side of the stage, too far off-mike to be heard clearly, there is aggravated chatter, and someone—it sounds like Wein again—says loudly, "Leave that one alone, Pete," followed by an indistinct response in Seeger's familiar timbre. At roughly the same moment, on the microphone, Yarrow is trying to reassure the audience and says, referring to Dylan rather than Seeger, but using a jazz musician's term for the guitar, which some audience members clearly misconstrued: "He's gonna get his axe."

The crowd meanwhile has begun a rhythmic chant: "We want Dylan! We want Dylan!" Yarrow responds: "He's coming," then, as the chanting continues, "He's gotta get an *acoustic* guitar." The chant is now backed with rhythmic clapping, interspersed with whistles. "Bobby's coming out now," Yarrow says again. "Yes, I understand, that's the case: 'We want

Bobby.' And we *do*. The time problem has meant that he could only do these three songs." There are more yells and the stentorian bellow of an irate folk fan: "Tell him to get a wooden box!" (Presumably meaning a hollow-bodied wooden instrument.) Another voice yells "Boo!" Yarrow soothingly responds, "He'll be out as soon as he gets his acoustic guitar." Cheers suggest that Dylan has been spotted, but quickly die down, and the shouts of "We want Dylan" rise again, broken by a louder male voice yelling, "We want the old Dylan," and a female voice echoing, with emphasis, "We want the *old* Dylan!" Apparently encouraged, the male voice yells, "We want Pete Seeger!" The woman echoes this cry as well, then Dylan is spotted: someone yells, "He's got it"; a voice offstage says, "Coming through"; and a last, angered male voice bursts out of the crowd: "Hey, come on, we paid for this!" Then Dylan is onstage, carrying a Gibson Southern Jumbo and greeted by wild applause.

Dylan was only offstage for two minutes, but it seemed much longer—some witnesses swear it was ten or fifteen—and he is clearly irritated. People are yelling, one woman encouraging him, "Stay all night Bob," another echoing: "Cancel the rest of the program!" He moans off-mike, "I can't believe this, man—can't believe what you're doing to me," then, more clearly: "Hey, Peter, you got another guitar, man?" It is not clear what is wrong with the Gibson, but Yarrow responds, "All right, I'll get you another one." Another minute passes, with Dylan plucking notes, tuning, blowing a few harmonica blasts, and pleading, "*Please*, can I have a different guitar?" Eventually Yarrow comes back with his own Martin D-28S, but then Dylan asks for a capo. The crowd is restless, yelling indistinct comments. One male voice cuts through: "Throw away that electric guitar. Damn!" Others respond: "Shush!" "Yeah!" "No!"

Dylan has been back for a bit more than two minutes, but has made no attempt to address or even acknowledge the clamor. Finally he blows a couple of harmonica chords, begins strumming a regular rhythm, and launches into "It's All Over Now, Baby Blue." Cheers greet the first notes of melody, and more are heard as he starts singing, "You must leave now, take what you need, you think will last."

It is a fierce performance, every line clearly enunciated, and the words are a bitter testament and farewell: "The empty-handed painter from your streets is drawing crazy patterns on your sheets / The sky too is folding over you." Dylan finishes to overwhelming applause, which this time does not die down, and starts to leave the stage, then returns to the mike and, as the cheering subsides, asks if Yarrow or someone backstage has a harmonica in the key of E. No one does, apparently, and he says, "Look in my case, man." Someone in the audience yells, "Do 'Tambourine,' Bobby!" and others take up the call: "Tambourine Man!" Dylan responds, "OK, I'll do this one for you," drawing wild cheers. There is more strumming and yelling—a man shouts, "I don't like your band!" A woman shouts, "Be quiet!" It has again been a couple of minutes since the last song. Dylan repeats, "All right, I'll do this one for you now," and starts playing a steady, loping rhythm, but instead of singing he just plays for a while, then asks over the microphone: "Does anybody have an E harmonica? An E harmonica, *any*body!" He pauses for a moment. "Just throw them all up." Harmonicas rain on the stage, and Yarrow bends over and hands one to him. "Thank you very much, man," Dylan says.

"It's an F, man, it's an F," Yarrow warns.

"OK," Dylan says, moving his capo up a fret. "Thank you very much." He starts blowing the first notes of "Mr. Tambourine Man," greeted by enthusiastic shouting and applause. It is a more subdued performance, but his voice is strong and he seems to be savoring the words, phrasing with particular care and gentleness. His face gleams with sweat. The song lasts five and a half minutes, then Dylan says "Thank you very much," and leaves the stage, Yarrow bidding him farewell over thundering applause: "Bob Dylan, ladies and gentlemen. Thank you, Bob. The poet, Bob Dylan. Thank you, Bob."

Dylan's set left some listeners thrilled, some baffled, some fascinated, some angry at him, some angry at other listeners. Whatever one's opinion, the naysayers have some facts on their side: The band was underrehearsed, and even if one thinks the first two songs sound great, "Phantom Engineer" was a high-energy train wreck. Aside from the music, Dylan's

performance was halting and disorganized, and he made no attempt to engage with the audience, to excuse the problems, or to distract from the confusion. His set lasted roughly thirty-five minutes, longer than anyone else's that night, but that included two minutes when he was offstage and eight when he was onstage tuning, waiting for the other guys to get ready, waiting for a new guitar, a capo, a harmonica, looking back over his shoulder, complaining, or simply strumming disjointedly and playing an occasional note on the harmonica.

The Newport audience was used to waiting patiently while old men set up hammer dulcimers or scraped through obscure fiddle tunes, and exulted in unrehearsed finales with performers crowding the stage to sing freedom songs. But Dylan's set was something different, and to many listeners it seemed like a deliberate affront or betrayal. Leda Schubert, a self-described Dylan fanatic who had followed him from his first album, says she was "stunned." She had always considered him an antidote to commercial acts like the Kingston Trio and Peter, Paul, and Mary, and now, "I thought Dylan was abandoning us. . . . I remember wandering through the crowd, sort of at loose ends. . . . Dylan was all of a sudden wearing a black leather jacket, and it was LOUD. I think I stayed for a while and then wandered off in some sort of daze."

Backstage, the feeling of betrayal was even stronger. Harold Leventhal recalled, "When Bob went up to the stand I was at the steps. He said to me then, 'Where's Pete Seeger?' I said, 'He's around somewhere.' And when he got off the stand he said to me, 'Where's Pete Seeger?' I almost said to him, 'You don't want to know.'"

Wein recalls that as the set began he was standing at the far left of the stage with Yarrow, Bikel, Grossman, and Seeger, and "at the sound of the first amplified chords, a crimson color rose in Pete's face, and he ran off."

The rest of us were just as shocked and upset—except, perhaps, for Grossman, who must have relished the moment. . . .
After a few excruciating minutes, someone tapped me on the shoulder. "Pete's really upset. Maybe you should talk to him."

I found Pete sitting in a parked car in the field behind the
stage.

"That noise is terrible!" he cried. "Make it stop."

I said: "Pete, it's too late. There's nothing we can do."

Others remember Seeger taking a more active role. Boyd writes that
Lomax, Bikel, and Seeger confronted him backstage, demanding he give
Rothchild an order from the festival board to turn the volume down.
He struggled through the crowd to the sound booth, which was over
to the left of the stage, and found Grossman, Yarrow, and Rothchild
there, "grinning like cats." When he delivered Lomax's message, Yar-
row responded that the volume was where the musicians wanted it and
the board was "adequately represented at the sound controls," and as a
return message he offered his raised middle finger. Rothchild recalled
Seeger himself showing up at the booth, "towering over us by a foot, eas-
ily, just screaming and threatening," and Yarrow saying, "Pete, get away
from here or I'll fucking kill ya."

The reports are contradictory and confusing—Rothchild was also the
one person who claimed to have seen Pete with an axe—but everyone
remembers Seeger's consternation. Yarrow describes him as "apoplectic,"
and Bikel recalled him saying, " 'I feel like going out there and smashing
that fucking guitar'—language quite out of character for Pete." Mika See-
ger remembers her father "rushing around unplugging things," and her
mother trying to stop him: "She was hollering at him, 'Just calm down,
Pete. . . .' We didn't see him lose his cool very often, but when he did, he
really did. He was totally unreasonable. . . . It kind of drove him over the
edge 'cause nobody would listen to him." She insists, though, that the
issue was the volume: "My father wasn't against electronic instruments.
He kept saying 'Turn it down!' He wasn't saying 'Turn it off.' "

For people who had never heard a loud rock show—which is to say,
almost everyone there—the volume was shocking, exhilarating, or excru-
ciating. "It was Godawful loud," Maria Muldaur recalled. "To me it was
exciting . . . but lots of people just freaked out. They just couldn't stand

it." Sylvia Tyson placed herself in the latter group: "The sound levels were totally fucked," she recalled, adding: "It could have been great, and it wasn't. . . . They played *badly*. They played so loud you couldn't hear them." The musicians tended to be clustered in front of the stage, and many agreed. According to Eric Von Schmidt: "It looked like he was singing with the volume off. . . . I was one of the first people that started hollering, 'Turn up Dylan's mike, turn down the guitar!' "

> It was obvious that Bloomfield was out to kill. He had his guitar turned up as loud as he could possibly turn it up, and he was playing as many notes as he could possibly play. . . . "Maggie's Farm" was one of my favorite Dylan songs, but Bloomfield couldn't have cared less whether they were playing "Maggie's Farm" or "Old McDonald Had a Farm." It was just his moment to scream.

Bloomfield's buddy Barry Goldberg says he can understand Von Schmidt's reaction: "He really was playing loud, and almost like maliciously, you know, trying to shove it down their throats, like, maybe—he had a little bit of that in his personality—'I'll show these motherfuckers.' " On the other hand, Bloomfield's playing on Butterfield's sets was just as ferocious, and everyone, including Von Schmidt, had applauded him for it. Fierce guitar solos were basic to Chicago blues, and Goldberg adds, "Maybe he was just getting off."

Bloomfield recalled being thrilled by the show and mystified by the reaction:

> I thought we were boffo, smasheroo. After it was over, I said. "Bob, how do you think we did?" And he said, "They were booing. Didn't you hear it?" I said, "No, man. I thought it was cheers." He didn't seem pissed, he seemed perplexed. He was a guy with a hit single, and they were booing him.

On the tape it is hard to hear much booing during the electric show—in part because the stage microphones were turned down to deal with the volume, so very little crowd noise came through—but almost everyone in the audience remembers it. Some have tried to quantify the reaction, saying half were cheering and half booing, or the proportions were sixty/forty, or eighty/twenty, or a third were booing, a third applauding, a third shocked, or that just a few were booing, but those few boos were so surprising that they got blown out of proportion—as Maria Muldaur pointed out, any negative reaction was astounding, "because every other time we'd seen Dylan perform it was like he was God and could do no wrong." In that huge crowd, no one was hearing anything but the people in their general area, so even if everyone remembered accurately, it is not surprising that reports would differ. It is not hard to find people who were troubled by Dylan's embrace of rock 'n' roll or felt it was inappropriate to bring his new style to Newport, even if in hindsight it is far easier to find people who say they were excited—and some of the reactions were sparked by factors other than what Dylan was doing onstage.

Eighteen-year-old Judy Landers and her boyfriend Herb Van Dam had been looking forward to the festival for months, and though they wanted to take in the whole scene, Dylan was their top priority. They enjoyed the crowds and craziness, collected photographs and autographs—pictures with Phil Ochs, Mary Travers, and Paul Stookey, of Donovan cadging a bite of Judy's pizza, and of "the wonderful Pete Seeger"; bits of paper signed by Von Schmidt, John Koerner, Odetta, and Theo Bikel—and sat through a lot of music, some of which they loved and some of which annoyed them. Like a lot of young fans, they were caught up in the buoyant spirit of the urban folk boom, but less interested in archaic rural traditions: "We were disgusted with some of the evening concerts," Landers wrote in her scrapbook, "because we didn't dig the old timers who couldn't sing or the wood choppers or the Cape Breton singers. They were truly a great part of folk singing, but not for us!!" They had spent the first two days asking other celebrities where Dylan was—Butterfield

was unresponsive, Baez said he had a cold—caught his Saturday after-noon set and got some great pictures, and Sunday they were primed and ready. At least they thought they were, until they heard him being intro-duced partway through the first set:

> Everyone expected Bob to appear last, so they were all eating and getting beer. Well, he came on 2nd. Thousands of people tried to rush back to their seats, thereby blocking everyone who was sitting down. Hundreds stood in the aisles. There he was at the culmination of everything clad in a black leather jacket with Paul Butterfield's Band behind him & an electric guitar. We had planned, when he was through to clap + clap for more, but as soon as he started to sing "rock" & kept look-ing back at his band, Herby just bowed his head. I had an awful sad feeling & ½ the crowd began to boo. . . . After 3 songs, he left the stage. 16,000 people came to see him & he left after 3 songs while Cousin Emmy did 10!! He came back + after much booing tried to find a regular guitar + harp—he couldn't. Finally he did & had to tune the guitar. He sang "Mr. Tambourine Man." I was glad he picked that one—it brought him ½ way back into my good graces.

Other people were happy with Dylan, but horrified by the audience. Anne O'Connell, a young fan on her second trip to Newport, says that in 1964 she and her friends had enjoyed all the music, but "this time we were all there to see Bob Dylan. Anyone else was gravy." They had heard "Like a Rolling Stone" on the radio, and when he came out with the band, she "really loved it. I don't remember the sound being terrible. . . . It was just really loud to me, which I liked."

> When people started booing I remember being somewhat astounded. I couldn't believe that people were being so rude. . . .

By the third song, the crowd felt really angry to me. . . . When Dylan walked off I was furious. I believed at the time that it was the rudeness of the crowd that drove him away, so my anger was not at Dylan. His coming back and doing a couple more songs didn't help. It seemed as though he'd given up and was playing things the angry crowd wanted to hear. I don't remember the next musicians well. I was very distracted and incredibly disappointed that we'd waited all day and then been so cheated. The last thing I remember clearly is Peter, Paul and Mary. I liked them a lot but I wasn't in the mood. People lit candles and were waving them around to one of their songs, which made me angry all over again. I thought that they were stupid and could only digest simple songs with simple melodies. We left before their set was over.

Alan Lomax, writing to a friend a few days later, reported that Dylan "more or less killed the festival," coming onstage "all in motorcycle black, in front of a very bad, very loud, electronic r-r band," then walking off "after four numbers, no word of which could be understood, to one single hand-clap of applause." He described the audience as sitting, "terrified and silent," until "George Wein shooed him back onstage with an acoustic guitar. Then he spent ten horrifying minutes changing guitars, hunting for his old harmonica, tuning up, while 16,000 people watched in horrified fascination." Finally, he finished his set, and "as soon as he did 4000 people rose as one man and left the grounds. Everyone else was gutted, and the rest of the evening was shambles. . . . That boy is really destructive."

Wein was waiting at the wings when Dylan came off with the band:

I said to Bobby, "You gotta go back out there and sing an acoustic song. We're gonna have a riot if you don't."

He said, "I don't have a guitar."

I turned around: "Does anybody have a guitar for Dylan?" And of course twenty guitars went up in the air.

Arnold Reisman, who was backstage reporting for the *Patriot Ledger,* described Dylan giving a more dramatic answer: "They don't want me out there."

Everyone agrees that Dylan was startled by the audience's response, but as with so much else that evening, the reports of his reactions are contradictory. A couple of people who had telephoto lenses trained on his face insist he was crying, but the film close-ups suggest they were probably seeing sweat, and Bernice Reagon insisted he was not: "He came offstage, and we were together, and so I totally reject that analysis." Dylan told Anthony Scaduto, "I did not have tears in my eyes. I was just stunned and probably a little drunk." Yarrow describes him as angry rather than sad—"unrepentant, unapologetic, and really pissed off," demanding, "What have you done to me?" Yarrow took this to be a reference to the board giving him such a lousy time slot, but Dylan made a different accusation in an interview a month later, saying, "They twisted the sound. They didn't like what I was going to play and they twisted the sound on me before I began."

With all the complaints about the sound, this reaction seems reasonable—except that almost without exception those complaints came from the people backstage and musicians standing up front. Not a single reviewer mentioned problems with the sound system or any trouble hearing Dylan's vocals, though most described the negative response of the crowd. According to *Billboard,* "Shouts from non-Dylan attendees that he go back to the 'Ed Sullivan Show,' or that he shun the electric guitar, brought cheers," and the *Newport Daily News* reported that as the band left the stage "there were numerous shouts for him to come back alone and to 'throw away that electric guitar.'"

As to the show itself, the reviewers had mixed reactions. The *Patriot Ledger* described Dylan leaving the stage after his electric set "bitter and dejected . . . in a torrent of mixed boos and yeas," but concluded: "It wasn't folk, but his music was good, nevertheless." *Billboard* countered its report of booing by adding, "With the air of one who relishes controversy, he soon had the crowd in his palm. A particularly moving rendition of his 'Tambourine Man' brought it to its feet with cheers for more."

The folk press was equally mixed. Phil Ochs weighed in with a mocking review in *The Realist*:

> Some booed, some cried, some yelled "Take it off," but most just sat silently in a state of shock sucking on crumpled beer cups. I was expecting God to open the heavens with his wrath, but instead Peter Yarrow embarrassingly brought Dylan back, and he obligingly played two encores alone on an acoustic guitar, the band apparently having been slaughtered beneath the diamond stage by unforgiving Dylantants.

Broadside reported that Dylan took the stage to "fanatic screaming," but his "black leather sports jacket, red shirt, tapered black slacks and electric guitar startled some in the audience and dismayed many." The writer noted "loud jeering and cat-calls from some parts of the audience. Then a regular battle between boos and cheers." She thought Dylan was "obviously quite perturbed, the first time I have seen him so in front of an audience," but when he returned for the acoustic songs, "once again he had the oldtime thunderous near-unanimous applause. All in all, it was a dramatic confrontation."

Broadside of Boston (a folk newsletter unrelated to the New York *Broadside*) reflected a widespread perception, refusing to believe that Dylan had been allotted only a limited time or only had three songs ready, and insisting, "He left the stage because he was being booed by a large segment of the audience." The reviewer felt this was encouraging, not because he agreed with the booers, but because it was good that listeners "had enough taste and self-determination to *have* an opinion." However, another writer in the same issue pointed out that Dylan "was not altogether rejected. . . . Dyed-in-the-wool Dylan buffs and those of the teeny-bop faction nodded their heads in beat with this new sound."

Only a couple of reviewers failed to mention the booing. The *Boston Globe,* referring to Dylan as "the leather-jacketed idol of the topical song set," noted only that "the one that had them screaming was his most

popular song, 'Tambourine Man.'" The *Providence Journal* described the band as "macabre-looking" and wrote, "Dylan now sings rock 'n' roll, the words mattering less than the beat. What he used to stand for, whether one agreed with it or not, was much clearer than what he stands for now. Perhaps himself." But despite this ambivalence the reviewer added, "The kids scream to the wild noises of electric guitar and organ."

There was certainly more applause than booing during Dylan's electric set, though it died down far more quickly than the ecstatic ovations of previous years. But as the old newspaper adage says, "Dog bites man" isn't news—for Dylan to be applauded was par for the course, while for him to be booed, and in particular to be booed at Newport, was a story.

Whatever consternation greeted the electric set, it was dwarfed by the reaction when Dylan left the stage. He faced some boos and catcalls, but the most obvious target of the crowd's anger was Yarrow and his earnest efforts to calm everyone down. As Yarrow's friend Mary Katherine Aldin puts it: "Nobody wants to hear, 'Sit down and behave yourselves, children, it's time for the Moving Star Hall Singers.' They came to see Dylan, they paid money to see Dylan, and they didn't care about the Moving Star Hall Singers."

There would be more post mortems in the months and years to come, but for the moment the concert had to continue. Yarrow came back to the microphone, pleading for respect, sympathy, or at least a bit of understanding: "Ladies and gentlemen, the next group that's coming up is the group from which all this music started. The traditions of, of blues in our country originally came from the African tradition, and the African tradition—" The crowd was screaming, and he broke off: "Ladies and gentlemen, Bob can't come back." No one paid the slightest attention, but he gave it another try: "The African tradition, when it was brought over originally, was brought over into the deep South—" His words were buried in an avalanche of boos, applause, and shouts of "Dylan!" Now there was a note of desperation in his voice: "Ladies and gentl—*Please* be considerate of Bobby. He can't come back. Please don't make it more difficult than it is." The crowd gradually got the

idea, becoming quieter—and many simply leaving—though occasional shouts of "Dylan!" and "We want Dylan!" continued until the gospel singers were actually onstage. They were clearly nervous, but gamely began their first spiritual, "He Is Everything to Me." It took a few verses before they got themselves together, but by the end they were in fine voice and received an appreciative response, finishing the first half of the concert to rousing cheers.

After a brief break, the second half began with the Ishangi Dance Troupe from Nigeria, described by the *Providence Journal* as providing "a colorful and most welcome part of the evening." The African American singer-songwriter Len Chandler was next, making his first mainstage appearance, and provided a reminder that there were larger controversies at hand than the volume of electric guitars. In that morning's *Providence Journal,* right under "Record 16,000 Pack Folk Festival," was an article headlined "U.S. to Step Up All Viet Nam Activities." President Johnson had convoked a conference reviewing US policy and, although his press secretary (a young Bill Moyers) adamantly denied that any decisions had been made, that weekend committed the United States to a ground war in Southeast Asia. Chandler seems to have been the only performer who reacted publicly: tuning up after his first song, he broke a string and while changing it remarked, "I would just like to take this second to say that I for one oppose United States policy in Vietnam." He was answered by loud booing from some listeners, matched by the cheers of others, and added, "President Johnson is calling up the reserves Tuesday. I hope all you people booing get to go." That drew yells of, "I hope they get *you,* boy!" and "I hope you love your country!" "I do," Chandler responded quietly. "That's why I'm doing what I'm doing."

Chandler was followed by a parade of old-guard folk stars. First came Ronnie Gilbert, who sang two Phil Ochs songs and "Masters of War," introducing Dylan's composition with a mix of respect and regret: "I would like to pay tribute, if I could, to that poetic genius that only comes in the very young, and that must resolve itself into some-

thing else, someday—but in the meanwhile, it's the thing that sparks all life, for all of us."

Josh White played a set of blues accompanied by Wein on piano and the jazz bassist Bob Cranshaw; then came a set of Appalachian ballads from Jean Ritchie, "whose voice," the *Newport Daily News* wrote, "is as refreshing as a cool mountain stream and whose performance was likewise refreshing after some that had gone before."

The evening was building to its intended finale, and Seeger brought Guy Carawan up to introduce the next singer: Fannie Lou Hamer, who had led the Mississippi Freedom Democratic Party to the previous year's presidential nominating convention. Carawan wasted no words, simply calling her a "folk hero" and ceding the stage, and Hamer brought the Freedom Singers to back her on four rousing songs of the civil rights struggle, gradually joined by a supporting chorus of Seeger, Bikel, Gilbert, Wein, Odetta, and Richie Havens.

Peter, Paul, and Mary were next, opening their set with "The Times They Are a-Changin'" and singing five songs, ending with Bruce Langhorne playing guitar on Gary Davis's "If I Had My Way." By then, *Billboard* reported, it was well after midnight, but they "drew a standing ovation with the crowd refusing to let them leave the stage. Mary begged off with the deftness of a polished performer who can handle a crowd. She then brought the festival performers to the stage." Travers planned to finish with the usual unifying sing-along, and led an old spiritual, "Come and Go with Me to That Land," joined by a growing backup chorus including Hamer, the Freedom Singers, Odetta, Seeger, Ritchie, Gilbert, Bikel, Baez, Davis, Chandler, Havens, Kweskin, Bob Beers, and the Fariñas.

That would normally have been the end, but Seeger was still upset and trying to rescue the evening. "No one wants to go home now," he announced, and asked Baez if she would lead a Portuguese song. She responded with the upbeat "Até Amanhã," singing the chorus as "La, la, la" so everyone could join in, with other performers clapping or playing

tambourines. Then Seeger brought Spokes Mashiyane, the South Afri-
can pennywhistler, forward to lead a rhythm jam that filled the stage
with a motley crew of singers, friends, managers, deejays, and a man in
a World War I flier's cap and goggles, clapping along and dancing the
twist, jerk, and frug. Finally, Seeger took over to lead a rousing "Down
by the Riverside."

The *Billboard* reporter was entranced by this rolling jam-and-sing-
along session, hailing it as one more example of Seeger's "aura of true
dedication to the folk cause," but many Newport insiders echoed Robert
Shelton's description of it as a "mob scene." In *Sing Out!*, Irwin Silber
wrote that, starting with Hamer's set, the evening devolved into watching
"hordes of singers, musicians, self-appointed participants and temporary
freaks take over the stage in a tasteless exhibition of frenzied incest,"
and he "sensed a feeling of revulsion even among some of the Newport
directors who were themselves participating in the debacle." Travers felt
upstaged, outraged, and miserable, pouring out her anger to Shelton and
Silber (who quoted her anonymously in their pieces) and writing to a
friend that "the only thing that finale was lacking was colored slides on
Art Nouveaux."

Phil Ochs gleefully suggested that the next year's finale should "feature
a Radio City Music Hall Rockette routine including janitors, drunken
sailors, town prostitutes, clergy of all denominations, sanitation engi-
neers, small time Rhode Island politicians, and a bewildered cab driver,"
backed by "the beloved Mississippi John Hurt's new electric band con-
sisting of Skip James on bass, Son House on drums and Elizabeth Cotton
on vibes being hissed and booed by the now neurotic ethnic enthusiasts."

And the *Newport Daily News* provided a coda: "Throughout it all
there were cries for Dylan but those on stage appeared not to hear."

The concert was over, but Mel Lyman felt he had to do something to
soothe the bad vibes. Boyd recalls him consulting Seeger shortly before
the finale and Seeger giving instructions that when everything was over,
the stage lights should be turned off and one microphone left on. As

the audience gathered their belongings, Lyman mounted the darkened stage with his harmonica and quietly began to play the old hymn "Rock of Ages." The notes spread over the field: thin, choked, throbbing with vibrato, gently mournful. For over a dozen minutes he explored and caressed the simple melody, until the last stragglers had left the field.

It had been a long evening, and the mood reminded Boyd of the aftermath of a battle: "The old guard hung their heads in defeat while the young, far from being triumphant, were chastened. They realized that in their victory lay the death of something wonderful." John Cohen took his wife and baby back to their room, then headed to the after-party and found Dylan there, alone. They talked briefly and quietly: "He was truly puzzled," Cohen says. "He asked me, 'What happened? What went wrong?' He wasn't being aggressive or forceful, he was just being honest, I thought. And I said, 'Well, it was really hard to hear the words.' I was ready to continue the conversation, but then everybody else came in." Shelton recalled Dylan "sitting off in a corner . . . sullen . . . on the lap of Betsy Siggins of Cambridge's Club 47." Siggins remembers this happening backstage rather than at the party, but in either case, she recalls, "He did not say one word. . . . He seemed to be exhausted, kind of overwhelmed, and it was just like I was his chair."

The performers gathered in the dining hall at Nethercliffe. "There was a dinner," Maria Muldaur recalls, "big long tables, and we were all at one end and the old guard was at the other, and you could cut the tension with a knife. . . . At a certain point Dick Fariña started playing Cuban rhythms, all kinds of syncopated rhythms with the cutlery on the glasses and tableware, and pretty soon everybody was doing it. It was like in a prison scene where the prisoners are all banging on a tin cup in the mess hall, only much more rhythmic and musical." The Chambers Brothers were there with their instruments and amps—some people remember them having been hired to play for dancing, others say it was an impromptu jam, but in any case Muldaur recalled the young performers who had grown up with rock 'n' roll were ready to shake off

their seriousness: "After all this folk shit was over, we couldn't wait to get up and boogie." She started dancing with Mimi Fariña—"We were the unofficial go-go girls of the folk scene"—then at one point came back to the table, and Dick drew her attention to Dylan: "He was sitting over in the corner, by himself, hunched over, legs crossed, wiggling his leg and his foot like he used to do. And Richard said to me, 'Maria, why don't you go over and ask Bob to dance?'"

Muldaur had never heard of Dylan dancing, but she went over, touched him on the shoulder, and asked if he would like to join her. "He just looked up at me with this kind of withering look—not like he was mad at me, but just this sort of weary look—and said, "I'd dance with you, Maria, but my hands are on fire." At that moment it seemed a reasonable response.

Seeger did not come to the party, but the following morning a young folk fan was eating breakfast at the Viking and noticed him sitting with his father, Charles, at the next table. "He was telling his father, who was hard of hearing, about what had happened and what he thought of Dylan, and he sort of leaned over, and these were his exact words: 'I thought he had so much promise.'"

Chapter 11
AFTERMATH

For many people the story of Newport 1965 is simple: Bob Dylan was busy being born, and anyone who did not welcome the change was busy dying. Paul Nelson laid it on the line in a diatribe and farewell as he resigned from *Sing Out!*: "Make no mistake, the audience had to make a clear-cut choice and they made it. . . . They were choosing suffocation over invention and adventure, backwards over forwards, a dead hand instead of a live one."

You didn't have to agree with him to recognize it as a dividing line: "When Dylan went electric, that was the beginning of the end," George Wein says. The Folk Festival "lasted four more years, but it was never the same. After that we were no longer 'It,' we were no longer hip, we were no longer what was happening. We were just old-time folksingers."

Wein is neither criticizing Dylan nor applauding him, just stating the facts as he sees them:

When the Beatles came on the scene, a tremendous amount of the young people went with the Beatles. But there were a whole bunch of people who were still fighting for acoustic music. And Bobby Dylan and Joan Baez were the king and queen of that world. Not Peter, Paul and Mary, not the Kingston Trio—they were the commercial ones. But the ones that kept the real die-

hards there were Bobby and Joanie. When Bobby left, they could go with their friends. They didn't have to fight their friends anymore, because their idol went there.

Of course, Dylan had already "gone there" six months earlier on *Bringing It All Back Home*. But at Newport something else happened. During the intermission that night, Theodore Bikel put it in a nutshell, telling a *Broadside* writer: "You don't whistle in church—you don't play rock and roll at a folk festival." For that analogy to hold, Newport had to be the church: the quiet, respectable place where nice people knew how to act. Pete Seeger was the parson. The troubled fans were the decent, upstanding members of the community. And Dylan was the rebellious young man who whistled. Which was exactly what he had always been, and what Seeger had been, and what Newport had celebrated.

It was not Dylan who was transformed by that weekend; it was Newport and the delicate balance of alliances that had formed the folk revival and the spirit of the 1960s—the old 1960s, which few people yet thought of as old, when the threat was a vague bomb hanging over everyone's heads, the young left still admired the old union organizers, and the hope was integration and civil rights for all. Or, to personify that era, it was not Dylan who was transformed; it was Seeger. That was how Nelson ended his characterization of the audience's choice: they could choose the past or the future, and they chose Seeger. It was not news that Dylan was the future; the news was that Seeger was the past.

Not just any past, either: he was the straitlaced, conservative past— the principal of Hibbing High School—standing with an axe in his hand. "We could clearly see him stomping around," one young audience member recalls, and "the next day everyone was talking about the axe."

> I detested Pete Seeger for the rest of his life for his on-stage fascism. Dylan and Butterfield spoke for and to *us*, while (I realized) Seeger spoke for . . . my parents' generation. All the martyrdom blather about blacklisting and guitars killing

fascists and trailing Woody Guthrie around like a puppy faded to zero for me when Seeger took the stage to try to enforce his hootenanny, Sing Out vision of what the music should be.

The great myth of Newport 1965 is Seeger with his axe. Paul Rothchild was an eyewitness, recalling that when Dylan and the band hit at rock 'n' roll volume, "Pete Seeger was livid. He ran back somewhere and came back with an axe, and he said, 'I am going to chop the power cables if you don't take them off the stage right now!'" Other people deny he actually had an axe, but agree he was looking for one: "I've heard that said by a number of people," Peter Yarrow says. "That he wanted to get an axe and cut the wires . . . which would have been consistent with his anger." Wein points out that Seeger had demonstrated his axe-wielding skills with the Texas work song group, adding verisimilitude to the story, and several people misremember the Texans or Seeger as performing a song while chopping a log that same night.

That is how legends form: Yarrow told seventeen thousand people, "He's gonna get his axe," and it was easy for the question "Is he talking about Pete?" to evolve into "Did you hear about Pete Seeger going for an axe?" Soon some people improved the story, saying they or a friend saw him wielding the weapon; others chimed in to explain where it came from; and eventually even Seeger found a way to fit it into his recollections. He was often asked about that night, and by the 1990s he had come up with an explanation of how the axe became part of the legend:

I was furious that the sound was so distorted you could not understand a word that he was singing. He was singing a great song, "Maggie's Farm," a *great* song, but you couldn't understand it. And I ran over to the sound man, said, "Fix the sound so you can understand him." And they hollered back, "No, this is the way they want it!" . . . I was so mad I said, "Damn, if I had an axe I'd cut the cable right now."

There is no reason to doubt the sincerity of that memory, just as there is no reason to doubt that Rothchild sincerely remembered Seeger wielding an axe, or that some audience members remember Dylan playing the greatest rock 'n' roll they ever heard while others recall the set as a disaster. At the time, though, Seeger was troubled by far more than the sound system. As he wrote a few days after the incident: "I ran to hide my eyes and ears because I could not bear either the screaming of the crowd nor some of the most destructive music this side of Hell."

It was a personal memo, an attempt to sort out his feelings. He had watched "the frail, restless, homeless kid who came to New York in '61" become "the frail, restless, homeless star on the stage" and change from the questing poet of "A Hard Rain's a-Gonna Fall" into someone who wrote, "There is no place I'm going to." He was dismayed that "the intriguing snarl of [Dylan's] voice now held no hope," and wondered why: "A girl gone perhaps. A manager come. The claws of fans. Or was he killed with kindness?" He worried that his own extravagant hopes had been part of the problem. Recalling his mother-in-law's death from cancer, he imagined "a beast with hollow fangs . . . [which] sucked the juices of life from her body," and wrote, "Who knows, but I am one of the fangs that has sucked Bob dry. It is in the hope that I can learn that I write these words, asking questions I need help to answer, using language I never intended. Hoping that perhaps I'm wrong—but if I am right, hoping that it won't happen again."

Even in his private musings, Seeger insisted he did not object to rock 'n' roll or electrification, writing that he liked Muddy Waters and Chuck Berry, but adding, "I confess that, like blues and like flamenco music, I can't listen to it for a long time at a stretch. I just don't feel that aggressive, personally." The volume, rhythm, and emotion felt to him like aggression, not an invitation to groove, and even if it had felt like an invitation, he might have mistrusted it. Looking back on that evening seven years later, he said, "I didn't understand 'Maggie's Farm' at all then. I thought it was a trivial song—I don't think I really paid attention to it." He had since heard Earl Scruggs perform the song at a

Vietnam moratorium rally and decided it was "magnificent, uncompromising," but he remained torn about the way the folk and pop scenes were evolving and overlapping, and often felt conflicted. In 1967 he sent his father a copy of Dylan's latest album, *John Wesley Harding,* with a précis of Dylan's evolution:

> The left tried to lionize him; he reacted violently against this, saying fuck you to them all. He dressed outlandishly, screamed out new songs with electric backing; cynicism came to the foreground. It was common assumption that he was on drugs of some sort.

The new record suggested yet another shift, and Seeger concluded, "Maybe Bob Dylan will be like Picasso, surprising us every few years with a new period. I hope he lives as long. I don't think there's another songwriter around who can touch him for a certain independent originality, even though he is part of a tradition."

For Seeger, that was the crux of the matter: on the one hand, the importance of artists creating personal, meaningful work; on the other, the importance of community and tradition. His first reaction to Dylan's electric performance was anguish and anger, his second to try to pull together a communal finale that would heal the wound. Later he would muse that he should have handled the situation differently, going onstage after Dylan's set to ask, "Why are you booing Bob?" In public he was careful not to criticize Dylan, saying he was angry about the sound system, not the music. He tried to put his objections in context: he had always considered pop music a kind of soma, lulling people into ignoring real-world issues, and saw rock 'n' roll as part of that process. To the extent he objected to what Dylan was doing, it was because he felt the huge Newport concerts were already a compromise with the ideal of sharing music in more egalitarian ways and high-volume electrification was yet another barrier between performer and audience. But over time he accepted that the evolution of rock in the mid-1960s was in some ways

positive, that although most of what was on the radio was still "commercial junk," there was more good pop music than ever before, and he credited Dylan with being "mainly responsible for the improvement."

By 1967 Seeger was even ready to try his own electric collaboration, recording some songs with John Hammond on harmonica, Danny Kalb of the Blues Project on electric guitar, an electric bass, and a drummer. In the notes he wrote, "I suppose this will shock some of my friends. But remember, I started out playing in a high school jazz band. And anyone who uses a microphone is electrified. The problem of who is going to rule, Man or Machine?, is an ever-continuing tussle." He had rigged the fight, though, keeping the electric instruments turned down so low that they might as well have been acoustic.

In any case, the focus on electrification was a distraction from what was really at stake. When Marlon Brando roared into Wrightsville at the head of his Black Rebel Motorcycle Club, the townspeople were not horrified because they hated motorcycles, and the audience at Newport was not shocked simply because Dylan was playing a Stratocaster. Peter Yarrow is convinced that Dylan could have played the same songs with the same instrumentation and been accepted, saying he advised him to ease into the electric set: "Sing a couple of songs acoustically, then say, 'I've been working in this new way and it's very exciting and I want to share it with you.' Because then they'll understand that this is not necessarily something that contradicts who you are and what you're about."

The problem with that advice was that Dylan was showing exactly who he was and what he was about, and had no interest in proving he was still part of a precious folk clique. Writing to the festival board, Jim Rooney framed the Sunday concert as a confrontation between two incompatible philosophies:

> Pete began the night with the sound of a new-born baby crying and asked that everyone sing to that baby and tell it what kind of a word it would be growing up into. But Pete already knew what he wanted others to sing. They were going to sing that

it was a world of pollution, bombs, hunger, and injustice, but
that PEOPLE would OVERCOME. And many people did sing
that way. That baby was given hope. Then came Dylan's explo-
sion of light, sounds, and anger. . . . The tone of the evening
had vanished. Hope had been replaced by despair, selflessness
by arrogance, harmony by insistent cacophony.

Rooney was torn, writing that Dylan's inability to sing "the song Pete
wanted to hear . . . is disturbing and upsetting for those of us who still
hope." But, he asked, was that not the point? "Must a folk song be of
mountains, valleys, love between my brother and my sister all over this
land?" It was not the 1930s anymore, or even the 1950s. Dylan was trav-
eling by airplane and wearing "high-heel shoes and high-style clothes
from Europe." If people felt offended or assaulted by his performance,
that was not an accident or a misunderstanding. Ronnie Gilbert had
introduced him the previous year as the spokesman of a young genera-
tion, telling the audience, "You know him, he's yours," but he found that
idea frightening and horrible. In Rooney's words:

"The people" so loved by Pete Seeger are the mob so hated by
Dylan. In the face of violence he has chosen to preserve himself
alone. . . . And he defies everyone else to have the courage to be
as alone, as unconnected, as unfeeling toward others, as he. He
screams through organ and drums and electric guitar, "How
does it feel to be on your own?" And there is no mistaking the
hostility, the defiance, the contempt for all those thousands
sitting before him who aren't on their own. Who can't make it.
And they seemed to understand that night as for the first time
what Dylan had been trying to say for over a year—that he is
not theirs or anyone else's.

It was not pretty, but "it was head and shoulders above the easy
mouthing of conventional liberalisms." Everyone had gotten used to being

affirmed and comforted at Newport, to feeling surrounded by like-minded people. "And the only one in the entire Festival who questioned our position was Bob Dylan. Maybe he didn't put it in the best way. Maybe he was rude. But he shook us. And this is why we have poets and artists."

Nelson reprinted much of Rooney's letter in *Sing Out!* along with his own, angrier manifesto. Rather than expressing concern, he wrote that the Sunday concert "split apart forever the two biggest names in folk music." Seeger tried to force everyone to follow his tired old party line, and Dylan confronted him "like some fierce young Spanish outlaw." The choice was stark:

> Was it to be marshmallows and cotton-candy or meat and potatoes? Rose-colored glasses or a magnifying glass? A nice guy who has subjugated and weakened his art through his constant insistence on a world that never was and never can be, or an angry, passionate poet who demands his art to be all . . . ?
> It was a sad parting of the ways for many, myself included. I choose Dylan. I choose art.

One could argue that Seeger's music was precisely meat and potatoes—the traditional, prosaic American meal—but Nelson's framing made perfect sense in *Rebel Without a Cause* terms: Dylan was James Dean; Pete was the querulous, emasculated father. Rooney resented his letter being used as a springboard for an attack on Seeger and wrote that he, for one, did not "feel forced to decide dramatically between the two giants," but Nelson was by no means alone, and Seeger's reputation would never be the same. He remained an icon of the left, but increasingly was positioned as respectable rather than rebellious, with a whiff of holier-than-thou. At the Philadelphia Folk Festival a few weeks later, Phil Ochs sang his attack on wishy-washy centrists, "Love Me, I'm a Liberal," then pointed to a stream of water near the stage and said, "If Pete Seeger were here, he'd walk on it."

There was irony in these attacks, since Seeger remained a red-tainted

pariah to conservatives and was barred from mainstream venues where Dylan and Ochs were welcome. It took a ruling by the New York State Supreme Court in 1966 to overturn a ban on him performing at a Long Island high school auditorium (the school board contended he was "a 'highly controversial figure' whose presence might trigger a disturbance dangerous to school property"), and in 1969 Johnny Cash complained that although he had hosted Dylan on his ABC television show, Seeger was still forbidden. The network relented the following year, but, as Seeger mused on the plane to Nashville, "What can I sing? They won't let me sing about Vietnam. They won't let me sing about a whole lot of real problems that people face. They'll want me to sing 'Goodnight Irene,' 'On Top of Old Smoky.' "

For many young listeners the problem was that Seeger's civil rights and antiwar songs sounded a lot like "Goodnight Irene" and "On Top of Old Smoky." The lyrics were more radical than ever—"Waist Deep in the Big Muddy" warning of a Vietnam quagmire, "Last Train to Nuremberg" accusing the United States of war crimes—but the music said summer camp.

By contrast, Dylan's music—along with his voice, his clothes, his hair, and his attitude to the nice people who thought the answer was blowin' in the wind—said rebellion. When a reporter on his next British tour asked why he had stopped writing protest songs, his response was: "Who said that? All my songs are protest songs. Every single one of them. That's all I do is protest." He might say the opposite on another day, but that was the point: he was refusing to go along with the program, and the response was itself a protest. The motorcycle T-shirt he wore on the cover of *Highway 61 Revisited* underlined his affinity to *The Wild One*: "What are you rebelling against?" the flirtatious blonde asks Brando, and Brando replies, "Whaddya got?"

Newport fitted neatly into that analogy as the idyllic rural community Dylan was threatening and that attacked him in return. And although at Newport the boos were relatively few and scattered, they grew louder and more insistent as he pursued his first electric tour around the United

States and on to Australia and Europe. His new guitarist, Robbie Robert-
son, recalled nightly battles with hostile crowds: "We set up, we played,
they booed and threw things at us. Then we went to the next town,
played, they booed, threw things, and we left again."

The first appearance after Newport was at Forest Hills Stadium in
Queens on August 20, and Dylan played the first set alone and acoustic,
then was joined by Robertson, Al Kooper on organ, Levon Helm on
drums, and Harvey Brooks on bass. The *Village Voice* began its review
by suggesting that at age twenty-four "Dylan may have been the oldest
person in the crowd of 15,000," and described the audience as divided
between the "folk purists, new leftists, and sensitive collegians" who
wanted to hear the lyrics, and rockers who had come "to stomp their
feet to Dylan's more recent explorations." Backstage, Dylan prepared
the band, saying, "If they start yellin' and booin' don't let it bother ya.
Just keep playin' the best ya know how." Murray the K, a New York
deejay who liked to be known as "the fifth Beatle," was met with a cho-
rus of contempt when he introduced Dylan as part of "a new, swinging
mood in the country" and "what's happening, baby." The first, solo
set was universally cheered, and the crowd listened rapt through the
new, ten-minute-long "Desolation Row," but when the band came on in
the second half, angry fans booed, threw trash, and chanted "We want
Dylan," and one yelled "Scumbag!," provoking Dylan's only retort of
the evening, a restrained "Aw, come on now," which was approved with
laughter and applause.

Meanwhile, mobs of enthusiastic teenagers rushed the stage, some
getting through the police barriers and a couple running among the musi-
cians with police in pursuit. One managed to hook Kooper's piano stool
on his way past, knocking the keyboardist onto the floor, and it is easy
to pick out the moment on the surviving tape, because the crowd erupts
in a pleasured cacophony of laughter, hoots, and clapping. Otherwise it
sounds noisy, restless, and exuberant. Every song is followed by a rowdy
mix of boos and applause, often continuing through the first verse of the
next song, but regardless of their feelings most listeners quieted down

and listened while Dylan was singing—this time his voice was mixed high and clear—and there was strong recognition applause on the first lines of the hits, "It Ain't Me Babe" (which had entered the Top 40 that week in a version by the Turtles) and "Like a Rolling Stone."

Forest Hills was a tennis stadium, and the crowd sounds like it is at a combination concert and sports event, there to listen but also to cheer its favorites and boo the opposing team. It was terrific theater, and while Dylan was upset by Newport, he was exhilarated by Forest Hills. When Kooper and Brooks arrived at Grossman's apartment for the post-concert party, "Dylan bounded across the room and hugged both of us. 'It was fantastic,' he said, 'a real carnival.'" A young woman admitted she had not enjoyed the band, and Dylan asked if she had booed, then scolded her when she said no: "Why didn't you let me know what you were feeling . . . ? You should have booed me. You should have reacted. That's what my music's all about." A few months later he cheerfully told reporters that over the course of the tour he was booed "just about all over," though quickly adding exceptions: "They didn't boo us in Texas or in Atlanta or in Boston, or in Ohio. They've done it in just about—or in Minneapolis, they didn't do it there." They also didn't do it when Dylan appeared at Carnegie Hall barely a month after the Forest Hills gig, and he exulted, "I knew they'd understand me. . . . Knew it wouldn't take 'em long to catch on."

Dylan had been getting bored with his solo concerts, going out every night, singing the same songs, seeing the same faces, getting the same reactions. Early in 1965 he told a friend, "I ask myself: 'Would *you* come to see me tonight?' and I'd have to truthfully say: 'No, I wouldn't come. I'd rather be doin' something else.'" Now, he said, "When I ask myself would I wanna come hear this tonight I gotta say I would. I dig it. You know? I really dig it. I don't think about quitting anymore." He had always loved rock 'n' roll, and if some fans were disappointed, his true supporters were with him: "I have a hunch the people who feel I betrayed them picked up on me a few years ago and weren't really back there with me at the beginning. Because I still see the people who were with me from

the beginning once in a while, and they know what I'm doing." It was
not the fans who had cheered for "Sally Gal" and "Highway 51" who
were upset; it was the people who had discovered him after "Blowin' in
the Wind." Nor were they, by and large, hardcore traditionalists—the
field-holler and fiddle-tune devotees who didn't like his new stuff mostly
hadn't liked his protest songs either—they were the Seeger, Baez, and
Peter, Paul, and Mary fans, the *Sing Out!* readers, people drawn to folk
music by a sense of camaraderie, moral purpose, and distaste for the
mainstream commercial pop scene.

Meanwhile Dylan was picking up an entirely new audience. Tony
Glover was at the Minneapolis show and recalled a young man arriving
partway through the first half, listening briefly, then asking, "Excuse me,
do you know who that is?" Glover asked who he had expected to see:
"Bob Dylan, 'Like a Rolling Stone,'" he replied. He seemed bemused when
I explained that was him and the band would be out later. That was the
point when I realized that the scene was moving to a whole other level."

Dylan was the big news of the pop world that summer and fall, and
despite his changes it hailed him in the same terms the folk world had
used two or three years earlier, as the quirky young poet of social con-
sciousness. "West Coast recording companies are rushing to cut Bob
Dylan songs," *Billboard* wrote in early September, "with his message-
protest material all but killing surfing, hot rod and other teen topics."
Once again his own records were the least of the story: "Like a Rolling
Stone" did well, and his follow-up single, "Positively 4th Street," made it
to the Top 10 in November, but *Billboard*'s main focus was the folk-rock
craze set off by the Byrds and Cher, followed by the Turtles' "It Ain't
Me, Babe" and Dylan covers by Johnny Rivers, Link Wray, Billy Strange,
the Liverpool Five, the Safaris, Joe and Eddie, Leroy Van Dyke, David
Rose (of "Stripper" fame), and dozens more. The Byrds, Turtles, and
Cher followed their singles with Dylan-centric LPs, as did Dino, Desi,
and Billy (a boy band led by the sons of Dean Martin and Lucille Ball),
and Duane Eddy released an instrumental album of Dylan tunes with a
cover photo of the guitarist reclining on hand-stitched pillows in a hippie

bachelor pad amid scattered volumes of an encyclopedia titled *Wisdom.* Meanwhile, on the East Coast, the Four Seasons weighed in with *Big Hits by Burt Bacharach . . . Hal David . . . Bob Dylan,* featuring their Chipmunkesque single of "Don't Think Twice."

The covers made Dylan a millionaire, but far more important were the myriad sound-alike and write-alike efforts, led by "Eve of Destruction." Sung by Barry McGuire, a gruff-voiced graduate of the New Christy Minstrels, and written by a nineteen-year-old surf songwriter named P. F. Sloan—apparently on assignment from the pop producer Lou Adler, who handed him Dylan's first electric LP as a model—it was an anguished laundry list of social concerns punctuated with cursory harmonica fills: the world was "explodin'," young people were "old enough to kill, but not for votin'" and "even the Jordan River has bodies floatin'." The lyrics were clunky, the music bombastic, but the record's defects were part of its power. It was an anguished howl of desperation, and when radio stations across the country banned it as controversial, that just proved it was the real thing. To the amazement of music biz insiders it reached number one and even crossed over to some R & B charts.

"Eve" was joined by dozens of discs with socially relevant themes, often set off with rudimentary harmonica fills. Sonny, without Cher, sang "Laugh at Me," about the trials and tribulations of hippie fashions, a theme also explored by Bonnie and the Treasures in "Home of the Brave" and the Barbarians with "Are You a Boy or Are You a Girl?" Richie Kaye sang of the anguish of receiving a draft notice in "Here Comes Uncle Sam." Bobby Vinton had "What Color (Is a Man)," with the immortal lyrics, "If you color him red, someone may steal his land . . . if you color him black, he may never be free." Glen Campbell cut Buffy Sainte-Marie's pacifist anthem, "Universal Soldier," then promptly backtracked in an interview for *Variety,* declaring, "If you don't have enough guts to fight for your country, you're not a man." Johnny Rivers and the Byrds weighed in with Seeger songs, the former taking "Where Have All the Flowers Gone" to number 26 and the latter going to number one with "Turn! Turn! Turn!" The formulaic nature of the exercise was underlined

by the producers who hired Dylan's sidemen; Kooper recalled the flood of session work he got in the next few months: "They didn't want *me,* of course, they wanted the new 'Dylan sound.' . . . All the Mister Joneses might not have known what was happening, but they sure knew what to *do* about it: *Cover it! Copy it!*" Judy Collins cut a Kooper-backed single of Dylan's "I'll Keep It with Mine"; Albert Grossman hired Kooper and Bloomfield to back a young Carly Simon on a version of "Baby, Let Me Follow You Down" and used the full Dylan studio team for Peter, Paul, and Mary's electric *Album* in 1966; and a Chicago singer named Dick Campbell recorded an LP of pseudo-Dylan originals backed by the Butterfield Blues Band. (Dylan, for his part, seems to have wanted the Johnny Rivers sound, saying that his original choice for a touring band was Rivers's rhythm section: Joe Osborn on bass and Mickey Jones on drums, with James Burton playing lead guitar.)

Most of these efforts were quickly relegated to the trivia bin, but the craze had lasting repercussions. In a large part that was due to the Beatles and Rolling Stones. The Stones were in full Dylan mode that summer, following "Satisfaction" with "Get Off My Cloud" and "19th Nervous Breakdown"—both more commercially adept follow-ups to "Like a Rolling Stone" than Dylan's own subsequent singles—as well as the openly folkie "As Tears Go By." The Beatles were less obvious about it: they were delving into increasingly complex lyrical themes with singles like "We Can Work It Out" and "Day Tripper," but their melodic ideas were very different from Dylan's, and instrumentally they were going the opposite way, adopting acoustic guitars and pop-folk textures. They announced their new direction with *Rubber Soul,* and while the UK version led off with "Drive My Car"—an upbeat rocker spiced with Dylanesque sarcasm—the US release opened with the folk-flavored "I've Just Seen a Face."

Unlike Dylan or the Stones, who were idolized by rock fans but continued to be regarded as abrasive by lot of mainstream listeners, the Beatles appealed across the board and were the most influential purveyors of the folk-rock fusion. Dylan's songwriting opened the door, changing rock and pop lyrics forever, and his rebel persona inspired thousands

of other performers—Eric Clapton even curled his hair so it would look like Dylan's tousled mop—but although the folk scene liked to think its main contributions to rock were intelligent lyrics and social consciousness, it also provided a bridge to listeners who liked their music to be less strident and more soothing. In marketing and genre terms, McCartney's "Yesterday" is part of the history of rock, but in musical terms it is an old-fashioned pop ballad by a tuneful singer with an acoustic guitar and a string octet, and it appealed to millions of people who had never liked either Chuck Berry or Pete Seeger but might well enjoy Joan Baez or Barbra Streisand.

Baez was still singing plenty of Dylan songs—there were four on the album she released that fall—and had her first chart single that summer with Phil Ochs's "There But for Fortune," but she was also thinking about recording "Yesterday," and Dylan's response to the news drew an aesthetic line a lot of rock and pop critics ignored:

> It's the thing to do, to tell all the teenyboppers "I dig the Beatles" and you sing a song like "Yesterday" or "Michelle. . . ." It's such a cop-out, man, both of those songs. If you go into the Library of Congress, you can find a lot better than that. There are millions of songs like "Michelle" and "Yesterday" written in Tin Pan Alley.

There was an element of rivalry there—Dylan was acutely conscious that the Beatles were outselling him, and he shortly recorded his take on their recent evolution, rewriting "Norwegian Wood" as "Fourth Time Around"—but it was true that their ballads provided musical conservatives with an easy way to feel up-to-date. "Blowin' in the Wind" had attracted a similar breadth of listeners thanks to Peter, Paul, and Mary and a host of other performers, but Dylan was not a write-to-order tunesmith, and it remained an anomaly in his catalogue. He reached a larger audience as a rocker than he had as a folksinger, but his voice was abrasive, his lyrics aggressively opaque, and while he got credit for sowing

the folk-rock crop, other performers reaped most of the hits. Simon and Garfunkel were an obvious example, their "Sounds of Silence" reaching number one after Tom Wilson overdubbed their two-year-old acoustic track with electric backing by his Dylan session crew. Their caressing harmonies were a much easier sell than Dylan's quirky rasp, and through the rest of the 1960s, while his albums sold in the mid-hundreds of thousands and the Rolling Stones only once cracked the million mark, each Simon and Garfunkel LP sold at least two or three million.

Acoustic or electric, Dylan was an unusual, difficult artist who turned off as many listeners as he turned on. In chart terms, the most successful exponents of folk-rock were pleasant-sounding vocal groups in the tradition of the Weavers and the Kingston Trio: the Byrds, the Turtles, the Lovin' Spoonful, the Mamas and the Papas, the Association, and eventually Crosby, Stills, and Nash and beyond. Some rocked harder than others, some were more connected to southern rural styles, some had more instrumental chops, but in commercial marketing terms "folk" almost always meant mellow, not rootsy. Nor would that list be complete without the Monkees, two of whom were folk scene veterans: Michael Nesmith had recorded go-nowhere singles of Tom Paxton and Buffy Sainte-Marie songs and a quirky Dylan satire, "What Seems to Be the Trouble, Officer" (sample lyric: "I'm very near nineteen, like to tell you about all my hard times I've seen"), and Peter Tork had worked the Greenwich Village basket-house circuit as a sort of second-string Peter Stampfel.

Some old-time Village regulars tried to hop the folk-rock train, but the main lesson most learned was that they were not Dylan. The week Dylan was cheered and booed at Forest Hills, Stampfel was opening for Dave Van Ronk at the Gaslight, and although both would form electric bands and record on major labels, Van Ronk recalled this as a brief period of irrational aspirations:

> There were essentially two reactions: The first was jealousy, variations on "Why him?" and "He copped this from me, he stole that from so-and-so." Of course, we had all been stealing

from each other all along, but it had never mattered because we were all in the same situation. We had been playing for tips and sleeping on floors, and when one of us suddenly could get a suite at the top of the Plaza, naturally that hurt. The other reaction, which was even more damaging, was, "I'm gonna be next. All I have to do is find the right agent, the right record company, the right connections, and I can be another Bob Dylan!" Yeah, sure you could. All you had to do was write "A Hard Rain's A-Gonna Fall"—for the first time. That was what Bobby did, and none of the rest of us did that. Even if everyone didn't admit it, we all knew that he was the most talented of us.

Like everyone else, Van Ronk tended to focus on Dylan's writing, but that was not the only thing that differentiated Dylan from his erstwhile peers. Dylan had been recognized as a distinctive musician and performer before his writing was an important factor and, coincidental as the title may have been, "Like a Rolling Stone" was a return to the roots he shared with Mick Jagger and Keith Richards. Electric or not, all three were more dedicated traditionalists than most sixties-era singer-songwriters. As he told Nat Hentoff that fall, "I know what folk music is, you know, that's why I really can't call myself a folksinger. . . . It's not a thing to play with. You know, you can't play around with it and have folk song groups and have folk gatherings and 'let's all sing a bunch of folk songs.'" Around the same time he told Robert Shelton, "My idea of a folk song is Jeannie Robertson or Dock Boggs. Call it historical-traditional music." For him, folk songs were not mellow, feel-good music; they were a connection to a tangled, mythic past. "It comes about from legends, bibles, plagues," he told Hentoff. "All these songs about roses growing out of people's brains and lovers who are really geese and swans that turn into angels." And, he added: "They're not going to die." Twenty years later he was still drawing that line: "Nowadays you go to see a folk singer—what's the folk singer doin'? He's singin' all his own songs. That ain't no folk singer. Folk singers sing those old folk songs, ballads."

Dylan was himself the most potent influence in the shift from old ballads to personal compositions, but he cared about the distinction. By his own standards he stopped singing folk songs back in 1963, and the break in 1965 was not with folk tradition but with the limitations some folk scene gatekeepers tried to put on his music. It was also a generational break. At a televised press conference in December a questioner asked, "Mr. Dylan, I know you dislike labels and probably rightfully so, but for those of us well over thirty, could you label yourself and perhaps tell us what your role is?"

"Well, I'd sort of label myself as 'well under thirty,'" he replied. "And my role is to just, y'know, to just stay here as long as I can."

In other situations, he refused that label along with the others. When an interviewer suggested that "The Times They Are a-Changin'" was an anthem of generational conflict, he responded, "That's not what I was saying. It happened maybe that those were the only words I could find to separate aliveness from deadness. It has nothing to do with age." He pointedly dismissed the cliché "Don't trust anybody over thirty" as "ridiculous" and a media fabrication, adding, "I'm almost thirty myself."

He was still six years away from being thirty, but also six years away from being eighteen—and in 1965 eighteen was an age that mattered more than ever, because eighteen-year-olds were getting draft notices and being shipped to Vietnam. The rupture between Dylan and the audience at Newport was instantly recognized as a symbol of larger ruptures, which is one reason the booing was blown so far out of proportion—the common phrase that circulated was not simply that he was booed, but that he "was booed off the stage." A lot of people genuinely thought that was what they were seeing, and he sometimes described it that way himself, in one instance even saying he was "booted out of town." But whatever the specifics of the story, it was less about what he played than about the crowd's reaction. It was about who they were, those people who would not accept him, almost always told from the point of view of people who did accept him, distancing themselves from the hidebound and misguided folkies. *Variety* wrote, "Dylan has apparently evolved too

fast for some of his young followers, who are ready for radical change in practically everything else," and that was the heart of the story: the familiar, folksinging left represented by Newport had fallen out of step with the times.

What made this narrative so powerful was that, music aside, the times were changing faster than ever, and a lot of people were feeling left behind. The Mississippi summer of 1964 had been a high point of white involvement in the civil rights struggle, but the end of that summer was the Democratic convention where the Mississippi Freedom Democratic Party sent an alternative delegation and came away feeling disrespected and betrayed. For many black activists the lesson was that white support would always be halfhearted, temporary, and patronizing. "Blowin' in the Wind" had expressed a dream that the world would change when the majority stopped turning its head and heard the cries of the oppressed, but that formulation assumed a majority that heard black Americans rather than including them and retained the power to listen or ignore. Now, SNCC's Cleveland Sellers wrote, that time was past: "Never again were we lulled into believing that our task was exposing injustices so that the 'good' people of America could eliminate them." By 1966 Black Power was the phrase of the day, and increasingly the attitude to even the most committed white supporters was that they should work in their own communities and leave black people to lead the black struggle. Some white activists understood, accepted, and agreed with this shift, but others were hurt and angry, and even the ones who agreed often missed the old spirit of camaraderie.

For a few years folk music had helped to unify and inspire a mass movement, the culmination of a dream Seeger's generation had nurtured since the 1930s. At Newport, whatever else happened, the weekend ended with a variation on that first grand finale when everyone linked arms and sang "We Shall Overcome," knowing that the "we" included not only African Americans and the frontline activists down south but all right-thinking people everywhere. By 1965 that sense of unity was fraying, and with it the connection of young activists in SNCC, CORE, and Students for a

Democratic Society (SDS) with the old leftists who still treasured battered Almanac Singers albums. In April SDS sponsored the first national demonstration against American involvement in Vietnam, and some twenty-five thousand people heard Judy Collins sing "The Times They Are a-Changin'" and joined Collins, Baez, Ochs, and Barbara Dane in "We Shall Overcome." But when Lyndon Johnson quoted the anthem of the freedom struggle in his announcement of a sweeping civil rights bill that March, the message was inevitably mixed: it was stirring to hear the president intone the familiar words, but as he dispatched more bombers and troops to Vietnam, that "we" took on another meaning.

For northern liberals, Vietnam was a much more divisive issue than voting rights and integrated drinking fountains, and many supported Johnson's effort to stem the spread of international Communism. Then, two weeks after Dylan's electric debut at Newport, the Watts ghetto exploded. In Chicago a singing community organizer named Jimmy Collier reacted by writing "Burn, Baby, Burn," and *Broadside* and *Sing Out!* quickly printed it, the former with an introductory note from Guy Carawan. But much as the old guard welcomed him—Collier was at Newport in 1966 and toured with Martin Luther King and Pete Seeger—it was hard to imagine Carawan, Seeger, or Baez singing, "All I had was a match in my hand, but I wanted to fight / So I said, 'Burn, baby, burn.'"

Newport tried to change with the times, but the times were not cooperating. In 1966 Julius Lester, a SNCC activist and associate editor of *Sing Out!*—and coauthor with Seeger of *The 12-String Guitar as Played by Leadbelly*—joined the board and spent much of the year helping to organize local festivals in Mississippi, but when SNCC set up a booth on the festival grounds the police responded to their chants of "Black power" by ejecting them and drawing the organizers into a pained round of arbitration. There were more electric bands that year, including Howlin' Wolf, Chuck Berry, the Blues Project, and the Lovin' Spoonful, but they were bedeviled by sound problems, their fans were obstreperous, and the lineup notably lacked Dylan, Baez, or Peter, Paul, and Mary. The

result was widespread irritation and a lower than usual turnout, and for the first time the festival lost money.

There was still plenty of great music—a stellar gospel contingent included the Dixie Hummingbirds, the Swan Silvertones, and the Gospel Harmonettes—but the feeling had changed. Newport had not just been a musical event; it had been an uplifting annual gathering with a strong sense of community and dedication. Now a lot of people were finding it harder to ignore the fact that the audience was almost entirely white and middle class or to believe in Newport as a model for the future. As Lester wrote in *Sing Out!* that fall:

> Now it is over. The days of singing freedom songs and the days of combating bullets and billy clubs with Love. We Shall Overcome (and we have overcome our blindness) sounds old, out-dated and can enter the pantheon of the greats along with the IWW songs and the union songs. As one SNCC veteran put it after the Mississippi March, "Man, the people are too busy getting ready to fight to bother with singing anymore."

The optimism of the early 1960s was slipping away, replaced with a volatile mix of radicalism and alienation. For young white activists, the shift from civil rights to Vietnam was in some ways liberating: instead of being part of someone else's struggle, they were fighting their own. But in the process many lost interest in old alliances. Folk music had been a link to the past, not only to old songs and rural traditions but to a left rooted in the progressive dreams of the New Deal and Henry Wallace's "century of the common man." Rock was the sound of a new generation with its own struggles and discoveries, breaking with the politics of the Cold War, McCarthyism, conservatism, racism, and militarism, but also the politics of the old left, whether tied to the old men in the Kremlin or the old anti-Communist liberals. It is too simple to call it an oedipal rebellion, but never had so many young people been so contemptuous of their parents and their parents' generation. The new struggles were not just

against particular injustices or ideologies, but against "the system," be it the capitalist system, the Communist system, or any system, any form of authority—including the organizers of the Newport Folk Festival.

When Dylan shouted his electric refusal to work on Maggie's farm, it was a declaration of independence for what was not yet known as the counterculture. The politics of words and manifestos were being supplanted by a politics of clothing, hair, sexuality, drugs, and music. Norman Mailer's "white Negro," the hipster who internally identified with an imagined black experience, was giving way to Abbie Hoffman's "white nigger," the hippie who personally experienced discrimination and fought the system simply by existing. Those formulations were always problematic, but they expressed how more and more young white Americans were feeling, and Dylan was the most visible icon of the new sensibility. On tour with Baez in 1963, he had been refused a hotel room because of his unkempt appearance and responded by composing "When the Ship Comes In." The image was from Brecht's "Pirate Jenny," in which a hotel maid dreams of a ship of avenging pirates who will sweep ashore and slaughter the complacent, respectable bourgeoisie.

By 1965 Dylan was a millionaire dressed in fashionable clothes, and for a moment it seemed he might have sold out to the system, but the battle of Newport proved he was as untamed as ever. He was not capitulating to the present, he was breaking with the past—and if the mainstream rewarded his rebellion, that was because it was changing, not because he was. In the 1950s Seeger was the only artist whose reputation was enhanced by his court battles. In the 1960s jail time became a badge of honor—first with the sit-ins and protest marches of the civil rights struggle, then as prisons filled with young draft resisters and dope smokers. Soon fans were trading stories of their favorite rockers' drug busts as proof of rebel authenticity, and in 1968 Columbia Records established a high-water mark of corporate co-optation with a full-page ad in underground newspapers using the slogan "The Man Can't Bust Our Music" (though, oddly enough, the records in question were avant-garde classical releases).

The paradox of Dylan at Newport is that it is famous as his split

with the folk world but is important because he took that world's stan-dards and most of its audience with him. Charlie Gillett wrote that "folk existed in a world of its own until Bob Dylan dragged it, screaming, into pop," and while folk fans might frame that the opposite way—Dylan had dragged pop, screaming very loudly, into their world—it was the iconic moment of intersection, when rock emerged, separate from rock 'n' roll, and replaced folk as the serious, intelligent voice of a generation. In the process, rock fans adopted many of the folk world's prides and preju-dices: Rock 'n' rollers had worn matching outfits, played teen-oriented dance music, and strove to cut hit singles. Rock musicians wore street clothes, sang poetic and meaningful lyrics accompanied by imaginative or self-consciously rootsy instrumentation, and recorded long-playing albums that demanded repeated, attentive listening. Those albums might sell in the millions, but they were presented as artistic statements, and by the later 1960s it was considered insulting to call someone like Jim Morrison or Janis Joplin "commercial."

In 1965 that transformation was just beginning. Albums were not yet a major factor in the rock world, and Phil Ochs was horrified when Dylan followed "Like a Rolling Stone" with the downbeat "Positively 4th Street" and the forgettable "Can You Please Crawl Out Your Window," argu-ing that he had a chance to release "fifteen grandly produced, musically exciting hit singles, with all the great lyrics, and thereby revolutionize the music business," but instead "threw it all away." Like virtually everyone else, Ochs could not imagine someone becoming a rock star the way Joan Baez had become a folk star, by explicitly refusing to be a cog in the pop machine. That was Dylan's accomplishment, and Newport played a vital role, proving he was making a difficult artistic choice rather than just grabbing for the brass ring. The instrumentation connected him to Elvis and the Beatles, but the booing connected him to Stravinsky.

Dylan proved Ochs wrong by equaling his "Rolling Stone" chart suc-cess in May 1966 with a song that directly referenced the angry crowds: "They'll stone you when you're riding in your car / They'll stone you when you're playing your guitar," he sang in "Rainy Day Women #12 &

35," blending his harmonica with a Salvation Army–style marching band and leading into a chorus of "Everybody must get stoned!" It sounded like no previous hit in any genre and was an anthem of outsiderdom, of being and getting stoned, and of refusing to conform to anyone's expectations. Some radio stations banned it; some of Dylan's old fans wagged their heads disapprovingly—"That's just the opposite of helping anyone to care," Baez lamented, "I mean, it's just so destructive"—but it perfectly captured the combination of paranoia and exuberance that marked the new youth movement. Drugs were obviously part of that equation, and many people believed marijuana and hallucinogens were important tools to open the doors of their perceptions, free their minds of societal brainwashing, and show them new ways to understand and hopefully change the world.

The Beatles were particularly prominent examples, and Dylan's central position in rock history is rooted in that brief period when he and the Beatles were running neck and neck. He released *Bringing It All Back Home* in the spring of 1965, *Highway 61 Revisited* that summer, and *Blonde on Blonde* a year later. *Rubber Soul,* the first Beatles album conceived as a cohesive artistic statement, was released in December 1965, followed by *Revolver* seven months later. In commercial terms the Beatles were in a different league: on the American market, they released four LPs of new material in 1965 and two in 1966, and each spent more than five weeks at number one on *Billboard*'s album chart, while Dylan would not have a number one album until the mid-1970s. But they were evolving from teen-pop hit-makers into mature, thoughtful artists, with Dylan as their acknowledged model. McCartney recalled playing him a tape of their new songs when he came through London in the spring of 1966: "He said, 'O I get it, you don't want to be cute anymore!' That summed it up. . . . The cute period had ended. It started to be art."

It was the dawn of the world we have lived in ever since, in which rock musicians are expected to do work that is not only fun and exciting but meaningful and important. Dylan's reception at Newport had so much resonance because he mattered to his audience in a way pop music had

never mattered before, and the power of that message came not only from Dylan but from Newport, from the fact that he was booed at a beloved and respected musical gathering, by an audience of serious, committed young adults. The fans who booed him from Forest Hills to the Manchester Free Trade Hall over the next year were showing not only their anger at his capitulation to the mainstream but their solidarity with that first mythically angered cohort of true believers.

The Newport board tried to have it both ways, preserving its mission while acknowledging that the scene was changing. In 1967 it expanded the festival to a full week, with a day of folk dance workshops, a children's day, and evenings of storytelling and topical songs, and the rock slot was filled by Buffalo Springfield (though they canceled at the last minute due to illness), with the Muddy Waters band covering electric blues. In 1968 it cut back to five days, and the blues was handled by Buddy Guy and B. B. King, but in Wein's words, "Rock music made the difference between a financial catastrophe and a self-sustaining box office," and the festival "was saved from ruin by a single group—a San Francisco psychedelic rock band managed by Albert Grossman that had performed to great acclaim the previous summer in Monterey. They were called Big Brother and the Holding Company, and their lead singer was Janis Joplin."

In the *New Yorker*, Ellen Willis wrote that the electric acts were hamstrung by limitations on their volume but nonetheless overshadowed the traditional performers, and the result was unsatisfying to everybody—workshops were interrupted by yells of "B.B.!" "Big Brother!" and "*Jan-niss!*" and although there was some great music, "it failed as a *festival*." Jim Rooney pointed out that Joplin had a fine time and "got very emotional" about appearing alongside King, Roy Acuff, and her old Texas patron, Kenneth Threadgill, and added, "Dylan wanted to come this year—and would have if family matters hadn't intervened—but he wanted to avoid a repeat of the past—the 'star' bullshit." It was very likely true: Dylan's only public appearance that year had been at a Woody Guthrie memorial concert, playing three songs with the Band

and a fourth with Seeger, Judy Collins, and Woody's son Arlo, and the Newport schedule included a recap of that program. But Newport's time had passed. In 1969 there were no rock acts, though the Everly Brothers and the Johnny Cash Revue provided some star power, and the Sunday afternoon Young Performers showcase suggested the board was still in touch with shifting trends, including Jerry Jeff Walker, Joni Mitchell, James Taylor, and Van Morrison. But it lost money, and that was the end of the line. That year's Jazz Festival went in the opposite direction, with a hard rock lineup including Jethro Tull, the Mothers of Invention, and Led Zeppelin, and broke all previous Newport attendance records with eighty-five thousand paid admissions, but the crowd was unruly, and George Wein described it as "four of the worst days of my life" and vowed never to repeat the experience. In 1970 the Folk Festival took what was planned as a one-year hiatus, but in 1971 the Jazz Festival had to cancel its final day after a riot of angry kids demanded free entry and tore down the fences, and the Newport City Council canceled the folk program as well. Other folk festivals carried on in various forms, but by the late 1960s anyone looking for an event that captured the spirit of the age was looking elsewhere.

At times elsewhere seemed pretty familiar: more than a quarter of the acts at the 1969 Woodstock festival had appeared in Newport folk lineups; the sound and lighting was by Newport veterans Bill Hanley and Chip Monck; and the weekend's opening day was an acoustic program that culminated with Joan Baez leading the crowd in "We Shall Over-come," lining out the lyrics in Seeger's familiar fashion. The mythic rock festivals—Monterey and Woodstock in particular, but there were many others—tried, at their best, to achieve the same sense of shared music and purpose that Newport had established, the feeling that what was happening onstage was an extension of what was happening in the audience. Inevitably, though, the technology made a difference: at Newport the audience was full of people with their own guitars and banjos, and when the official program was over the unofficial music-making continued, sounding very similar to what was happening onstage. Electric

instruments, for better or worse, demanded amplifiers and electrical outlets and established a divide: players behind the amps, listeners in front. It was not impossible to sing along with a rock band, but it was irrelevant. As Dylan put it, Seeger made his listeners "feel like they matter and make sense to themselves and feel like they're contributing to something," while listening to a rock band "is like being a spectator at a football game. Pete is almost like a tribal medicine man, in the true sense of the world. Rock 'n' roll performers aren't. They're just kind of working out other people's fantasies."

Dylan's experience undoubtedly colored his view—the rock band, for him, was a form of communication but also a protective shell. As a solo performer he had chatted, mugged, and kidded with his audiences, always filling the spaces, always engaging in one way or another. One of the things that made that last Newport performance so hard for old fans was the contrast: he was turning his back on them, huddling with his electric gang, listening only to the amplified echoes of his guitar and harmonica. From then on he was known for his truculence, playing entire concerts without saying a word. Many people found his disengagement more troubling than the instrumentation. Ruth Perry missed the Newport show but saw him shortly afterward and recalls, "He sang 'You don't know what's happening, do you, Mr. Jones' with such a sneer at his audience that we all recoiled. It was his tone of voice, not his electricity, that went through us." Others recall him disengaging in other ways—John Lennon described the next year as their shared heroin period, and Shelton wrote that Dylan looked strung out and dying, whether from drugs or exhaustion—and electricity was not the whole story, but was part of that process.

Then, a week after the release of *Blonde on Blonde* and almost exactly a year after he led his metaphoric motorcycle gang onstage at Newport, Dylan spun out of control on a real motorcycle on a country road near Woodstock. It was a mythic end to his story, the hero dying like James Dean at the height of his career, and though he trickily followed it with a corporeal resurrection, he would not give a concert for the next eight years.

Which is to say the Dylan who presided over what most of us remember as "the sixties"—the Vietnam era, the campus riots, the summer of love, the hippies, the drug culture, the Weathermen—was truly a Zeitgeist, the ghost of a sacrificial Dylan who stood before the elders in the temple of folk music and was condemned, scourged as he carried his electric cross up the Gethsemane of his yearlong tour (the fan in Manchester who called him Judas had it backwards), and finally died so rock could be redeemed.

When he returned, it was at first as a rumor, perhaps lingering between life and death, perhaps permanently disabled, perhaps just using the accident as a cover to retire to another life as a quiet husband and father. He shunned publicity, and when he broke the silence it was as a mystic hermit, rescuing rock from its excesses. For a year and a half he had vied with the Beatles for the pop-art throne, and when they established their supremacy with *Sgt. Pepper* in 1967 everyone wondered how he would respond. What almost no one expected was *John Wesley Harding*, an understated, mostly acoustic album with lyrics more self-consciously archaic than his earliest blues and ballads. A lone exception was Ellen Willis, who published a profile of him in *Commentary* a month before the new record's release in which she wrote: "Dylan is no apostle of the electronic age. Rather, he is a fifth-columnist from the past."

In hindsight, that may be the most powerful message of that night at Newport. In 1965 it made news because it captured the tensions and conflicts of the moment, and for people who lived through that moment it only became more emblematic with the passage of time. That was the year of Vietnam, of Watts, of the Free Speech Movement and the first acid tests, and the confrontation at Newport marked the end of the folk boom and the arrival of rock as a mature art form, the break of the New Left from the old, and the triumph of the counterculture. It was a handy, compelling symbol, recycled in myriad documentaries, and eventually became something of a cliché. But it continues to resonate because, if its details are emblematic of a particular moment, the central conflict was timeless. It was not the death of an old dream and the birth of a new, but

the clash of two dreams, both very old and both very much still with us. They are the twin ideals of the modern era: the democratic, communitarian ideal of a society of equals working together for the common good and the romantic, libertarian ideal of the free individual, unburdened by the constraints of rules or custom. At Newport that night, Seeger was standing up for one ideal and Dylan for the other, and many people felt forced to choose sides, and for a while the verdict of history seemed to be that Dylan was right and Seeger was wrong.

Fifty years later it doesn't look that simple. Dylan today is a patron saint of roots music and Americana, and Seeger remains a symbol of progressive struggle. In hindsight we can understand why some people in that moment stood with Seeger and others fought for Dylan, but we are not confronted with the same choice. Young musicians are still picking up banjos and acoustic guitars, still forming rock bands, still learning old styles and writing new songs, still looking to the past and trying to find a place in the future. The clashing ideals they represented half a century ago are still with us and still clash, and some people still feel forced to choose. But both Seeger and Dylan long ago recognized that the challenge was not to defend one against the other but to reconcile the two.

In their very different ways, Seeger and Dylan each found a solution to that problem. Dylan kept exploring new directions, but always circled back to his musical roots. He became a gospel singer, a country singer, an acoustic blues and ballad singer, a southern roots music revivalist, even an old-fashioned Tin Pan Alley tunesmith. After a fallow period in the 1980s, he came back with renewed energy and began touring nonstop, assembling hot bands and making albums that reworked the roadhouse jukebox styles of the 1930s and 1940s, from jump blues to honky-tonk, western swing, and romantic pop standards. As he sang on 2001's *Love and Theft*: "She says, 'You can't repeat the past.' I say, 'You can't? What do you mean, you can't? Of course you can.'" In the twenty-first century, he is the only major performer of the 1960s who consistently draws audiences of new, young fans, many of whom do not even know his early work. He plays a hundred concerts a year, far more than any other star,

and although even his most devoted followers often have mixed feelings about his performances, they keep coming back because he is constantly surprising, rearranging old songs, adding new ones, and working with some of the most exciting sidemen on the current roots scene. Many fans continue to think of him as embodying the rebel spirit of the 1960s, and when he made a commercial for Chrysler in 2014 the internet exploded with accusations and laments that he was selling out. But if the medium was corporate hucksterism, the underlying message of the ad was that he continues to embody the populist ideals of the early Newport years: A paean to vanishing traditions and the midcentury iconography of the industrial Midwest, it showed a montage of farms and factories, James Dean, motorcycles, and dusty highways stretching to the horizon. The opening image was a clip from the Saturday afternoon workshop at the 1965 festival, with Dylan facing the crowd on the grassy field in the bright sunlight, playing an acoustic guitar.

Seeger dealt with the changes of the later 1960s by grounding himself in local issues, forming a community group to rebuild an old Hudson River sloop, the Clearwater, and sailing it up and down the river to draw attention to ecological dangers. In 1978 he started a music festival, the Great Hudson River Revival, which continues as the annual Clearwater Festival. He kept playing concerts all over the country and around the world, maintaining a balance of paying jobs and benefits for leftist causes and community organizations. In 2006, a *New Yorker* profile ended with the image of him standing on the road near his home in Beacon on a cold winter day at the start of the Iraq war, an old man but still tall and straight as ever, holding up a cardboard sign saying "Peace." His voice grew weaker, but he kept performing, making his last major television appearance in 2008, joined by his grandson Tao, Bruce Springsteen, and a gospel choir to lead the crowd in "This Land Is Your Land" at the inauguration of the first African American president. He made his last album in 2010, joined by old friends and a chorus of kids he had been singing with at a nearby school. It was called *Tomorrow's Children,* and won a Grammy. He died on January 27, 2014.

The Newport Folk Festival reappeared in 1985, but it was just a two-day concert, without workshops or more than a hint of traditional music, and old-timers bemoaned the change. In 2002 Dylan returned and played a two-hour show—though, presumably recalling old slights, he wore a fake beard and wig and insisted that the Newport Festival banner be removed before he came onstage. In 2009 George Wein, who had not been directly involved for forty years, took the helm again and presented a fiftieth anniversary lineup including Seeger, Baez, Judy Collins, Ramblin' Jack Elliott, and other sixties veterans alongside a broad bill of young roots artists, and the festival has since become an annual showcase for the burgeoning Americana scene. Dylan has not been back, but his influence is everywhere—the dominant style is original compositions that draw on American rural traditions, electric guitars mixing with fiddles and mandolins. In 2014 a new showcase was added, a revival of the old Newport workshops dedicated to traditional styles and "intimate performances with Q&A discussions on hammered dulcimer, bagpipe, hurdy gurdy, nickelharp, autoharp, banjo, fiddle, [and] dance." It is called "For Pete's Sake."

NOTES

Introduction

4 "How . . . for the war?" John Cohen and Happy Traum, "Conversations with Bob Dylan," *Sing Out!*, Oct–Nov 1968, 67.

5 When he turned . . . "the hard blues stuff" Echo Helstrom, quoted in Thompson, *Positively Main Street*, 73.

5 "melodramatic and maudlin" Pankake and Nelson, "Flat Tire," 24.

5 "What is this shit?" Tony Glover in Heylin, *Bob Dylan*, 126.

5 "wasting our precious time" Irwin Silber, "An Open Letter to Bob Dylan," *Sing Out!*, Nov 1964, 23.

1. The House That Pete Built

9 "It wasn't . . . a house" Dunaway, *How Can I Keep*, 182.

11 "The truth . . . in there" Seeger, *Where Have All the Flowers Gone*, 12.

13 immigrated . . . in 1787 Ann M. Pescatello, *Charles Seeger: A Life in American Music* (Pittsburgh, PA: University of Pittsburgh Press, 1992), 5.

14 "Compared to . . . honest" Seeger, *Incompleat Folksinger*, 13.

14 "A little . . . himself" Seeger, *Incompleat Folksinger*, 42–43.

14 "because everything . . . chase girls" Seeger, *Where Have All the Flowers Gone*, 17.

15 advising young fans Seeger, *Incompleat Folksinger*, 168, 556.

15 "Even though . . . sounds swell" Dunaway, *How Can I Keep*, 121.

17 "If you . . . play a clarinet" Dunaway, *How Can I Keep*, 135.

17 "tall, slim Sinatra . . . people's songsters" "Night Club Reviews," *Billboard*, 11 Jan 1947, 40.

17 "congratulating myself . . . more use than me" Dunaway, *How Can I Keep*, 164; Seeger, *Pete Seeger*, 259.

18 "The act . . . commercial value" Bill Smith, "Village Vanguard, New York," *Billboard*, 4 Feb 1950, 51.

19 "Decca Records . . . pickers now" Seeger, letter in *Broadside*, 30 Jun 1964, 6.

20 "emasculating . . . forgiven" Notes, *Broadside*, 10 Mar 1964, 14.

20 "Can . . . Negro Culture" Dunaway, *How Can I Keep,* 174–75.

21 "taking a blues . . . exciting music" Joe Boyd, interviewed by Jasen Emmons, 23 March 2007, courtesy of Experience Music Project Museum.

22 "It must . . . having tried" Pete Seeger, introduction to Dunaway, *Singing Out,* xi.

23 "phenomenal . . . temporary kick" Jon Pankake, "Pete's Children: The American Folksong Revival, Pro and Con," *Little Sandy Review* 29, 1964, 26–30.

24 "Pete only . . . around him" Pete Seeger and Toshi Seeger, "Record Review: Pete Seeger," *Sing Out!,* 1965, reprinted in Seeger, *Incompleat Folksinger,* 268.

24 "Not that . . . with Pete" Tom Paley, interviewed by author, 3 May 2014.

24 first solo album David King Dunaway's *Pete Seeger Discography: Seventy Years of Recordings* (Lanham, MD: Scarecrow, 2010) lists three earlier solo albums, but one of them, *American Banjo,* from 1944, was never issued, and the other two were single 78s, though with snatches of multiple songs.

25 "Words and melodies . . . British ballad" Seeger, *Incompleat Folksinger,* 145.

25 "Perhaps the role . . . he knows" Seeger, *Pete Seeger,* 66, 42.

26 "lying on . . . the banjo" Pete Seeger, *The Goofing Off Suite,* Folkways FA 2045, 1955.

26 "purposely composed . . . and professional" Pete Seeger, *Folksongs of Four Continents,* Folkways LP 6911, 1955.

27 "most union leaders . . . union local" Seeger, *Incompleat Folksinger,* 21.

27 *by* the working class . . . *for* it Dunaway, *How Can I Keep,* 126.

29 "the job . . . for amateurs" Seeger, *Pete Seeger,* 261. Further information from Dave Samuelson, notes to *The Weavers: Rarities from the Vanguard Vault,* Vanguard VZCD47, 2003, and personal communication, 12 May 2014. The note in the Rosenthal book is dated January 1958, but Samuelson is reasonably certain the commercial was recorded on March 2, 1958, possibly for Lucky Strike.

30 "The woman . . . about feeling" Peter Stampfel, interviewed by author, 10 Apr 2014.

30 "We were all . . . so fantastic" Bush, *Greenback Dollar,* 61.

31 "Dangerous Minstrel . . . on the outside" Dunaway, *How Can I Keep,* 248.

31 "Some of my ancestors . . . You may not" Dunaway, *How Can I Keep,* 252.

31 "They're framin' . . . him up" Scaduto, *Bob Dylan,* 83.

2. North Country Blues

34 "He's sincere . . . to the surface" Jonny Whiteside, *Cry: The Johnnie Ray Story* (New York: Barricade, 1994), 85, 133.

34 "He could really . . . love with" Sounes, *Down the Highway,* 22; Shelton, *No Direction Home,* 37.

35 "Late at night . . . figure them out" Loder, "Bob Dylan."

35 Stan Lewis . . . recalled Spitz, *Dylan*, 34–36; radio listings, *Monroe News Star*, 10 Oct 1955, 27.

36 "A stampeding . . . pinnacle" John Szwed, *Alan Lomax: The Man Who Recorded the World* (New York: Viking, 2010), 311.

36 "They wore . . . booed them" Alan Lomax, interviewed by Nick Spitzer, 25 Jul 1990, courtesy of Spitzer and *American Routes*.

36 "cliché . . . something special" Susan Heimann, letter in *Sing Out!*, Fall 1957, 2, 35.

37 "Hearing [Elvis] . . . Buddy Holly a lot" Sounes, *Down the Highway*, 27; Rosenbaum, "Playboy Interview."

37 "Trying to make . . . becoming popular" Spitz, *Dylan*, 41; Sounes, *Down the Highway*, 27.

38 taped conversation with Bucklen John Bucklen tape, circa 1958. Sections of this tape have circulated since being broadcast on a BBC TV documentary, *Highway 61 Revisited*. The narration adds a false Elvis connection, saying Dylan and Bucklen sang "Blue Moon" and intercutting their performance with Presley's recording of that song, but in fact they sing "We Belong Together," a similar-sounding hit by the black duo Robert and Johnny.

39 "We found . . . more square" Hadlock, "Kingston Trio," 20.

39 the Jokers Sounes, *Down the Highway*, 25, 27–28.

39 " 'Maybellene' . . . Gatemouth Page?" Thompson, *Positively Main Street*, 65.

40 "People would laugh . . . almost crying" Thompson, *Positively Main Street*, 68.

40 "He and the others . . . got so *crazy*" Sounes, *Down the Highway*, 35.

40 "He was as big-eyed . . . in the least" Thompson, *Positively Main Street*, 69.

41 Winter Jamboree "Queen Jessie, King Dick Rule at JJS Jamboree," *Hibbing Hi Times*, 23 Jan 1959, 1. "Time Goes By" was a hit in 1955 for Marty Robbins and "Swing, Daddy, Swing" was a rockabilly blues by Jerry Hawkins with a girl backup chorus.

42 Gorgeous George Dylan, *Chronicles*, 44.

42 "furious . . . he was like" Thompson, *Positively Main Street*, 71.

43 "I like blues . . . right place" Heylin, *Bob Dylan*, 25.

43 "Bob almost shouted . . . in 1959" Shelton, *No Direction Home*, 48.

44 "One day my brother . . . University of Minnesota" Mackay, *Bob Dylan*, 53.

45 "Campus-Type Folknik Hipsters" Bob Rolontz, "Campus-Type Folknik Hipsters in Demand," *Billboard*, 23 May 1960, 5.

45 "The swathe . . . they'd do him" Peter Stampfel, interviewed by author, 10 Apr 2014.

45 "Harry was . . . tough guy" Dylan, *Chronicles*, 68.

46 "Right then . . . flat-top Gibson" Rosenbaum, "Playboy Interview."

46 "it wasn't enough . . . I needed that" Crowe, notes to *Bob Dylan*, 35.

47 "He had a very sweet . . . it became" Shelton, *No Direction Home*, 56.

47 "an unusual . . . he was doing" John Koerner, interviewed by author, 19 May 2014.

48 "It was like . . . rockabilly beat" Shelton, *No Direction Home*, 57.

48 audition tape John Koerner, interviewed by author, 19 May 2014.

48 "I could never . . . all the time" Dylan, *Chronicles*, 16.

48 "You'd go . . . resented it" Sounes, *Down the Highway*, 64.

48 "There was a black . . . that guitar" Heylin, *Bob Dylan*, 43.

49 "When you need . . . changes" Shelton, *No Direction Home*, 38.

49 "and there were . . . and wow!" Jon Pankake, interviewed by author, 19 May 2014.

49 "a general . . . folk song" Jon Pankake, and Paul Nelson, "Editor's Column," *Little Sandy Review* 2, ca. Apr 1960, 2.

50 "It is pathetic . . . 'Sail Away, Ladies' " Edmund Gilbertson, review of *Folksingers 'Round Harvard Square* (Joan Baez, Bill Wood, and Ted Alevizos), *Little Sandy Review* 7, ca. Oct 1960, 9.

50 "in so daringly . . . succeeding" Jon Pankake, and Paul Nelson, "The English Record Scene," *Little Sandy Review* 2, ca. Apr 1960.

50 "Literally . . . you get it" Sounes, *Down the Highway*, 57. Dylan apparently had a habit of "borrowing" other people's records—he later took some of Walt Conley's in Denver. Pankake told Shelton (*No Direction Home*, 61), "I didn't feel that there was anything malicious about his stealing the records. I think he believed that he needed them more than I did."

51 "most of the stuff . . . like that" Jack Elliott, interviewed by author, Dec 1998.

51 first Guthrie records Dylan fell in love with Santelli, *Bob Dylan Scrapbook*, 13.

51 "the best Woody . . . pressed anywhere" *Little Sandy Review* 5, ca. Jul 1960, 34, 36.

51 scant five songs Along with "Pastures of Plenty" and "This Land is Your Land" from Odetta, Dylan recorded Guthrie's "Jesus Christ," "Talking Merchant Marine," and "Talking Columbia." He paired the latter two with Tom Glazer's "Talking Inflation," indicating his source was John Greenway's *Talking Blues* album (Folkways 5232, 1958), which included all three.

52 "He came back . . . Columbia record" Heylin, *Bob Dylan*, 48. Nelson says something similar in Shelton, *No Direction Home*, 61, though allowing two weeks rather than two days for the change.

52 four songs that were on that album The four songs were "900 Miles," "Two Sisters," "House of the Rising Sun," and "Sinner Man," which Dylan was doing already. Aside from "Two Sisters," all were common, but the record showed there was a place to play this kind of material in Denver, and his affinity with African American folksingers may have made the opportunity to work with Conley—whose picture was on the back of the LP—particularly tempting.

53 special Woody Guthrie issue *Little Sandy Review* 5, ca. Jul 1960.

53 **"If you didn't . . . wouldn't answer"** Sounes, *Down the Highway*, 65.

3. New York Town

56 **the only Fuller song** "San Francisco Bay Blues" seems to have been his only Fuller song at this point. Later he picked up another, "You're No Good," from Jim Kweskin.

56 **"He had that Guthriesque . . . his story"** Van Ronk, *Mayor of MacDougal*, 162.

57 **"There were detractors . . . from the beginning"** Tom Paxton, interviewed by author, 22 May 14.

57 **"He didn't mold . . . always"** Sounes, *Down the Highway*, 111.

58 **"I knew Woody . . . with Bob"** Shelton, *No Direction*, 80.

58 **"His relationship . . . for himself"** Daniel Mark Epstein, *The Ballad of Bob Dylan* (New York, HarperCollins, 2011), 71, 73.

58 **"with someone like Bob . . . just delightful"** Sounes, *Down the Highway*, 78.

58 **"That boy's . . . sing it"** Joe Klein, *Woody Guthrie: A Life* (New York: Alfred A. Knopf, 1980), 427.

58 **"I know Woody . . . Goddamn"** Scaduto, *Bob Dylan*, 53.

58 **"I learned this . . . anybody"** Bob Dylan, "Minneapolis Party Tape," recorded May 1961.

60 **"This street . . . Coney Island"** J. R. Goddard, "MacDougal Street: Fruitcake Version of Inferno, Says Artist," *Village Voice*, 23 Jun 1960, 1.

60 **"They said . . . that sells"** Hentoff, "Folk, Folkum," 170.

61 **"Like from Halls of Ivy"** *Time*, 11 Jul 1960, 56.

62 **"The popularization . . . music comes"** Carroll Calkins with Alan Lomax, "Getting to Know Folk Music," *House Beautiful*, Apr 1960, reprinted in Alan Lomax, *Selected Writings, 1934–1997*, ed. Ronald D. Cohen (New York: Routledge, 2003), 203.

62 **"the kind of folk . . . Willie Johnson"** Cohen, *Rainbow Quest*, 160. Blind Willie Johnson seems an esoteric choice, but Folkways had issued an LP of his old recordings in 1957.

62 **"Why should we . . . experience"** Brand, *Ballad Mongers*, 148.

63 **"Their version of . . . skunk piss"** Van Ronk, *Mayor of MacDougal*, 119–20.

63 **"actual fist fights . . . like us"** Montgomery, "Folk Furor," 100.

63 **her cousin's husband** Rotolo, *Freewheelin' Time*, 278.

64 **kicked out of his high school band** Billy Novick, personal communication.

64 **"Someone would go . . . matter of principle"** Van Ronk, *Mayor of MacDougal*, 47.

65 **"There could be . . . work songs"** Santelli, *Bob Dylan Scrapbook*, 16.

68 "We were sort of . . . performers" Mikal Gilmore, "Bob Dylan, at 60, Unearths New Revelations," *Rolling Stone,* 22 Nov 2001.

68 "We all lived . . . doing it" Van Ronk, interviewed by author, ca. 1995.

69 "He just had it . . . owned it" Jim Kweskin, interviewed by author, 24 May 2014.

69 "Back then . . . saying a word" Van Ronk, *Mayor of MacDougal,* 161.

70 "I thought . . . his technique" Heylin, *Bob Dylan,* 65.

70 "When I first . . . in fact one" Peter Stampfel, interviewed by author, 10 Apr 2014; Bauldie, *Wanted Man,* 36.

71 "Folk songs . . . you could get" Dylan, *Chronicles,* 18, 35, 228.

72 "into a tasteless . . . automobile" Randolph Bourne, "Trans-National America," *Atlantic,* Jul 1916, quoted in Dwight MacDonald, "Masscult and Midcult," *Partisan Review* 27 (1960), reprinted in Macdonald, *Masscult and Midcult: Essays Against the American Grain* (New York: New York Review of Books, 2011), 33.

73 "Since his training . . . generally" Brand, *Ballad Mongers,* 145.

73 "I played all . . . be heard" Crowe, notes to *Bob Dylan,* 35.

75 "He's erratic . . . that well" Scaduto, *Bob Dylan,* 96.

76 first newspaper interview Shelton, *No Direction Home,* 85–86.

76 "I sing old jazz . . . listen to" Bob Dylan, interviewed by Izzy Young, 1961, from Young's notes, courtesy of Ronald Cohen and Scott Baretta.

77 "It was just . . . right away" Scaduto, *Bob Dylan,* 94. This description also draws on John Hammond, *John Hammond on Record* (New York: Summit, 1977), 276.

78 "Resembling a . . . Lemon Jefferson blues" Shelton, "Bob Dylan: A Distinctive Folk-Song Stylist."

78 "much of the Village . . . 'making it' " Shelton, *No Direction Home,* 89.

78 "Bob Dylan . . . ancient bard" Hentoff, "Folk, Folkum," 96.

79 "The tradition . . . deeply care" "Folk Singing: Sibyl with Guitar," *Time,* 23 Nov 1962.

80 "a skinny little . . . wanted to do" Heylin, *Bob Dylan,* 84.

4. Blowin' in the Wind

83 "singing on streetcorners . . . these songs were bad" Guy Carawan, notes to *Songs With Guy Carawan,* Folkways LP 3544, 1958, 2.

84 "to help get people . . . they were feeling" Seeger and Reiser, *Everybody Says Freedom,* 38, 39.

85 Bob Moses . . . "Mississippi's next to go" Seeger and Reiser, *Everybody Says Freedom,* 162.

85 "Our only hope . . . would overcome" Seeger and Reiser, *Everybody Says Freedom,* 55.

86 "There are . . . *some* words" Seeger, *Incompleat Folksinger,* 106.

86 "In prison . . . favorites" *Broadside,* April 1962, 6.

87 "songs demanding . . . stick 'em" Agnes "Sis" Cunningham and Gordon Friesen, *Red Dust and Broadsides: A Joint Autobiography* (Amherst: University of Massachusetts Press, 1999), 282.

88 "We sincerely . . . personal style" *Little Sandy Review* 22, ca. Mar 1962, in Thomson and Gutman, *Dylan Companion,* 61.

90 "White people . . . urine" Rotolo, *Freewheelin' Time,* 87.

92 flamenco guitarist . . . "Near-East musicians" Nightclub listings, *Village Voice,* 16 Aug 1962, 8. The flamenco guitarist was Juan Serrano; the "Near-East" group was the Dolphins.

92 "a young poet, a true poet" Ralph J. Gleason, "A Singer Who Meets You Half Way," *San Francisco Chronicle,* 11 Jul 1965, in Cohen and Capaldi, *Pete Seeger Reader,* 186. Gleason writes that Seeger said this three years earlier, which would place it before this concert, but I have not found his source.

92 "mystified . . . swimmy waters" Robert Shelton, "Carnegie Is Still Going Strong: Capacity Crowd at Hootenanny," *New York Times,* 24 Sep 1962; Pete Seeger, "Woody Guthrie and the Gift to Be Simple," *Little Sandy Review* 5, ca. Jul 1960, 20.

93 "high renaissance . . . experience of it" Stephanie Gervis, "The Years Folk Music Grew Up—and Old," *Village Voice,* 4 Oct 1962, 1.

94 "one of the most . . . his songs" Robert Shelton (as Stacey Williams), notes to *Bob Dylan,* Columbia LP 8579, 1961; Robert Shelton, "Bob Dylan Sings His Compositions," *New York Times,* 13 Apr 1963.

94 "with such champions . . . Guthrie's" "Let Us Now Praise Little Men," *Time,* 31 May 1963, 42.

95 "searing intensity" Shelton, "Bob Dylan: A Distinctive Folk-song Stylist"; "exciting, bluesy" Jon Pankake and Paul Nelson, review of *Bob Dylan* LP, *Little Sandy Review* 22, ca. Mar 1962.

95 "Flock of . . . herself" "Flock of Fresh Folk Singers," *Life,* 9 Mar 1962, 99–102.

95 "He terrified me . . . up with him" Baez, *And a Voice,* 58, 63.

96 "the Madonna of the disaffected" Joan Didion, *Slouching Towards Bethlehem* (New York: Farrar, Straus & Giroux, 1968), 47.

96 contract terms The details of Grossman's business dealings are largely drawn from Sounes, *Down the Highway,* 115–19.

97 "Albert scared . . . history" Jonathan Taplin, interviewed by author, 30 Mar 2014.

97 "He actually . . . unscrupulous" Van Ronk, *Mayor of MacDougal,* 167.

97 "Bob Dylan could not . . . rent" Von Schmidt and Rooney, *Baby,* 280.

98 "Some of the . . . smarter" Bob Dylan, "Blowin' in the Wind," *Sing Out!,* Oct–Nov 1962, 4.

98 "He was a populist . . . view" Van Ronk, *Mayor of MacDougal,* 204.

98 "Dylan was perceptive . . . level" Scaduto, *Bob Dylan*, 116.

99 "the maniacs . . . radiation" Rotolo, *Freewheelin' Time*, 194–95.

100 "When I started . . . bunch of them" "Folk Singing: Sibyl with Guitar," *Time*, 23 Nov 1962, 55.

101 "sick and evil . . . public protests" Ren Grevatt, "Greenbriars Balk at 'Hootenanny' Booking," *Billboard*, 13 Apr 1963, 1.

101 "[Pete] always felt . . . a season" Van Ronk, *Mayor of MacDougal*, 199.

102 Daytona Beach "Beach Hoot a Splashing Success," *Billboard*, 27 Apr 1963, 16.

102 national television debut The TV special was on the Westinghouse network, which had five stations, in Boston, Philadelphia, San Francisco, Pittsburgh, and Baltimore.

102 on Pete Seeger's urging Seeger's role in arranging Dylan's concert is mentioned in Shelton, "Bob Dylan," n.p.

104 "You can't label him . . . black and white anymore" *Studs Terkel's Wax Museum*, WFMT, Chicago, 26 Apr 1963.

105 "the dirt farm songs . . . Bill Moore's highway" Bob Dylan, "—for Dave Glover," 1963 Newport Folk Festival program, 5–6.

106 "pretty good people . . . scapegoat" *Studs Terkel's Wax Museum*, WFMT, Chicago, 26 Apr 1963.

107 "He would withdraw . . . together" Rotolo, *Freewheelin' Time*, 94.

108 "Too many . . . in the wind" Bob Dylan, "Blowin' in the Wind," *Sing Out!*, Oct–Nov 1962, 4.

5. Newport

114 "At first he seemed . . . on you" Hadlock, "Kingston Trio," 20.

115 "I was dead set against . . . a visionary" Wein, *Myself Among Others*, 188.

116 "predominantly youthful . . . before" Robert Shelton, "Folk Music Festival," *The Nation*, 1 Aug 1959, 59.

116 "the most ambitious . . . Trio" Robert Shelton, "Folk Joins Jazz at Newport," *New York Times*, 19 Jul 1959.

116 "a visual impression . . . Folk Festival" Wein, *Myself Among Others*, 315.

117 "with their characteristic . . . spinster's home" Robert Shelton, "Folk Joins Jazz at Newport," *New York Times*, 19 Jul 1959.

117 "in the rudest terms" Bush, *Greenback Dollar*, 175.

117 "A wildly cheering . . . seats again" Herbert P. Zarnow, "Kingston Trio Hit Of Festival—Huge Crowd Demands 'More,'" *Newport Daily News*, 13 Jul 1959.

118 "For some folk . . . redemption" Wein, *Myself Among Others*, 316.

118 "Second Newport . . . over to folk music" Robert Shelton, "Second Newport Folk Festival Combines Primitive and Popular," *New York Times*, 25 Jun 1960.

119 "their old country . . . music" Irwin Silber, notes to *The Folk Music of the Newport Folk Festival: 1959–1960*, Folkways LP 2431/2, 1961, 2.

120 "blues and union songs . . . boulevard" Montgomery, "Folk Furor," 98–99.

121 "all those tremendous artists . . . real well" Alan Lomax, interviewed by Nick Spitzer, 25 Jul 1990, courtesy of Spitzer and *American Routes*.

122 Seeger requested that instead of paying him Wein, *Myself Among Others*, 318–19.

122 "would uphold . . . Pete Seeger" Wein, *Myself Among Others*, 318.

123 Toshi had wondered . . . fifty dollars a day Brauner, "Study," 59–60.

123 "to the benefit . . . by the festival" Theodore Bikel, Pete Seeger, and George Wein, "Proposal for the Newport Folk Festival to be held in Newport July 1963 on the 26th, 27th and 28th," in Brauner, "Study," 254–57.

124 "Though his first . . . one will" *Billboard*, 20 Jul 1963, 10.

125 "to know and relate . . . oddball demeanor" Wein, *Myself Among Others*, 321–22.

126 "like the two Smith . . . by turn" Ted Holmberg, "Entertainers Offer Variety in Program," *Providence Journal*, 27 Jul 1963, 1.

127 "slightly stooped . . . little man" Jane Nippert, "Initial Festival Performance Had Something for Everyone," *Newport Daily News*, 27 Jul 1963, 1.

128 Saturday morning ballad workshop Many sources have Dylan and Baez making their festival debut at the Friday "Whither Folk Music" workshop, a mistake that seems to have started with Robert Shelton's biography (*No Direction*, 131), which merges the Friday workshop with the Saturday morning ballad showcase.

128 "It was obvious . . . bitter songs" "Workshops Become Folk Festival Magnet," *Providence Journal*, 29 Jul 1963, 18.

129 "proved that . . . within them" " 'This Land Is Your Land' Ends Festival On High Note," *Newport Daily News*, 29 Jul 1963, 1.

130 "There is only one . . . like that" Jackson, Bruce, "Newport," *Sing Out!*, Aug–Sep 1966, 9.

130 "nearly equaled . . . significance" Wein, *Myself Among Others*, 323.

130 "sounds much like . . . a six shooter" Ted Holmberg, "Verve, Rhythm Set Second Night's Tone," *Providence Journal*, 28 Jul 1963, 33. Hooker sang his own lyric, "Let's Make It," over the "Green Onions" bassline.

130 "Baez and Dylan . . . trading songs" Wein, *Myself Among Others*, 324.

131 "This was all very private . . . kind of songs" Paul Rothchild, interviewed by Ronald Cohen, 26 Jun 1990, courtesy of Cohen.

131 "so they wouldn't . . . be themselves" Brauner, "Study," 78–79.

131 "They're going to get . . . off stage" "Dewey Balfa and the Balfa Brothers," http://www.balfatoujours.com/brothers.html, archived at the Internet Archive Wayback Machine, https://archive.org/web/.

132 "I don't want . . . Kentucky" Wein, *Myself Among Others*, 340.

132 "I can understand . . . do you want?" Frank Proffitt, "Good Memories for
 Me," *Sing Out!*, Nov 1965, 36.

133 "There was an awkward . . . were seated" Wein, *Myself Among Others*, 326–27.

134 "What do you . . . around himself" Scaduto, *Bob Dylan*, 148.

134 "The sense of business . . . the ground" Rotolo, *Freewheelin' Time*, 231.

135 "With his raggedy . . . planning" Shelton, *No Direction*, 131.

135 "Dylan arrived . . . a star" Shelton, *No Direction*, 130.

135 "22-year-old . . . between" Biographical blurb, 1963 Newport Folk Festival
 program.

137 "Most young white guys . . . Tom Wolfe" Sam "Lightning" Hopkins and Eric
 Von Schmidt, "Whose Blues?" 1963 Newport Folk Festival program. Hal
 Holbrook was famous for his one-man show *Mark Twain Tonight*. Tom Wolfe
 was presumably the pioneering "new journalist" who was currently a rising star
 at the *New York Herald Tribune*, though Von Schmidt may instead have meant
 the progressive novelist Thomas Wolfe, a less up-to-date but more familiar name
 in 1963.

138 "pedants . . . thickety footing" Mitchell T. Jayne, "The Vanishing Race," 1963
 Newport Folk Festival program.

139 "there was a camaraderie . . . Grossman" Peter Yarrow, interviewed by author,
 8 Jul 2014.

139 "the greatest experience . . . selfless way" Emil E. Jemail, "Folk Festival's
 48,000 Assures It of Future," *Newport Daily News*, 29 Jul 1963, 1.

139 "a series of . . . things happened" Jean Ritchie, Board of Directors statement,
 1964 Newport Folk Festival program, 3.

6. Times a-Changin'

141 "a dress rehearsal . . . culture" Shelton, *No Direction Home*, 130.

144 "We all know . . . fallout" William H. Young, "Folk Music's Future Dis-
 cussed," *Providence Journal*, 27 Jul 1963, 5.

145 "He has become . . . pretentious" Pankake and Nelson, "Flat Tire," 24.

146 "Dragging my little . . . genius" Baez, *And a Voice to Sing*, 91.

146 "Dylan, whatever . . . college groups" Van Ronk, *Mayor of MacDougal*,
 166–67.

147 "People, regardless . . . of it" Dunaway, *Singing Out*, 45.

147 "a huge assemblage . . . repertoire" "The First Annual University of Chicago
 Folk Festival," *Little Sandy Review* 12, ca. 1961, 3, 49.

148 "doesn't do a damn thing . . . world" Shelton, *No Direction Home*, 100.

148 "blind young . . . parties" "Topical Songs and Folksinging, 1965: A Sympo-
 sium," *Sing Out!*, Sep 1965.

148 "terrible thought . . . oblivious" Dunaway, *Singing Out*, 143.

148 "without knowing . . . Negro" "Talking About," *Jet*, 3 Jan 1963, 43.

148 "these black kids . . . splitting" Von Schmidt and Rooney, *Baby*, 218.

149 "revelation . . . in the world" Julius Lester, interviewed by author, 9 May 2014.

149 "This lady . . . register" Josh Dunson, *Freedom in the Air: Song Movements of the Sixties* (Westport, CT: Greenwood, 1965), 110.

149 "The black people . . . understand them" Dunaway, *Singing Out*, 143.

149 "We were not . . . all colors" Hajdu, *Positively 4th Street*, 183.

150 "My Son . . . strictly an act" Walter Eldot, "My Son, the Folknik: Youth from Hibbing Becomes Famous as Bob Dylan," *Duluth News Tribune*, 20 Oct 1963, available online at http://attic.areavoices.com/2008/11/01/bob-dylan-1963, accessed 8 Jun 2014.

150 "mostly high school . . . that matters" "I Am My Words," *Newsweek*, 4 Nov 1963, 94–95.

151 "All I could think . . . a person" Pete Seeger letter, Nov 1963, in Seeger, *Pete Seeger*, 316.

151 "the second coming . . . resurgence" Hajdu, *Positively 4th Street*, 210.

152 on the cover of *Esquire* Esquire, Sep 1965.

153 "far more likely . . . dispositions" Richard Fariña, "Baez and Dylan: A Generation Singing Out," *Mademoiselle*, Aug 1964, in Thomson and Gutman, *Dylan Companion*, 82.

154 "they're all young . . . to do with it" Bob Dylan, speech to the Emergency Civil Liberties Committee, 13 Dec 1963, available online at http://www.corliss-lamont.org/dylan.htm, accessed 8 Jun 2014.

155 "They looked . . . all living in" Nat Hentoff, "The Crackin', Shakin', Breakin' Sounds," *New Yorker*, 24 Oct 1964, 88.

155 "We all share . . . my life" Bob Dylan, "A Message," available online at http://www.corliss-lamont.org/dylan.htm, accessed 8 Jun 2014.

156 "were challenging . . . behavior" Rotolo, *Freewheelin' Time*, 89–90.

156 "I am now famous . . . tongues blazin" Bob Dylan, "A Letter from Bob Dylan," *Broadside*, 20 Jan 1964, 7–12.

157 "Don't bad-mouth . . . SING!" Johnny Cash, "A Letter from Johnny Cash," *Broadside*, 10 Mar 1964, 10.

159 By comparison . . . top of the charts It is hard to find reliable sales figures, but Baez's first three albums each reached the *Billboard* Top 20 and stayed on the LP chart for more than two years. Cash's albums climbed less high and fell off sooner—*Ring of Fire* was the longest lasting at sixty-eight weeks, but only reached number 26, while Baez's album from 1963, *In Concert, Part 2*, went to number seven. Peter, Paul, and Mary's two LPs from 1963 stayed at numbers one or two for over a month and on the chart for eighty and ninety-nine weeks. Dylan's album sales may well have been on a par with Cash's by then, but Cash was also selling singles and Dylan was not.

159 "Where are your . . . middle age" Johnny Cash, advertisement, *Billboard*, 22 Aug 1964, 31.

160 "surrounded by . . . South alone" 1964 Newport Folk Festival program, 35.

160 "Cash was . . . pop world" Robert Hilburn, *Johnny Cash: The Life* (New York: Little, Brown, 2013), 269.

161 "Never was there . . . grassroots interest" Wein, *Myself Among Others*, 326.

163 "For some of them . . . around him" Samuel Charters, notes to *The Blues at Newport 1964, Part 1*, Vanguard LP 9180, 1965.

164 "many whites from . . . either direction" William Buchanan, "Folk Festival Offers Sounds and Sights," *Boston Globe*, 26 Jul 1964, 13.

164 "Under virtually . . . 25 or 30" William Buchanan, "Folk Festival Ends," *Boston Globe*, 27 Jul 1964, 14.

164 "the most beautiful" . . . twist "Newport (notes)," *Broadside*, 20 Aug 1964, 11.

165 "gaunt and twitchy . . . as hell" Glover, "Second Annual 2000 Words." Jack Elliott recalled Cash driving to Woodstock the following winter to retrieve a guitar from Dylan, so it is not clear whether this was a gift, as Glover remembers, or a loan (see Michael Streissguth, *Johnny Cash: The Biography* [Boston: Da Capo, 2013], 120).

165 "I don't have . . . like kids" Johnny Cash with Patrick Carr, *Cash: The Autobiography* (New York: HarperCollins, 2003), 266.

165 "strange mixture . . . for the music" Glover, "Second Annual 2000 Words."

166 "Old men with banjos . . . anyway" Nelson, "Newport," 48–49.

167 "If someone asks . . . not object" Pete Seeger, "Long Live Plagiarism," *Broadside*, 20 Aug 1964, 7, 8.

167 "Now, isn't that . . . the world?" Seeger, *Incompleat Folksinger*, 262.

169 "the social commitment . . . conclusion" Robert Shelton, "Symbolic Finale: Folk Festival Winds Up with Songs of the Negro Integration Movement," *New York Times*, 2 Aug 1964.

170 "anti-love . . . out of control" Shelton, *No Direction Home*, 181.

170 "wonderful . . . school boys" Ted Holmberg, "A Magnificent Windup," *Providence Journal*, 27 Jul 1964, 1.

170 "appearing better . . . magnificent" Jane Nippert, "Odetta Leads Stageful of Singers to Perfect Festival Ending," *Newport Daily News*, 27 Jul 1964, 1.

170 "painful . . . seven or eight" Nelson, "Newport," 66.

7. Jingle-Jangle Morning

173 "HOW MANY . . . Not A folksinger" Santelli, *Bob Dylan Scrapbook*, 35 (insert).

173 "What a drag . . . makes life fun" Faithfull , *Faithfull*, 53.

174 Dylan's road trip This chronology is mostly drawn from Heylin, *Bob Dylan*, 55–57.

174 "Their chords . . . made it all valid" Von Schmidt and Rooney, *Baby*, 260.

175 "this great blues . . . flipped" "Jackie DeShannon's New 'Bag,'" *Rock Folk Songs* magazine, Winter 1966, 27.

176 "basically folk music . . . definite line" Keith Richards with James Fox, *Life* (New York: Little, Brown, 2010), 69, 71–72, 84.

178 "Baby, Let Me Take You Home" "Baby [or Mama, or Daddy], Let Me Lay It On You" was first recorded in 1936 by four different artists including Blind Boy Fuller, whose version was adapted by Eric Von Schmidt in the 1950s and learned by Dylan. It was also revived in 1957 by the New Orleans R & B pianist Professor Longhair as "Baby, Let Me Hold Your Hand," and Bert Berns, a New York songwriter and record producer, rewrote that version in 1963, cut it with a soul singer named Hoagy Lands, then reworked it as "Baby, Let Me Take You Home," cut his own demo in pop-folk style, and gave a copy to the Animals' manager, Mickey Most. The Animals added the line from Dylan's version.

178 "I'll follow you anywhere, Bob" Sounes, *Down the Highway*, 152.

179 "We created a culture . . . option" Paul Rothchild, interviewed by Ronald Cohen, 26 Jun 1990.

179 "in front of the mirror . . . order of things" Rotolo, *Freewheelin' Time*, 10.

180 "It was the real thing" Mackay, *Bob Dylan*, 10.

181 "I like his whole . . . polished" Coleman, "Beatles Say," 3.

181 "This is going . . . eyes" Bosley Crowther, "The Four Beatles in 'A Hard Day's Night': British Singers Make Debut as Film Stars A Lively Spoof of the Craze They Set Off," *New York Times*, 12 Aug 1964.

181 "the brilliant . . . authorities" Andrew Sarris, "Bravo Beatles!," *Village Voice*, 27 Aug 1964, 13.

182 "There must be . . . knocks us out" Coleman, "Beatles Say," 3.

182 "something of merit . . . the losers" Robert Shelton, "The Kingston Trio Vs. Beatlemania," *Hootenanny*, Nov 1964, 13, 66.

183 "Folk music is still . . . now" Bob Dylan, interviewed by Paul J. Robbins, March 1965, printed in the *Los Angeles Free Press*, 17 and 24 Sep, 1965, available online at http://www.interferenza.com/bcs/interw/65-nov08.htm.

183 "shuddered . . . rock-n-roll" Thom Hurwitz, letter to *Sing Out!*, May 1965, 105.

184 "Jazz was hip . . . seething irony" Faithfull, *Faithfull*, 15, 32, 73, 40.

186 "were raw . . . original" Ellen Willis, notes of interview with Tom Wilson, 4 Jan 1967, in the Ellen Willis Papers, Arthur and Elizabeth Schlesinger Library on the History of Women in America, Radcliffe University.

186 "If you put . . . a message" Crowe, notes to *Bob Dylan*, 13.

186 "played the same . . . rhythmic structure" Bruce Langhorne, interviewed by Richie Unterberger, available online at http://www.richieunterberger.com/langhorne.html, accessed 13 Feb 2014.

187 **"I could have . . . It's true"** Jonathan Cott, "Mick Jagger: The Rolling Stone Interview," *Rolling Stone*, 12 Oct 1968, at available online at http://www.rollingstone.com/music/news/the-rolling-stone-interview-mick-jagger-19681012. Cott started the interchange by asking, "What other group ever wrote a song like '19th Nervous Breakdown,' or 'Mother's Little Helper'?" Jagger promptly responded, "Bob Dylan."

187 **"folk-rock" trend** "New Vee Jay Post to Siegel," *Billboard*, 25 Jul 1964, 4; "Large Folk Groups Make Bids on Coast," *Billboard*, 25 Jul 1964, 36. The term was not new. In 1959 *Billboard* referred to Lonnie Donegan's "Fort Worth Jail" as "a pounding, rocking folk effort," wrote in 1963 that the Glencoves' "Devil's Waitin' (On Bald Mountain)" had a "wide open folk-rock sound"; and in March 1964 mentioned Chubby Checker's "new folk-rock groove," but the July articles were the first to suggest this had become a marketing term.

188 **"the Beatles . . . their direction"** Cary Ginell, notes to *Washington Square Memoirs: The Great Urban Folk Boom*, Rhino CD 74264, 2001, 56.

188 **"Jim suggested . . . more poetic"** Einarson, *Mr. Tambourine Man*, 54.

189 **what if it worked?** As it happened, two of the Sellouts became the rhythm section of the Lovin' Spoonful.

189 **"If you would like . . . Alabama"** Pete Seeger, *We Shall Overcome*, Columbia LP 2101, 1963.

190 **"Man, what a . . . song this is!"** Einarson, *Mr. Tambourine Man*, 54.

190 **"one of the big separators . . . at that point"** Paul Rothchild, interviewed by Ronald Cohen, 26 Jun 1990.

191 **"the paraphernalia . . . a little cruel"** Irwin Silber, "An Open Letter to Bob Dylan," *Sing Out!*, Nov 1964, 22–23.

191 **"the pressures . . . a celebrity"** Paul Wolfe, *Broadside*, 20 Dec 1964, 13.

191 **"Afta years . . . Who does?"** Adam Simms, letter, *Sing Out!*, May 1965, 110.

191 **"There's nothing noble . . . the world"** Jack Newfield, "Blowin' in the Wind: A Folk-Music Revolt," *Village Voice*, 14 Jan 1965, 11.

191 **"who not only . . . picket line"** Phil Ochs, "An Open Letter from Phil Ochs to Irwin Silber, Paul Wolfe and Joseph E. Levine," *Broadside*, January 1965, 11–12.

192 **"I'd rather . . . Brando movies"** Bob Dylan, interviewed by Paul J. Robbins, March 1965, printed in the *Los Angeles Free Press*, 17 and 24 Sep, 1965, available online at http://www.interferenza.com/bcs/interw/65-nov08.htm.

193 **"The kids were calling . . . funeral parlor"** Hajdu, *Positively 4th Street*, 239.

195 **"My friends were playing . . . do you?"** D. A. Pennebaker, dir., *Dont Look Back*, 1967.

195 **"It just didn't . . . with the band"** "The Folk and the Rock," *Newsweek*, 20 Sep 1965.

195 **"serious bad boys . . . Pensacola"** Faithfull, *Faithfull*, 54.

197 **PP&M would never again equal his sales** Dylan's singles sold less well than his LPs, and Peter, Paul, and Mary got a number one hit in 1970 with "Leaving on a Jet Plane," but their album sales were never again in his range.

197 **"I wanted to meet him . . . it was groovy"** Wolkin and Keenom, *Michael Bloomfield*, 99–101; Mike Bloomfield, "Impressions of Bob Dylan," *Hit Parader*, Jun 1968, n.p.

199 **"It was not . . . 'big beat' music"** Robert Shelton, "Folk Event Opens with a 'Big Beat,' " *New York Times*, 18 Jun 1965.

199 **"I want to avoid . . . each other"** Robert Shelton, "Banjos and Ballads," *New York Times*, 13 Jun 1965.

199 **"With Chuck Berry's . . . music"** "What's Happening," *Sing Out!*, Sep 1965, 4.

199 **"The topical-song . . . musical diet"** Robert Shelton, "The Year that Was—In Folk," *The Folk Scene*, handout at the New York Folk Festival, reprinted from *Cavalier*, Jul 1965, n.p.

199 **"genius poet . . . than the folk revival"** Shelton, "Bob Dylan," n.p.

8. Electricity in the Air

201 **"From all parts . . . folk pilgrimage"** De Turk and Poulin, *American Folk Scene*, 33.

202 **"Just when everybody's . . . folk scene"** De Turk and Poulin, *American Folk Scene*, 13.

203 **"close to Utopia . . . fiasco again"** Travers, Letter to Archie Green.

204 **on the board's short list of invitees** Newport Folk Festival Board meeting minutes, Ralph Rinzler papers, Smithsonian Folklife Archive.

204 **"He's got a tremor . . . that music"** Michael Bloomfield, interviewed by Murray Lerner at Newport, 1965, courtesy of Lerner.

205 **"the usual gamut . . . of denim"** Robert Shelton, "Music: Folk Fete Opens," *New York Times*, 23 Jul 1965.

206 **"would have to be . . . the Beatles"** Ted Holmberg, "Some Strange, Some Wonderful," *Providence Journal*, 23 Jul 1965, 1.

206 **"four lanky . . . folk 'n' roll"** Arnold Reisman, "Joan and the Folks Assemble at Newport," *Quincy Patriot Ledger*, 23 Jul 1964, 22.

207 **"the English Dylan"** "Spotlight Singles," *Billboard*, 24 Jul 1965, 14.

208 **"We realize . . . Baez's numbers"** Jane Nippert, "Joan Baez Stars in Opening; Fans Cool to Protest Songs," *Newport Daily News*, 23 Jul 1965, 1.

210 **"its similarity to Hollywood . . . Dylan!"** Arthur Kretchmer, "It's All Right, Ma, I'm Only Playin' R & R," *Village Voice*, 5 Aug 1965, 6.

210 **"the Cannes . . . deals"** Mary Katherine Aldin, notes to *Phil Ochs: Live at Newport*, Vanguard CD77017, 1996.

210 **"the big beat . . . a new style"** Robert Shelton, "A Little Behind the Beat," 1965 Newport Folk Festival program, 16, 57.

212 "Many of the younger . . . about country music" Rooney, "Reflections on Newport '65."

213 "The clear-cut . . . folk music" Paul Nelson, "What's Happening," *Sing Out!*, Nov 1965, 6.

213 "the three-ring circus . . . folk music" Robert Shelton, "Beneath the Festival's Razzle-Dazzle," *New York Times*, 1 Aug 1965.

213 "The audiences . . . *anyone* have said?" Bill Brown, "Donovan Talks (Guardedly) about Idol Dylan," *New Musical Express*, 10 Sep 1965, 10.

214 "You could hear . . . here yet?" Boyd, *White Bicycles*, 96.

214 "who was literally . . . unnoticed" De Turk and Poulin, *American Folk Scene*, 277; Bradford F. Swan, "Workshops Worth Wear on Feet," *Providence Journal*, 24 Jul 1965, 1.

214 "genuinely terrified . . . and everything" Scaduto, *Bob Dylan*, 192.

214 "People start to idolize . . . forget him" Lerner, *Festival!*

215 "so immense . . . the other side!" Heylin, *Bob Dylan*, 207.

215 "Paul was the real thing . . . his own" Mike Bloomfield interviewed by Dan McClosky, 1971, on *Bloomfield: A Retrospective*, Columbia LP 37578, 1983.

216 "They never get to hear . . . different story" Lerner, *Festival!*; additional interview footage courtesy of Lerner.

217 "too easily . . . folk festival" additional Lerner interview footage.

218 "This was what . . . people listened to" Ward, *Michael Bloomfield*, 44.

218 "There's no white . . . into the blues" Lerner, *Festival!*

218 "We were Chicago . . . toughness" Barry Goldberg, interviewed by author, 2 May 2014.

219 "an articulate . . . modernity" Robert Shelton, "Folklorists Give Talks at Newport," *New York Times*, 24 Jul 1965.

221 **Butterfield's first record** Some sources say Butterfield was booked because "Born In Chicago" had caught on after being issued on Elektra's *Folk Song '65* sampler, but that LP was not issued until August.

222 "ludicrous . . . nice thing" Jim Delehant, "Mike Bloomfield Puts Down Everything (Part II)," *Hit Parader*, Feb 1967, 57.

222 "from a cane fife . . . from Chicago, played on" Lomax's introduction of Butterfield is the only part of this workshop that was not recorded in full. The earliest quote is from Robert Shelton's notebook, archived at the Experience Music Project; the bulk of the introduction is from audio recorded by Murray Lerner, courtesy of Lerner.

223 "What the fuck . . . of yourself" Paul Rothchild, interviewed by Ronald Cohen, 26 Jun 1990.

223 "Do you . . . the mouth?" Reuss, "Folk Scene Diary."

223 "I don't . . . like you" Travers, Letter to Archie Green.

223 "Lomax symbolized . . . the flesh" Wein, *Myself Among Others*, 331.

223 "It was a gas . . . joy" Spitz, *Dylan*, 576.

224 "Kick that . . . boogie" Bloomfield, "Dylan Goes Electric," 150.

224 "Paul Butterfield . . . Rolling Stones" Arnold Reisman, "Two Petes, a Paul and a Mary," *Quincy Patriot Ledger*, 24 Jul 1965, 16.

225 "I was almost . . . ever heard" Maria Muldaur, interviewed by author, 4 Sep 2014.

225 "To me . . . on that model" John Milward, *Crossroads: How the Blues Shaped Rock 'n' Roll (and Rock Saved the Blues)* (Lebanon, NH: University Press of New England, 2013), 72–73.

225 "the songwriter . . . phenomena" Paul Rothchild, interviewed by Ronald Cohen, 26 Jun 1990.

225 "For me . . . Sir Douglas Quintet" Jeffrey Jones interview, Newport Folk Festival, 24 Jul 1965, published in Jones, "Bob Dylan's Ballad of Mister Jones . . . by Mister Jones," *Rolling Stone*, 18 Dec 1975. Available online at http://www.rollingstone.com/music/news/bob-dylans-ballad-of-mister-jones-by-mister-jones-19751218.

226 "all that embellishment . . . *just like us*" David Dann, "Michael Bloomfield at Newport," available online at http://www.mikebloomfieldamericanmusic.com/newport.htm, accessed 1 May 2014.

226 "At this point . . . inaudible" Mary Katherine Aldin, personal communication, 19 Apr 2014.

227 "when the verdict . . . of life" Boyd, *White Bicycles*, 99. Neither Wein nor Yarrow remembers the attempt to ban Grossman, but both find the story credible.

9. Younger Than That Now

229 Recording made by Pete and Toshi Seeger The recording was made in February 1951 by a team including Pete and Toshi Seeger, who did the accompanying interviews and seem to have brought the equipment and supervised the taping, along with John Lomax Jr., Chester Bower, and Fred Hellerman, and was issued with notes by Pete on *Negro Prison Camp Work Songs*, Folkways LP 4475, 1956.

230 "the glad, mad . . . ocean" Bob Dylan, notes to Eric Von Schmidt, *Who Knocked the Brains Out of the Sky*, Smash/Mercury LP 67124, 1969.

230 "I'm gonna tell . . . LORD!" Williams was one of the singers on the original recording of "Grizzly Bear," but it was a much older song, and he did not compose it.

232 "You listen to people . . . not there," Andrew F. Blake, "Symbol of Genuineness," *Providence Journal*, 25 Jul 1965, 14.

232 "I shut my eyes . . . story too" Norman Kennedy, interviewed by author, March 2014.

232 "swinging a mean axe . . . work song" Clara F. Emerson, "Musical Workshops Spread Folk Culture," *Newport Daily News*, 24 Jul 1965.

233 "It was one of the wonderful . . . anyone listened" Bradford F. Swan, "Work-shops Worth Wear on Feet," *Providence Journal*, 24 Jul 1965, 1.

233 "just a handful . . . the desert?" Bradford F. Swan, "Part Workshop, Part Concert," *Providence Sunday Journal*, 25 Jul 1965, 14.

234 "I didn't think . . . the ranks" Greg Pennell, "Newport Folk Festival 1965," available online at http://farinafiles1.tripod.com/id22.htm, accessed 5 Feb 2014.

236 "everything should be fused" Robert Shelton, Newport 1965 notebook, archived at the Experience Music Project, Seattle.

237 "the Beatles wiped us all out" John Einarson, *Four Strong Winds: Ian and Sylvia*, with Ian Tyson and Sylvia Tyson (Toronto: McClelland & Stewart, 2011), 147.

238 "fused bouzouki . . . sounds" Robert Shelton, "Folk Music Fills Newport Coffers," *New York Times*, 26 Jul 1965.

239 "I was very angry . . . to do that" Hajdu, *Positively 4th Street*, 256.

239 "to move as quickly as he does" Robert Shelton, *No Direction Home*, 228.

239 "drawn to himself . . . obnoxiously apparent" Joe Spiegel, "Newport Folk Festival Mixes Talent with Trash," *New Paltz Oracle*, 6 Aug 1965, 6.

242 "Droll pixies . . . native Boston" Ted Holmberg, "Laughter Takes Its Turn," *Providence Sunday Journal*, 25 Jul 1965, 1.

243 "swinging shepherd beat" Reisman, "Folkniks Boo," 20.

243 "Whatever . . . to the seaside" Kooper, *Backstage Passes*, 38.

243 "Who the hell is Bob Dylan?" Unterberger, *Turn!*, 8.

244 "pretty fun . . . the show was" Wolkin and Keenom, *Michael Bloomfield*, 105.

244 "We're practicing . . . sounding horrible" Heylin, *Bob Dylan*, 209.

244 "We just learned . . . the band" Mike Bloomfield, "Impressions of Bob Dylan," *Hit Parader*, June 1968.

244 Odetta . . . "a folksinger once again" M. Charles Bakst, " . . . But Bobby Dylan Played On," *Providence Journal*, 26 Jul 1965, 5.

10. Like a Rolling Stone

247 "by a strange . . . Ritchie did" Bradford F. Swan, "Folk Singing in the Rain," *Providence Journal*, 26 Jul 1965, 4.

249 "We were angry" . . . starting to rain Hajdu, *Positively 4th Street*, 257; the following description is based on the audio tapes and film, helped by hints from Greg Pennell, "Newport Folk Festival 1965," available online at http://farinafiles1 .tripod.com/id22.htm, accessed 5 Feb 2014. The song list diverges from Hajdu's because he had access only to the Vanguard tapes, which are incomplete.

249 "a sight I'll . . . wonderful" Pete Seeger, *Rainbow Quest*, WNJU, 26 Feb 1966, quoted in Unterberger, *Turn!*, 7.

250 "The images . . . that afternoon" Boyd, *White Bicycles*, 102.

250 "a perfect way . . . the festival" Hajdu, *Positively 4th Street*, 258.

250 "as we called . . . colors" Boyd, *White Bicycles*, 102.

251 "the drenched . . . stomping accompaniment" Clara F. Emerson, "Festival Fans Weather Pelting Rain, Show Artists Undampened Fervor," *Newport Daily News*, 26 Jul 1965, 3.

251 "It was really . . . the whole thing" Barry Goldberg, interviewed by author, 2 May 2014.

251 "It was completely . . . neither was Bloomfield" Jonathan Taplin, interviewed by author, 30 Mar 2014.

252 "Back onstage . . . to be hungry" Boyd, *White Bicycles*, 103.

255 "stage-cured ham . . . smile" Reisman, "Folkniks Boo," 20.

256 "He was affronted . . . disrespected" Yarrow, interviewed by the author, 8 Jul 2014.

259 seventeen thousand people The standard newspaper figure the next day was sixteen thousand, but that seems to be derived from the fifteen thousand seats plus some overflow, and does not account for the two to four thousand reported in the parking lot.

259 film clips were edited The two most familiar versions in release are *Festival!*, in which "Maggie's Farm" ends with an overdub of the last words of Yarrow's introduction and the cheering that greeted Dylan's arrival, and *The Other Side of the Mirror*, which overdubs the mix of booing and cheering that followed his departure from the stage. In reality, he said, "Thank you very much"—included on neither film soundtrack—presumably in response to the largely inaudible cheering that is covered by the last notes of the instruments, and the crowd noise died down almost immediately afterward.

259 the sound system Bill Hanley, interviewed by author, 7 Aug 2014.

259 "It was very emotional . . . confusing" Peter Bartis, interviewed by author, 5 Aug 2014.

265 "stunned . . . sort of daze" Leda Schubert, personal communication, 29 Mar 2014.

265 "When Bob . . . 'want to know'" Harold Leventhal, interviewed by Jeff Rosen, courtesy of White Water Productions.

265 "at the sound . . . we can do" Wein, *Myself Among Others*, 333.

266 "grinning like cats" . . . middle finger Boyd, *White Bicycles*, 104–5.

266 "towering . . . kill ya" Paul Rothchild, interviewed by Ronald Cohen, 26 Jun 1990.

266 "I feel like . . . for Pete" Dunaway, *How Can I Keep*, 306.

266 "rushing around . . . 'Turn it off'" Mika Seeger, interviewed by author, 4 Jul 2014.

266 "It was Godawful . . . stand it" Von Schmidt and Rooney, *Baby*, 262.

267 "The sound levels . . . hear them" Unterberger, *Turn!*, 12.

267 "It looked like . . . moment to scream" Scaduto, *Bob Dylan*, 215; Wolkin and Keenom, *Michael Bloomfield*, 107–8.

267 "He really was . . . getting off" Barry Goldberg, interviewed by author, 2 May 2014.

267 "I thought we were . . . booing him" Bloomfield, "Dylan Goes Electric," 150–51.

268 "because every other . . . wrong" Wolkin and Keenom, *Michael Bloomfield*, 106.

269 "Everyone expected . . . good graces" Judy Landers scrapbook, courtesy of Herb Van Dam.

269 "really loved it . . . was over" Ann O'Connell, personal communication, 19 Mar 2014.

270 "more or less killed . . . destructive" Alan Lomax, letter to John Henry Faulk, 30 Jul 1965, in the Faulk papers, University of Texas, Austin, provided by Ronald Cohen.

270 "I said to Bobby . . . in the air" Wein, interviewed by author, 8 Jul 2014.

271 "They don't . . . out there" Reisman, "Folkniks Boo," 20.

271 "He came offstage . . . analysis" Dunaway, *Singing Out*, 152.

271 "I did not . . . drunk" Scaduto, *Bob Dylan*, 213.

271 "unrepentant . . . done to me?" Yarrow, interviewed by author, 8 Jul 2014.

271 "They twisted . . . before I began" Bob Dylan, interviewed by Nora Ephron and Susan Edmiston, ca. Aug 1965, available online at http://www.interferenza .com/bcs/interw/65-aug.htm.

271 "Shouts from non-Dylan . . . cheers" Zhito, "Newport Folk Festival," 7.

271 "there were numerous . . . guitar" Nippert, "Finale of Festival," 1.

271 "bitter and dejected . . . nevertheless" Reisman, "Folkniks Boo," 20.

271 "With the air . . . for more" Zhito, "Newport Folk Festival," 7.

272 "Some booed . . . Dylantants" Ochs, "Newport Fuzz," 58.

272 "fanatic screaming . . . confrontation" Mirken, "Newport," 13.

272 "He left the stage . . . new sound" Ed Freeman, "Notes From a Variant Stanza Collector," *Broadside of Boston*, 18 Aug 1965, 4; Michael J. Carabetta, "In Defense of Dylan," *Broadside of Boston*, 18 Aug 1965, 5.

272 "the leather-jacketed . . . 'Tambourine Man'" Ernie Santosuosso, "Newport Folk Festival Winds Up—City Can Relax, Heave a Deep Sigh," *Boston Globe*, 26 Jul 1965, 17.

273 "macabre-looking . . . organ" Ted Holmberg, "A Triumph to the Final Note," *Providence Journal*, 26 Jul 1965, 6.

273 "Nobody wants . . . Hall Singers" Mary Katherine Aldin, personal communication, 1 Apr 2014.

274 **many simply leaving** Jon Bixler, "Folk Festival Sets Attendance Record," *Newport Daily News*, 26 Jul 1965, 2, reported: "Bob Dylan signified the end of the festival for many, as several hundred left after his 10 p.m. performance."

275 **"is as refreshing . . . gone before"** Nippert, "Finale of Festival," 2.

276 **"aura of true . . . cause"** Zhito, "Newport Folk Festival," 7.

276 **"mob scene"** Robert Shelton, Newport 1965 notebook, archived at the Experience Music Project, Seattle.

276 **"hordes of singers . . . debacle"** Irwin Silber, "What's Happening," *Sing Out!*, Nov 1965, 5.

276 **"the only . . . Art Nouveaux"** Travers, Letter to Archie Green.

276 **"feature a Radio City . . . enthusiasts"** Ochs, "Newport Fuzz," 58.

276 **"Throughout . . . not to hear"** Nippert, "Finale of Festival," 1.

277 **"The old guard . . . something wonderful"** Boyd, *White Bicycles*, 106.

277 **"He was truly puzzled . . . came in"** John Cohen, interviewed by author, 11 Apr 2014.

277 **"sitting off . . . his chair"** Shelton, *No Direction*, 211; Betsy Siggins, interviewed by author, 1 May 2014.

277 **"There was a dinner . . . and musical"** Maria Muldaur, interviewed by author, 4 Sep 2014.

278 **"After all this folk shit . . . and boogie"** Hajdu, *Positively 4th Street*, 262.

278 **"We were the unofficial . . . on fire"** Maria Muldaur, interviewed by author, 4 Sep 2014.

278 **"I thought he had so much promise"** Dick Levine, interviewed by author, 10 May 2014.

11. Aftermath

279 **"Make no mistake . . . live one"** Nelson, "What's Happening," 8.

279 **"When Dylan went electric . . . went there"** George Wein, interviewed by author, 8 Jul 2014.

280 **"You don't whistle . . . festival"** Mirken, "Newport," 13.

280 **"We could clearly . . . should be"** Christopher Brooks, personal communication, 19 Apr 2014.

281 **"Pete Seeger was livid . . . right now!"** Von Schmidt and Rooney, *Baby*, 261.

281 **"I've heard that . . . his anger"** Peter Yarrow, interviewed by author, 8 Jul 2014.

281 **"I was furious . . . right now"** "We Shall Overcome: An Hour with Legendary Folk Singer and Activist Pete Seeger," *Democracy Now!*, 4 Jul 2007, http://www.democracynow.org/2007/7/4/we_shall_overcome_an_hour_with, accessed 10 Jul 2014. Seeger told almost identical versions of this story to multiple interviewers, but none I have found before the 1990s include the axe.

282 **"I ran to hide my eyes . . . that aggressive, personally"** Pete Seeger, memo, 28 Jul 1965, revised 20 Aug 1965, in Seeger, *Pete Seeger*, 318–20.

282 **"I didn't understand . . . uncompromising"** Marine, "Guerrilla Minstrel," 38.

283 **"The left tried . . . a tradition"** Pete Seeger, letter to Charles Seeger, 1967, in Seeger, *Pete Seeger*, 320.

284 **"commercial junk . . . improvement"** Marine, "Guerrilla Minstrel," 38.

284 **"I suppose . . . tussle"** Pete Seeger, notes to *Waist Deep in the Big Muddy and Other Love Songs*, Columbia CS 9505, 1967.

284 **"Pete began the night . . . clothes from Europe"** Rooney, "Reflections on Newport '65."

285 **"You know him, he's yours"** Dylan emphasized his distaste for this introduction in *Chronicles*, making it worse by adding a third phrase that Gilbert did not in fact say: "Take him."

285 **"'The people' so loved . . . why we have poets and artisits"** Rooney, "Reflections on Newport '65."

286 **"split apart . . . I choose art"** Nelson, "What's Happening," 8.

286 **"If Pete Seeger . . . walk on it"** Reuss, "Folk Scene Diary."

287 **"'highly controversial' . . . property"** Sydney Schanberg, "L.I. School's Ban on Seeger Concert Is Ruled Unconstitutional," *New York Times*, 8 Jul 1966.

287 **Seeger was still forbidden** Tom Dearmore, "First Angry Man of Country Singers," *New York Times Magazine*, 21 Sep 1969, 42.

287 **"What can I sing . . . 'Smoky'"** Robert Elftstrom, dir., *A Song And A Stone*, 1972, excerpt posted at https://www.youtube.com/watch?v=1HfOILbAq-E, accessed 14 Jul 2014.

287 **"Who said that . . . protest"** *Eat the Document*, 1966 film footage, officially unissued but widely available as a bootleg.

288 **"We set up . . . again"** Mackay, *Bob Dylan*, 102.

288 **"Dylan may have been . . . explorations"** Jack Newfield, "Mods, Rockers Fight Over New Thing Called 'Dylan,'" *Village Voice*, 2 Sep 1965, 1, 10.

288 **"If they start . . . ya know how"** Scaduto, *Bob Dylan*, 216.

289 **"Dylan bounded . . . 'carnival'"** Kooper, *Backstage Passes*, 45.

289 **"Why didn't you . . . all about"** Scaduto, *Bob Dylan*, 217.

289 **"just about all over . . . do it there"** "Television Press Conference," KQED, 3 Dec 1965, in Cott, *Bob Dylan*, 73.

289 **"I knew they'd understand . . . catch on"** Scaduto, *Bob Dylan*, 217.

289 **"I ask myself . . . quitting anymore"** Scaduto, *Bob Dylan*, 211, 222.

289 **"I have a hunch . . . what I'm doing"** Haas, "Bob Dylan Talking."

290 **"Excuse me . . . other level"** Tony Glover, notes to *Bob Dylan: Live 1966*, Columbia/Legacy CD 65759, 1998, 32.

290 **"West Coast . . . teen topics"** Eliot Tiegel, "West Coast Clamors for Dylan Tunes," *Billboard*, 4 Sep 1965, 12.

291 **"If you don't . . . you're not a man"** James Perone, *Songs of the Vietnam Conflict* (Westport, CT: Greenwood, 2001, 32). The *Variety* headline was "Protest Disker Hits Draft Vandals."

292 **"They didn't want . . . *Copy it!*"** Kooper, *Backstage Passes*, 49.

292 **Dylan . . . wanted the Johnny Rivers sound** Jann Wenner, "Bob Dylan," in *The Rolling Stone Interviews* (New York: Paperback Library, 1971), 311.

292 **Clapton even curled his hair** Jann Wenner, "Eric Clapton," in *The Rolling Stone Interviews* (New York: Paperback Library, 1971), 18.

293 **"It's the thing . . . Tin Pan Alley"** Shelton, *No Direction Home*, 241–42.

294 **"There were essentially . . . of us"** Van Ronk, *Mayor of MacDougal*, 216–17.

295 **"My idea . . . historical-traditional music"** Shelton, *No Direction Home*, 239.

295 **"I know . . . folk songs"** and **"It comes about . . . to die"** Nat Hentoff, transcript of an interview for *Playboy*, Autumn 1965, printed in Artur, *Every Mind*.

295 **"Nowadays . . . ballads"** Loder, "Bob Dylan."

296 **"Mr. Dylan . . . as I can"** "Television Press Conference," KQED, 3 Dec 1965, in Cott, *Bob Dylan*, 76.

296 **"That's not . . . with age"** Haas, "Bob Dylan Talking."

296 **"ridiculous . . . thirty myself"** Nat Hentoff, transcript of an interview for *Playboy*, Autumn 1965, printed in Artur, *Every Mind*.

296 **"Dylan has apparently . . . everything else"** Shelton, *No Direction Home*, 307.

297 **"Never again . . . eliminate them"** Cleveland Sellers, *The River of No Return: The Autobiography of a Black Militant and the Life and Death of SNCC* (Jackson: University Press of Mississippi, 1973), 111.

299 **"Now it is over . . . anymore"** Julius Lester, "The Angry Children of Malcolm X," *Sing Out!*, Nov 1966, 25.

301 **"folk existed . . . into pop"** Charlie Gillett, *The Sound of the City: The Rise of Rock and Roll* (Cambridge, MA: Da Capo, 1996), 287.

301 **"fifteen grandly produced . . . away"** Scaduto, *Bob Dylan*, 223.

301 **"That's just the opposite . . . destructive"** De Turk and Poulin, *American Folk Scene*, 244.

302 **"He said . . . to be art"** Bauldie, *Wanted Man*, 72.

303 **"Rock music made . . . Janis Joplin"** Wein, *Myself Among Others*, 341.

303 **"B. B.! . . . failed as a *festival*"** Ellen Willis, "Newport: You Can't Go Down Home Again," *New Yorker*, 17 Aug 1968, 86–87.

303 **"got very emotional . . . bullshit"** Jim Rooney, letter to Ellen Willis, ca. Aug 1968, in the Ellen Willis papers, Arthur and Elizabeth Schlesinger Library on the History of Women in America, Radcliffe University.

304 **"four of the . . . days of my life"** Wein, *Myself Among Others*, 286.

305 **"feel like they matter . . . fantasies"** Scott Cohen, "Bob Dylan: Not Like a
Rolling Stone," *Spin*, Dec 1985.

305 **"He sang . . . through us"** Ruth Perry, personal communication, 24 Feb 2014.

306 **"Dylan is no apostle . . . the past"** Ellen Willis, "The Sound of Bob Dylan,"
Commentary, Nov 1967, 72. *John Wesley Harding* was released in December,
and Willis integrated a discussion of it into her rewrite of this piece, published
in *Cheetah* the following March.

BIBLIOGRAPHY

Artur, ed. *Every Mind Polluting Word: Assorted Bob Dylan Utterances*. Don't Ya Tell Henry Publications, 2006 (online), http://dvdylanjim50reviews.yolasite.com/resources/Reference%20%281%29.pdf.

Baez, Joan. *And a Voice to Sing With: A Memoir*. New York: Simon & Schuster, 2009.

Bauldie, John, ed. *Wanted Man: In Search of Bob Dylan*. New York: Citadel, 1990.

Bloomfield, Michael. "Dylan Goes Electric," in *The Sixties*, edited by Lynda Rosen Obst. New York: Rolling Stone, 1977.

Boyd, Joe. *White Bicycles: Making Music in the 1960s*. London: Serpent's Tail, 2006.

Brand, Oscar. *The Ballad Mongers: Rise of the Modern Folk Song*. New York: Funk & Wagnalls, 1962.

Brauner, Cheryl Anne. "A Study of the Newport Folk Festival and the Newport Folk Foundation." MA thesis, Memorial University of Newfoundland, 1983.

Bush, William J. *Greenback Dollar: The Incredible Rise of the Kingston Trio*. Lanham, MD: Scarecrow, 2013.

Cohen, Ronald D. *A History of Folk Music Festivals in the United States*. Lanham, MD: Scarecrow, 2008.

———. *Rainbow Quest: The Folk Music Revival and American Society, 1940–1970*. Amherst: University of Massachusetts, 2002.

Cohen, Ronald D., and James Capaldi, eds. *The Pete Seeger Reader*. New York: Oxford, 2014.

Coleman, Ray. "Beatles Say—Dylan Shows the Way." *Melody Maker*, 9 Jan 1965.

Cott, Jonathan. *Bob Dylan: The Essential Interviews*. New York: Wenner, 2006.

Crowe, Cameron. Notes to *Bob Dylan: Biograph*. Columbia C5X 38830, 1985.

De Turk, David A., and A. Poulin Jr. *The American Folk Scene: Dimensions of the Folksong Revival*. New York: Laurel, 1967.

Dunaway, David King. *How Can I Keep from Singing: Pete Seeger*. New York: Random House, 2009.

———. *Singing Out: An Oral History of America's Folk Music Revivals*. New York: Oxford University Press, 2010.

Dylan, Bob. *Chronicles*. New York: Simon & Schuster, 2004.

Einarson, John. *Mr. Tambourine Man: The Life and Legacy of the Byrds' Gene Clark*. San Francisco: Backbeat, 2005.

Faithfull, Marianne. *Faithfull: An Autobiography*. With David Dalton. New York: Cooper Square, 2000.

Glover, Tony. "Second Annual 2000 Words." Mariposa Folk Festival program, 1972.

Haas, Joseph. "Bob Dylan Talking." *Chicago Daily News*, 27 Nov 1965; available online at http://www.interferenza.com/bcs/interw/65-nov26.htm.

Hadlock, Richard. "The Kingston Trio: Tom Dooley—Tom Dooley!" *Down Beat*, 11 Jun 1959.

Hajdu, David. *Positively 4th Street: The Lives and Times of Joan Baez, Bob Dylan, Mimi Baez Fariña, and Richard Fariña*. New York: Farrar, Strauss & Giroux, 2001.

Hentoff, Nat. "Folk, Folkum and the New Citybilly." *Playboy*, June 1963.

Heylin, Clinton. *Bob Dylan: Behind the Shades Revisited*. New York: HarperCollins, 2003.

———. *A Life in Stolen Moments: Day by Day, 1941–1995*. New York: Schirmer, 1996.

———. *Revolution in the Air: The Songs of Bob Dylan, 1957–1973*. Chicago: Chicago Review, 2009.

Holzman, Jac, and Gavan Daws. *Follow the Music: The Life and High Times of Elektra Records in the Great Years of American Pop Culture*. Santa Monica, CA: FM Group, 1998.

Kooper, Al. *Backstage Passes and Backstabbing Bastards: Memoirs of a Rock 'n' Roll Survivor*. New York: Billboard Books, 1998.

Lerner, Murray, dir. *Festival!* Patchke Productions, 1967; Eagle Rock DVD 39101, 2005.

Loder, Kurt. "Bob Dylan, Recovering Christian." *Rolling Stone*, 21 Jun 1984; available online at http://www.rollingstone.com/music/news/bob-dylan-recovering-christian-19840621.

Mackay, Kathleen. *Bob Dylan: Intimate Insights from Friends and Fellow Musicians*. New York: Omnibus, 2007.

Marine, Gene. "Guerrilla Minstrel." *Rolling Stone*, 13 April 1972; reprinted in Cohen and Capaldi, *Pete Seeger Reader*.

Mirken, Caryl. "Newport: The Short Hot Summer." *Broadside*, 15 Aug 1965.

Montgomery, Susan. "The Folk Furor." *Mademoiselle*, Dec 1960.

Nelson, Paul. "Newport: Down There on a Visit." *Little Sandy Review* 30, 1965.

———. "What's Happening." *Sing Out!*, Nov 1965.

Nippert, Jane. "Finale of Festival Fills Every Chair." *Newport Daily News*, 26 Jul 1965.

Ochs, Mississippi Phil. "The Newport Fuzz Festival." *Realist*, Aug 1965, 11–12; reprinted in Ochs, *The War Is Over* (New York: Barricade Music, 1968).

Pankake, Jon, and Paul Nelson. "Flat Tire: The Freewheelin' Bob Dylan." *Little Sandy Review* 27, ca. Dec 1963.

Reisman, Arnold. "Folkniks Boo the New Dylan." *Quincy Patriot Ledger*, 27 Jul 1965.

Reuss, Richard A. "Folk Scene Diary: Summer 1965." Unpublished manuscript, courtesy of Ronald D. Cohen.

Rooney, Jim. "Reflections on Newport '65." Unpublished manuscript attached to letter from Rooney to Irwin Silber, 6 Aug 1965, from a copy in the private collection of Ronald Cohen. Extended excerpts with slightly different wording appear in Nelson, "What's Happening," and in Jim Rooney, *In It for the Long Run: A Musical Journey* (Urbana: University of Illinois Press, 2014), 48–49.

Rosenbaum, Ron. "The Playboy Interview: Bob Dylan." *Playboy*, Mar 1978.

Rotolo, Suze. *A Freewheelin' Time: A Memoir of Greenwich Village in the Sixties.* New York: Broadway, 2008.

Santelli, Robert. *The Bob Dylan Scrapbook: 1956–1966.* New York: Simon & Schuster, 2005.

Scaduto, Anthony. *Bob Dylan: An Intimate Biography.* New York: Grosset & Dunlap, 1971.

Seeger, Pete. *The Incompleat Folksinger.* New York: Simon & Schuster, 1972.

———. *Pete Seeger: His Life in His Own Words.* Edited by Rob Rosenthal and Sam Rosenthal. Boulder, CO: Paradigm, 2012.

———. *Where Have All the Flowers Gone: A Singer's Stories, Songs, Seeds, Robberies.* Bethlehem, PA: Sing Out, 1993.

Seeger, Pete, and Bob Reiser. *Everybody Says Freedom: A History of the Civil Rights Movement in Songs and Pictures.* New York: W. W. Norton, 1989.

Shelton, Robert. "Bob Dylan: The Charisma Kid," *The Folk Scene*, handout at the New York Folk Festival, reprinted from *Cavalier*, Jul 1965.

———. "Bob Dylan: A Distinctive Folk-Song Stylist." *New York Times*, 29 Sep 1961.

———. *No Direction Home: The Life and Music of Bob Dylan.* Milwaukee, WI: Backbeat, 2011.

Sounes, Howard. *Down the Highway: The Life of Bob Dylan.* New York: Grove, 2001.

Spitz, Bob. *Dylan: A Biography.* New York: McGraw-Hill, 1989.

Thompson, Toby. *Positively Main Street: Bob Dylan's Minnesota.* Rev. ed. Minneapolis: University of Minnesota, 2008.

Thomson, Elizabeth, and David Gutman. *The Dylan Companion.* Cambridge, MA: Da Capo, 2000.

Travers, Mary. Letter to Archie Green, 6 Aug 1965. Archie Green Papers, #20002, Southern Folklife Collection, Wilson Library, University of North Carolina at Chapel Hill.

Unterberger, Richie. *Turn! Turn! Turn!: The '60s Folk-Rock Revolution*. San Francisco: Backbeat, 2002.

Van Ronk, Dave. *The Mayor of MacDougal Street*. With Elijah Wald. Cambridge, MA: Da Capo, 2005.

Von Schmidt, Eric, and Jim Rooney. *Baby, Let Me Follow You Down: The Illustrated Story of the Cambridge Folk Years*. Garden City, NY: Anchor, 1979.

Ward, Ed. *Michael Bloomfield: The Rise and Fall of an American Guitar Hero*. New York: Cherry Lane, 1983.

Wein, George. *Myself Among Others*. With Nate Chinen. Cambridge, MA: Da Capo, 2003.

Wolkin, Jan Mark, and Bill Keenom. *Michael Bloomfield: If You Love These Blues*. San Francisco: Miller Freeman, 2000.

Zhito, Lee. "Newport Folk Festival Hit as Artistic and Financial Success." *Billboard*, 7 Aug 1965.

INDEX

Bantu Choral Folk Songs (Seeger album), 26

"Barbara Allen," 168, 232

Barbarians, the, 291

Bare, Bobby, 237

Barry, Margaret, 212, 231

Bartis, Peter, 259

Beach Boys, the, 187

Beatles, the, 173, 174–75, 178, 181–84, 196, 197, 211, 226, 292–93, 302, 306

beatniks and Bohemians, 59–60, 62–64, 67, 96, 184–85

Beecher, Bonnie, 50, 53

Beers family, 255, 275

Belafonte, Harry, 45–46, 47, 61, 71, 72, 74, 147, 149–50, 183

Belafonte Singers, the, 61

Berline, Byron and Lou, 248

Berry, Chuck, 39, 115, 175, 176, 183, 187, 199, 204, 218, 221, 298

Bibb, Leon, 47, 67, 143

Big Maybelle, 115

Bikel, Theodore, 6, 61, 101, 109, 111, 123–24, 127, 143, 162, 212, 250, 265–66, 268, 275, 280

Bill Monroe and His Bluegrass Boys, 126, 199, 231

Billboard, 18, 31, 82, 100, 111, 159, 197, 203, 271, 275, 290

Birmingham church bombing, 3, 152

Bishop, Elvin, 216, 219

Bitter End, 89, 93, 101

Bitter Tears: Ballads of the American Indian (Cash album), 158

"Black Crow Blues" (Dylan), 179

black power movement, 3, 297

Blonde on Blonde (Dylan album), 302

Bloomfield, Mike, 197–98, 204–5, 215–19, 226, 231, 243–44, 251, 256–62, 267, 292

"Blowin' in the Wind" (Dylan), 74, 81, 87, 90–92, 96, 98–99, 103, 107–8, 111, 124, 125, 126, 127–28, 128, 138, 143, 147–48, 151, 159, 168, 184, 194, 290, 293, 297

"Blue Moon of Kentucky" (Presley), 37, 71

Blue Ridge Mountain Dancers, the, 6, 241

bluegrass, 24, 65, 66, 126, 138

blues, 66, 73, 74–81, 90, 100, 103, 129–30, 153, 198; in England, 178, 195–96; at Newport festivals, 115, 122, 160, 162–63, 221–27; socially conscious, 194; white performers, 136–37, 215–19, 221–27

Blues Project, the, 284, 298

Bob Dylan (Dylan album), 78, 79–82, 104, 124, 178, 197

"Bob Dylan's Blues" (Dylan), 81

"Bob Dylan's Dream" (Dylan), 99, 105

"Bob Dylan's New Orleans Rag" (Dylan), 102–3

Boggs, Dock, 68, 295

Bono, Sonny, 291

"Boots of Spanish Leather" (Dylan), 145

Boston Globe, 162, 164, 272

Bourne, Randolph, 72

Boyd, Eddie, 220–21, 222

Boyd, Joe, 21, 214, 215, 226, 250, 252, 265–66, 276

Bradford, Alex, 115

Brand, Oscar, 6, 116, 118, 151, 212; *The Ballad Mongers,* 73

Brando, Marlon, 2, 30, 41, 42, 284, 287

Brecht, Bertolt, 194, 300

Bringing It All Back Home (Dylan album), 82, 186, 193–94, 196–97, 239, 280, 302

British folk scene, 87, 99–100, 242–43

British rock, 173–79, 180–81, 188, 292–93

Broadside (radio show), 89

Broadside newsletter, 19–20, 86, 87–92, 99, 101, 152, 156, 158, 162, 164, 167, 191, 196, 272, 280, 298

Broadside of Boston newsletter, 272

Brooks, Harvey, 288, 289

Broonzy, Big Bill, 26, 79

Brothers Four, the, 30, 61, 102, 118, 120, 183